PAINT AND PURPOSE

Shepperton Arts Centre
Shepperton Road
London N1 3DH
Tel: 0171 226 6001

Paint
and Purpose

A study of technique in British art

Edited by
Stephen Hackney
Rica Jones
Joyce Townsend

Tate Gallery Publishing

Published with the assistance of Tarmac Group plc.

Tarmac Group plc is an award winner under the
Pairing Scheme (the National Heritage Arts Sponsorship
Scheme) for its five year sponsorship of the Tate
Gallery's Conservation Department. The Pairing
Scheme is a Government Scheme managed by ABSA
(Association for Business Sponsorship of the Arts).

Front cover: (from left to right, top to bottom)
J.M.W. Turner, *Snowstorm – Steam-boat off a Harbour's Mouth* (detail) *c.*1842
John Everett Millais, *Ophelia* (detail) 1851–2
Duncan Grant, *Bathing in the Serpentine* (detail) 1911
Cross-section of Sir Joshua Reynolds, *The Age of Innocence c.*1788
Joseph Wright of Derby, *Vesuvius in Eruption* (detail) 1776–80
Edward Wadsworth, *Bronze Ballet* (detail) 1940
 © Estate of Edward Wadsworth 1998. All rights reserved DACS
David Bomberg, *The Mud Bath* (detail) 1914
James Abbott McNeill Whistler, *Nocturne in Blue-Green* (detail) 1871

Back cover:
Thomas Gainsborough, *The Rev. John Chafy Playing the Violoncello in a
Landscape* (two details) 1750–2 and microscopic image of yellow pigments
from the cello

Published by order of the Trustees of the Tate Gallery
by Tate Gallery Publishing Ltd
Millbank, London SW1P 4RG
Copyright © Tate Gallery 1999

A catalogue record for this book is available from the British Library

ISBN 1 85437 248 3

Designed by Caroline Johnston
Printed in Hong Kong by South Sea International Press

CONTENTS

ACKNOWLEDGEMENTS

Many individuals and institutions have provided invaluable help during the preparation of *Paint and Purpose*. On behalf of the editors and the other authors who feature in the book, we would like to thank them all. A name alone can give no idea of the scale of an individual's contribution; we wish there were space to be specific in this respect but, in default of it, refer the reader to the note at the end of each chapter, where details are given.

Firstly thanks are due to all the scientists who undertook analysis of paint and provided information and advice: Dr Marianne Odlyha of Birkbeck College; Dr Aviva Burnstock of the Courtauld Institute of Art; Dr Jaap Boon, Jos Pureveen, Dr David Rainford and Gisela van der Doelen of the FOM Institute for Atomic and Molecular Physics, Amsterdam; Dr Peter Klein of Hamburg University; Robert Tye of Kings College, London; Peter and Ann Mactaggart; Dr Ashok Roy, Raymond White, Dr Jennifer Pilc and Jo Kirby of the National Gallery Scientific Department; Dr Tom Learner from the Tate; Catherine Hassall and Libby Sheldon of UCL Painting Analysis Ltd; Dr Brian Singer and Dr Sarah Vallance of the University of Northumbria at Newcastle; Graham Martin of the Victoria and Albert Museum.

The following people and institutions have contributed in numerous ways: Kathleen Adler; Brian Allen; Liz Alsop; John Anderson and his team in the Tate's frame conservation department; Nancy, Lady Bagot; Shelley Bennett and her staff at the Huntington Library, San Marino, California; Jennifer Booth and her staff in the Tate Archive; Peter Booth; Peter Bower; Spike Bucklow; Dr Leslie Carlyle; David Clarke and his staff in the Tate photography department; Jim Coddington; Dr Judith Collins; Sarah Cove; Richard Cork; Jo Crook; Arabella Davies; Dave Davies; Hélène Dubois; Judy Egerton; Elizabeth Einberg; the Syndics of the Fitzwilliam Museum; Dr Susan Foister; Jim France; Veronica Franklyn-Gould; David Fraser Jenkins; Dr Matthew Gale; Angela Geary; The Getty Foundation; Karin Groen; Bret Guthrie; Robin Hamlyn; Karen Hearn; Sam Hodge; Richard Jeffries; Elaine Kilmurray; Andrew and Sheila Lanyon; Susan Lawrie; Jeremy Lewison; Anne Lyles; Ian McClure; Margaret MacDonald; The Paul Mellon Foundation; Paul Moorhouse; Edward Morris; Daniel Moynihan; the staff of the National Library of Wales, Aberystwyth; Andrea Nottage; Richard Ormond; Leslie Parris; Roy Perry; Viola Pemberton-Pigott; Norman Pollard; Cathy Proudlove; St Ives Trust Archive Study Centre; Joseph Sharples; Dr Roger Slack; Anna Southall; Charlotte Speleers; Lesley Stevenson; David Thickett; Piers Townshend and his team in the Tate paper conservation department; Robert Upstone; Charu Vallabhbhai; Jack Warans and his team in the Tate conservation workshop; Elizabeth West Fitzhugh; Andrew Wilton; Sally Woodcock; Martin Wyld; the staff at the Yale Centre for British Art, New Haven, especially Teresa Fairbanks.

Finally grateful thanks are due to Tarmac, our sponsors. The Tarmac Group plc is an award winner under the Pairing Scheme (a National Heritage Arts Sponsorship Scheme) for its five-year sponsorship of the Tate Gallery's Conservation Department. The Pairing Scheme is a Government Scheme managed by ABSA (Association for Business Sponsorship of the Arts).

Stephen Hackney, Rica Jones and Joyce Townsend

INTRODUCTION

RICA JONES

To my ideal history of art all sorts of servants would bring tribute, all sorts of workmen would be summoned to help. The delver in archives surely would be among them. So would the student of materials and techniques ... We must not mistake the history of techniques, or the history of artists, for the history of art ... I regard all questions of technique as ancillary to the aesthetic experience. Human energy is limited, or at least mine is; but if I had greatly more, there is nothing about all the ancillary aids to the understanding of a work of art that I should not try to master.[1]

So wrote Bernard Berenson in his foreword to D.V. Thompson's *Materials and Techniques of Medieval Painting*, published in 1936. Since that time, not only has the delver in archives achieved higher status, but studies into artists' techniques have multiplied both in number and kind, documentary investigations such as Thompson's having been massively augmented by detailed scientific analyses of actual paintings. Looking at the work done over the last twenty years at the National Gallery alone – a Technical Bulletin every year since 1977, three major exhibitions on technique and a number of other projects which have all involved the collaboration of conservators, scientists and art historians[2] – it is clear that this ancillary aid has an established role in the study of art history and in the evaluation (or re-evaluation) of the aesthetic experience.[3] Today pictures in art galleries, particularly when they undergo restoration, are routinely examined for their technical content not only as an aid to treatment but for the light it may throw on the painter's inheritance and intent.

Hence this book, which draws on some of the information accumulated in the Tate Conservation Department over the past fifteen years. Like the publication that inspired it, *Completing the Picture* of 1982,[4] *Paint and Purpose* presents detailed technical analyses of a number of Tate paintings. They range in date from 1594 to 1958, comprise

portraits, landscapes, allegories, oil sketches and subject paintings but have in common that all were painted in England (or by British artists working abroad) with media which have a tradition of use in Western art – oils, egg, natural resins, glues, gums and waxes. Paintings in synthetic media such as acrylic, therefore, are not included but will appear in a separate publication in 1999.[5] In its capacity as the national collection of British art the Tate exhibits painting from the sixteenth century to the present day. In selecting the artists for *Paint and Purpose*, we have tried to represent something of this time-span while shying away from presenting the chapters as a history of technique in Britain. For all that it has burgeoned in the last few decades, the study of methods and materials is deficient in the wealth of comparative evidence necessary for drawing conclusions, both for individual artists and their national schools. Reading through the chapters on the different painters, it is possible to discern patterns emerging which may one day turn out significant when viewed in a wider context, but on the whole we have tried to avoid the temptation of exploring them, preferring simply to assess the technical information from individual paintings and to look forward to some future time when our analytical knowledge of British and European art is such that these forays might be made with confidence.

Above all then, this book is about individual artists going about the creation of unique works of art using a range of materials that, like the letters of the alphabet, may be combined and recombined in numberless ways. The reasons for studying particular artists vary. Some of them, such as Whistler, Sargent and Wright of Derby, have been or will be the subject of major exhibitions; others such as Gainsborough, Turner, Gwen John and Wadsworth have been chosen as special subjects for research by individual conservators or scientists; Reynolds has been targeted for investigation specifically with a view of trying to restore the Tate's large collection of his work; all new acquisitions at the Tate now need a technical as well as an art historical catalogue entry, and

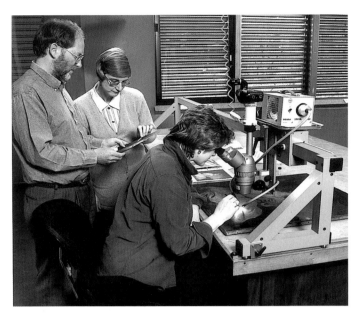

fig.1 Reynold's *Age of Innocence* being examined with a stereo microscope

all paintings undergoing restoration are examined in depth. This range of interest is reflected in the type of information contained in each chapter. We have not sought to impose too rigid a format except to exclude explanatory details of conservation treatments for every piece; on the other hand, the visible effect of conservation treatments, whether past, recent or proposed for the future, is very much part of the brief and is included wherever relevant.

Over fifteen years a great debt has been incurred to all the people and institutions who have contributed their knowledge and practical help. Specific references may be found in the notes at the end of the book and we would also urge the reader to consult the acknowledgement section on page 7. The technology required to isolate a complexity of materials in a microscopic sample of paint can seem very remote. A section on methods of examination and analysis can be found between pages 17 and 24. A glossary defining the materials used in painting and the methods of applying them can be found at the end of the book.

The paintings are presented chronologically in three separate sections defined by their support – canvas, panel and paper, the three types of support that have predominated in English easel painting, as in Europe generally. Until the turn of the sixteenth and seventeenth centuries, when linen canvas became popular in England, most fine paintings were done on wooden panels.[6] Thereafter, until the early nineteenth century when it became fashionable to paint on mahogany panel, their use was only sporadic (see page 46). In the nineteenth century wooden panels were used mainly for landscapes, genre and subject paintings;[7] they have never been revived on any consistent scale for portraiture. The example described in this book, Reynolds's *Portrait of George IV when Prince of Wales* of 1785 (see pages 146–151), is an exception both in date and genre. In the twentieth century cheap manufactured solid supports such as hardboard, plywood or 'Sundeala' (see page 178) have been much used for paintings whose dimensions fall within the standard manufactured sizes. Since the early seventeenth century, however, canvas has been the principal support for oil painting, usually primed with a ground to render it more suitable for receiving paint. Paper came into use as a support for oil painting in the late eighteenth century when the idea of doing landscapes out of doors in this medium became acceptable.[8] But in the work of both Thomas Jones (see pages 190–5) and John Constable (pages 196–201) there is a hint that this support was more than just cheap, easily portable and convenient to store away; in Jones's paintings of Naples, done for his own pleasure, and Constable's oil sketches, which were usually if not always a first step in the complex evolution of his landscapes, there is also a sense of intimacy. It is as if this support, traditionally associated with the writing down or drawing out of ideas, lent itself to the quiet production of a type of painting that had no great history in Western art.

Until twentieth-century technology introduced so many synthetic products, the materials available for use as media for painting did not change much over five centuries or more. Since the eighteenth century, new pigments have appeared which have altered the chromaticity of the artist's palette, but, when it came to mixing pigments with a medium to make paint, a sixteenth-century artist such as Gheeraerts could have chosen to employ materials very similar to those used by Sir Joshua Reynolds. Conventions of use have played a larger role in the history of painting than we may care to admit at first glance. In the 1670s, for example, Sir Walter Bagot, a Staffordshire landowner, set out to have his family recorded in a series of portraits. How might he have responded if his chosen artist, John Michael Wright, had, instead of oil paintings, produced images bound in printers' ink and carpenters' glue, believing like William Blake that oil paint was deadening to painting and that the glue had

been sanctioned by the 'divine carpenter'? (see pages 32–7 and 66–9). Sir Walter Bagot and J.M. Wright were still bound by the traditional view that the materials must suit the function of the painting, or in other words that the materials and methods must to a greater or lesser extent be durable.

The concept of durability lies deep in the history of painting as a craft, yet it did not disappear when Renaissance theorists and artists argued successfully that painting was also a liberal art. Until the late seventeenth century the guilds in northern Europe ensured the survival of the craft and, even when the French Academy assumed such powers in the 1660s, aspiring academicians there were still required to learn painting in an artist's workshop.[9] In England, however, the Company of Painter-Stainers, which had existed as a single entity since the early sixteenth century, never achieved the control over painting that it desired, despite a charter of 1581 that decreed amongst other things that no person, English or foreigner, should 'lay or work anything to be sold with varnish' unless he was known to be skilful by the Company, that all practitioners within a radius of four miles of the city should be subject to Company rules and that apprentices should be registered and trained for seven years,[10] although it has been pointed out that no details of their training were given.[11] Its published history is one of litigation and complaint – against other guilds such as the plasterers when they practised the art of painting other than with the five colours 'whiting, blacking, red lead, Yellow oker and Russet mingled with size only', or, more portentously, that 'Strangers coming into the Nation not subject to the government of the Company practised the art and mistery of painting staining.'[12] This complaint of 1624 refers to the long established habit of foreign artists working at court as the painters of and for the nobility. They usually lived in districts that lay beyond the Company's jurisdiction; Van Dyck, for example, was settled at Blackfriars, at that time a 'liberty' and therefore not in the Company's control. This meant that they could employ their own, foreign-born assistants and organise their own systems of training, which was usually done in their country of origin.[13] While the court and so many aspiring to it patronised and protected foreign artists, the powers of the Company were necessarily limited. With the arrival of the Hanoverian monarchy in 1714, a lineage not noted for interest in the arts, the Company's powers might have been revived but it was too late. The day of the guild was over in Europe as a whole. The Painter-Stainers's last

recorded search of artists' premises, one of its statutory rights in maintaining standards, was in 1708 and thereafter it regulated the affairs only of the trades of painting.[14]

Between this period and the time leading up to the foundation of the Royal Academy in 1768, a very interesting situation existed in England. With no restrictions from guild, academy or court, artists were free to set themselves up and bid for work at all levels with or without formal training.[15] While a section of the aristocracy still favoured foreign painters, others patronised British artists and there was a growing urban middle class eager to have its portrait painted and which was freer from inherited ideas about what might or might not constitute art.[16] Artists' colourmen had existed to supply materials for fine artists, amateurs and painters-and-decoraters from at least as early as the seventeenth century. Turquet de Mayerne, writing about the practice of fine painting from about 1620 to about 1646, lists three places where colours could be bought: 'At Mr Burtons in Lothbery against the exchange in the back seid. Against the stockes by the fishmarket. In Newgatt market, at the signe of the Tabard Mr Therlow',[17] and, as noted on page 36, an author of 1668 mentions being able to buy canvases ready primed. A few years earlier Richard Symonds reported under *Pryming of Cloathes* (canvases) that 'Fenn the Liegois in Purpoole Lane, layes on no size. demands 5s for a pott of colors of the bigness of a Walnut.'[18] By 1710 colours 'are all to be bought ready ground at the colour shops in London, tied up in bits of bladders … All painters generally have them thus'.[19] While it may be inferred from the inventory made of the contents of Jervas's studio after his death in 1739 that artists also still prepared their own canvas and ground their own paint if they desired,[20] the situation existed that no one need have gone through a studio training in order to be a painter, or to be a successful one if his work caught the fancy of the new, fickle, urban market. Those who did undergo training were not committed to a lengthy stay. To take Jervas again, he studied for one year with Sir Godfrey Kneller, made copies of paintings at Hampton Court and then took off for France and Italy, where he studied the painting of the old masters.[21]

In general there was a simplification of technique during the first half of the eighteenth century. Some painters modelled themselves on a particular trait they had observed in Kneller: 'He painted with an amazing quickness, without any appearance of study, and often times at the first stroke. This set them all upon painting quick, tho'

they were far from being obliged to it by the multiplicity of their occupations.'[22] Others, Gainsborough being the outstanding example, developed out of that simplicity a superb technique of their own (see pages 48–53). One surprising feature common to all, until Reynolds came back to London from Italy in 1753, is that despite the reduction in the factors that have traditionally underpinned the craft of painting – workshop training, guilds, knowledgable patrons – so much sound technical practice survived. As described on pages 46 and 47, paintings of this period do suffer from an inbuilt problem of microscopic crackle that reduces their visual impact on the viewer and which may be attributed to lack of craft training, but apart from that they are resilient. What was left of the workshop tradition presumably was backed up by an oral tradition, which must have flourished for example at the evening academies for life-drawing, and by the manuals of painting that had been increasing in number since the later decades of the seventeenth century.[23] Few of these were without valuable information. Some of them plagiarise books that themselves relied heavily on earlier sources, representing therefore a continuity of sorts; others were more original – Bardwell's *Practice of Painting* of 1756[24] was according to its lights a genuine attempt to unravel the secrets of colouring in the old masters and provide a dependable method of painting likewise.

It needed an act of will to overturn the heritage of sound technical practice and one artist did it. It is a great irony that Joshua Reynolds, unusual in any case in having done a two-and-a-half-year training with an established artist, became heir to the strongest technical tradition available in the 1740s by having chosen to study with Thomas Hudson the portrait painter. Hudson's master, Jonathan Richardson, had trained with Riley, who in his turn had been a pupil of Soest, a Netherlandish-trained painter who worked in England from the 1640s until his death in about 1680.[25] The technique underlying Soest's highly polished style of portraiture is rock solid and, although it became simplified as it was passed down the generations, it is recognisable in Hudson's work. It is also visible in the portraits Reynolds did between leaving Hudson and travelling abroad. A portrait by Hudson is a very stable item. In Reynolds's eyes it was also a tired remnant of the system of 'portrait manufactories', large studios in which paintings were produced by the master with copious help from assistants, drapery painters and pupils. This system had a long and not undistinguished history in Europe. In the hands of a painter like Van Dyck it was

simply a reasonable way of producing high-quality portraits for a large demand and was not much different from a large architectural firm today operating under one name; indeed once he became established, Reynolds himself proceeded similarly. In some hands, however, it was reduced to something like a production line, in which the poses, props and above all the painterly effects were stock. The last major foreign-born exponent of this system was Kneller, who in much of his output produced formulae that some of his contemporaries found cynical. Reynolds must have regarded Hudson similarly.

In the light of this then it was not sufficient for Reynolds to introduce the grand style into portraiture by iconographic means alone; in order to achieve the glowing colours and varied textures he had seen in old master paintings in Italy, he invented new techniques using a combination of materials whose inability to withstand the test of time has become legendary. When first painted though, his veils of colour and richly worked textures must have looked magical and strikingly different from the average new portrait. In such a climate of freedom as surrounded the making of art in London, this factor alone would ensure that his techniques were remarked on. It should, however, be remembered that he did not himself teach the use of these methods either to his own pupils or to the artists at the Academy while he was its president. His annual discourses did not deal with craft and he did not concern himself with the day-to-day teaching. His impact came from the appearance and content of his paintings and the enormous success of his life as an artist, advocate for painting and friend of the cultural great.

Reynolds, however, was not the only catalyst for change; other artists incorporated new techniques more cautiously. Interest in encaustic painting, for example, originated in France in the 1750s[26] and at least one painter there, Joseph Vien, practised painting with wax. George Stubbs used waxy media and also produced paintings in enamel on metal and ceramic supports.[27] Richard Wilson was using 'a magylph or majellup of linseed oil and mastic varnish' in the mid-1760s[28] (Reynolds's first written reference to megilp dates from 1767).[29] As the British School grew in confidence, it seems its appetite for ingredients which would enrich its paint grew with it, though not all painters chose to follow. Hudson's other successful pupils, Joseph Wright (see pages 54–9) and John Hamilton Mortimer, developed personal techniques which respected their early training and on the whole have proved stable. Gainsborough remained largely a sound techni-

fig.2 Detail of the shrinkage cracks in William Hilton's *Editha and the Monks searching for the Body of Harold*, exhibited in 1834. The area depicted in the photograph measures 150 × 265 cm

cian. James Barry wrote from Italy in the 1760s criticising 'such people as ours who are floating about after Magilphs and mysteries'[30] but as the recipient of the letter was Reynolds his words were wasted.

For artists born in the late eighteenth century the megilps, asphaltums (bitumen), waxes and secret nostrums[31] widely available to enrich the appearance and enhance the handling properties of oil paint were a lure that must have been hard to resist and the Tate Gallery is far from alone in possessing paintings which have cracked alarmingly (fig.2), become seriously darkened or reacted badly to nineteenth-century methods of restoration.[32] A good proportion of Turner's paintings have altered demonstrably[33] (see pages 70–3); people in his own day begged him in vain to take more care over materials. Ruskin wrote in *Modern Painters*,

> How are we enough to regret that so great a painter should not leave a single work by which in succeeding ages he might be entirely estimated? The fact of his using means so imperfect … appears to me utterly inexplicable … If the effects he desires cannot be to their full extent produced except by these treacherous means, one picture only should be painted each year as an exhibition of immediate power, and the rest should be carried out, whatever the expense of labour and time, in safe materials, even at the risk of some deterioration of immediate effect.[34]

Whether or not an artist succumbed to the lure seems to have been a matter of his own choosing; it certainly did not come from training. By this time the workshop tradition was severely reduced and the Royal Academy Schools did not supply the deficiency. Ruskin complained that 'The Academy taught Turner nothing, not even the one thing it might have done,– the mechanical process of safe oil-painting, sure vehicles, and permanent colours.'[35] From the turn of the century, however, warnings began to appear that substances like megilp could lead to ruin, not least from John Opie, professor of painting at the Academy, who lectured in this vein in 1807.[36] But many continued the practice, half-hoping their own technique would prove longer lasting, such were the attractions of using these media which were delightful to paint with and produced the mellow tones and richly textured surfaces seen in old masters.[37]

Yet to concentrate on the cracks and the darkening is to miss more important and positive points. For a start not

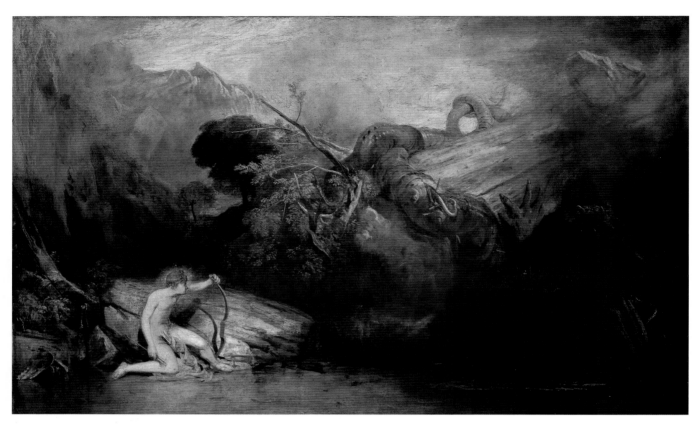

fig.3 *Apollo and Python*, exhibited in 1811, by J.M.W. Turner.
The 'strange gleams of blue and gold' that Ruskin described
in the sky have faded away[38]

all painters used these damaging materials to excess; Constable for instance did not (see pages 196–201), his natural caution reinforced by his friendship with George Field, the colour chemist, whose research into artists' materials proved beneficial to many.[39] More important still, the freedom from technical restraint that permitted the use of damaging materials had the inspiring corollary that artists were able to develop a technique and style entirely personal to themselves.[40] This can be seen as early as the 1740s; a face painted by Ramsay, for example, was constructed in a completely different way from a Hogarth, a Gainsborough or a Highmore.[41] Artists were free to manufacture a technique to suit their own vision and if, as in Constable and Turner, the vision and the manual skills were above the common weal then the results were stupendous. It had repercussions in France. When Constable won the gold medal at the Paris Salon of 1824 for the *Hay Wain* (fig.4) and two other paintings, the technique was commented upon as well as the subjects and the naturalism. One of the critics, A. Jal, published an imaginary conversation at the Salon between an artist and a philosopher which illustrates the responses of the opposing schools of thought:

ARTIST. I see that Monsieur Gassies wanted to imitate the English artists, and squandered great thicknesses of colour in his foregrounds solely to try out Constable's wild and bizarre manner.
PHILOSOPHER. I read in a newspaper that …
John Constable had sent some paintings to Paris which have caused a stir amongst all our landscape painters …
AR. … Here they are.
PH. But my friend, you know this one is very good. It is nature itself … I don't know if, as art, they are worthy of estimation; but for me, I regard them highly; I think they have a marvellous naivety.
AR. They are indeed extraordinary in respect of their tones. They are just like the countryside. These landscapes are true, this cart is true, these boats are true; but the process which leads to this expression of the truth is very close to *affectation*. One might say

a perpetual groping. This work in relief, these lumps of brown, yellow, green, grey, red and white, all thrown down one on top of the other, stirred up with a trowel, cut with a palette-knife and then glazed over to return them to the realm of harmony and mystery; these, I tell you, are less artistic than mechanical; and what is more this mechanism is without grace.

PH. What does it matter if it creates for me the perfect illusion?

AR. But the illusion dissipates if you draw a bit closer; and as landscapes are made to be seen at close quarters, the painter has missed his mark, because he has calculated his effect like that of a decoration, in which the lines, tones and details would only reach the eye across large tracts of air.[42]

For many other reasons besides the arguments made here, the *Artist*, representing the academic school, was fighting a losing battle but the fact remains that Delacroix was not the only French painter to find inspiration in English freedom of expression. A characteristic of most of the 'movements' in nineteenth-century painting (and since) is that the new vision required a new technique or techniques, even if the practitioners often ended up combining the new with a good deal of old; in England Pre-Raphaelitism is an example (see pages 74–85).

Aware of the visible decay in so much of the painting from the near past, artists born in the nineteenth century often turned to books and responsible artists' colourmen for knowledge of materials. This period saw the first scholarly attempts to understand historical painting techniques, with translations being published of ancient treatises; for example Mrs Merrifield published her translation of Cennino Cennini's *Il Libro dell'Arte* in 1844[43] and Eastlake's great *Materials for a History of Oil Painting*[44] came out in 1847. Manuals of painting appeared thick and fast throughout the century, the authors' introductions

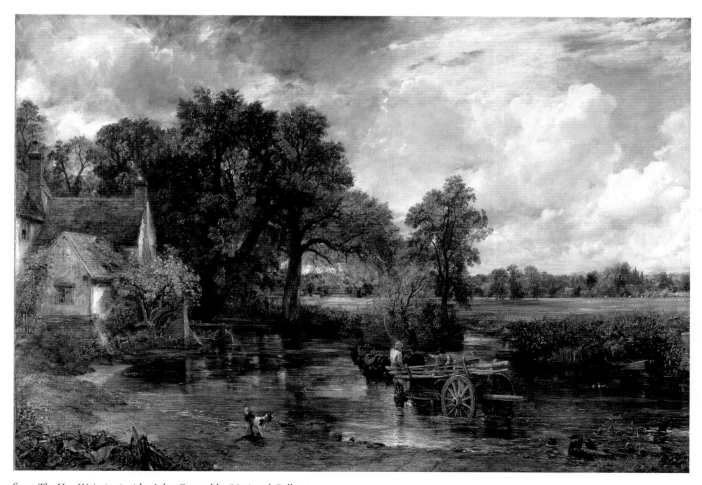

fig.4 *The Hay Wain* (*c.*1820) by John Constable (National Gallery)

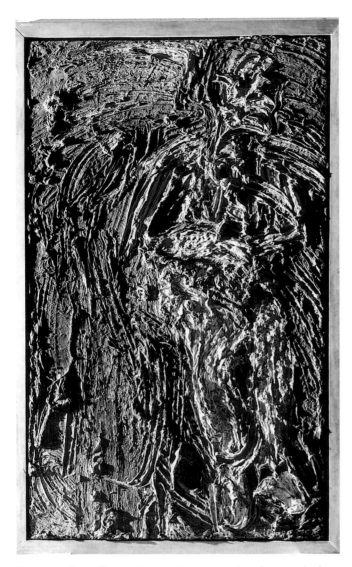

fig.5 Leon Kossoff's *Man in a Wheelchair* (1959–62). Photographed in raking light from the left to show how the artist has created his image in low relief, using only oil paint. The painting is on board, measures 214.5 × 123 cm and weighs 100 kg

often making the point that there was hardly any technical training for artists elsewhere.[45] William Holman Hunt of the Pre-Raphaelites (see pages 80–5) and later on George Frederic Watts (see pages 90–5) were amongst those who corresponded with colourmen in an attempt to avoid impermanent materials (Roberson[46] and Winsor and Newton respectively). It can be argued that since the mid-nineteenth century the colourman has been more influential in painting technique than the art schools, so many of which have effectively continued the academic tradition by teaching a great deal of drawing but hardly any craft. Whistler persuaded Sickert that he could teach him to paint better than the Slade School (see page 120), and Whistler himself had done his training in France (see page 86).

Industrial methods of production have prevailed in the manufacture of oil paint since the nineteenth century. Colourmen have sought to introduce consistent handling properties in their range of colours, a quality that is not inherent in pigments; a tube of paint, therefore, contains in addition to pigment and medium much material to achieve this effect.[47] In the twentieth century this has suited some painters, for example Gwen John and Stanley Spencer (see pages 102–7 and 132–7), who were content to use paint more-or-less straight from the tube; others have preferred to substitute or supplement tube colour with home-made paint. Lanyon sometimes ground his own oil paint (see page 182); Wadsworth was amongst those who turned to egg tempera for its clean precision and bright opaque tones (see pages 170–5). Household paint has also found favour in the twentieth century, for example Wallis and Nicholson (see pages 158–63 and 164–9). Above all, the twentieth century has been the age of 'no rules', a concept that visitors to the modern collection at the Tate may be forgiven for thinking a very modern phenomenon but which, as we have seen, has a long and fertile pedigree in British art.

METHODS OF EXAMINATION AND ANALYSIS

STEPHEN HACKNEY AND JOYCE TOWNSEND

Knowledge of how paintings are made is constantly being refined by the accumulation of further evidence and by the availability of scientific examination methods or analytical tools. Throughout this century scientific analysis has become increasingly sophisticated, exploiting specific characteristics of atoms and molecules to achieve very high sensitivities. This has made possible the analysis and characterisation of very small quantities of complex material on paintings. Methods of examination and mapping of whole paintings have also advanced.

Effective examination of a painting can be achieved by a combination of simple but thorough observation reinforced where necessary by more sophisticated analysis. The process of examining a painting is constrained by many factors, time and expense being the most obvious. The simplest and most predictable methods are employed first and, depending on the need, more sophisticated, costly and time-consuming methods are resorted to later. Ideally examination is non-destructive but sometimes very useful information can be gained only by taking tiny samples from the painting. Any sampling of a painting must effectively be invisible. Therefore any analytical tool employed must be sensitive at the microgram level, and should be capable of identifying several components of a complex mixture of aged materials.

Simply inspecting a painting on display or in the studio reveals an enormous amount of information. When looking at a painting or any other complex object the eye and the brain have to filter and sort large amounts of data. To some extent we are victims of hereditary responses that have evolved to help us survive; we see what we are looking for. Initially we may not notice quite significant aspects if we do not consider them important in establishing our first impressions. On further observation these may become very obvious, sometimes completely changing our perception of a painting (fig.6). It takes time to sort through the large amount of information that bombards the eye. Quiet, informed contemplation is required to scan a static image and to assess different

levels of interpretation of a painting, essential before any conclusions are attempted.

This approach is traditionally used by a connoisseur to form an opinion on a painting. It is possible to identify the subject, the artist and many other attributes of a painting such as the medium, the nature of the support, varnish, and colour of the ground. The reliability of this approach depends on the painting conforming to the observer's

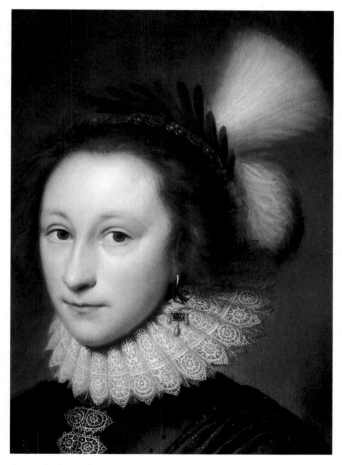

fig.6 The face of *Susanna Temple, later Lady Lister* by Cornelius Johnson (1620). At first sight, her left ear-ring seems to 'float' in front of the ruff. On closer examination, the viewer becomes aware of a white bird linking the ear-ring to its fastening

previous experience. A connoisseur uses considerable prior knowledge of the work of a range of related artists in order to make an attribution.

Detailed observations give the examiner vital clues. Observations can be recorded photographically or by written descriptions. In addition, simple measurements can be made. Measurement of dimensions, including overall thickness, canvas weave type and yarn count, estimates of crack separation, breadth of brushstrokes and varnish and paint thickness help to characterise a work and can be carried out without recourse to specialist equipment.

An image and each of its components can best be read under an even, broad and continuous spectrum of light; typically slightly diffuse daylight from overhead skylights is used in many galleries and conservation studios. This gives the best colour rendering, optimises the scatter of light by pigments, and makes good use of the full distribution of wavelengths of reflected sunlight. Diffuse light spread evenly across the painting surface is ideal for reading an image but denies the eye evidence of shadows from the third dimension of the paint surface. The brushstrokes and other evidence of the application of paint by the artist, left in the surface of a painting, are revealed best in directional light. Very strongly **raking light** creates intense shadows, exaggerating surface conformation and helping to reveal much detail, as can be seen in the photograph (fig.7).

Light simply reflected from the surface of an object without taking on its colour is called **specular reflection**. By lighting a painting with a diffuse light from a point source and viewing it at a corresponding angle to the sur-

fig.7 A raking light photograph of *Yellow Landscape* (1892) by Roderic O'Conor showing unevenness in the stretching of the canvas and thickly brushed paint

face, specular reflections can be observed. Effectively the surface of the painting behaves like a mirror. Specular reflections provide information about a surface, in particular, about the various types of gloss or mattness of areas and also about the extent to which regular texture such as a canvas pattern is revealed in the final surface.

A **stereo microscope** (fig.1), typically in the range of times 7 to 40 magnification, is used to assist visual examination. A light is concentrated on the area to be inspected, typically from a tungsten-halogen bulb through fibre-optic guides, which also filter out unwanted radiation and prevent excessive heating of the illuminated area. The angle of illumination can be adjusted to create raking and diffuse conditions as described above. At the lower magnification, features evident to the naked eye become easier to observe, for instance, brush-strokes, canvas texture, cracks, small damages or lifting and flaking paint. A delicately painted image that remains convincing in its depiction of detail even under closer inspection begins to unfold under the microscope. Changes of brush pressure during painting, the impression of a pen, pencil or other tool on paper, slight unsteadiness of hand, the overlay of one colour on another, and the rheological properties of the wet paint become apparent. Such information is of interest in defining the overall characteristics of a painting and may be of immediate importance to a conservator; for instance, if it can be seen that a varnish or paint film extends across age cracks, then it may be deduced that it is unlikely to be original (fig.8).

fig.8 Detail of *Nocturne in Blue and Silver: Cremorne Lights* (1872) by James McNeill Whistler examined through a stereo microscope at low magnification (× 10) showing the application of paint to depict a light on the distant river bank (see pages 86–9)

Zooming to higher magnification (× 40) increases detail at the expense of depth of focus and field of view. Some features revealed at lower magnification are not as efficiently inspected at this level, but others can only be seen at higher magnification. It is possible to observe the finest cracks at these levels and to distinguish coarsely ground pigments, some of which can be identified *in situ*. Finer pigments can be seen but not distinguished. Other phenomena such as some types of surface degradation are also visible, for instance, sometimes the effects of surface shrinkage caused by drying can be seen.

Technical photography is a useful non-destructive tool, sometimes to record what has already been observed and sometimes to reveal invisible aspects. Raking, reflected or transmitted light photographs record the visual examination previously described and can be used for future comparison particularly if taken before a major treatment such as lining. Many organic materials including paint media and varnishes and certain pigments fluoresce, that is, emit visible light when illuminated with UV (ultra-violet) radiation. When a painting is illuminated under UV radiation it exhibits in varying degrees **UV fluorescence**. This effect is used as a standard examination technique usually accompanied by photography. Old and unpigmented natural resin varnishes fluoresce quite strongly whereas many pigmented media are comparatively non-fluorescing. It is therefore usually possible to see whether there is retouching on top of a varnish. Such retouching may be the work of a previous restorer and can be distinguished from the artist's own work. There are other ways of identifying later 'overpaint', microscopy for instance, but this is one of the most convenient. Fluorescence can also reveal the thickness and evenness of application of a varnish. An unvarnished or thinly varnished painting under UV may also show fluorescence associated with a particular pigment, for instance that of purpurin, a component of natural madder (fig.9 and fig.79).

Infra-red photography or, alternatively, **infra-red reflectography** exploits differences in reflectance of a painting exposed to infra-red (IR) radiation. Unlike fluorescence this reflected radiation cannot be seen directly by the eye. It requires either a photographic film or an electronic sensor sensitive in the infra-red region. The photographic film is processed in the usual way; the sensor is connected to a cathode ray display for direct viewing and later image capture. Whichever technique is chosen, the purpose is usually to detect action by the

fig.9 Ultra-violet fluoresence photograph of *Yellow Landscape* (1892)
by Roderic O'Conor, an unvarnished painting, showing fluorescence
of the pigments

artist that is now covered by thin layers of later work. The most dramatic example of IR reflectography is to observe the original drawing, a technique that has been effectively exploited on Flemish panels. The transmission of IR radiation through a paint film depends on the pigments used and the thickness of the film. With the best IR reflectography equipment it is possible to select wavelengths that are transmitted by the paint film but absorbed by graphite drawing underneath. IR photography is less effective since it is sensitive to a range of wavelengths in the near infra-red. Reds are more easily penetrated since their absorption bands are in the blue-green region, but blues and greens have absorption bands that spread into the IR and they may remain opaque and therefore dark on the IR print. Prussian blue is, for example, opaque whereas less expectedly ultramarine is transparent because its

absorption band ends immediately at the end of the visible range. Infra-red techniques are most useful when the paint film is very thin and the underdrawing opaque. They are often employed when some feature underneath is visible but not easily discerned, in which case they can demonstrate better what is there. Interestingly, after having seen some drawing revealed by an IR image, it is much easier to interpret that drawing on the painting with just the naked eye (fig.10 and fig.11).

As in medical applications **x-radiography** is used to reveal material that is opaque to x-rays. In the medical field x-rays are absorbed by bones and transmitted by most other body tissues. For paintings, heavy metal pigments, by far the most abundant one being lead white, are opaque and appear light on the x-ray film (fig.12). The x-rays are produced by an x-ray tube placed behind a

fig.10 Infra-red photograph detail of *The Awakening Conscience* (1853–4) by W. Holman Hunt revealing underdrawing indicating a change to the composition of the arm (see pages 80–5)

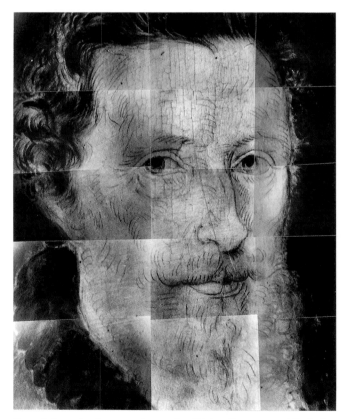

fig.11 Infra-red reflectograph mosaic of *Robert Devereux, 2nd Earl of Essex* (c.1596–9) by Marcus Gheeraerts (Trinity College, Cambridge), showing drawing under the thin flesh paint of the face very clearly. Kindly provided by Spike Bucklow of the Hamilton Kerr Institute (see pages 26–31)

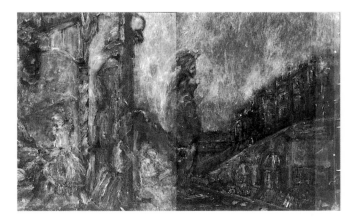

fig.12 X-radiograph (2 plates) detail of *Brighton Pierrots* (1915) by Walter Sickert. The nervous brushmarks are not visible in the final image. Absence of major alteration is to be expected in this, the second version of this image (see pages 120–5)

painting, or more usually underneath a painting laid on a flat surface. The film is placed on the front of the painting as close as possible, usually resting on it. Exposure is by trial and error, altering the kilovoltage to compensate for differing thickness and materials. After development the negatives are viewed on a light-box. Opacity depends on thickness as well as the mass of the metal nucleus. Relatively thick iron or copper tacks used to attach the canvas to the stretcher are easily seen on the x-radiograph whereas a thin film of red ochre (iron oxide) is not so visible. More importantly x-radiographs show any alterations to the composition during painting, particularly those involving the use of lead white, such as alterations to the position of feet or hands, or reworking of faces. But they will not reveal areas of lighter metal pigments, such as zinc, aluminium or titanium, when these are obscured by lead white. Sometimes, when the artist has reused an old painted canvas, the entire composition underneath will be revealed. As important as these dramatic examples is the more subtle information that can be read on an x-radiograph. Connoisseurship can be extended beyond what is normally visible. It is sometimes possible to identify the work of particular artists by their methods of applying lead white, to distinguish between those who carefully plan their work and those who make alterations throughout or to parts of their painting. When presented with two identical paintings it is often possible to tell which was the first version, with its tentative experiments and alterations, and which was the copy, more deliberately and confidently laid down.

To obtain further information about a painting small samples can be taken for analysis. This can only be done if the painting is in some way damaged or degraded and is often justified to solve a conservation problem where an incorrect analysis would put the painting at risk. The maximum size of a sample is limited by the need for its removal to be invisible under all normal viewing conditions, and its minimum size depends on the use to which it is to be put. For identifying the principal component, most analytical techniques are sufficiently sensitive to succeed on the smallest sample that can be removed and manipulated, for instance, analysis of the surface pigments may only require a few scrapings. But for detecting some minor components of a complex mixture or the medium of a lean paint film it may not always be possible to take a sufficiently large sample.

Cross-sections also provide sampling problems because a sample must be taken through more than one layer and remain coherent. A cross-section gives the best overall view of how a painting is constructed. The sample is placed on a block of transparent synthetic resin in a mould, and further resin is added to embed the sample. The laminate is then ground down close to the sample at right angles to the paint sample surface, and then further abraded until the sample is exposed edge-on. It is then polished and viewed in reflected light under the microscope. Different layers of varnish, paint and ground can be examined. Any hidden layers, glazes, scumbles and sometimes drawing can be seen. The interface between layers indicates whether they were applied wet-in-wet or after a period of drying, and the thickness of each layer indicates its purpose and application. The use of **UV fluorescence microscopy** allows observation of the fluorescence of each layer. This helps to examine the distribution of organic components such as the medium or any organic pigments. It adds further information but does not provide a definitive analysis. **Staining of the cross-section** with stains specific for proteins or oils further helps to distinguish the different layers.

Inorganic pigment analysis can be carried out with **optical microscopy**. A small sample of paint is made into a dispersion on a microscope slide in a liquid or resin of known refractive index, and is viewed in transmitted, plane-polarised light. Examining the optical properties of the inorganic pigments present allows a skilled and experienced microscopist to identify most of the commonly used pigments, even in quite complex mixtures. Virtually

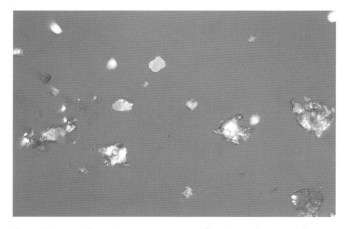

fig.13 Pigment dispersion at × 400 magnification under crossed polars showing individual pigment particles of green earth and red and yellow ochres. Sample taken from *The Rev. John Chafy Playing the Violoncello in a Landscape* (c.1750–2) by Thomas Gainsborough (see pages 48–53)

all historic pigments can be identified, because they were ground by hand and tend to have large particles (fig.13). From the mid nineteenth century onwards, many pigments were machine-ground, and most today are too finely-ground for the optical microscope to resolve their distinguishing features. Other techniques have to be used to back up judgement in these cases. However, optical microscopy also reveals the presence of extenders, ground glass, sand and other unusual components of a paint formulation, and shows whether the medium and/or varnish are discoloured. It can be used to identify fibres taken from wood, paper or textiles employed for the support of the painting.

The choice of a particular analytical technique is informed by the holistic examination of the painting and seeks to answer specific questions posed by the examination. It is also informed by a knowledge of the sensitivity of a particular technique to the small quantity of sample that is usually available. The identity of pigments in a tiny fleck of paint, or in a layer within a cross-section, can be confirmed by analysing the elements that are present, and subsequently deducing which combination of pigments gave rise to the range of elements detected. Most **scanning electron microscopes (SEMs)** are equipped to carry out such analysis, which is known as **EDX, energy-dispersive x-ray analysis**. In practice the technique is often used to distinguish among two or three possibilities when the pigment particles look similar, or are very finely ground. It reveals unexpected elements, should they be present, and can also be used to infer the presence and type of extenders in the paint (fig.14). Electron microscopes can provide very high magnifications, which are useful when a study of paint defects or deterioration is being carried out. **X-ray fluorescence spectroscopy (XRF)** is a related technique to EDX, which can be used to analyse the surface of paintings non-destructively. Its drawback is that only the immediate surface can be analysed, whether this is dirt, varnish, overpaint or the top layer of the artist's paint.

On occasion it is necessary to identify a compound more exactly – perhaps to confirm whether a particular material was used in the ground, when the artist wrote about the use of something other than the commonly found lead white and chalk or gypsum, and implied that he used it only over a certain time period. **X-ray diffraction (XRD)** is a suitable method for the identification of crystalline compounds such as pigments and extenders. The structure and spacing of atoms can be characterised

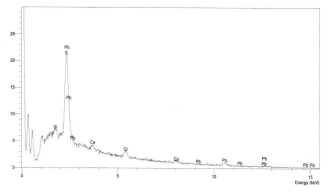

fig.14 Energy Dispersive x-ray analysis (EDX) spectrum showing the elements present in the yellow flower which Ophelia holds (John Everett Millais, 1851–2, see pages 74–9). Chromium and lead from the chrome yellow pigment can be detected. The chrome yellow is mixed with lead white, hence the peak for lead is very strong. Small peaks for silicon and calcium suggest the presence of kaolin and chalk extenders. Optical microscopy confirmed these interpretations

by the way x-rays interact with them. The resulting diffraction pattern can be compared to patterns for known minerals and pigments.

The **identification of paint media** can still provide a considerable challenge. Oils traditionally used by artists, such as linseed, walnut and poppyseed, are chemically somewhat similar, and consist of different proportions of a number of common components. Some of these components alter chemically on ageing, and some can interact with other materials found in traditional paint, such as natural resins and waxes. As a consequence, the analysis of historic paint media may involve the recognition of compounds that were not even present in freshly dried paint. Two approaches have been used for this problem: broad characterisation of chemical class, and initial separation of all the components so that the more abundant or more characteristic ones can be identified separately.

The technique known as **FTIR (Fourier transform infra-red spectroscopy)** is used for broad characterisation of chemical class. Its working principle is that particular chemical bonds absorb infra-red radiation of characteristic energy: the amount of infra-red energy transmitted at each wavelength then indicates whether and how strongly a bond has absorbed energy. This information can be used to work out the structure of a compound, or more usually, to compare its infra-red spectrum with that from known materials. The method can for example indicate that a wax or a resin is present in paint, but not which ones. Complex formulations such as

Reynolds's or Turner's paint can be very difficult to interpret with this technique, though simpler mixtures can be identified with confidence.

Another analytical technique for the broad characterisation of materials is **differential scanning calorimetry (DSC)**. This technique relates the heating and melting behaviour of a paint sample to the energy supplied to it by means of controlled heating to several hundred degrees Celsius. Linseed, walnut and poppyseed oils, for example, will all behave in a broadly similar way when they are new. When they are old, they respond differently to heating. A glue medium will respond in still another way, and will change phase or melt over completely different temperature ranges. If a mixture of materials is present in the sample, it is possible to recognise their individual responses to heating. **Thermomicroscopy** is a simpler version of this technique. It involves heating a paint fragment at a controlled rate, while observing it through a microscope to see when it softens, melts, or starts to darken and char. Waxes, for example, melt over a narrow temperature range, and if the paint sample remains unchanged when heated beyond the melting point of common waxes, this gives the conservator useful information on the absence of waxes.

The best characterisation of complex paint samples involves separating all the components, by a technique known as **chromatography**. Typically, the paint medium is extracted with solvents and the solution is run through a specially prepared column which slows each component by a different amount. Then the components are detected as they come out one by one. If gas is used as the carrier, the technique is called **gas chromatography (GC)**. If the carrier is a liquid, **HPLC or high-performance liquid chromatography** is the term used. The best way to make use of valuable and tiny samples from paintings is to detect all the components as efficiently as possible. Today a **mass spectrometer (MS)** is used, linked to the chromatograph, to characterise the mass of each component exactly. The combined techniques are called **GC-MS** (a technique which is used to analyse oils, resins, waxes and gums) and **HPLC-MS**, often confusingly referred to simply as HPLC, used in this publication for the analysis of proteins.

Another method of preparing a tiny paint sample would be to heat it in a controlled way, and then analyse the fragments as they are dissociated from the main sample, with the object of calculating which mixture of materials gave rise to the fragments. The heating to high temperatures is called **pyrolysis**, usually abbreviated to **Py** or **PY**. These fragments can then be fed directly into a mass spectrometer for characterisation by **Py-MS**, or can be further separated by a gas chromatograph as a second stage (for components that are many and complex) when the technique is known as **Py-GC-MS**. More information can be obtained from a pyrolyzed sample by the technique known as **DTMS, direct temperature-resolved pyrolysis mass spectrometry**, where the fragments split off at each of many narrow temperature ranges are fed into the mass spectrometer for identification. This generates a great deal of information which can show, for example, whether the oil component was prepared with a drier, and if natural resins and waxes in the sample are as old as the paint itself, or whether they derive from a coating or varnish applied long after the artist's lifetime.

For the analyst there is another challenge. To make effective and reliable use of these methods of analysis requires a knowledge of the way artists' materials, including all the different pigments and media available, interact with one another, and age naturally in the indoor conditions in which most paintings are kept. This is a source of much demanding research. Oils were the first class of materials to be studied, notably at the National Gallery, London. It is only in recent years that commercially available instruments have had sufficient sensitivity for the analysis of tiny (microgram) paint samples which are known to be complex mixtures. Some of the work done to develop suitable methods of sample preparation for chromatography has been carried out recently. In fact, many of the paintings analysed and discussed in this book were studied in the course of collaborative projects between the Tate Gallery and research institutions such as FOM-AMOLF (FOM Institute for Atomic and Molecular Physics, Amsterdam), the National Gallery, the University of Northumbria at Newcastle, and Birkbeck College, University of London. Such projects involve the trials of many different methods and techniques, to select one which is suitable and reproducible for the analysis of each type of artists' materials. The Tate Gallery, like other museums, increasingly works with other research institutions in order to combine all the analytical resources available, and to increase our understanding of the many and complex materials which artists use to communicate their vision.

PART I

Paintings on Canvas

MARCUS GHEERAERTS the younger (1561–1635/6)
Portrait of Captain Thomas Lee 1594

RICA JONES

Born at Bruges and son of the painter of the same name, Marcus Gheeraerts was brought by his father to England in 1568 and apparently remained there for most of his life. He probably received his training in London from his father and, it has been suggested, from the Flemish painter, Lucas de Heere.[1] He may also have trained in the Netherlands. He made his career as a portrait painter and this is one of his earliest portraits.[2]

It is painted on linen, the earliest painting on canvas in the Tate. Woven linen as a support for painting was used in Ancient Egypt, and there are documentary references to its use in Europe during the fourteenth century.[3] Many paintings in tempera on fine canvas from the late fourteenth and fifteenth centuries survive in northern Italy,[4] but the earliest examples north of the Alps are from the late fifteenth century. This is a period from which a few religious paintings have survived, for example *The Entombment of Christ* by Dieric Bouts[5] in the National Gallery. By the mid-sixteenth century in Venice stretched linen had all but replaced panel for most genres of painting, but elsewhere the change was more gradual; considerations of size, the need for portability and its greater suitability for the 'painterly' style probably vied with tradition for many years as the factors in the choice. There are examples of full-length portraits on canvas from various courts in Europe from the 1560s but in this, as in so many other matters artistic, England lagged behind. Gheeraerts, the heir to Continental tradition, was amongst the first, possibly the earliest artist to popularise canvas for formal English portraits. His full-length, *Queen Elizabeth I, The Ditchley Portrait* (National Portrait Gallery), is from about 1592 and the Woburn Abbey *Robert Devereux, 2nd Earl of Essex* from around 1596.[6] Like theirs, the canvas of *Captain Lee* is plain-woven and of fine weight.

There are two ground layers, both off-white in colour. The first, which was applied after the canvas had been given a thick coat of animal glue size, is composed mainly of chalk with gypsum, lead white, some ochres and lamp black. The second layer is a thicker coat principally of lead white with small amounts of the other ingredients, making it whiter and less absorbent than the layer beneath. Both layers appear to be bound in oil.

Before Gheeraerts drew out the figure that we see in this painting, he had started another portrait, whose painted head and collar appear in the x-radiograph (fig.15). It is off-set from centre and no other trace of the figure is visible with either x-ray, infra-red, surface microscopy or cross-sectioning. The absence of a beard makes it unlikely that this is a false start for *Captain Lee*. A cross-section taken from the right side of Captain Lee's

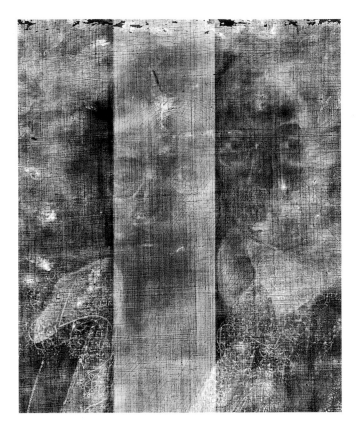

fig.15 X-radiograph of *Captain Lee's* head with the underlying head off-set to the right

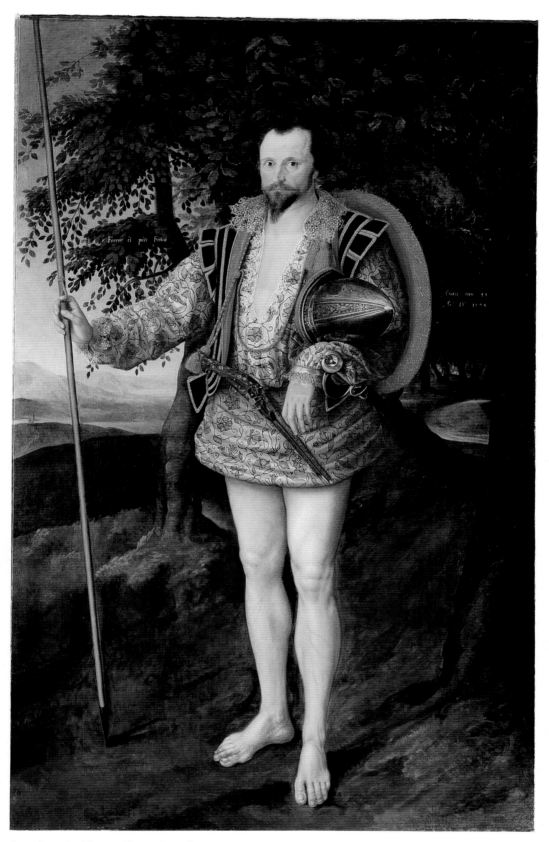

fig.16 *Portrait of Captain Thomas Lee*, oil on canvas 215 × 133
(84⅜ × 52⅜). After restoration in 1994–5. T03028

hair, showing the smooth surface of the underlying pink flesh paint and its similar thickness to all the layers in the final painting indicates that Gheeraerts did not scrape down the head. Instead he obliterated it locally with off-white paint similar to the second ground layer. He then appears to have drawn the outline of the present figure fairly simply in black crayon, although with one exception discussed below it is not easy to detect with either infra-red or surface microscopy. It is unlikely that the under-drawing for Captain Lee was as detailed as that for the panel portrait *Robert Devereux, Earl of Essex* of 1596–9 from Trinity College, Cambridge (see page 21) and this may constitute a technical difference between Gheeraerts's work on canvas and panel in this period. Only wider analysis of his œuvre will tell, but it seems likely that one might expect to find a more elaborate underdrawing in the panel portraits; perhaps because their solid surfaces were easy to draw on, there was a long tradition of employing dark lines of drawing as tonal half-shadows in the face. This device, which has become known as the 'turbid medium effect', relies on the knowledge that a dark line or mark beneath a thin layer of lighter paint will read as a darker, pearly tone of the overlying colour. Many a sixteenth-century portrait painter utilised it in the flesh tones.[7] Here, however, Gheeraerts has not used it in the densely painted face and hands, in which all the tones were mixed up on the palette and applied wet-in-wet; he has kept it only for the striking presence of the veins in the legs. Fig.17, a cross-section through the vein on the front of his left leg, shows the black crayon-line beneath the flesh tone, in which colour there is no modulation at this point. Given the tendency of oil paint to become more translucent with time, these lines are probably more visible now than in 1594; nevertheless they would always have been a noticeable and quite intentional feature of this portrait.

The technique of painting is fairly straightforward. Most colours are opaque and were made from mixtures on the palette before being worked into one another on the canvas. There is no discernible preparatory under-painting anywhere. The sky was made from mixtures of lead white and smalt, in which pigment there has been some fading. The principal pigment in all the greens is azurite mixed with varying amounts of yellow and red ochres, lead tin yellow or massicot, Cologne earth, black, green earth and pale smalt or ground glass. For the distant, bluey green hills he mixed the azurite with lead white and smalt. There has been loss of colour in the centre of the woods to the right of his head, an area that now looks yellowish brown. Originally it was probably a dark bluish green, smalt apparently being the component that has faded. The flesh tones contain lead white, chalk, vermilion and small amounts of black, azurite and yellow ochre. His shirt is lead white mixed with bone or ivory black, and the blackwork embroidery was applied on top. His jerkin appears to be lamp black, the blackest black but a very slow drier in oil. This probably accounts for the presence of ground glass or pale smalt in the mixture to act as a siccative. Ground glass occurs also and for the same reason with the yellow ochre describing the braid on his jerkin. The highlights here are lead tin yellow or massicot. The shield was painted first in an opaque red mixture before being given a thick glaze of red lake with a bit of black mixed in to enrich its tone.

The whole upper section of the painting above an imaginary horizontal line about 3 cm from the top of his head is a later addition. When acquired by the Tate in 1980, the painting appeared as in fig.18 and it was evident on stylistic grounds that all four sides had been extended at some later period. The extensions were not made by sewing pieces of canvas to the perimeter of the original; instead the painting was lined on to a double thickness of canvas and mounted on to a larger stretcher. Some time since then, probably in the late nineteenth century, another double lining was added to reinforce the first. While the varnish was being removed in 1994, these edges were examined microscopically to ascertain their date and to see if they might be replacing original canvas now lost. The presence of Prussian blue in the foliage above his

fig.17 Cross-section through his left shin, showing the black underdrawing applied directly to the ground and lying beneath the unmodulated flesh paint. Photographed at × 100 magnification

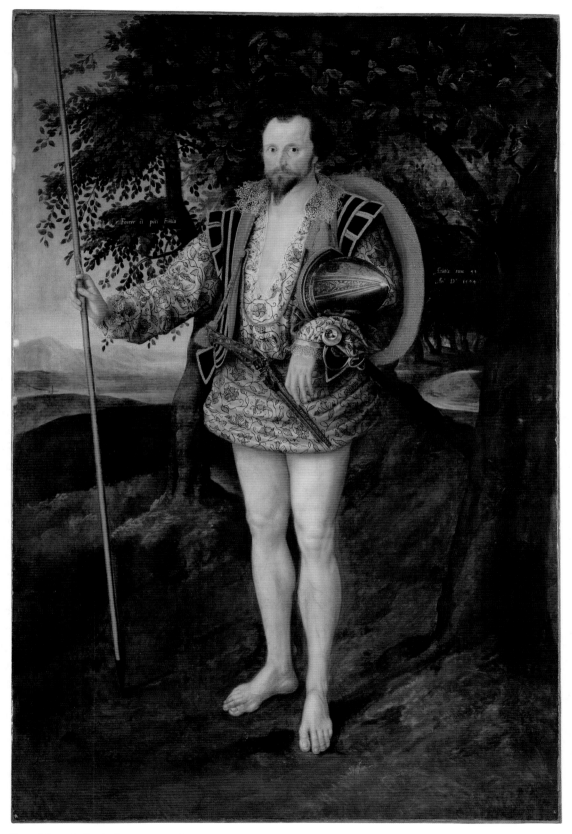

fig.18 The painting before conservation treatment
with some test cleans through the varnish at the left edge.
Its dimensions were 233 × 152 cm

head indicated an earliest possible date of c.1710. Large quantities of bituminous pigments in all the added areas except the sky suggested an actual date in the late eighteenth or early nineteenth century. Until the 1930s the painting remained at Ditchley, the home of Captain Lee's cousin and patron of Gheeraerts, Sir Henry Lee. It is possible that the enlargement was done in order to incorporate the painting into a decorative scheme containing full-lengths of a later date, in which on average there is more space around the figure than in late Elizabethan portraits. The x-radiograph and subsequent varnish removal revealed that by the time of the first lining the edges of the original canvas had suffered much damage (fig.19 and fig.20). Each edge was punctured at regular intervals by old tack-holes around each of which the paint and canvas were worn. There are two ways of interpreting these holes: possibly the picture was first painted on a loom and then, when finished, tacked to a strainer of smaller dimensions, which would mean that the irregular line of broken paint just inside the tack-holes represents the original turnover edge and therefore the painting's original dimensions as exhibited. Alternatively the original turnover edge could have run some small distance beyond the tack-holes. If the painting had been left to deteriorate on its original strainer, falling loose as the canvas rotted around each tack, a ready solution found often enough in old collections would be to reattach the paint-

ing by nailing into the strainer from the front. In this case the line of broken paint could be explained by the deteriorating canvas creasing against the inner front edge of the strainer. Either way it was clear that the painting could never have been much larger than 2 or 3 cm beyond the tack-holes because on each edge apart from the top the x-radiograph revealed arcs of weave distortion (cusping) related to the dimensions of the canvas when it was first stretched for priming (fig.19). The lack of cusping along the top edge and the knowledge that it cuts through the crown of the earlier head (fig.15), indicated that more original canvas had been removed here and there was no evidence to suggest how much. So the decision was made

fig.19 X-radiograph of the top right corner before cutting down, showing the original canvas and the extensions (attached to the stretcher). 'Cusping' from the first stretching of the original canvas prior to priming is visible just below its corner

fig.20 The painting after varnish removal, cutting down, strip-lining and remounting on a new stretcher, showing the original extant edges punctuated by tack-holes and the irregular line of paint abrasion running inside them

to cut the upright and bottom edges back to their maximum possible original size, using the cusping as a guide, and to leave the top as it was. Fig.20 shows the painting after cutting down and after the removal of most of the varnish and all later overpaint except on the retained edges in the upper half of the picture. The quality of painting in the sky and foliage on the top extension was good enough to leave in place.

Apart from the losses at the edges and the colour changes noted above, the painting is in exceptionally good condition, particularly for this period in which historical methods of varnish removal have in too many examples wrought damage on a sad and serious scale. One reason for this fortunate escape may be the presence in some areas of a very old varnish, which is resistant to the gentler methods of varnish removal used these days and may have protected delicate areas in the past. There is no way of telling if it might be the original varnish but its presence in samples taken from the real top edge, where it is overlapped by paint from the extension, indi-

cates an eighteenth-century or earlier origin. It extends over most of the dark greens and browns in the lower half of the painting and in some areas on the right. A few, very minor patches of abrasion in the embroidered shirt and in the legs suggest that this tough varnish once covered the whole painting, and we have been lucky that the person who had to rub hard to remove it from the figure and sky stopped there, either because he knew in advance that the dark areas would be more sensitive to cleaning action (the lead white in the light areas produces a stronger paint film) or because it was quicker just to clean the lighter parts. This varnish was not removed in the recent cleaning because it would have required the use of solvents considered too strong for the painting. There is probably, therefore, more contrast than originally in the tonal relationship between the figure and the landscape.

Analysis of pigments was carried out in 1995 by Rica Jones using optical microscopy followed up in most cases with EDX by Dr Joyce Townsend.

JOHN MICHAEL WRIGHT (1617–1694)

Mrs Salesbury with her Grandchildren, Edward and Elizabeth Bagot 1676

MARY BUSTIN

With a down payment of £70 on 9 December 1675, Sir Walter Bagot secured the services of John Michael Wright, artist and antiquarian, to paint a series of six portraits of his family for his country seat of Blithfield Hall in Staffordshire. These paintings were to be 'put into gilded frames and sent down to Blythfield in a case all together'.[1] This is a portrait of Sir Walter's mother-in-law, Mrs Salesbury, of Bachymbyd, Denbighshire, with her grandchildren Edward, Sir Walter's heir, and Elizabeth.[2] It was a good commission, worth £140.

On 27 July 1676, the artist contacted Sir Walter to say that the pictures were in 'great forwardnesse, three are done (besides the head of Mr Salisbury) the fourth is in hand; and the fifth to witt, Madam Salisbury's with the two children I intend to goe in hand withall about the latter end of the next week'. At this point he was anticipating having all the paintings finished by the end of August. Even so he was taking longer over them than normal, as he had reserved them 'to be done by my owne hands, and therefore have taken the more tyme'.[3] In the event, the pictures were dispatched in two deliveries, the last, which included the portraits of Mrs Salesbury (fig.23) and one of Sir Walter (fig.22), left London on 24 October 1676.

The delay may not have been due to tardiness on Wright's part. His correspondence suggests that Sir Walter kept a close interest in the commission through 'earnest, frequent letters'[4] which prompted Wright to alter the composition and key design elements in *Mrs Salesbury and her Grandchildren*, now visible in the x-radiograph, to include the imminent arrival of another child. Back in December 1675, when Wright visited the family in Staffordshire, Elizabeth was 9 months old and probably

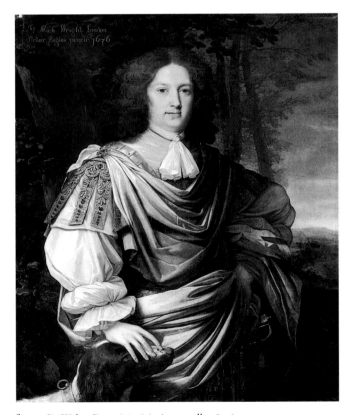

fig.22 *Sir Walter Bagot* (1676) (private collection)

fig.21 Wright's signature was found when the eighteenth-century lining canvas was removed from the back of the painting in 1994. He was not the king's painter as he stated: that honour belonged to his rival, Sir Peter Lely

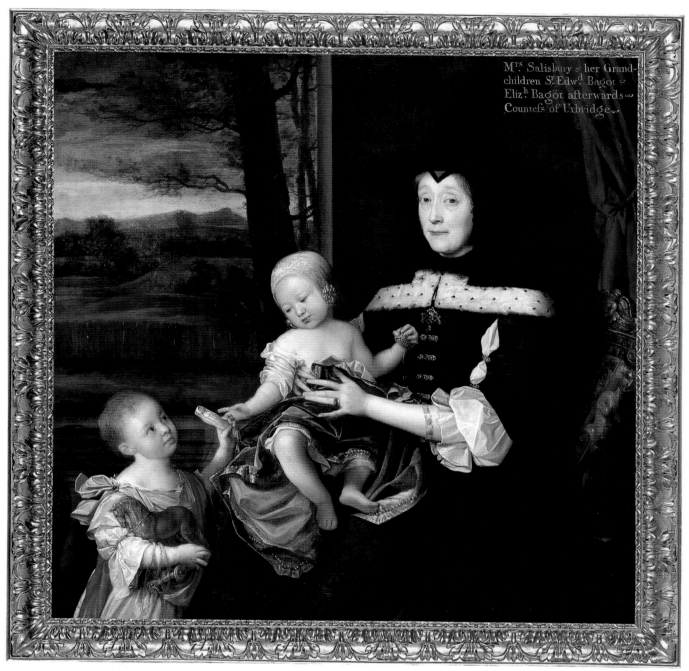

fig.23 *Mrs Salesbury with her Grandchildren, Edward and Elizabeth Bagot,*
oil and oil-and-resin on canvas 127.5 × 133.1 (50³⁄₁₆ × 52³⁄₈). In its
original frame, recently re-gessoed and re-gilded by John Anderson,
Tate Gallery Frame Conservation Department. The family name was
sometimes written 'Salisbury' in the eighteenth century, the probable
date of the inscription. T06750

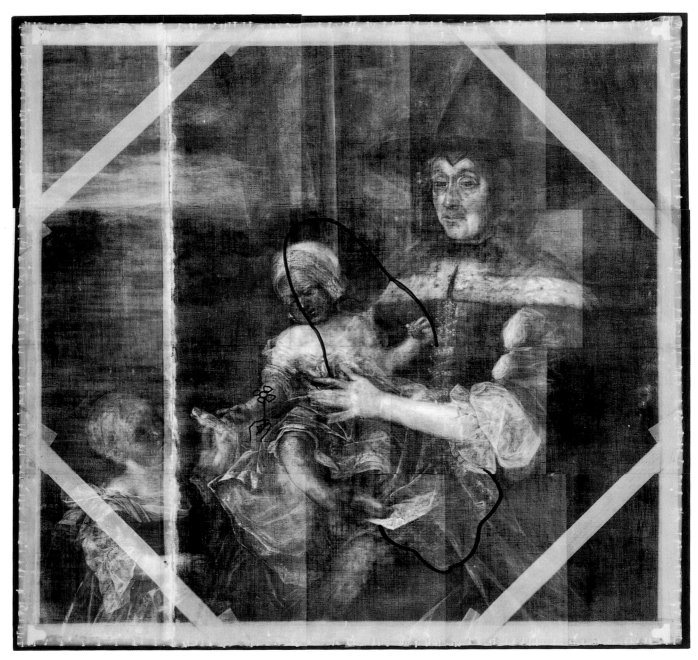

fig.24 X-radiograph showing the oak stretcher. The vertical white
line running through the boy's cheek represents the double thickness
of primed canvas at the seam. Some of the underlying, rejected
images are marked, for example the curved outline of the swaddled
baby and the flower

still partly in swaddling clothes.[5] By the time he started the painting, her mother, Jane, was pregnant again. On 24 September 1676, a baby sister was born.

Originally, as the x-radiograph reveals (fig.24), Mrs Salesbury grasped a swaddled baby instead of a squirming infant. She held it upright, gathering the bearing cloth behind her fingers so that the little boy could show his sister a flower; the anemone-like flower was proffered gently between his forefinger and thumb. With another baby in the family, the picture had quickly to be brought up to date. A bouncing child was superimposed over the swaddled shape, and Edward's arm was shifted (several times as is now apparent to the naked eye). Instead of a flower, he holds a toy, a swaddled doll, perhaps to represent their new sister. The bearing cloth was reinstated beneath the infant Elizabeth. The blue silk with its costly border of pearls recalls the rich textiles used for christenings. These blankets were highly valued, and became family heirlooms, a feature recognised by the artist who endeavoured to present it in the most valuable of blue pigments, ultramarine. Along with the gilded teething ball,[6] which replaced a rattle of beads and ribbons, it may have belonged to the Bagot family.

'I could not hinder my selfe from making [this] peece curious and full of variety', Wright wrote topically to Sir Walter on 24 October 1676. 'It hath beene extraordinary taking heere. And as I have often promised (much after the humour of women in labour) never to make more childrens picturs againe, yett after the trouble is over I have still relapsed, but now I thinke I have done, having almost killed two or three children with colds though in the heat of summer designing them naked, they crying and bawling about mee and the mothers ready to scold me out of my house ...'[7] The shifting positions of arms and legs visible in the x-radiograph bears this out. The children were models. Wright used them for this tricky stage, to set the poses while he painted the figures and costume. Similarly a model was used for Mrs Salesbury. He used studio props to try and entertain the children while he was painting. The horse on wheels also appears in his portrait of *James Cecil, 4th Earl of Salisbury and his Eldest Sister, Lady Catherine Cecil, later Lady Downing* (*c.*1668), at Hatfield House, Hertfordshire.

The unusual dimensions of the portrait necessitated the use of two pieces of cloth sewn together. By act of parliament, linen cloth was sold in widths of one ell; 45 inches (114 cm), with 2 inches (5 cm) allowance in the brown cloth for shrinkage during bleaching.[8] Once the fabric was stretched, this produced the standard width of 40 inches (100 cm) used for half-length portraits 'to the knee'. To make the square canvas for Mrs Salesbury's picture, the artist reused two discarded paintings, increasing the width of an old half-length by 10 inches (25 cm) by adding a strip of primed cloth to the left edge. Although crudely stitched with tent stitch, not an easy task given the thickness of the dry priming that had to be pierced, the position of the seam was carefully considered; it had to run between the principal figures. Traces of the previous unfinished paintings may be seen in the x-radiograph. Mrs Salisbury was preceded by a lady in ringlets wearing a feathered headdress, another of Wright's studio props; it appears in other portraits, notably in the *Lady in Masquerade Costume* of 1679.[9] The image is thin and may have been rubbed down before the new portrait was started.

The trough created by the seam is filled with pink oil paint mixed to match the surrounding salmon-coloured priming. Discrepancies in the pigments used in the priming and in the pink infill may mean that Wright bought his canvases ready primed. The author of the *Excellency of the Pen and Pencil* in 1688 found the priming of canvas 'moiling work and besides, it may be bought ready primed cheaper and better than you can do it yourself'.[10]

Wright's palette for painting included lead white, smalt, natural ultramarine, red lake, dry-process vermilion, yellow ochre, charcoal black, verdigris, malachite, green earth, umbers and a green, glass-like pigment.[11] For 'rich lakes and rich oltramarine bleu', Wright levied a charge of £3.10s, When Sir Walter balked at paying extra, the painter replied, 'it is customary among artists to have those colours payd particularly by themselves'.[12] Earlier, in January, he commented that 'I could have saved that charge and given you colours wch would have seemed as rich at the present but would not have lasted as these will'.[13] This anticipates a noticeable change in the visual appearance of the cheaper alternatives soon after completion of the painting.

Ultramarine was an expensive commodity. At the sale of the contents of Sir Peter Lely's studio[14] the best ultramarine was priced from £3.12s to 16s.8¼d the ounce. Smalt, a similar shade, but an unstable pigment, was by contrast 3d the ounce. Wright was sparing in his use of the ultramarine. On the bearing cloth he used only a small quantity as a glaze over a rich undercoat of smalt which in turn had been strengthened by an underlying opaque grey. The smalt has discoloured to a pale greyish brown hue which now overwhelms the ultramarine glaze. It

fig.25 Cross-section, photographed at × 250, from Edward's red cloak which was painted over the landscape. The brown landscape was painted in two layers worked wet-in-wet on top of the pink ground (bottom layer). A thin layer of varnish was laid on top to seal the surface. This made it possible for the artist to continue to paint in a lighter colour on top without disturbing existing paint. Wright then laid in a base layer mixed from charcoal black, lead white, and red lake over the dark underlayers to create a pale purple. The cloak was then modelled in pink, working from dark to light, with a thin final glaze on top, seen as a broken layer below the discoloured varnish

fig.26 The same cross-section seen in ultra-violet light, photographed at × 125. The retouching varnish on top of the brown landscape fluoresces as a thin line

should match the brilliant blue of the cloth beside the grandmother's fingers. This blue area is unfaded because the artist corrected the position of the fingers using a brush loaded with ultramarine paint instead of smalt. Wright was insistent that 'the pictures would have been good without them [the best pigments], though not so rich and beautiful the workmanship would have been as well, for many persons will not goe to the price of rich lakes and rich oltramarine bleu'.[15]

The oil paint was prepared by grinding the powder pigments in oil until they formed a stiff paste. Richard Symonds, an English traveller who met Wright in Rome, reported that he 'told me 8 May 1651. He always uses Vernish mixt with his colours.'[16] The addition of a natural resin, suspected by the low softening point and solubility of the black paint in the dress, would affect the handling, the drying time and would impart a high gloss to the paint giving the appearance of 'thorough finishing'[17] that enabled Wright to deliver the portrait to the owner when it was barely touch-dry. Mrs Salesbury's portrait took barely ten weeks from start to finish.

Wright pre-mixed most of his shades on his palette. Working wet-in-wet, he feathered the boundary between tones to create a smooth transition, particularly in the flesh, to contrast with a crisp brushwork used for the fabrics. He worked from dark to light, initially in opaque layers. When these were barely dry, he modified the shade with thin washes of semi-transparent colour: for example, in a mixture of vermilion and red lake over the pink base of Edward's cloak (fig.25). Adjustments to the composition, where new paint was required over well-dried paint, involved a rewetting of the paint surface. For this, Wright applied a thin layer of natural resin; notably where the boy's cloak strays over the landscape (fig.26).

The commission included frames. Wright upgraded the pattern that Sir Walter had chosen without consulting him first. He reported to his client: 'Yor frames are all in hand … they are richer than the first pattern I shewed you wch you liked, but my Lady Wilbraham coming hither caused her's to bee made broader and richer in breadth of the wood and gilding wch occasioned that I did the like to all yors that they might not bee inferior to any in that county.'[18] The new frames, of raffle leaf Bolection moulding,[19] are deeply carved both in the wood and in the overlying gesso. They were to be water-gilded which used the same amount of gold leaf but required more labour in burnishing the gold to a high finish than oil gilding. Wright had included the cost of the oil-gilded frames in his original estimate. Subsequent bills indicate that Wright readjusted the figures to take into account the difference in cost at Sir Walter's insistence. As a result of the changes, Mrs Salesbury's frame had increased to £5.10s from £3.15s but Wright eventually allowed his client an 'abatement' of £16.12s for the whole set but complained heartily.

On 24 October 1676, he sent word that the last two paintings had been dispatched. Mrs Salesbury's portrait must have been barely dry by the time it was crated up for transportation to Staffordshire: a piece of straw was found embedded in the paint, presumably from the packing. Wright was clearly worried:

> I desire the Case may bee opened when it comes to you, for I feare you may have done some pregudice to ye first pictures I sent you in keeping them so close and so long without ayre as hee sayes you have done never having opened the Case since you had it. Pray Sir, lett all the pictures be taken out and sett upon chayres round in yr great roome … for, new pictures must have ayre.[20]

Identification of pigments was done by Mary Bustin and Peter Mactaggart in 1997 using optical microscopy. Dr Joyce Townsend used thermomicroscopy to characterise the medium of the black dress in 1994.

— 3 —

JAN SIBERECHTS (1627–c.1703)
View of a House and its Estate in Belsize, Middlesex 1696

RICA JONES

Jan Siberechts was a Flemish painter who had practised at Antwerp before moving to England some time between 1672 and 1674. In England he specialised in landscapes, in particular bird's-eye views of country estates. This painting depicts a perspective from what is now Rosslyn Hill, showing in the distance Westminster Abbey (minus Hawksmoor's towers which had yet to be built), St Margaret's church, the old Houses of Parliament and to the left Northumberland House at Charing Cross.[1]

The painting is on plain-woven linen canvas, which was given a thickish coat of animal-glue size before being primed for painting. Examination of the tacking edges suggests that the picture was laced into a temporary loom for priming and painting, a common though not invariable practice amongst Netherlandish painters in the seventeenth century. Both the priming and the paint layer extend over on to the tacking edges, and in the narrow unpainted margin of canvas beyond them there are regular, sharply 'pulled' holes where the lacing exerted its tension. When completed, the painting would have been unlaced and nailed on to a wooden strainer, which has not survived. The double ground has a brown first coat consisting of ochres, umbers, black, lead white, ground glass and fine sand bound in oil. The second layer, also bound in oil, is a light tan colour formed from a mixture of lead white, yellow and red ochres, chalk, ground glass and fine sand. The presence of silica in the form of powdered quartz or sand has been found in some of Rembrandt's grounds.[2] Siberechts was Flemish not Dutch and has no known association with Rembrandt's tradition, so it is probable that silica was used by Netherlandish artists when they wanted a hard ground that would not absorb oil from the paint to be applied on top of it. Used in very coarse qualities it could also provide texture, though in this instance its moderate particle size probably just gave a degree of 'tooth' to the painter's brush.

The first stage in making the painting would have been the underdrawing but we do not know what sort of materials Siberechts used to draw out this composition; no lines are visible with either microscopic or infra-red examination, though this need not mean they are absent. The paint layers are very dense and an underdrawing in say brown or red would be difficult to detect with infra-red against the tan ground. A number of pen and watercolour topographical drawings by Siberechts exist (fig.27), and though none relates to this painting, it is possible that he might have done one of this view in preparation for the oil painting. That there would have been at least an elementary underdrawing on the prepared canvas is indicated by the precise way of painting this complex composition (there are no pentimenti for example), and by the method he used to create the effect of aerial perspective in the most distant hills. The first stage of painting was the underpainting of the sky, where Siberechts blocked out the dark priming with a thick layer of off-white paint to provide a reflective ground for his blue (fig.29). This underlayer does not end at the horizon but lower down the composition at the base of the furthest range of hills, its light tone emphasising the hazy blue distance.

The technique used thereafter is consistent throughout the picture; the colours, which are mostly opaque, were

fig.27 *A view of Beeley, near Chatsworth* (1694), watercolour and bodycolour, heightened with white, on paper (British Museum)

fig.28 *View of a House and its Estate in Belsize, Middlesex,*
oil on canvas 108 × 139.3 (42½ × 54¾) T06996

fig.29 Cross-section from the sky, showing, from the top: blue made from ultramarine and lead white; off-white underpainting made from lead white, yellow ochre, black and ground glass, which can be seen as dark particles; upper layer of priming made of lead white, ochres, ground glass and fine sand; lower layer of priming made from ochres, umbers, black, glass and sand. Photographed at × 250 magnification

fig.30 Detail of artichokes from a field at the back of the house, photographed through a stereo microscope at × 7 magnification. Foliage is painted on top of the brown colour of the field. Large particles of lead white and lead tin yellow show as light dots

mixed up on the palette and applied wet-in-wet with no preparatory underpainting. Large areas were blocked in before tonal or figurative details were added on top (fig.30) and in each element of the picture dark tones were put on before light. Glazes are present here and there in the trees but as local patches rather than large passages. The tan priming is hardly ever left visible as a tonal element in the composition nor does it contribute much through reflective powers to the intensity of the colours in this painting. For this quality the artist has relied on the type and mixtures of pigments and it is worth examining them in some detail, as they illustrate much about the sophisticated training a continental artist such as Siberechts would have received. Indirectly, it also indicates the status of the person who commissioned and paid for this painting. The sky is composed of lead white with very good quality ultramarine and a small amount of colourless glassy particles. The off-white underpainting in the sky is lead white mixed up with a large quantity of glassy particles, some kaolin and small amounts of yellow ochre and black. The glass is easily visible in the cross-section illustrated in fig.31. For the bluish green foliage in the far distance beyond the grove of trees surrounding the house, he mixed what appears to be a less intensely coloured (and therefore less expensive) ultramarine with green earth (a bluish toned variety), yellow ochre, sienna, black, lead white, kaolin and glassy particles. All the dark greens found in the trees over the rest of the picture have instead of ultramarine the mineral pigment, azurite, mixed with varying quantities of green earth (two types appear to have been chosen, one bluish green, the other yellowish green), yellow and red ochres and siennas, black and glassy particles (fig.31). For semi-translucent top glazes he added brown pink and for the lighter, yellowish green strokes in the trees he mixed in large quantities of the bright opaque pigment, lead tin yellow. The creamy-yellow clouds brushed wet-in-wet into the blue sky are mixtures of lead white, lead tin yellow and glass. A consistent feature throughout these mixtures is the large size of the particles, especially the green earth, azurite, lead tin yellow, black and red ochre.

The first point to note about the paint mixtures is the high quality of the pigments. Ultramarine and azurite are both minerals of comparatively high tinting strength and very high cost, especially ultramarine. During this period opaque greens used in oil painting were very often made from optical mixtures, as there was no single green pigment which could combine the required tinting strength

fig.31 Particles of azurite, green earth and ground glass photographed in dispersion in transmitted, polarised light at × 400 magnification. The sample is from dark green foliage

with the ability to withstand fading from exposure to light. Verdigris, though it has proved stable in many paintings,[3] was known to be fugitive in some circumstances and troublesome when mixed with certain other pigments. Green earth is very stable but it is not a strong colour when used in oil. Of the blues available to vary and intensify it, Siberechts chose the brightest, the most durable and the most expensive. Their very different hues (ultramarine is the bluest of blues whereas azurite has a greenish cast) ensured a variety of tones, a factor he exploited in a subtle way when using ultramarine for the most distant greens. Receding orthogonals may be the principal device for the perspective of the house and its gardens but the ultimate sense of space and great distance comes from this use of a cool blue for the sky, hills and foliage in the wide expanses beyond.

Siberechts had become a master in the powerful Guild of St Luke at Antwerp by 1648. In order to qualify for this he would have had to undergo several years of training in the studio of an established painter. We do not know which one it was but this mastery over pigments – their comparative hues, tinting strengths, durability and optimum particle size – was one of the benefits to be drawn from the years spent serving a master. The use of ground glass in paint may also prove to be a characteristic of artists trained in the Netherlandish tradition, though analysis may prove its use was widespread on the Conti-

nent, it being mentioned for example in Spanish treatises on painting.[4] It has been found in some of Rembrandt's browns[5] and most notably in the 'tonal' landscapes of Jan van Goyen and Salomon van Ruysdael.[6] Gheeraert's *Captain Lee* (pages 26–31) contains it, as do similar areas of a set of portraits by the Dutch sixteenth-century painter, Cornelis Ketel.[7] In some instances the glass may actually be pale or discoloured smalt, a glassy blue pigment. In this painting, however, it appears to be simply glass; there is no blue colouration in it and none of the samples showed the presence of cobalt in elemental analysis (smalt contains cobalt). In terms of the reasons for use there would have been two advantages in choosing either one – glass or pale smalt. As a bulking agent they would thicken the paint without obscuring the bright (and expensive) pigments and, being rich in lead or cobalt, they would act as a siccative in mixtures containing colours that dried slowly in oil, green earth for example. This is the reason given for its use in the manuals of painting. Marshall Smith, in his book *The Art of Painting* which was first published in 1692, says 'For your *Powder-Glass*, take the Whitest Glass, beat it very fine in a Morter, and grind it in water to an Impalpable powder; being thoroughly dry, it will dry all Colours without drying Oyle, and not in the least Tinge the purest Colours, as *White, Ultramarine*, etc.'[8] In this painting, however, its presence in such mixtures as lead white with lead tin yellow, both excellent driers, suggests that its use as a bulking agent was equally important.

Siberechts, then, was a soundly trained technician who, with this painting, was fortunate in finding a patron who could afford the best. Partly as a consequence, it is in very good condition. There has been no fading and it looks as if the recent lining (done some time before the painting was acquired by the Tate in 1995) is the first it has had. The original varnish, long since removed, would probably have been mastic in an organic solvent. The present one is a modern synthetic resin, chosen for its aesthetic resemblance to the natural resins but which will not go yellow with age.

Identification of all pigment samples in this painting was carried out in 1995 with optical microscopy by Rica Jones, followed up with EDX by Dr Joyce Townsend.

– 4 –

WILLIAM HOGARTH (1697–1764)
Mrs Salter 1741

RICA JONES

Mrs Salter[1] is a splendid example of Hogarth at a confident stage of his career and with a sitter he clearly found sympathetic. He began his career as a painter in the 1720s and introduced head-and-shoulder portraits into his œuvre during the 1730s. In his youth he had spent several years apprenticed to a silver-plate engraver but, in his own words, 'he soon found that business too limited in every re[s]pect … Drawing object[s] something like nature instead of the monsters of Heraldry became necessary … this and other reasons made him turn his head to painting'.[2] Although never apprenticed to a painter, he had watched them at work during his childhood: 'an early access to a neighbouring Painter drew my attention from play … I pickt up acquai[n]tance of the same turn …'[3] Later on, his attendance at the first St Martin's Lane Academy 'for the Improvement of Painters and Sculptors by drawing from the Naked',[4] which he joined in 1720, would have brought him into contact with a range of thriving contemporary artists. Although the craft of painting was not taught at this academy, the informal exchange of ideas that must have taken place would not have been lost on him, eager as he was to make his mark in the world. Technically *Mrs Salter* demonstrates much about his approach to painting at this stage of his career and also, indirectly, some of the technical difficulties that beset many British artists in this period where formal training was no longer the norm.

The painting is on plain-woven linen canvas and, like most English pictures from about 1730 to the mid-1750s, has a pale grey priming. It is composed of lead white, chalk, black and ochres bound together in linseed oil. Although Van Dyck used warm-toned grey primings from time to time,[5] Thomas Bardwell, the artist and writer, was probably right when he attributed the introduction and popularity of grey primings to Sir Godfrey Kneller, whose outstanding success as a portrait painter in England could not be ignored by up-and-coming generations.[6] Kneller's portraits after he became established in England are on cold grey primings, which he left visible to

work as cool half-shadows in the flesh tones and sometimes in the wig also.[7] This device became popular with many younger British artists, including Hogarth in some portraits, and probably accounts for the ubiquitousness of the colour. Unlike many a contemporary, however, Hogarth varied his practice; consequently the tone of his primings ranges from pale beigey-grey to darker grey, though the very dark colour visible in the painting on the easel in his *Self Portrait* (fig.33) has not been found on an actual painting.

That same self-portrait shows an underdrawing in white and we may suppose a similar beginning, in a colour that would show up against the priming, for his other work. Occasionally, as in the oil sketch for his wall-painting at St Bartholomew's Hospital, *The Pool of Bethesda* (Manchester City Art Galleries), he corrects an already painted figure with a sketchy white outline for future guidance.[8] The underdrawing is never visible in completed pictures. *Head of a Lady, called Lady Pembroke* (fig.34), abandoned at a very early stage of painting, has a sketchily brushed underdrawing in greyish brown paint. It also shows the thin muted tones of what was traditionally called the dead-colouring or first stage of painting. (Before setting the painting aside, he had begun the second stage, which is visible in the brighter tones around the nose, mouth and cheeks.) Though Hogarth was innovative in his range of subjects for painting, he was conservative at this period when it came to technique. In his private notes he makes a scathing reference to a painter whom he does not name but characterises by the 'new stratagem of painting a face all red or all blue or all purple at the first sitting'.[9] This was Allan Ramsay who, after coming back from study in Italy in 1738, took the fancy of the portrait-buying public partly with the aid of a technical device: '[he] accustoms himself to draw the faces in red lines, shades etc., finishing the likeness in one red colour or mask before he puts on the flesh colour', commented George Vertue.[10] Hogarth had no use for such novelty, preferring to take his inspiration from more traditional practices and altering

fig.32 *Mrs Salter*, oil on canvas 76.4 × 63.5 (30⅛ × 25).
After restoration in 1991. N01663

fig.33 *Self Portrait* (c.1757) (National Portrait Gallery)

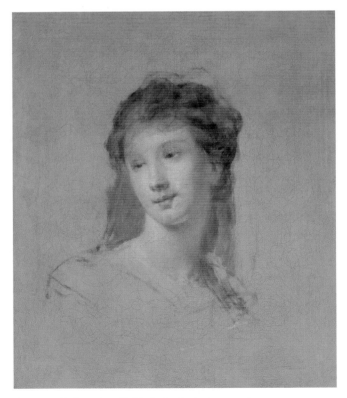

fig.34 *Head of a Lady, called Lady Pembroke* (c.1735–40)

them to suit his own brush. All the manuals of painting published in the seventeenth century instruct the painter to use monochrome or low-key tonal underpainting to establish the likeness, pose and overall space in portraiture. However much individual artists would have modified this procedure (and we know that Kneller, for example, modified it sometimes to the point of elimination, his great public acclaim causing many a young English artist to follow his example), it remained the traditionally accepted way of developing a portrait in this period. This was the sort of practice that Hogarth could have witnessed as a boy when he frequented artists' studios.

However sketchily Hogarth began his portraits, the final painted surface is opaque and gives no ready hint about its evolution on the canvas. Close inspection reveals that the faces were painted in several stages and this is often most easily appreciated in black and white photographs. If fig.35, showing *Mrs Salter*'s face, is read as an abstract tonal map, then it is quite clear that the lightest areas, comprising the prominent parts of the face – the forehead, bridge and end of nose, cheeks, pouches around the mouth and the tip of the chin – were applied last in thick opaque paint with brushwork that follows the curves of the real facial structure. At the stage before this, the face would have looked complete but composed throughout in the recessive tones which he left unmodified in all the recessive areas, most notably the eye sockets (apart from the highlights on the eyeball and the edge of the lower lid). Hogarth's portraits of the 1740s are characterised by the sharply defined eye sockets, caused when he applied his final highlights to the cheeks, ending in a semi-circular brushstroke that matches the bone below the eye. In some of these paintings, slight differential ageing in these two stages of painting has emphasised the tonal differences between the eye sockets and the cheeks, leaving more than one sitter looking as if they have had too many late nights.

Hogarth's works usually underwent a good deal of alteration in the course of painting and *Mrs Salter* is no exception. Examination of the yellow dress in cross-section shows that it started off lilac coloured. This paint layer is solid and is present beneath the whole yellow area. There is no possibility that he might have been aiming at a 'shot' effect, as no trace of the lilac is visible without the aid of a microscope. There has been a suggestion that he had some esoteric system of underpainting large areas of colour in a contrasting tone in order to modify the final

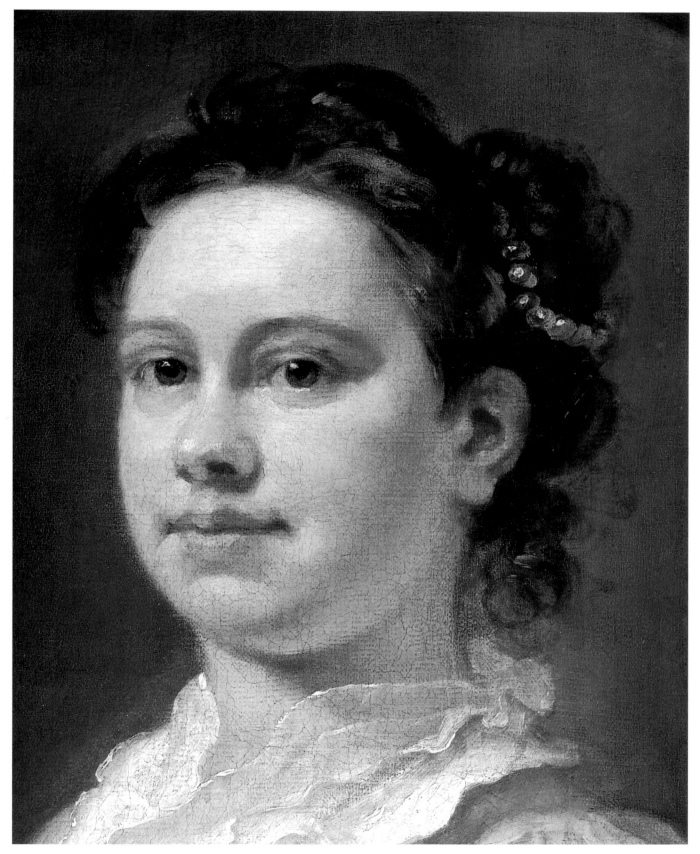

fig.35 Detail of face in *Mrs Salter*

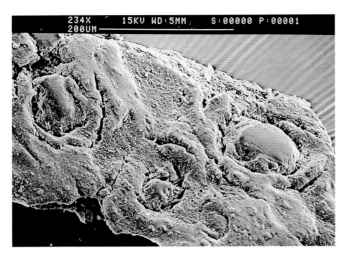

fig.36 The surface of a fragment of paint from the yellow dress, photographed at × 234 magnification in a scanning electron microscope by Dr Aviva Burnstock of the Courtauld Institute of Art (formerly of the National Gallery). The paint has shrunk into tiny polygonal craters, bounded by cracks, and each containing a build-up of old varnish residues

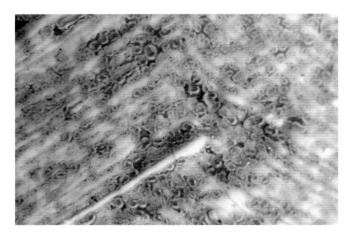

fig.37 Detail of a white linen cap from Hogarth's *Heads of Servants*, photographed through the stereo microscope at × 15 magnification. Polygonal craters in the paint and old varnish residues lodged inside them

colour subtly, first noted during the examination of *Marriage à la Mode* at the National Gallery in 1982. It was observed that several, though not all, garments were thinly underpainted with a contrasting colour, green beneath opaque yellow for example.[11] Until more paintings are examined we cannot be certain about this and even then one would not expect such a fertile-minded person as Hogarth to be unvariable. In the meantime it should, however, be noted that to find a painting by Hogarth without changes of mind, be they of colour or composition, is rare. In his *Self Portrait with Pug*, examined at the Tate in 1996, the red coat underwent many alterations of tone, usually reds or orange. Other changes in *Mrs Salter* are visible in fig.32; the lines of the shoulders and the back of the hair have been altered.

Mrs Salter is in good condition but she suffers from an interesting form of paint shrinkage (microcissing) that interferes slightly with our appreciation of the quality of the painting and which is very common in English paintings from around this time.[12] Fig.36 shows a tiny area of the dress photographed through a scanning electron microscope at × 234 magnification. This shows the paint broken up into polygonal craters, each bounded by cracks and containing in the cupped centre a build-up of old varnish residues. Similar craters found in the white linen depicted in Hogarth's *Heads of Servants* are shown at lower magnification in fig.37. This is a characteristic form which develops in the thick light areas of paint. In the thinner dark tones the paint more often forms equally microscopic blobs, each bounded by a crack that usually allows the unbroken underlying priming to show through. It is unlikely that Hogarth would have been aware of this problem during painting or within his lifetime. Perhaps the affected areas might have looked slightly mottled but nothing more, the form of individual distortions being too small to be appreciated as discrete elements with the naked eye. In an aged, deteriorated state, however, their overall effect is evident in the following ways: the microscopic cracking on the surface of the brushstrokes alters their surface topography, reducing the effect of spontaneity or continuity; the build-up of old, discoloured residues in each minute crack and crater makes the light tones appear worn even when they are not; the differently coloured substrate visible at the base of each crack in the dark areas makes the overall colour appear lighter than it should be, consequently tonal contrasts within the painting are reduced.

This form of microscopic cracking occurs in many English paintings done between about 1730 and 1760 and, although its exact cause is not fully understood, it is clear that it is a drying problem. The probable reason is that painters like Hogarth were using too much siccative in their oil, causing it to dry too quickly. That their principal driers were lead compounds dissolved in the oil means that it is impossible to isolate them during analysis (the pigment lead white being ubiquitous in the paintings). *Mrs Salter* was painted probably with linseed oil throughout, though it is just possible that the background is in walnut oil. This would be unusual, walnut oil being traditionally used in light areas, but even so, it could not be responsible on its own for a development like this. Pending the results of further analysis, it is probably safe to say that in this respect Hogarth and his contemporaries suffered from lack of formal training in the craft of painting (it cannot be insignificant, after all, that this problem is rarely seen in the work of foreign painters resident in England). It has made many English paintings of the period appear less substantial than they should be, a criticism one might think not applicable to Hogarth, whose sitters rarely appear less than robust. But, if you consider that the whole of *Mrs Salter*'s face and significant parts of her linen and yellow dress are broken up with microscopic cracking containing old, discoloured residues, then it is worth pausing to imagine how she might have looked when first painted. Her vitality must have been stunning.

Analysis of the binding medium in the paint and priming was carried out by Dr Jennifer Pilc at the National Gallery in 1990 using GC.

THOMAS GAINSBOROUGH (1727–1788)
The Rev. John Chafy Playing the Violoncello in a Landscape c.1750–2

RICA JONES

This painting was done while John Chafy was living near Sudbury, Suffolk.[1] There Gainsborough had set up as a painter in the late 1740s and would stay until he moved to Ipswich in 1752. In these early years Gainsborough specialised in 'portraits-in-little' or conversation pieces, achieving within their small format a remarkable facility and directness with paint. Here we see on a miniature scale all the features for which his work from later periods has since been valued: the light touch, elegant forms, glowing colours, subtle tones, varied surfaces and inspired brushwork. It was to be some years (after his move to Bath in 1758) before he found an equally brilliant technique for portraiture nearer the scale of life.

In common with all his work in this genre, this painting is on plain-woven, linen canvas. The priming layer is pale grey and it was applied in two coats, composed largely of lead white mixed up with a large amount of chalk, some lamp black and brownish ochre and all bound together leanly in oil. Between the two layers is an unpigmented coat of animal-glue size, a feature found commonly in

English primings of the period and probably, therefore, an indication that the canvas was primed by a colourman.[2] The exact function of this interlayer is not known. Perhaps it made the final support stiffer or perhaps, being water-based, it allowed the second coat to be applied before the first was completely dry. Other characteristics shared with many other English primings of the period are the grey colour and the minutely ridged surface (figs.38 and 40). These striations, which are always entirely regular either vertically or horizontally over the picture surface, measure two or three to a millimetre in width and are the marks left by the tool with which the preparation was applied. Their presence, along with the absorbent qualities imparted by the chalk and the low proportion of oil (which are not characteristic of all contemporary primings), would have given good purchase to Gainsborough's swiftly moving brush and thin paint.

There is hardly any preparatory underdrawing in this painting. Gainsborough's technique is so direct that a very few sketchy lines of thin paint were almost certainly all he needed to establish his composition and poses in these small-scale paintings. Here one can discern the occasional painted outline in the cupola, urn, treetrunk and fingers (fig.40) but to think of them as a formal system of underdrawing would be to miss the combination of spontaneity and surehandedness that by 1750 was well established in his conversation pieces. 'Gainsborough in his early works, owing to his great execution, finished as he went on',[3] said a nineteenth-century descendent of his great friend, Joshua Kirby, meaning that Gainsborough completed each part of the picture more or less in one go. This, together with his graphic sense of form, is the key to his technique in this period.

In fig.41, the pond and landscape to the right of *Chafy*, we can trace his brush in action. Whether the brushstrokes are fine or broad, thick or thin, worked into one another or overlapping themselves, is dictated by the shape of the separate elements and above all by their texture. So, having described the fields and hedgerows in a

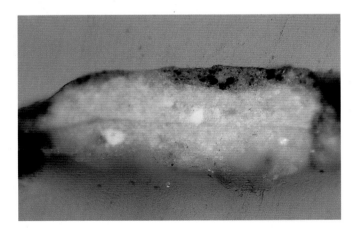

fig.38 Cross-section through the sky near the left edge, photographed at × 250 magnification. Two layers of pale grey priming (at the bottom) are separated by a coat of animal-glue size. The surface is ridged from the tool used to apply the priming and the overlying paint has been abraded on the peaks

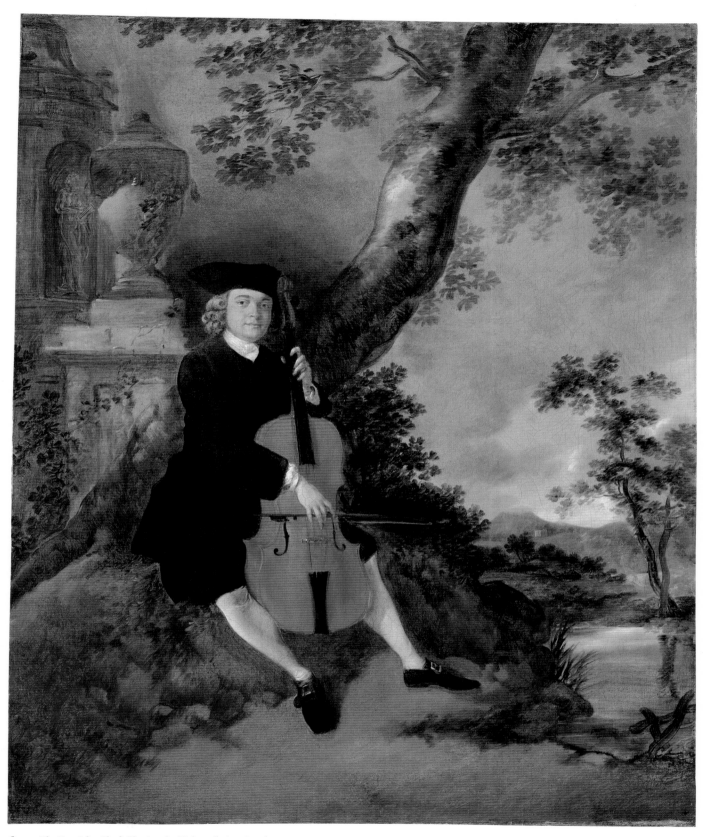

fig.39 *The Rev. John Chafy Playing the Violoncello in a Landscape*,
oil on canvas 74.9 × 60.9 (29½ × 24) T03895

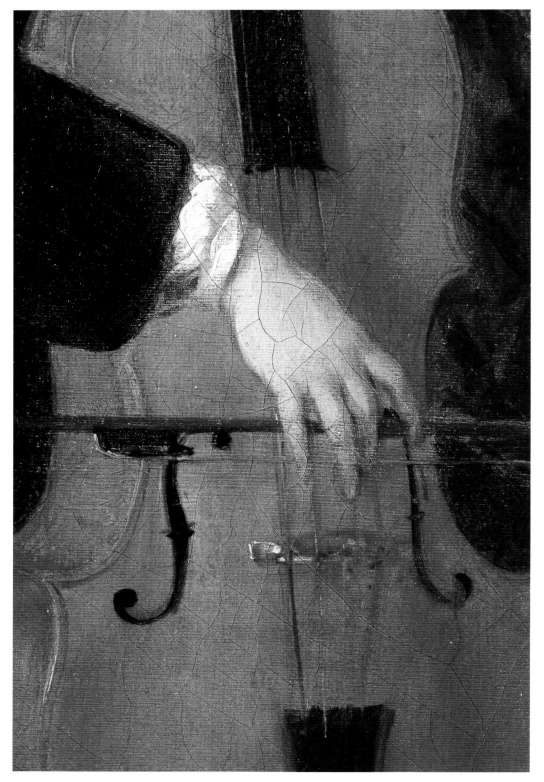

fig.40 Detail of the cello, showing horizontal lines of
abrasion in the paint along the ridges in the priming

few deft movements with two shades of thin green paint and depicted the banks and water similarly in shades of brown and grey, he added a second layer of thicker paint only for the smooth white reflection in the water and for the reeds, whose tops acquired their delicate, tapering profile through being brushed into the white paint while it was still wet. The range of expressive yet minimal brushwork is as plentiful as there are different parts of the picture. Note how the architectural elements are constructed with just a few tones of thin brushwork, reinforced with a second layer only in the shaft of sunlight hitting the urn and in the ivy-shaped brushstrokes and wavy lines on its base. Yet another device was used for the statue in the niche; sgraffito is a technique where paint is scraped away to leave the differently coloured substrate showing as part of the design; he appears to have used a squared-off solid point.

All this is ample evidence of how much his vision was honed by the time spent working for the French graphic artist and designer, Hubert Gravelot. Yet Gainsborough is also one of the colourists of British art. As we have seen, his paint in this period is thin and more often than not applied as a single layer, albeit made up of separate strokes. Traditional means of enriching colour such as glazing were not normally used by Gainsborough at this stage, nor much by his British contemporaries;[4] like most of them he made complex mixtures of pigments instead – opaque and translucent together. What then are the distinguishing features of Gainsborough's paint and how might they differ from the work of his fellow artists in this period? Fig.42, a microscopic sample of green paint, illustrates Gainsborough's method of mixing colours. The large, bluish green particles are green earth, a semi-translucent pigment that forms the basis of all his greens in this period. Here it is darkened and varied with black and a translucent Prussian blue. There are three different yellows in this sample: two are opaque – Naples yellow and yellow ochre – while the other, which is present in large quantities, is brown pink, a translucent pigment made from the dye of a plant. There are also small quantities of the semi-translucent brown Cologne earth, plus an opaque orange ochre and some lead white. In addition there are significant amounts of colourless, glassy particles. The same range of yellow, orange and glassy pigments were found in a sample from the cello. From these and other paint samples from his work, three characteristics emerge: on average the pigments are coarsely ground, allowing large particles to rest on the surface of

the thinly applied paint; from the range of pigments available at the time, he chooses a majority of translucent or semi-translucent colours rather than opaque; finally, rather than submerge these large, bright, particles in the opaque matrix which the average admixture of lead white would provide, he uses significant proportions of ground glass (or sometimes pale smalt) in the mixtures. The transparency of glassy particles allows light to penetrate the paint film and illuminate the translucent pigments contained within.[5] The glass may also have served as a drier for the oil. Although the medium of this painting has not been analysed, others similar have been found to be untreated linseed, walnut or poppy oils. Particularly when used in conjunction with his choice of pigments, which on the whole may be classed as 'slow driers' in oil, these untreated oils would have benefited from a siccative; and, in the seventeenth century at least, ground glass was recommended as a drier which would not discolour the oil (see page 41).

The possible context behind this methodology is fascinating, though the research into it is still in the early stages. The first comparison to be made is with Netherlandish landscape of the seventeenth century, here exemplified by Siberechts's *View of A House and its Estate in Belsize* (pages 38–41), in which large pigment particles, judicious mixtures of translucent and opaque pigments, and ground glass all appear. Other similar examples from Dutch painting are cited there. It may be then, as has been suggested in another context,[6] that Gainsborough in his youth came into contact with Netherlandish immigrant painters in East Anglia. His iconographic and stylistic debt to Dutch seventeenth-century landscape has long been acknowledged[7] and it is an undoubted fact that he had seen and probably even restored these paintings[8] as they passed through the London art market; but this cannot in itself explain the similarities of technique. High-powered, analytical microscopes are necessary to discern the subtle mixtures of pigments and the presence of ground glass in a dried paint film. To know of these methods an eighteenth-century painter would have to have seen a painter using them or been given the details by someone who was a witness to the tradition. Or he could have been supplied with ready-made paint that contained them.

This brings his British contemporaries into play. Does any of their paint share these characteristics? If the use of significant amounts of glass in paint was introduced via the Netherlands, then by the mid-eighteenth century

fig.41 Detail of the pond to *Chafy*'s right

many a painter or artists' colourman could have taken it up. And, moreover, the progress of research indicates that glassy pigments have been used in painting more than we have realised; viz. the presence of what appears to be ground-up green glass in John Michael Wright's *Mrs Salesbury and her Granchildren* (page 36). The situation, therefore, is complex.[9] In this long, analytical quest it seemed sensible in respect of Gainsborough's work to start with Francis Hayman, a slightly older painter with whom Gainsborough worked in his early years and whose paintings from this period are close enough stylistically for confusion of authorship to have occurred in at least one instance. There are indeed many similarities in their respective paint mixtures but, although ground glass and other extenders are present in Hayman's paint, their proportions compared to his coloured pigments are smaller than in Gainsborough's paintings.[10] Some of Hogarth's paint also contains ground glass, the green curtain in *Self Portrait with Pug* for example, but again, in so far as research has progressed, the feature is not consistent throughout his colours and the proportions on average are smaller.[11] So, pending further analysis, it is evident that the use of ground glass in paint was known to English artists – and probably also artists' colourmen – in the mid-eighteenth century but in general they appear not to have used it so frequently as Gainsborough nor in such large proportions.

Finally, in the light of the possible connection with Netherlandish painting, it is worth looking at the differences in appearance between the two landscape traditions. One feature that cannot be ignored when comparing any early English landscape, *Chafy* for instance, and a Netherlandish example such as the Siberechts, is how much more intense are the colours in the latter, particularly the greens and blues. Large areas of *Chafy*'s skies and the main tree have been thinned through abrasion in later years but, even when first painted, the picture is unlikely to have displayed the rich hues of a Wijnants or van Ruisdael; this low-key tone was a noticeable characteristic of all the early Gainsboroughs in the *Young Gainsborough* exhibition at the National Gallery in 1997, compared to the seventeenth-century Netherlandish landscapes near which they were hung. Taking the Siberechts as analytical comparison, one of the principal reasons for this must be the use by Gainsborough and his

fig.42 A fragment of paint from the yellowish green grass to the left of *Chafy*, photographed at × 120 magnification by Dr Ashok Roy of the National Gallery

contemporaries of Prussian blue rather than the mineral pigments azurite and ultramarine. Prussian blue, a manufactured pigment which came into use in the early eighteenth century, has not the crystalline characteristics of a mineral blue. On the other hand it was much cheaper than ultramarine or azurite, and also, being a greenish blue, could substitute at least tonally for the latter when it seems to have become very difficult to obtain in the 1700s. So Prussian blue quickly became popular but in its early decades was not always light-fast when mixed with large quantities of lead white; fading has occurred, for example, in the skies of *Gainsborough's Forest* and *Mr and Mrs Andrews* in the National Gallery[12] and very slightly in the sky to the far right of *Chafy*. It is also known to have become greenish in oil,[13] a fact that might have accounted for the distinctly greenish skies to *Chafy*'s right. On being analysed, however, this paint was found to contain amounts of green earth, Prussian blue being a very minor component in a complex mixture. In this passage, then, the greenish sky full of incipient stormy weather is quite deliberate; Gainsborough the poetic painter was active right from the beginning.

Pigment analysis using EDX was carried out in 1986 by Dr Ashok Roy of the National Gallery and with optical microscopy by Rica Jones and Peter Mactaggart in 1995. I am also grateful to Dr Roy and Mr Raymond White for information on Gainsborough's media, analysed by GC-MS.

– 6 –

JOSEPH WRIGHT OF DERBY (1734–1797)

An Iron Forge 1772
Vesuvius in Eruption c.1776–80

RICA JONES

Unusually amongst British painters in the eighteenth century, Wright underwent a long, traditional training in the studio of Thomas Hudson, the fashionable portrait painter.[1] Although he was to complain in later life that he would have preferred a superior master, Wright never abandoned the sound respect for materials that he learned there. Wright's vision led him far from conventional territory, but, unlike Reynolds or the painters born in the next generation, Turner and Constable the prime examples, he remained essentially a traditionalist in his use of paint.

This is not to say that he is predictable as a technician. He painted *An Iron Forge* in 1772[2] and it is one of the latest of the great series in which he explored the effects of moonlight or of artificial lighting. Starting in the 1760s with candlelit scenes with two half-length figures, a genre popular in the Netherlands during the seventeenth century, he soon embarked on heroic compositions of his own devising, lit not only by the moon or half-hidden candles, but also by the incandescence of other materials. *The Alchymist ... Discovers Phosphorous*, for example, is lit by the glow of that element in a retort and in *An Iron Forge* the white-hot bar of steel, set low in the picture, is the only source of light. He produced four different paintings of iron forges and, although two share very similar compositions, the lighting of each is different. Within a theme he constantly explored subtly different effects and the same is true of his technique; always controlled and orderly, the structure of his paintings varies according to the effects of light being depicted.

Wright painted most of his work on stretched linen canvas of medium weight. Occasionally, as in *An Iron Forge*, he used two pieces sewn together. This can be seen in the x-radiograph (fig.43); the broad white line passing vertically through the back of the girl on the right is caused by the double thickness of primed canvas at the seam. Both pieces had been primed with lead white paint before being sewn together and he then appears to have reinforced the front of the seam with extra white priming, applied thickly in patches. The composition of the priming is not quite the same on the two pieces of canvas. In the larger it is composed of lead white, gypsum and a small amount of Prussian blue bound in oil. In the smaller it is a mixture of lead white with a few particles of rose madder, Prussian blue and clear glass in oil. The glass would have been added to speed up the drying time. The white priming is the first of the three technical phases found in all the 'candlelight' paintings. Its principal function was to provide maximum reflectance of light within the paint. It is hardly ever visible as an element in its own right within these compositions.

The second phase in the evolution of these paintings upon the canvas is the monochrome underpainting, with which Wright worked out the whole composition.[3] In *An Iron Forge* and several other 'candlelights' it is in shades of

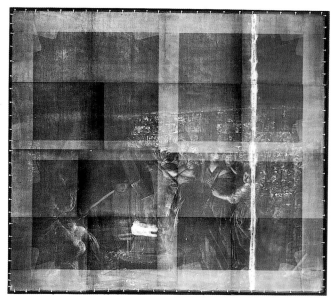

fig.43 X-radiograph of the whole painting, showing the seam as a white line running vertically

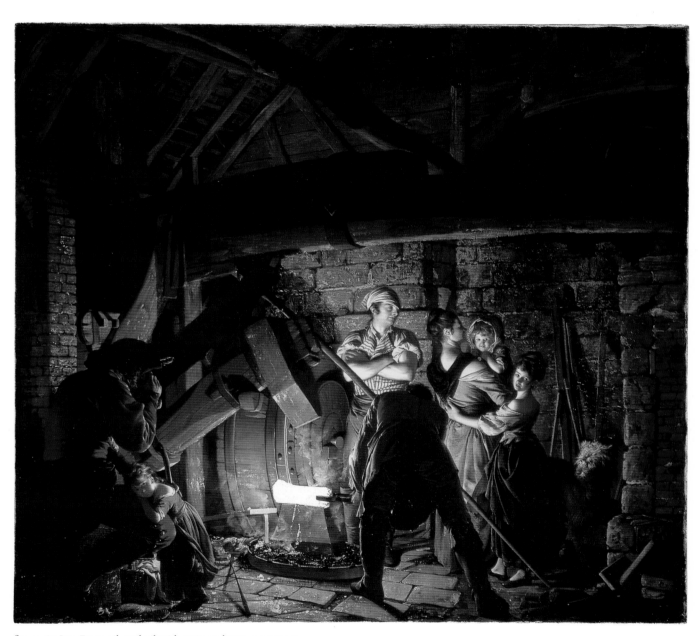

fig.44 *An Iron Forge*, oil, and oil with resin and wax, on canvas
121.3 × 132 (47¾ × 52) T06670

reddish brown, composed of the pigments lead white, red ochre and umber bound together leanly in oil; in others he used beige, red and grisaille as well as brown. The idea of starting with a low-key or monochrome underpainting, a 'dead-colouring' or 'first lay' as it was known, has a history going back at least to the seventeenth-century portraitists who came from northern Europe, Soest and Lely for example. In a very pale, sketchy form Wright would have been familiar with its use from Hudson's studio. Simply by deadening the reflectance from the priming layer in those parts blocked in with toning, it helped impart a solid, three-dimensional quality to the ensuing image. Also it was easily removed and put back until the artist was satisfied with his composition. This may be the reason why there are no extant drawings on paper for these very complex compositions and why there are so few pentimenti in most of them. There may also have been a more personal, ideological significance for Wright. In 1756, while Wright was learning his craft in Hudson's studio, a provincial portraitist named Thomas Bardwell published in London a treatise on painting that we know from later writers was much acclaimed by artists of Wright's generation. In the introduction to *The Practice of Painting and Perspective Made Easy*,[4] Bardwell explains that the methods of painting set out in his book are the result of long study of the old masters. He advocates a fairly complex dead-colouring in 'teints' of red and reddish brown, claiming to have found these colours in the 'first lay' of the masters he reveres most, Rembrandt and Van Dyck. It may have been of significance to Wright, working alone in Derby, that these paintings, conceived in the heroic tradition and priced by him accordingly (*An Iron Forge* was sold for £210 as opposed to £31 for a 50 × 40 inch (127 × 106 cm) portrait of the same year),[5] shared some of the methods thought to have been used by great masters.

Once the dead-colouring was dry, Wright embarked on the third phase, applying the colours. In this painting he worked in one or two layers, using opaque tones mixed up on the palette with a stable oil medium and then applied to the painting wet-in-wet. Some of the highlights and shadows were reinforced later. The number of pigments used in each colour is not as large as one sometimes finds in this period; to make the blue skirt, for example, he mixed Prussian blue with lead white and gypsum with a touch of vermilion and ivory black. He departed from his usual smooth, straightforward application in two places: the background wall and the bar of metal (fig.45 and fig.46). The method used in the former

fig.45 Detail of the background wall and overhead beam. The process called 'the finishing' is visible in the wall and, less pronounced, in the beam

fig.46 Red and yellow glazing on top of the thick white paint of the anvil

had its beginnings in his work of the late 1760s and it became his principal method of depicting textured surfaces catching the light. Taking very bright pigments (vermilion and orpiment were used here, with ochres and white lead) he mixed up stiff paint which he applied roughly and thickly either with a palette knife or with stiff brushes. Although its binding medium in this picture was not analysed, in other similar paintings it was found to be a mixture of oil, natural resin and wax. Then when this was dry he glazed over the thick paint with browns in this instance. These glazes are bound in a mixture of oil and natural resin. For the metal bar he applied lead white very thickly, which when dry he glazed with Naples yellow

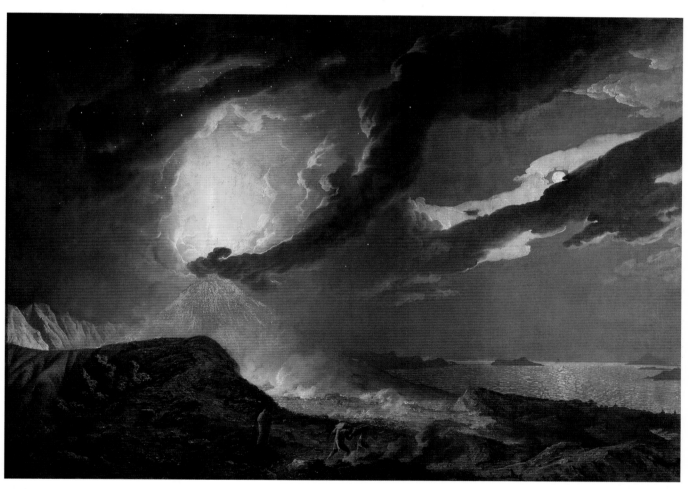

fig.47 *Vesuvius in Eruption*, oil on canvas 122 × 176.4 (48 × 69½) T05846

and vermilion mixed with oil and natural resin. Examination with the microscope indicates that this glazing, now visible as a few dots and small patches, was once more extensive (it is present in minute specks in all the furrows of the brushstrokes in the white paint). Wright sometimes used a wiping technique to vary the intensity of his glazes; but, given the resinous medium, this reduction could also have occurred during a harsh varnish removal. The distinct yellow cast of the flesh tones suggests that the bar was once yellower, since the source of light usually sets the tone of the rest of the painting with Wright; on the other hand the rest of the painting, including the soft glazes on the background wall, are in excellent condition, so we cannot be sure either way.

We do not know what sort of varnish Wright put on this painting. That he did varnish his work and that he disliked discoloured coatings is clear from his notes and letters. Mastic was the resin used most commonly in his day. When the painting was acquired by the Tate it was covered with two layers of very discoloured varnish, neither original since they lay on top of restoration work. They were removed and replaced with a modern synthetic resin that does not go yellow with age. Other conservation measures, such as the glue lining applied during the nineteenth century, are still strong, so were left in place.

Wright's *Vesuvius* oil paintings date from after his sojourn in Italy from 1773 to 1775. This trip in the middle of his life was of critical importance to him as a painter, though paradoxically perhaps it had little effect on his techniques. His subject-matter changed. After his return there were no more 'candlelight' dramas; instead he painted volcanoes, fireworks, romantic scenes with sorrowing figures, and serene landscapes of Italy and of his home country, all interspersed with the portraits that kept him going financially throughout his lifetime. We do not know the exact date of this *Vesuvius*; it has been placed tentatively some time between 1776 and 1780.[6] It is painted on a single piece of plain-woven, medium-weight linen canvas. Its white priming is a double thickness of gypsum bound leanly in oil, the two coats separated by a layer of glue size (fig.48). Used with lead white rather than gypsum, this particular construction is very common in English primings from about 1730 to 1760, indicating perhaps that the canvas was prepared in England rather than Italy. Gypsum, on the other hand, is much less common as the principal ingredient of primings in English paintings, traditionally being associated with paintings from Italy and Europe south of the Alps. By this time, however, its use appears to have been widespread; it occurs in many paints in the eighteenth century.

All but one of Wright's pure landscapes date from during or after the Italian period.[7] With the exception of that first one they do not share the red-brown underpainting of the 'candlelight' series. Instead he used a system with which he could exploit the reflectivity of his primings. So his skies, for example, are painted with one blue layer directly on top of the priming, whereas in the landscape there is usually a pale grey or green dead-colouring lying between the priming and the visible paint layers. In this way the sky automatically appears the more luminous area. This painting being a night scene, where three areas need to be luminous – the sky, the glowing cone and the surface of the water, we find underpainting only in the dark foreground mass. The sky is painted from mixtures

fig.48 Thick yellow paint applied on top of vermilion in the cone of the volcano

of vermilion, Naples yellow, orpiment, Prussian blue, black and lead white, mainly in one layer. There is glazing here and there in the clouds, and the yellow plume of fire is built up of numerous glaze layers on top of bright, opaque pigments. In the water he used one layer of opaque paint, applied evenly. Before it dried, he took the sharp end of a brush and scraped out the highlights of the waves, a device found again and again in his work (fig.49). The volcano is painted in one layer of pure vermilion directly on top of the white priming (fig.48). The yellow lines of lava-flow at the apex of the cone were applied last and appear to be composed of sulphur, a substance not normally associated with painting. Did this literal equation between a volcanic element and its painted form appeal to Wright? Perhaps it also reflects his friendship with geologists such as John Whitehurst.[8]

In the foreground we find a very complex paint structure, which illustrates a process that Wright called 'the finishing'. Here, on top of a dead-colouring, the surface topography of the landscape is built up of opaque strokes, dots and squiggles of paint interlayered with resinous glazes, a variation on the technique used in the wall of *An Iron Forge*. The finishing became almost an obsession with Wright and indeed there is one recorded instance of a patron paying him extra to 'finish it highly'. In some paintings this has led to cracking in these areas; this has not happened in Vesuvius, though it is probable that the

fig.49 Sgraffito work in the water

foreground has darkened more than the rest of the picture on account of its resinous content. Other than that, however, the painting is in excellent condition. It was cleaned of discoloured varnish and relined shortly before being acquired by the Tate in 1991.

Analysis of the pigments in *An Iron Forge* was done by Dr Joyce Townsend using EDX in 1991. Optical microscopy was done by Rica Jones. Analysis of the binding media in Wright's work was done by Dr Marianne Odlyha at Birkbeck College, using FTIR. Analysis of pigments in *Vesuvius* was done using EDX by Dr Ashok Roy at the National Gallery.

SIR JOSHUA REYNOLDS (1723–1792)
The Age of Innocence c.1788

RICA JONES

The Age of Innocence, one of Reynolds's best-known images, depicts a child seated in a wooded landscape. The title dates from 1792, when the picture was first engraved, and Reynolds family tradition has it that she is Theophila Palmer ('Offy'), the daughter of his niece of the same name.[1] She was born in 1782. As revealed in the x-radiograph (fig.50), however, the picture started off as a version of *The Strawberry Girl*[2] (fig.51), in which a child is portrayed standing three-quarter length and looking more to the front. Only the clasped hands were left unchanged. It is clear from the technical evidence that this earlier painting was at an advanced stage if not completed. The cross-sections, two of which are illustrated in figs.53, 54 and 55, show a very complex, multi-layered painting. Only the lack of an overall varnish suggests it might be unfinished (a layer of varnish is present in two out of four areas sampled) – but we do not know whether Reynolds himself always put a final varnish on his paintings; selective or intermediate varnishes, on the other hand, are common in his work. It is known that he sometimes reused his paintings; Eastlake notes, 'he is reported to have said of his *Infant Hercules*, now at St Petersburg, "there are sever-

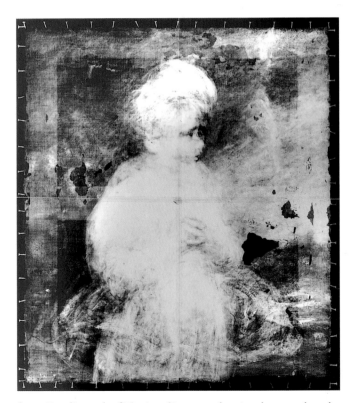

fig.50 X-radiograph of *The Age of Innocence* showing the pose altered from standing to sitting, with the original head turned more to the front. The black patches to the left and right of the child and above her head represent paint losses in one or both of the images

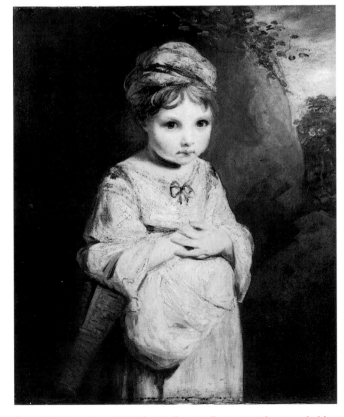

fig.51 *The Strawberry Girl* (The Wallace Collection). (This is probably the prime version which was exhibited at the Royal Academy in 1773. Another version is in a private collection)

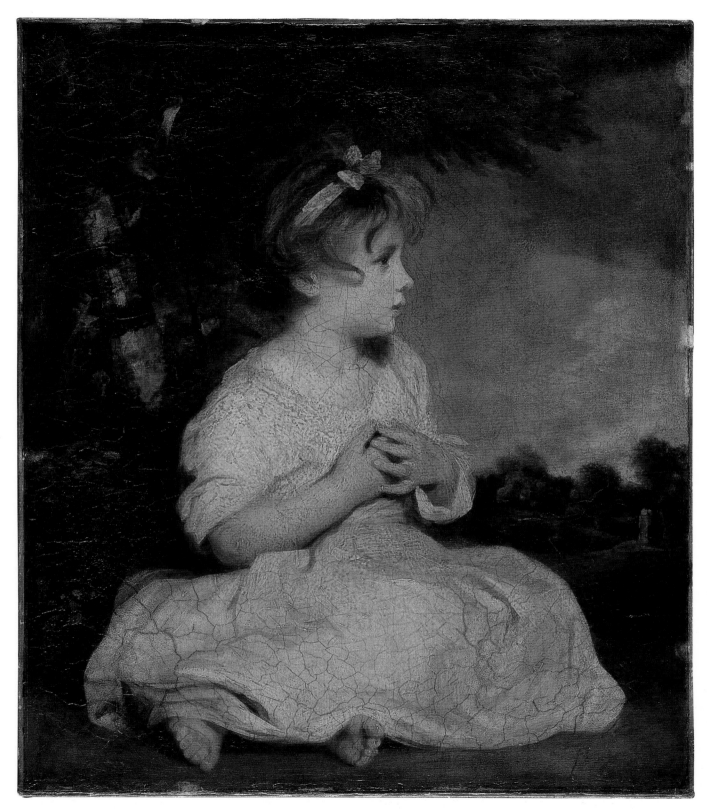

fig.52 *The Age of Innocence*, oil and beeswax on canvas
76.2 × 63.5 (30¾ × 25¾) N00307

al pictures under it, some better, some worse."[3] There is also a possibility that *The Strawberry Girl* was completed and then was altered by Reynolds on account of the large paint losses visible in the x-radiograph. As we know from early sources, some of his paintings had to be returned to him for restoration within a few years of completion because large areas of paint had fallen off.[4] In the picture's present state, obscured by several layers of discoloured varnish and glazes of retouching, it is not possible to be precise about the status of the paint on top of the large losses. When the painting undergoes restoration in the near future, this question may be resolved, and we may then be able to posit that Reynolds himself restored the losses, and, if it is the same child in both, altered the pose to account for her growth.

The painting entered the national collection in 1844 and its conservation dossier, begun in 1859 and continued through to the present day, records a history of cracking and flaking. The lining, an operation utilising hot animal glue and heavy pressure, a method which we think was introduced in the early decades of the nineteenth century, presumably predates its acquisition, since it is not listed. It is evident from fig.56, a view in raking light from the left taken in 1997, that the problem of cracking persists and will need to be addressed in the near future. In order that any relevant treatment might be successful, at least some of the varnishes covering the paint layer will have to be removed. Apart from obscuring the colours and the illusion

of space, old varnishes exert traction on paint, thereby encouraging any inherent tendency for it to delaminate and flake off. This technical examination, therefore, was designed principally to establish feasible methods of treatment, other aspects of analysis such as detailed identification of pigments being left for a later date. This study has been supported by a grant from The Getty Grant Program.

The painting is on plain-woven, linen canvas of medium-coarse weight. In common with other works from Reynolds's later decades examined recently at the Tate, it appears to have very little priming, just a thin white application scraped into the weave of the threads. As a caveat it must be said there are so many layers of paint in this picture and so much restoration at the very edges where one normally takes samples, that it was impossible to be certain that any one sample contained the whole thickness of the picture. Nevertheless, nothing like a conventional priming for this period emerged during examination and, in conjunction with the evidence from other works and studies, for the moment we have had to conclude that Reynolds's views on primings after about 1760 were esoteric and very various.[5] There appears to be a 'separating' layer between the two paintings. In the sky to the right it appears to be a thin layer of brown paint to block out the image beneath, whereas above her head it seems to be an unpigmented coat of varnish or wax.

Reynolds's own technical notes, which are mostly

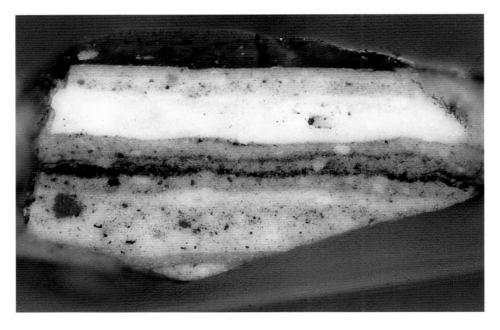

fig.53 Cross-section taken from the sky near the right edge just above the horizon. Photographed in polarised light at × 100 magnification. The nine lowest layers belong to The *Strawberry Girl* (the area ending up as blue sky after several changes of mind). Then there is a thin dark layer presumably applied to block out the first image and this was followed by three layers building up the sky of *The Age of Innocence*. The dark greenish layer on top is several thicknesses of varnish

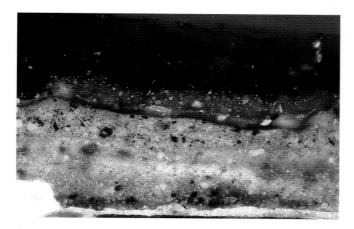

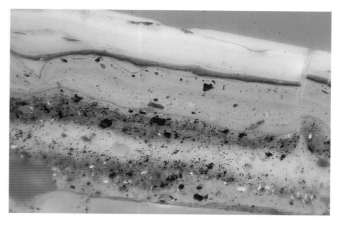

fig.54 Cross-section from the foliage about 5 cm above the child's head. Photographed in polarised light at × 250 magnification. The dark, apparently unpigmented layer about halfway up the sample is the line of demarcation between the two paintings. Beneath it the pink and blue layers relate to *Strawberry Girl*'s turban, which in the Wallace Collection painting has on it a faintly purple band. The first application in the foliage of *The Age of Innocence* was an opaque green paint composed of bright yellow orpiment mixed with vermilion and black. This was then glazed with several dark greenish layers which in this lighting are difficult to distinguish from the murky layers of varnish on top

fig.55 Same cross-section viewed in ultra-violet light and photographed at × 250 magnification. The fluorescence emitted by the different materials within each layer give a clearer view of the dark paint and varnishes on *The Age of Innocence*. The demarcation line looks resinous or waxy. The bright yellow particles in the lower half of the sample are Indian yellow, which appears to have been used throughout *The Strawberry Girl* but not in *The Age of Innocence*

recorded in accounts-ledgers now in the Fitzwilliam Museum,[6] are the normal starting-point in assessing the technique used in his paintings. Although this painting is not mentioned, the references are characterised by the range of binding media to be found in a single painting. Take, for instance, an entry for a portrait of *Miss Kirkman*, 2 October 1772, written in the mixture of Italian, English and Latin that he favoured : 'Gum Dr. Et Whiting poi cerata poi ovata poi verniciata e ritoccata cracks.' Translated literally, this reads: 'Gum Tragacanth and Whiting then waxed then egged then varnished and retouched cracks.' There are a number of possible interpretations of this. The gum and chalk may be the priming applied to the whole painting, or it may constitute a white priming for the face alone, a method he used often, though not necessarily with these materials.[7] The wax may have been rubbed on all over to create a translucent interlayer – or a wax-based paint may have been used next – or both. The same might apply to the egg, varnishes of egg white being used occasionally in this period and there is no reason why he should not have tried it as a binding medium also. The varnish too may have been pigmented but in this case it sounds as if it was a normal clear varnish, after which he retouched the painting. Then it cracked – or, given that

his Italian grammar was variable, it may mean that after varnishing he retouched the cracks which had already developed. Either way they would have been of the type known as 'drying' or 'shrinkage' cracks, usually caused when superimposed layers of paint dry at different rates. 'Heavens! – Murder! Murder! It must have cracked under the brush', wrote Benjamin Robert Haydon against the particularly complex technique of a self-portrait as he copied out Reynolds's notes in the 1840s.[8] It is possible that some of them very nearly did.

It is evident from fig.55, a cross-section viewed in ultra-violet light, that some of the layers on *The Age of Innocence* are not straightforward oil; the milky fluorescence exhibited by the dark paint in the upper half of the sample, for example, suggests a waxy or resinous component in the binding medium. Analysis of four samples confirmed the presence of beeswax in several areas: the sky, sampled near the right edge, appears to be a mixture of oil (not linseed, so probably poppy or walnut) and beeswax; green foliage at the top left edge has beeswax as the major component with traces of oil; grey underpaint from beneath the green foliage appears to contain only beeswax as the binding medium; the white dress is bound in poppyseed oil with traces of natural resin, which may be from the

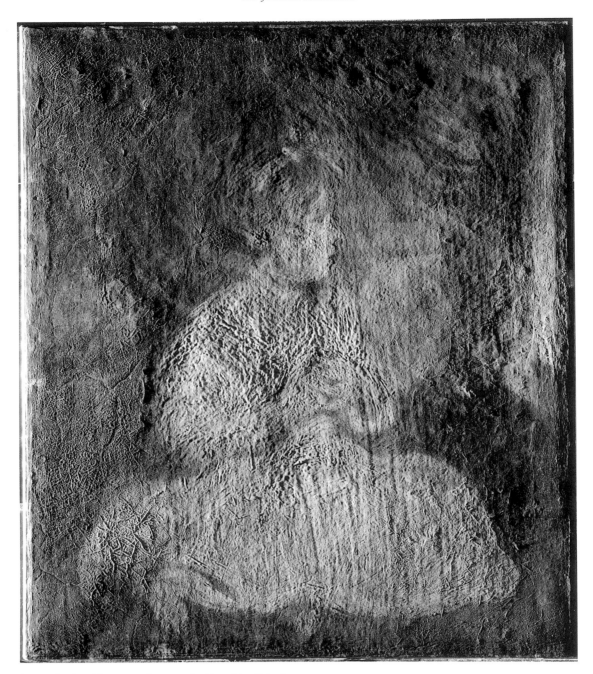

fig.56 *The Age of Innocence* photographed in raking light from
the left, showing the extensive cracking in most of the painting
and the different textures created as Reynolds built up layer upon
layer of paint. Some of the vertical ridges down the centre relate to
Strawberry Girl's dress; others probably were caused by the lining
glue. There are two basic types of cracking here: age cracks,
common to all oil paintings on canvas, caused when the priming
and paint crack in response to movement in the canvas; and drying
cracks, caused when superimposed layers of paint cannot 'grip'
properly during the process of drying and shrink to form islands
of paint. The latter are characterised by their rounded edges

overlying varnishes or may be intermediate varnishes within this thick paint layer (fluorescence in the cross-section when it is viewed in ultra-violet light suggests this may be the correct interpretation). No analysis was carried out at this stage on the media used in the lower painting. A reference in his notes to a *Strawberry Girl*, dated 1788, says 'cera Sol' (wax alone). Further analysis when the top varnish layers are removed may throw some light on the question of which version this may be, although it must be said that in ultra-violet fluorescence the cross-sections of the lower painting do not look particularly waxy and this date would not fit Offy's age if she were the model for both. What is clear from the evidence of his notes, and which is being increasingly confirmed by analysis, is that beeswax played a significant role in Reynolds's technique during the later decades of his career. This subject is discussed further in the chapter on *George IV when Prince of Wales*, together with a note on contemporary European usage of wax in painting (pages 146–51). It is interesting that bitumen, the substance traditionally associated with cracking in his paintings, has not been found on *The Age of Innocence*. It has been analysed in other of his works but, as B.R. Haydon indicated, with so many different ingredients present, cracking would occur anyway.

Ultra-violet photography also shows several layers of varnish with lines of dirt between them. This appears to be consistent throughout the picture. They are all aged natural resins. It is not possible to say whether the lowest of them might be an original layer but, given the anticipated fragility of the waxy or resinous areas of the painting, cleaning tests have been carried out with a view to leaving this earliest extant varnish in place to protect the paint and also impart a unifying tone to this complex painting in which different areas have aged in quite disparate ways.

Analysis of the binding media was carried out in 1997 with DTMS by Dr Jaap Boon and Jos Pureveen of FOM-AMOLF. Initial examination and cross-sectioning of the painting was done in 1992 by Hélène Dubois and Rica Jones at the Tate. Further examination and sampling has been carried out in 1997 by Arabella Davies, Rica Jones and Dr Joyce Townsend.

WILLIAM BLAKE (1757–1827)
Moses Indignant at the Golden Calf c.1799–1800

Joyce Townsend

William Blake was apprenticed to the engraver James Basire I, and earned a meagre living by engraving for most of his life. He produced illustrated copies of his poetry in limited editions, using a means of relief etching words and designs on small copper plates, the prints from which were hand-coloured by Blake and his wife. Blake disliked working in oil,[1] which he considered to deaden every colour, and to be liable to yellow and darken as time passed. Instead he worked in watercolour, or in a water-based method which he called 'fresco',[2] but which would have been described by his contemporaries – and by us today – as 'tempera'. Either medium allowed him to make use of a graphic line, generally sinuous and applied with ink both before but more often after the work was coloured, and transparent washes of pure colour. According to Blake, the one merit of oil medium was that it could be used with a white priming to give luminosity. He therefore advocated the use of a white plaster or whiting priming for both tempera and watercolour work.[3] When Blake read the first (Italian) copy of Cennino Cennini's book to reach England, he 'was gratified to find that he had been using the same methods and materials as Cennini describes, particularly the carpenters' glue'.[4]

Until now, hardly any analyses of Blake's tempera medium have been attempted. The small size of the works, and the complication of extra materials added during conservation treatments, makes it a particularly difficult analytical problem. Descriptions by his artist contemporaries do indicate which materials to seek: according to his biographer Gilchrist, Blake began with a very thick priming of glue and whiting, then he ground and applied his colours simply in 'common carpenters' glue' after 'Joseph, the sacred carpenter, had appeared in vision and revealed that secret to him'. Thereafter Blake added another coating of glue on top, and in some cases, a coat of 'hard white varnish', or natural resin.[5] He came to regret this procedure, when the varnish yellowed and darkened at least as much as oil paint did. It is implicit in the artists' descriptions that Blake drew first in pencil and or ink, and applied successive layers of paint to build up depth of colour without losing transparency. It has been noted before, for example by Maheux,[6] that the appearance of Blake's temperas and watercolours suggests that they have paint layers of varying thickness, because he used a material which was free flowing when warm, and which set into a thicker film as it cooled. Animal glue would behave like this, and would have the added advantage that each layer sets in turn, and is not readily redissolved when another glue-based layer is applied on top.

Gilchrist stated that Blake produced 'numberless' temperas, the first mention of the medium being *c.*1799. There are several small Blake 'temperas' dated to 1799–1800 in the Tate's collection, such as *Moses Indignant at the Golden Calf*, *The Body of Christ Borne to the Tomb*, *Bathsheba at the Bath*, *Christ Blessing the Little Children*, and *The Agony in the Garden*. The first of these, *Moses*, will be considered in detail. *Moses* is a small, jewel-like work whose vibrant tones have been revealed by the removal of layers of non-original yellowed varnish in recent years. At least one varnish layer remains, since it was not clear whether this layer could have been applied by the artist. Some of the varnishes were applied over old paint losses which reveal the canvas threads, and so cannot have been original.

Moses has a stretched canvas support, like all but one of the others in the group, which is on tinned steel. Cracks in the paint indicate that the original stretcher was lighter than the present one, and had narrow stretcher bars. The present one is old, and could date from the nineteenth century. Its label indicates that it came from Roberson the colourman. The stretcher bars are thick, and cover most of the canvas on the reverse. The paint appears very thin in the x-radiograph, and even light-coloured areas such as Moses himself are hard to discern. This suggests that the white priming visible beneath red and blue areas of paint (fig.58), and also white areas such as the book in the foreground, must be made from an x-ray transparent pigment such as chalk. Chalk is a useful white in a 'tempera' or water-based medium, though its refractive index is too

fig.57 *Moses Indignant at the Golden Calf*, glue and gum tempera
on canvas 38 × 26.6 (15 × 10½) T04134

fig.58 Detail of the blue paint at Moses' feet, applied over a bright white priming. Photographed at × 10

close to that of linseed oil for it to be a useable opaque white paint in that medium.

Analysis of the white priming confirmed that it consists of chalk (or whiting) with small amounts of kaolin extenders. Other temperas gave the same analytical results, and all the primings have a similar appearance in cross-section. Cross-sections also show that the paint medium has been absorbed into the upper part of the single layer of priming, in every case, as illustrated in fig.59. The lean priming of *Moses* could not be analysed successfully, but it is presumed to be glue based. Glue could be detected in the primings of some of the other temperas.

Blake applied a thick layer of unpigmented glue over the priming, and it sank in (fig.59). The paint layer above this is thin in this section, and, over much of the surface where the white priming is visible, it must be equally thin. Again, the medium of this layer includes glue. A thick, unpigmented layer of glue overlies it, and may have been applied by Blake as a varnish. The blue-white fluorescence of all these layers when they are viewed in ultra-violet light suggests that glue is a major component, and both staining of the cross-section and analysis confirmed this. The other temperas mentioned above have a similar layer structure, and were also analysed with the same result. This gives more confidence in the analysis for *Moses*, for it has been consolidated with gelatine in recent years, and it is always possible that a sample, taken deliberately from an edge or an area of damage, might include both gelatine (refined animal glue) and Blake's medium. The other temperas had not been so treated. Some of Blake's tempera paint (green from *The Body of Christ borne to the Tomb* and blue and white from *Bathsheba at the Bath*) contains a mixture of gum arabic, gum tragacanth, and unrefined sugar as well as glue, while paint from *The Agony in the Garden* includes karaya and tragacanth gums, again with unrefined sugar, in the glue. These gums are assumed to be present in every layer, but methods of staining cross-sections are being developed to confirm this. The priming of *The Body of Christ* contains karaya gum, and once again unrefined sugar, all soaked in from the glue layer above. It is not yet clear what are the relative proportions of glue, gum and sugar. *Moses* may also have some gum in the glue medium.

The sugar was added by Blake to prevent the thick glue layers from cracking as soon as they dried. But thick glue layers all crack eventually, and the loosening of substantial areas of paint made lining necessary, probably in the nineteenth century, and again in the mid-twentieth century. Glue lining was used in both cases (another reason to suspect that glue found in the paint might not all be Blake's medium), and has caused considerable visual changes, such as flattening of form, and the trapping of dirt within cracks, a particularly distressing feature of light-toned areas such as Moses' cloak and flesh.

Karaya gum was used by printers and engravers, and though it seems unusual to find it used as a painting medium, it would have been a readily available material for Blake. It has been found independently in another Blake tempera.[7] The gums may have been combined by the colourman each time new supplies arrived from distant countries, so as to give a formulation with fairly uniform solubility, needed for the engraving or printing processes.

Yellowed resinous varnishes on the temperas obscure Blake's fresh colours. Some fill old cracks which already

fig.59 Cross-section, photographed at × 250 in ultra-violet light, showing blue paint from the right edge

had dirt settled inside them. Such varnishes are clearly not original, and may have been applied partly to unify tone and partly to lock cracking and flaking paint into position. Some of the natural resin varnishes include oil as well and are less likely to be original, since the oil-free resinous varnish corresponds to Blake's 'hard, white varnish'. When the paint of *Moses* was sampled, the varnish flaked cleanly off the glue. It is still not clear whether Blake applied this first varnish.

Gilchrist states that Blake ground his own colours, in preference to using the moist gum-based watercolour blocks available from colourmen.[8] If he ground them in gum-water before adding glue, this would account for the analytical results. His chosen palette at this period (1799–1800) was quite limited. The paint in *Moses* includes Prussian blue, natural ultramarine, vermilion, madder, bone black, and yellow and brown ochre. Prussian blue was used for the clouds behind Moses (fig.60), and was mixed with a yellow organic pigment for the green in the foreground. This may be gamboge, which was said to be a popular colour with Blake, and indeed has been found in several temperas by Maheux, along with the range of pigments mentioned here.[9] The ultramarine was used for the pale sky behind the golden calf. Vermilion with a localised madder glaze was used for the red clouds, and vermilion was mixed into yellow ochre for the calf's hair. Probably it was used for the pale flesh tones as well. Some of the temperas include Mars red or red lead instead of vermilion.

Analysis has confirmed the accuracy of recall of the artists who described Blake's techniques to Gilchrist some decades after his death, and has confirmed that Blake had a consistent working method for tempera paintings over the latter period of his life. Their condition today is a sad but inevitable consequence of his choice of materials, his methods of applying them, and the treatments used in consequence of early deterioration. The fresh appearance of many of his unfaded watercolours, which have the same limited palette but are free of both glue and resinous varnishes, give us some insight into the original appearance of these works. So do contemporary descriptions, for example of the *Last Judgment* of *c*.1810–27, now lost, of which it was written, 'The lights of this extraordinary performance have the appearance of silver and gold; but, upon Mrs Blake assuring me that there was no silver used,

fig.60 Detail of blue and red smoke behind Moses

I found, upon a closer examination, that a blue wash had been passed over those parts of the gilding which receded; and the lights of the forward objects, which were also of gold, were heightened with a warm colour, to give the appearance of two metals.'[10] These are just the effects whose subtlety is lost forever amidst dirt-filled cracks, and which are eclipsed by a yellowed varnish.

Analysis of glues and other proteins by HPLC, and of gums by GC, was carried out by Dr Sarah Vallance of the University of Northumbria at Newcastle in the course of doctoral research.[11] Dr Brian Singer, who supervised her research with Dr Joyce Townsend, is now developing staining methods for gums and sugars. Optical microscopy and EDX were used for pigment identification, backed up by XRD carried out at the British Museum with David Thickett for priming samples. Anna Southall carried out initial research into the artist's materials and techniques in 1986.

J.M.W. TURNER (1775–1851)
Snowstorm – Steam-boat off a Harbour's Mouth c.1842

JOYCE TOWNSEND

Ruskin described this painting as 'one of the very grandest statements of sea-motion, mist and light, that has ever been put on canvas, even by Turner. Of course it was not understood; his finest works never are …'.[1] Many other criticisms of the painting were highly adverse when it was shown in 1842, one of the less charitable ones comparing it to 'soap-suds and whitewash'.[2] Some of those who saw the painting in Turner's gallery must have experienced dangerous storms as they crossed to Continental Europe. Turner referred to the inspiration of the painting as an actual storm which he had not expected to survive, though it has been questioned whether any responsible ship's captain would have allowed an elderly man, not one of the crew, to be lashed to the mast for four hours to watch it, as Turner claimed he had been.[3]

His general method[4] was to begin with a support – usually canvas, but not invariably – with a fairly white priming which was thin enough to reveal its texture, and quite absorbent. By the 1840s, he was buying all his canvases ready-primed and stretched.[5] The absorbency meant that the paint dried quickly, so that work could proceed fast in the early stages. Turner did not produce detailed preliminary sketches for exhibited works in any medium, but over his lifetime he filled hundreds of sketchbooks with pencil drawings of buildings, landscapes, figures, details of skies, and many other subjects, occasionally worked them in watercolour afterwards, and sometimes integrated these ideas into large-scale works painted many decades after the initial sketch. Nor did he draw a design on the priming, except occasionally for intricate buildings or battleships. For *Snowstorm* he painted directly onto the commercially prepared white priming of lead white and oil, applying washes of highly thinned grey oil paint for sea, dark sky, landscape and large elements of the composition, cooler than the tone of the priming. He tended to leave some areas of the canvas blank so that the white priming would give maximum luminosity to light areas of the image when painted later. Then he applied more opaque paint made by mixing lead white with the same selection of pigments. (This method can be seen in unfinished works, and by means of cross-sections from the finished works (fig.61), but is not actually visible to the viewer in *Snowstorm*.) If the result was close enough to his mental image, he continued to work on the same canvas. When it was not, he put the canvas aside in his studio, sometimes to return to it years later with a new subject in mind.

Some areas of *Snowstorm* have only thin washes of paint corresponding to the initial stages, while others are built up with thin scumbles of oil paint applied in small brushstrokes of pale yellow, blue, and pink, juxtaposed to make use of simultaneous contrast. They can be seen generally at the outer reaches of the vortex which is centred on the ship, and particularly in the lower left corner. Small brushstrokes of unthinned oil paint form flecks of spray in these areas (fig.63). The next stage of painting involved modified oil paint, less intractable than pure oil paint. Turner tried practically every material and technique available to an artist in the nineteenth century, and if he liked the visual effects which he could produce with it, he used it regularly. By the 1840s there was a selection of

fig.61 Cross-section photographed at × 100 magnification, showing sky paint at the upper left edge, applied in several layers of unmodified oil paint over the white priming

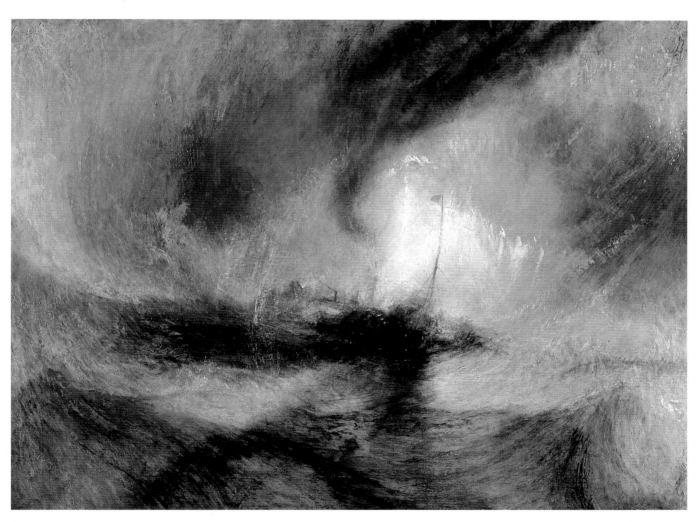

fig.62 *Snowstorm – Steam-boat off a Harbour's Mouth*, oil and modified oil on canvas 91.4 × 121.9 (36 × 48) N00530

fig.63 Detail showing crisp white oil paint for a fleck of foam. All detail photographs in this chapter were taken at the same magnification

fig.64 Detail of large-scale contraction cracks in a surface layer of bitumen-rich paint

fig.65 Detail showing long, coarse brush-hair embedded in the paint

them which he used regularly, in the later stages of finished works.[6] Paint formed from linseed oil, beeswax and sometimes spermaceti wax, and lead white, applied with a soft and long-haired brush, was used for very soft, off-white areas of cloud or troubled water. Both glazes of medium-rich paint, and scumbles of dry oil paint run over this soft paint. Other areas of foam were painted in a megilp, which was made by combining linseed oil prepared with lead acetate drier and mastic varnish, to form a thixotropic medium which held a stiff impasto without slumping as it dried. It could be mixed into oil paint on the palette, when it dried with a pleasing gloss and impasto. This paint medium is likely to be present in the smoke plume of the steamship too, thinned with turpentine, and brushed out to give a thin, continuous, dark glaze. When used unmixed with paint it would have been yellow: localised golden-coloured, transparent glazes of this material can be seen in the upper left corner. Unmodified oil paint was difficult to apply in a controlled manner for details over partly dried paint. When a great deal of thinner was added, it tended to shrink into little islands of matt paint as it dried. Turner made use of this property when it suited his purpose, especially for rigging and other distant objects seen through spray, though in *Snowstorm* few details on this scale would be visible through the squall. The paint of the smoke plume and the dark foreground area includes areas with deeper cracks than those seen elsewhere (fig.64). This is typical of a mixture of bitumen, linseed oil and mastic resin which Turner employed to paint deep, glossy shadows in landscapes.

A great deal of the complex and varied surface effects have been achieved by successively applying the paint formulations described above, generally in thin layers, while using tonally similar colours. Turner used a stiff brush for applying much of the paint, and many brush-hairs can be seen entrapped in paint (fig.65), as evidence that he worked ferociously fast on the surface. He also used a palette knife to apply and spread much of the opaque white in the sky. Most of Turner's later paintings show extensive use of the palette knife, and since he tended to apply fewer glazes to the sky, the knifework can be seen most clearly in such areas.

In *Snowstorm*, much of the paint has been mixed with a great deal of lead white, and either includes small amounts of ivory black, cobalt blue, Prussian blue, or natural ultramarine in the cool-toned brushstrokes, or chrome yellow, a reddish brown ochre, a more purple-toned one, or vermilion in the warm-toned brushstrokes.

The brightest areas of the image, the hot smoke and sparks from the funnel, are painted in vermilion. Turner often used newly manufactured pigments[7] as soon as he could obtain them, and before much was known about their long-term stability, but *Snowstorm* does not illustrate any such early uses. It does not even have a very wide range of pigments, for a finished painting by Turner.

Turner was often described as finishing large sections of his paintings at the Royal Academy on the three 'Varnishing Days' which preceded the annual exhibition (fig.66). On these days, artists were allowed to modify any areas which had dried unevenly, or which had been damaged in transit, and to apply a final coat of varnish, in the frame. *Snowstorm* was framed while the paint was still wet, so at least some of the finishing, or 'soap-suds and whitewash' must have been done before Varnishing Day, in Turner's studio.

Turner painted *Snowstorm* with more regard for effect than for permanence, which was typical of him. Conservators have had to intervene regularly with many of his paintings, in order to preserve them at all. Turner applied most brushstrokes to wet paint, since new paint applied to already-dried paint was unlikely to adhere well. But when the next brushload had a different medium from the one before, it did not always adhere very well either. Very medium-rich paint, such as the megilp glazes which Turner often used, is brittle when it ages. Now the slightest pressure to the surface can cause the paint to separate, creating a loosened flake of paint ready to fall off whenever the painting is moved. Over the years, some of the surface has been treated locally to reattach such flakes. This means that the paint medium includes conservation materials, in addition to Turner's often complex paint formulations based on similar materials. Much of the information on *Snowstorm* has been obtained from a study of a range of Turner's later oils, with judicious sampling and analysis of the better-preserved ones, combined with close observation and more limited analysis on this one.

Bitumen-based and megilped paints darken with age, or when they have been heated during glue lining, which emphasises the darks in the image unduly.[8] Here, the effects of ageing and glue lining are very minor, for much of the paint surface is not dark. The cracks seen in the surface are generally modest, and not visually disturbing,

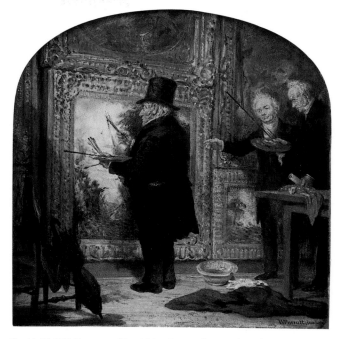

fig.66 *J.M.W. Turner on Varnishing Day at the Royal Academy* (1846), by S.W. Parrott (Ruskin Gallery, Collection of the Guild of St George, Sheffield)

because the paint has been applied thinly, by comparison with other finished works by Turner. The worst cracks indicate areas of modified oil medium.

It is not certain whether Turner ever varnished *Snowstorm*. He tended to apply a natural resin varnish only when a work was sold, and this one was not. In fact, varnishing a newly painted surface was potentially damaging to it, and many artists would arrange for the first varnish to be applied in the purchaser's home several years after painting.[9] The surface of *Snowstorm* has no residues of old varnishes, and after a non-original varnish had been removed, a light coating of wax was applied to protect the surface. This has virtually no effect on the surface appearance, and allows the viewer to see the painting as it would have appeared when Turner completed it.

Analysis of the pigments was carried out by Dr Joyce Townsend with optical microscopy and EDX.

– 10 –

JOHN EVERETT MILLAIS (1829–1896)
Ophelia 1851–2

S T E P H E N H A C K N E Y

John Everett Millais, a founder member of the Pre-Raphaelite Brotherhood and an enormously gifted artist, worked closely with Hunt[1] at this early stage in their careers. They shared studios and even worked on each other's portraits. Both artists had independently developed techniques to exploit the luminosity of their paint and priming. Millais was described by Hunt as having explored methods of painting without the use of dead-colouring (see pages 80–5). Together they evolved the Pre-Raphaelite technique. Millais's early masterpiece *Ophelia* (1851–2) demonstrates his successful use of the Pre-Raphaelite technique in a pure form. Hunt remained faithful to Pre-Raphaelite ideals but later, as a Royal Academician, Millais changed both his aims and methods.

A preliminary study for the figure of Ophelia survives, now in the Pierpoint Morgan Library; a finished sketch at Plymouth City Museum and Art Gallery; a study for the head at Birmingham City Art Gallery and an oil study for the head (whereabouts unknown) also exist. Even for such a major undertaking Millais did few preparatory sketches, instead he attempted to settle the composition in the drawing on the canvas itself. This allowed him to develop a consistent design and avoided the introduction of any disparate elements at a later stage. It also allowed him to do the painting in two parts.

Millais executed the landscape parts of the painting by the banks of the Hogsmill River at Ewell in Surrey whilst lodging with Hunt. During this summer in the Ewell meadows Hunt was painting on a canvas of the same size and method of preparation the background to *The Hireling Shepherd* (1851–2), which was to be exhibited together with *Ophelia* at the following Royal Academy exhibition. Millais spent up to eleven hours a day during the summer (July to October) sitting on the riverbank under an umbrella painting the scene in painstaking detail. He was bothered by many irritations, such as the voracity of the flies, the wind that he suspected might blow him into the water, the complaints of trespass by the landowner and two swans that would take up position at

'the exact spot I wish to paint, occasionally destroying every water weed within their reach'. The scene, begun in July 1851, was not finished until late October of that year.[2]

The flowers in *Ophelia* are in part taken from those mentioned in Shakespeare's *Hamlet* but also include a compilation of the wild varieties that would have been growing on the banks of the Hogsmill river. Millais has closely observed their forms and condition, depicting them with their dead and broken leaves, not as idealised botanical specimens. Although painted in great detail from nature the flora are also chosen for their symbolic value. Significantly they would not have been in bloom simultaneously as depicted. The fauna were important too. Millais was persuaded to paint out a water rat by C.R. Leslie who thought it inappropriate. A small study for this rat and also for the robin and some loosestrife were painted in the areas at the top of the canvas to be covered by the frame spandrels, indicating that although the composition was fixed Millais was continuously adapting details.

The figure of Ophelia was painted during the winter months in time for the picture to be exhibited at the Academy in April 1852. Elizabeth Siddall was the model who somewhat reluctantly posed for sittings during the period from late January to March in a bath full of tepid water heated by lamps beneath. Millais purchased a 'really splendid lady's ancient dress, all flowered over in silver embroidery' for her to wear. On one occasion when the lamps went out, Siddall, who was extremely fragile, caught a serious cold and Millais was forced by her father to pay the doctor's bills. Because of these technical constraints, it would have been virtually impossible for Millais to paint the figure and pose of Ophelia out of doors. Hunt too painted his figures for *The Hireling Shepherd* indoors whereas Ford Madox Brown, also working in the same year in Stockwell, painted his first truly Pre-Raphaelite work entirely out of doors (*The Pretty Baa-Lambs* (1852), including the figures who were modelled by his wife and daughter).

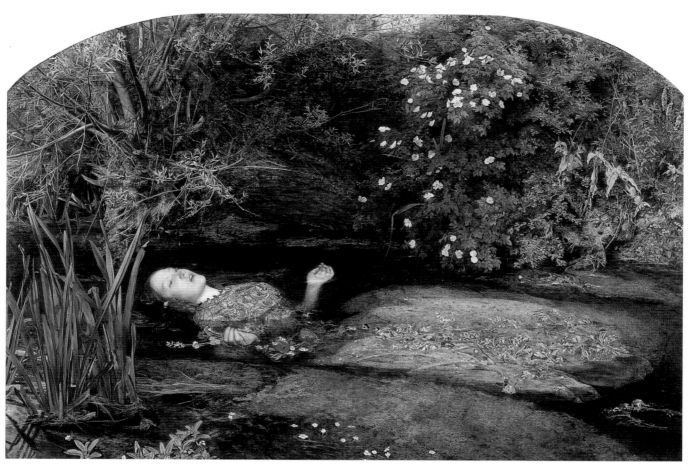

fig.67 *Ophelia*, oil and copal resin on canvas 76.2 × 111.8 (30 × 44) N01516

Painting to the level of detail and finish achieved by the Pre-Raphaelites was difficult enough, to do so out of doors was a considerable achievement but made possible by suitable equipment readily available in the 1850s. Most significant was the invention of the collapsible metal tube, first patented by John Rand in 1841 and adopted by Winsor and Newton and other colourmen in 1842. These tubes were a great advance on bladders and remain the most convenient way to store and dispense oil paint. Their use in the second half of the nineteenth century freed artists to paint out of doors on lightweight tripod easels. A special feature of Millais's equipment was a porcelain palette that was easy to clean thoroughly and thereby prevent accidental adulteration of the colours.

The best known description of the technique of the Pre-Raphaelites is in Hunt's autobiography[3] and is with reference to his painting of *Valentine Rescuing Sylvia from Proteus* (1850–1), the background of which was painted the previous year at Knole. Hunt claims to have painted 'the heads of both Valentine and Proteus, their hands and the brighter costumes in this way'.

Select a prepared ground originally for its brightness, and renovate if necessary with fresh white when first it comes into the studio; white to be mixed with a very little amber or copal varnish. Let this last coat become of thoroughly stone-like hardness. Upon this surface complete with exactness the outline of the part in hand. On the morning for the painting, with fresh white from which all superfluous oil has been extracted by means of absorbent paper, and to which again a small drop of varnish has been added, spread a further coat very evenly with a palette-knife over the part for the day's work, of such consistency that the drawing should faintly shine through. In some cases the thickened white may be applied to the forms needing brilliancy with a brush, by the aid of rectified spirits. Over this wet ground, the colour (transparent and semi-transparent) should be laid with light sable brushes, and the touches must be made so tenderly that the ground below shall not be worked up, yet so far enticed to blend with the superimposed tints as to correct the qualities of thinness and staininess which over a dry ground transparent colours used would inevitably exhibit. Painting of this kind cannot be retouched except with an entire loss of luminosity.

When in November William Rossetti (brother of the artist D.G. Rossetti) brought Ford Madox Brown to Ewell to see their work, Millais could not resist telling him their supposedly secret method for 'the flesh and brilliant passages of paint'. Hunt also records Millais's use of a 'ground of wet white, which gave a special delicacy of colour and tone' for the head of the boy in *The Woodman's Daughter* (1850–1; Guildhall Art Gallery).[4] Although they were clearly using bright white grounds, Hunt and Millais used the wet-ground technique described above only sparingly. Both Hunt's and Millais's comments imply that the wet-ground technique was not used for most of the landscape. Hunt further noted that the background of *Valentine Rescuing Sylvia from Proteus* took much longer than he had anticipated. The drying time of oil paint in the open air is much reduced and therefore the wet-ground technique would have been more difficult than indoors, requiring the application of ground to quite small areas to be consistent with Millais's rate of progress. It might also have trapped some of the annoying midges. In combination with Millais's other outdoor problems, the consistent use of a wet-ground technique throughout these paintings would have made the difficult and time-consuming process of recording nature accurately and in such detail even more burdensome.

Evidence from Roberson's archive reveals that Millais bought '2 Prep Cloths (one very white on Stretcher 44 × 30) on 7 June 1851 for 15/-'.[5] The canvas for Millais's *Ophelia* bears a Roberson's stamp on the reverse. It is a double canvas, with the auxiliary canvas primed on the reverse to protect it. Both the main (painted) and auxiliary canvas primings consist of three oil-based lead white coatings each with chalk, barium sulphate and kaolin extenders. The top layer of these commercial primings is more opaque than the lower ones. On the painted canvas over the colourman's priming there is an application of zinc white and lead white in oil. Cross-sections reveal that this layer has seeped into cracks in the colourman's priming suggesting that it was applied later by Millais (fig.68). This zinc white layer extends over the unpainted areas beneath the spandrels and was therefore applied as one continuous layer before painting. It would have provided the whitest ground possible as well as a smoother and fresher surface on which to paint. The limited cross-sections taken do not reveal a further layer, applied by the artist on a day-by-day basis for working wet-in-wet, but two identical layers might not be easily distinguished. Therefore there is no conclusive evidence that Millais was working

fig.68 Cross-section in ultra-violet light, photographed at × 250, showing a layer of fluorescent zinc white priming applied by Millais, over the commercially prepared lead white ground, which has cracked

fig.69 Photomicrograph of part of a loosestrife flower from the extreme right. Small brushstrokes of paint are applied over the reserved white ground

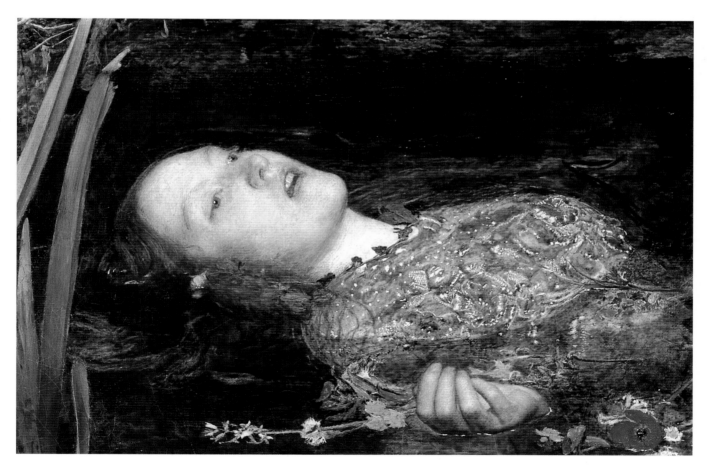

fig.70 Detail of Ophelia showing the range of colours used for flowers

in a wet-ground technique in this painting. A sample taken from the face or figure would have been instructive if it had been possible. It would also have answered the question whether Millais left a reserve for his figure of Ophelia or whether he applied a new ground when he restarted painting in January. The face and flesh of Ophelia appear to be painted in a different way from the rest of the painting (fig.70). The flesh looks stippled or slightly hatched with short brush-strokes.

The opportunities for systematic sampling of Pre-Raphaelite work are limited and as a consequence their methods have not been analysed in sufficient detail to answer this question conclusively. What is clear from a close examination of the painting is that it was accurately drawn and then painted in, leaving reserves of bare zinc white priming for each area of bright colour (fig.69). In general the colours were mixed sparingly in order to preserve their purity and worked gently over the white ground to gain maximum translucency (fig.71). An inter-

esting exception to this is the isolated flowers of the wild rose, some of which show strongly in the x-radiograph (fig.73). Most of the flowers in this group (fig.72) do not show on the x-radiograph because they are thinly painted over the zinc white ground, but those that do show up strongly are in thicker, presumably, lead white paint and are executed spontaneously and with colours only partly mixed on the brush. In this as in other aspects of technique Millais was less purist than Hunt. Evidence that the pragmatic Millais deviated somewhat from their idealised technique is apparent in the way that the bright colours employed for the flowers and figure do not work against each other in direct juxtaposition; by isolating these colours in a matrix of green the artist has unified his image

The results of Millais's labours have proved to be relatively stable but *Ophelia* was not without problems. In 1873 Millais retouched parts of the painting to restore faded yellows in the green water-weeds and to modify the

fig.71 Detail showing reeds and leaves

fig.72 Detail of the background showing wild roses

fig.73 X-radiograph detail of the same patch of wild roses. Only those painted in x-ray opaque white lead are visible

colouring of the face. Some evidence of fading of the yellows in the background leaves remains today. Possibly other areas have changed, but in general the pigments and medium have survived well. Lead white, zinc white, ultramarine ash, vermilion, chromium oxide, zinc yellow, chrome yellow, cobalt blue, Prussian blue, burnt Sienna, Naples yellow, madder lake, ivory and bone blacks were all found on the painting and under the spandrel. Millais's greens were mixed greens of chrome yellow and Prussian blue, possibly from a tube of green paint. It was the chrome yellow in the mixed green that Hunt blamed for the fading, but gamboge is also notoriously fugitive in strong light.

The artist's monogram, 'J Millais', and date, 1852, is painted in red at the bottom left. The painting was varnished, including the areas underneath the spandrel, probably with mastic, and the frame is an original gilded moulding. The Royal Academy concept of finish was very much in the artist's mind.

Pigment analysis was carried out by Dr Joyce Townsend with optical microscopy and EDX. Information from the Roberson Archive is published by permission of the Syndics of the Fitzwilliam Museum.

– 11 –

WILLIAM HOLMAN HUNT (1827–1910)
The Awakening Conscience 1853

STEPHEN HACKNEY

William Holman Hunt's interest in materials and techniques was a dominant factor throughout his lifetime and it is from his writings that the techniques used by the Pre-Raphaelites are known. The *Awakening Conscience* was painted between August 1853 and January 1854, and was regarded by Hunt as a complementary work to *The Light of the World*, begun at Ewell in 1851 where Millais was working on *Ophelia* (see pages 74–9).[1] Hunt rented a room, at Woodbine Villa, 7 Alpha Place, St John's Wood, for the scene of the painting and the model for the woman is Annie Miller. It was Hunt's first attempt at a contemporary subject and illustrates his obsession with the depiction of detail. The rendition of many objects in sharp focus and the use of a variety of largely unmixed pigments creates a disturbing sense of visual confusion. Ruskin, recognising the symbolic value of these objects, observed 'the fatal newness of the furniture'. The painting was bought by Sir Thomas Fairbairn who eventually asked Hunt to repaint the face since he found it too painful.[2]

We are fortunate that Hunt left inscriptions on the unpainted spaces under the frame spandrels (fig.74) which give useful information on his original painting methods and materials, and on the subsequent retouching and restoration of this work. Hunt's inscriptions and the presence of paint over the brown paper tape applied to the edges during lining confirm that this work had several campaigns of treatment including being at least twice returned to the artist.

Direct evidence of the origins of the canvas have been covered by the lining and the use of a blind stretcher. Roberson's archives record a canvas of these dimensions purchased by Hunt on 17 August 1853, and describe it as extra-primed.[3] Analysis reveals that the priming consists of a thick glue-size layer followed by a coat of lead white, extended with chalk and barium sulphate, in oil. On to this were applied two further pure lead white layers, the second of which is presumably the reason for this canvas being termed extra-primed. Roberson's prepared canvases are noted for their thick glue-size layers like the one identified on *The Awakening Conscience*. This glue size was applied cold using spatulas to give good coverage. Such canvases are particularly susceptible to moisture. It is not known whether the blind stretcher is original or if it dates from the lining. All the oil primings have been applied in relatively quick succession and are the work of the colourman: they extend over the unpainted areas under the frame spandrels. It is interesting to observe that only a few years after he and Millais had started working on white grounds, Hunt was able to buy a prepared canvas with a priming sufficiently white for his demanding needs.

The intense colours in Hunt's work derive from his exploitation of the reflective qualities of his white ground through a variety of pigments. In 1853 he could choose his hues from a wide spectrum of colours, informed by the

fig.74 Detail of the left spandrel. The inscription reads 'Painted in Copal (oil) weak, originally, diluted in use with R.[rectified] S.[spirit] of Turps [turpentine] for drawing out parts. E.[emerald] Green & Gamboge in transparent part of foliage. Picture retouched with same vehicle in 1864. W Holman Hunt. Please copy the above notes before obliterating it.' On the right spandrel the inscription reads: 'Mastic in 64 on all parts but the girl. After a few years all the varnished parts were cracked the rest not at all. A restorer filled up the cracks with colour and mastic. This has now been taken off and I have now filled up with amber 86.'

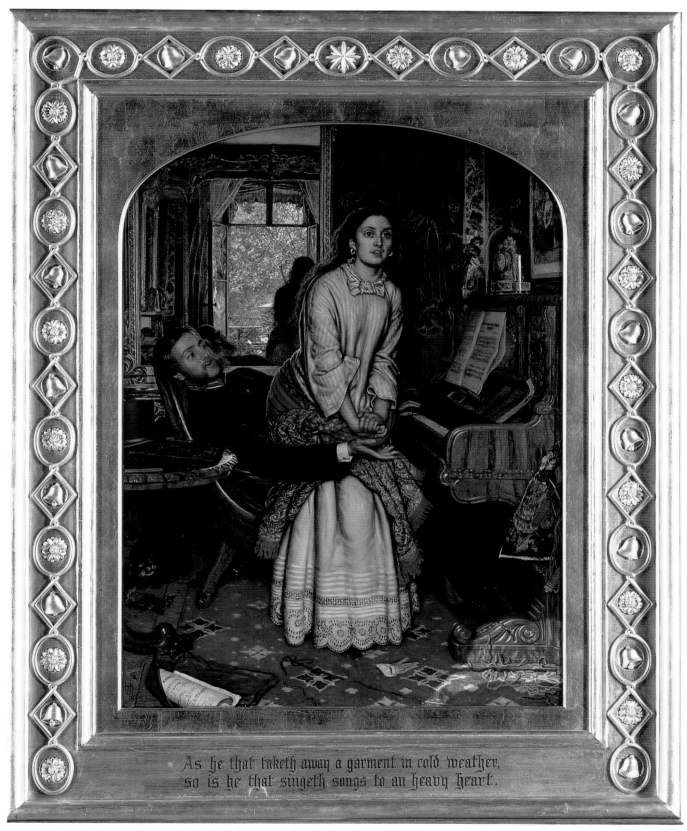

As he that taketh away a garment in cold weather,
so is he that singeth songs to an heavy heart.

fig.75 *The Awakening Conscience*, oil and copal resin on canvas 76.2 × 55.9
(30 × 22). The frame is original and was designed by Hunt. T02075

scientific theories of Goethe, Brewster and others. Primary colours such as Prussian blue, cobalt blue, natural and French (artificial) ultramarine were all well established, and artists had become familiar with their properties and disadvantages. There was a good range of traditional reds such as vermilion and red earth pigments as well as more stable lakes such as madder. Most importantly, strong yellows based on chromium and cadmium were available as well as the traditional but less intense Naples yellow and yellow earth pigments. Secondary colours such as viridian, mixed greens, cadmium orange and iodine scarlet were also sold. Hunt made good use of the colours available to him but with time became increasingly cautious and critical of the colourman's trade. Information on the stability and purity of pigments was mainly in the hands of the colourmen. Later in his life Hunt corresponded with Field, a chemist concerned with the permanence of pigments, but at this stage he must have been uncertain of some of his materials. The inscription on the spandrel refers specifically to the use of gamboge and the highly poisonous emerald green, presumably because Hunt had doubts about these pigments. Identified by analysis on this work were vermilion, rose madder, natural ultramarine, Prussian blue, cobalt blue, lead white, zinc white, ivory black, chrome yellow, strontium yellow, Mars orange, umbers and ochres as well as emerald green. Gamboge was not detected in the limited sampling.

Although exploiting the whiteness of his ground, his approach was not that of a watercolourist nor that of a tempera painter. It was not his intention to paint in thin washes of pigment or in hatched lean brushstrokes. He used a medium of oil and natural resin, somewhat similar to coach paint which he bought from Roberson. Instead of adding mastic to oil, as was common for artists, he added copal (referred to as amber in the 1886 inscription) which is a hard fossil resin originally from Zanzibar.[4] It is more difficult to mix with oil and is traditionally melted and then 'run' into heated oil. The high temperature of this operation made it a serious fire risk and it was therefore left to the colourman. Archives reveal that in 1852 Hunt bought copal varnish and nut oil from Roberson.[5] In a later report on his technique Hunt described his medium as copal varnish, poppy oil and rectified spirit of turpentine in equal quantities and added that they can be mixed by heating or by the addition of spirits of turpentine. Poppy oil and nut oil are more or less interchangeable, having similar drying properties; both dry less hard and less yellow than linseed oil and are therefore

fig.76 Raking light photograph showing the application of paint. In the shawl it is brushed more thickly; whereas elsewhere the paint is more evenly applied

often recommended for use with whites. To achieve a thixotropic medium equivalent to megilp he would have had to add driers to his oil. There is no evidence of this, though Field notes that 'if about an eighth of pure bees'-wax be melted into it, it will enable the vehicle to keep its place in the manner of magilp'.[6]

Hunt believed that Venetian painters used amber as a varnish to achieve an enamel-like finish and also described a method of locking-up less stable pigments such as iodine scarlet in layers of pure copal. His intention was to produce paintings with a stable, high-gloss finish that required merely a thin coat of mastic varnish on top, which of course he knew would soon become yellow and have to be removed. Copal medium has two main advantages. It has the ability to dry to a hard, glossy surface which is unaffected by the solvents used to remove and replace mastic varnish. It has a high refractive index (1.54) which means that pigments dispersed in it produce more

transparent paint. The covering power of paint depends on the difference in refractive index between the pigment and the medium, as well as other factors such as pigment particle size, light absorption and pigment-to-medium ratio. By using white sparingly and avoiding unnecessary mixing of pigment, where required Hunt could keep his paint translucent and his hues pure. The disadvantages of copal are its strong amber colour and its tendency to crack if applied too richly or thickly before the underlying paint has had time to dry.

But to Hunt an important requirement was the ability to paint minute detail deliberately and precisely. Copal medium's body allowed Hunt to build up glazes, if necessary working them into a wet white underlayer to achieve maximum brightness and a certain solidity. The surface appearance of this painting when viewed in raking light (fig.76) illustrates the extent to which Hunt was able to dab and work minutely without smearing his colours. Not all his pigments were translucent; more opaque pigments were also used to give solidity to the forms. The light parts of many of his forms were more stiffly brushed in paint largely consisting of lead white and remain as significant impasto. The shawl was painted or repainted at a later reworking stage on top of the dress and has more painterly brush marks that follow the embroidery designs. Interestingly the foliage outside the window, reflected in the mirror, is quite heavily worked and opaque compared with the rest of the painting. Although just as precisely painted, it represents the transmission of light through imperfect glass mirrors and windows and provides some relief from the oppressive detail of the room.

Hunt's original plans were accurately worked out and drawn in pencil on the white ground. An infra-red photograph (fig.10) reveals only one major change to the position of the man's arm which is straighter now than in the original drawing, but apart from this alteration most of the painting corresponds closely with the drawing. Indeed, Hunt's technique did not allow much freedom for significant changes and those to the arm would have been made quite early. However, in this case he was required to make major alterations to the expression on the woman's face after completion and he seems to have made further additions to the dress and shawl. The need to change the face and the appearance of drying cracks elsewhere cannot have been very satisfactory to Hunt and probably explains his delay in completing this repainting of the face and his later decision to retouch the cracks. To repaint

fig.77 Detail of the bottom right corner of the painting

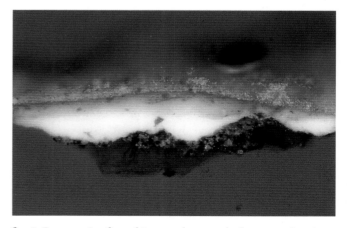

fig.78 Cross-section from this area, photographed at × 250, showing a layer of lead white applied over the earlier paint to provide a new ground for the depiction of the intensely sunlit carpet

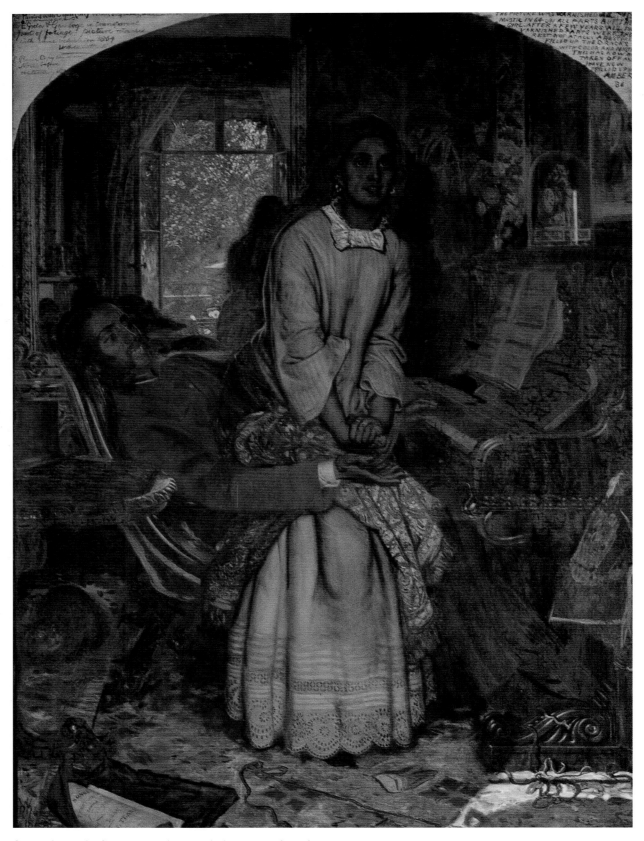

fig.79 Ultra-violet fluorescence photograph showing cracks and
madder pigment which fluoresces strongly

areas he would have had three options. He could remove the paint,[7] by scraping it off, or he could apply a new ground over the area to be altered or else he could apply relatively opaque pigments directly over existing colours. From cross-sections, the last of these options is evident in the blue fabric on the carpet and in the shawl. In the bottom right corner (fig.77) in the area of carpet illuminated by sunshine he has painted over the area with a fresh white ground and then continued to paint on top. This is probably an example of what Hunt described as a wet-ground technique used for the brightest parts of the picture.[8] To depict intensely lit surfaces such as the sunlight on the carpet he had to start with a fresh white ground (fig.78). By painting into this wet ground, churning it up slightly, he could introduce a little opacity into a colour without losing its intensity. Elsewhere he could afford to use mixtures, opaque pigments and superimposed layers, though he did so sparingly.

The Awakening Conscience retains much of Hunt's original intentions. Because of the white ground there is none of the darkening and loss of contrast associated with darker grounds. It is much more likely that the shadows will have become lighter relative to the highlights. The absence of pentimenti is because, except for those mentioned above, Hunt allowed himself few changes, in part a consequence of the discipline imposed by his high refractive-index medium. The depth and richness associated with his amber medium has been largely retained and the painting has not suffered from damage during varnish removal. The paint film is in such excellent condition, despite its moisture-sensitive support, that it was difficult to take samples for analysis.

However, there are a few unsatisfactory aspects; for instance, his rich medium has probably darkened further and it has certainly cracked (fig.79). This seems to have occurred after the face was repainted and the rest of the work was varnished, as noted in 1864. At some later date the painting was filled and retouched by a restorer. It may also have been sent by the restorer to be lined, but more likely by Hunt in 1886 before he redid the fillings and retouchings, some of which extend over the liner's kraft paper. The evidence of a reference to electricity on some undated fragments of newspaper left from the lining and the use of a blind stretcher point to the latter possibility. The repainting of the face has also caused problems; there is a halo effect around the head where the new paint ends and also some associated drying cracks in the hair. Elsewhere some small raised and compressed cracks and associated contractions of the canvas caused by its early glue lining are also visible. These are a typical response of heavily sized canvases such as those made by Roberson at this period and occurred when the canvas was exposed to water and heat during the glue-lining process.

Hunt was very careful to design an appropriate frame. In keeping with the Pre-Raphaelite ideal he designed a gold frame with spandrels, a symbolic bell and marigold motif, and a suitable inscription 'As he that taketh away a garment in cold weather, so is he that singeth songs with a heavy heart'.

Dr Joyce Townsend carried out pigment analysis with optical microscopy and EDX, and measured the refractive index. Information from the Roberson Archive is published by permission of the Syndics of the Fitzwilliam Museum.

— 12 —

JAMES ABBOTT McNEILL WHISTLER (1834–1903)
Nocturne in Blue and Silver: Cremorne Lights 1872

STEPHEN HACKNEY AND JOYCE TOWNSEND

The young Whistler studied in Paris with the academic artist Charles Gleyre, who also trained Renoir, Monet, Bazille and others. Although far from being a conscientious student, unlike Monet and Renoir, Whistler retained throughout his career the techniques that he learned there. Gleyre taught the arrangement of the palette, the use of a diluted medium he called a 'sauce', and that ivory black was the base of tone, a 'universal harmoniser'.[1] The addition of ivory black to white grounds, and also throughout the artist's palette, has proved to be a consistently recurring theme. Indeed when Whistler taught at the Académie Carmen in the 1890s he repeated this same advice to his own students. 'Black … he was never without it,' wrote Mortimer Menpes, 'Even if he painted a white shirt front, black was always used … this colour … gave … a certain marvellous pearly grey quality. Then, of course, the grey-toned panel upon which he painted shone through the pigment and gave an added greyness.'[2]

The paint of the nocturnes and later portraits includes additions of ivory black in many areas – it was indeed Whistler's universal harmoniser over many decades. It is, however, rare to find ivory black as the sole component of an area of black. Whistler is also said to have used a ground of ivory black in lead white in interior decorative schemes.[3] Among the very few invoices from colourmen found among the artist's correspondence, the only one which mentions paint refers, among eighteen tubes of paint, to six tubes of ivory black.[4]

Painting a nocturne presented Whistler with a number of technical problems. His biographers the Pennells describe the initial process as follows: 'His method was to go out at night, and all his pupils or followers agree on this, stand before his subject and look at it, then turn his back on it and repeat to whoever was with him the arrangement, the scheme of colour, and as much of the detail as he wanted. The listener corrected errors when they occurred, and, after Whistler had looked long enough, he went to bed with nothing in his head but his subject. The next morning, if he could see upon the untouched canvas the completed picture, he painted it; if not, he passed another night looking at the subject.'[5]

In nocturnes and other paintings Whistler was concerned to paint alla prima, and attempted to work with 'nature at once his master and his servant'.[6] Although he selected his impressions from nature, he was determined to record his image in one harmonious whole and, when he failed, he would rub everything out and start again. 'His letters to Fantin[-Latour] are full of regret for his slowness … No one knew the hard work that produced the simplicity. In no other paintings was Whistler as successful in following his own precepts and concealing traces of toil.'[7] In his *Ten O'Clock Lecture* Whistler stated that 'a picture is finished when all trace of the means used to bring about the end has disappeared'.[8]

Most of the nocturnes are small; Whistler thought it important that the image should be the size that he actually saw the subject, that is, if placed in front of the real scene and, viewed from painting distance, the painting would match it in size. The painting of full-length life-size portraits gave Whistler more serious logistical problems.[9]

When *Nocturne in Blue and Silver: Cremorne Lights* recently had a yellow discoloured varnish removed it was examined in some detail. This very simple composition can be appreciated for its cool overall colour and narrow range of tonal harmonies, the blue of the river and sky, and the silvery lights on the opposite bank, contrasting with the dark wharf buildings and reflected in the calm river. A stylised Thames barge or lighter occupies the centre, and two Japanese motifs, bamboo-like leaves and Whistler's butterfly monogram, are added decorative elements. The deliberate flatness of perspective, the decorative use of forms, the repetitive use of colour typical of Japanese woodblock prints are evident, and less obviously the restrained and contemplative application of paint in the Chinese tradition. The painting is displayed in a gilded frame which may be original and is in a style that was typically used by the artist.

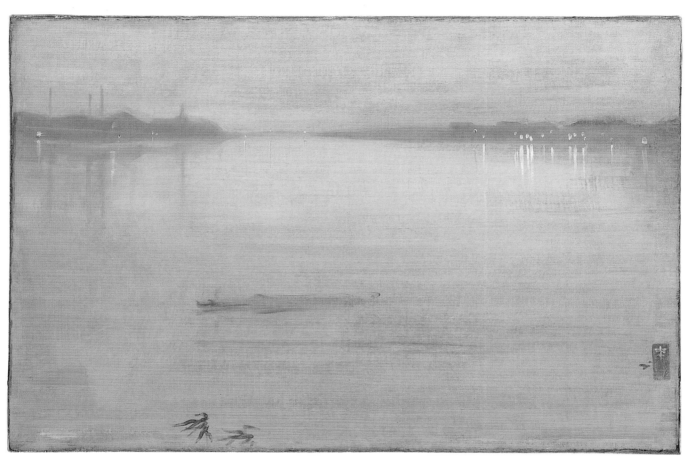

fig.80 *Nocturne in Blue and Silver: Cremorne Lights*, oil and mastic resin
on canvas 50.2 × 74.3 (20 × 30) N03420

Over the commercially applied white priming Whistler originally primed his canvas with a warm off-white priming giving the canvas a smoother texture than when it had been bought. The composition has been enlarged at the right side by 2 cm, by flattening the right tacking margin and including it in the composition. This required the glue lining and restretching of the canvas on to a new stretcher to accommodate the increase. The artist's monogram overlaps the flattened margin, indicating that this extension was his work and also confirming his acceptance of the inevitable enhancement of the weave pattern typical of glue-lined paintings.

Whistler's first composition on this canvas was not the one described above but was related to his earlier *Six Projects*, a group of six paintings based on Japanese prints. It was of a Japanese figure, trailing a fan, standing looking into the scene, which has become visible as the transparency of the overlying paint film has increased with age (fig.81). The first composition has very thin dark passages which were scraped down after the painting was abandoned, leaving dark discontinuous paint in the weave surrounding the abraded tops of the canvas weave. This too can be discerned through the blue paint above. The sketch has been largely rubbed out before the canvas was reused for the nocturne.

The present composition involved the application of a thin wash of dark paint (mainly ivory black and raw umber, perhaps mixed with other pigments) to form the buildings. Whistler used flat brushes. The wash must have been allowed to dry to the touch, then a sauce made of diluted oil paint was brushed across the painting in long wide sweeps. This paint is a very pale blue made up of ultramarine, Prussian blue and madder, but mostly lead white. Whistler experimented during this period to get the right formula. Oil diluted with large amounts of turpentine would tend to dry matt so he modified his medium with drying oil and natural resins. The temperature at which the paint softens, the tendency of some of the paint to fluoresce in ultra-violet light, and its refractive index revealed by examination, all suggest the presence of mastic resin. Detailed analysis of palette samples from the Hunterian Art Gallery reveals a network of heat-bodied oil (stand oil) and some evidence for mastic resin. Two oils were present: oil from the tube, and added oil from the sauce.

As the sauce would flow freely, Whistler must have placed his canvas nearly flat. In this case it was brushed with a stiff hogshair short-bristled brush about $1/2$ inch

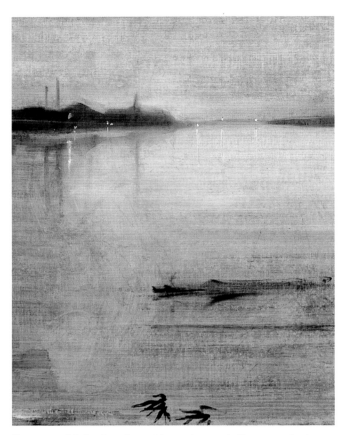

fig.81 Detail, left side, taken with panchromatic film to emphasise the earlier image

fig.82 Detail showing hesitation at the end of a long brushstroke

wide, the bristles of which have left characteristic furrows in the paint. The brush was fairly evenly loaded and the paint applied confidently and sparingly in distinct horizontal bands with just a few deviations around the buildings and only occasional slight hesitations (fig.82). The low viscosity of the paint precluded the artist from allowing his brush to pause for long on the surface of the work. The dark paint of the building and boat was covered very thinly or not at all and with no strong boundaries, the blue paint being merged and gently worked around them. Features such as chimneys were quickly worked in the wet paint, some by thinning the sauce on application with a sharp edge, and others by scraping immediately afterwards with the brush handle. There would have been plenty of time to work wet-in-wet on the painting, indeed Greaves said 'the medium was sometimes so wet that it could be floated around on the canvas as it lay on the floor, or dripped as it was left to dry outside'.[10] The lights on the far riverbank and their reflections were applied using a finer bristle brush, some into the still wet paint (fig.83) and others later when it had dried. The effect of ripples in the water was achieved by painting the reflected line wet-in-wet in the pale blue then by dragging blue paint across it (fig.84). The lights in the distance are made of lead white and cadmium yellow with some added vermilion.

By these very simple devices Whistler managed to capture the ethereal effects of the Thames on a still, slightly foggy night, just at dawn. The scene is not an accurate representation but is a record of visual effects that could not easily be captured by any other means. He used the pale blue scumble to cool and soften his image of the far shore, emulating atmospheric perspective. The process of first defining the dark passages, then methodically scumbling almost the entire surface with a relatively uniform colour, defines Whistler's nocturne technique, and a similar approach can be seen in many passages of his more complex compositions and portrait backgrounds. It was clearly a visual effect that fascinated the artist. Although in time the increased transparency of such a thin film raises the concern that significant changes in appearance may have occurred, in this case the light ground has not had a serious impact on the overall tone. However, differences in thickness of the pale blue brushmarks are likely to have increased our awareness of the brushed application of this layer, and we are now also confronted by a ghostly image in the foreground.

Whistler expected his paintings to be exhibited with an

fig.83 Detail showing the passage of a small flat tipped brush through the wet paint

fig.84 Detail showing very liquid white paint applied to form a reflection in the still wet blue paint of the river, then dragged horizontally to depict the ripples

overall varnish and in gilded frames. He appears always to have varnished his work, for instance, *Nocturne in Black and Gold: The Fire Wheel* is recorded as being varnished for the artist, and later cleaned of varnish and revarnished at least once for him[11]. Now many of his varnishes are excessively darkened and yellowed. In particular the discoloration of varnish has affected dramatically the cool tones of nocturnes and some portrait backgrounds. In the nocturnes, there is no evidence of significant glazing or reworking, because discoloured glazes or retouching would have threatened the nocturne's harmony. *Nocturne in Blue-Green: Chelsea* is described on pages 152–7.

DTMS analysis carried out by Dr Jaap Boon of FOM-AMOLF, pigment analysis with optical microscopy and EDX by Dr Joyce Townsend. David Lambert, Tate Gallery Photographic Department, suggested the use of panchromatic film.

− 13 −

GEORGE FREDERIC WATTS (1817–1904)
Sic Transit 1891–2

JACQUELINE RIDGE

A shrouded body lies behind a still life of discarded world-ly objects; above, the text on the curtain reads, 'WHAT I SPENT, | I HAD, | WHAT I SAVED, | I LOST, | WHAT I GAVE, | I HAVE'. The artist's wife Mary Watts stated that, 'When I read a letter to him from a preacher who had used this picture as the text for a sermon, Signor [Watts] remarked, "He makes the mistake of imagining a person, and not taking the shrouded figure as the symbol of human life ended, and with all its possibilities laid away."'[1]

Though successful in portraiture from an early age, Watts, through his subject paintings, which were consid-ered by him to be the highest form of art, looked to con-tribute to the improvement of moral standards and the human condition. For such paintings, he often laboured over decades to capture his concept on canvas, but, in marked contrast, *Sic Transit* was painted over a compara-tively short period of time. He began on 11 July 1891 at his studio at Melbury Road, London, after one of his frequent bouts of ill health and finished it in the winter of 1892 in his new home 'Limnerslease', Compton, Surrey. Mary Watts noted, 'Almost the first canvas he began to work upon was the picture we then called the "Epitaph pic-ture," subsequently named *Sic Transit*. The weather was fine, and for the first few days he worked in the garden studio with the door wide open. It was one of the paint-ings that cost him little trouble.'[2]

Watts's painting method, along with that of many of his contemporaries, was influenced by the Italian Renais-sance. Visiting Italy, he was excited by the passion and vibrant colours of the Renaissance painters. Mrs Barring-ton (close friend, amateur artist and his biographer) recalls, 'Here his own imagination was awakened and his artistic instincts were set loose'[3] and 'it was Titian's actu-al painting which inspired his greatest admiration'.[4] The impact spread to most aspects of his life: he was referred to as Signor by his wife and admirers, and described by the artist Lord Leighton as England's Michelangelo; his self-portrait requested for the Uffizi Gallery, Florence, echoed in style the self-portrait of Titian, and for the pref-ace to his 1887 New York exhibition catalogue he used a translation of Boschini's near contemporary account[5] of Titian's late working method to describe his own prac-tice.

Watts experimented extensively with his materials, attempting to balance texture, colour and vibrancy of image with sound technique. In *Sic Transit*, helpers pre-pared the support from two layers of stretched hessian, saturated and then coated with layers of a coloured gesso (fig.85). His occasional use of hessian as a support dates from this period. Mary Watts recorded, 'The quality of the canvas, which had been prepared with plaster of Paris soaked in water for many weeks to remove all lime, had a texture that suited him.'[6] To this,[7] he added yellow ochre and lead white and bound it all together with animal glue. The process of pre-soaking the plaster of Paris, which pro-duces a finer material, echoes Renaissance recipes which were being translated into English during the nineteenth century: 'Take fine gesso sifted, that is passed through a sieve, and put into water to dissolve, and change the

fig.85 Preparing canvases in the garden at Compton. From left to right: Mary Watts [?], Louis Deuchars (sculptor and assistant to Mary Watts), Moses Bowler (first attendant of the Watts Gallery). The splashes and dribbles on the back of *Sic Transit* resemble those on this stretcher. (Watts Gallery, Compton)

fig.86 *Sic Transit*, oil on canvas 102.9 × 204.5 (40½ × 80½).
In its original 'Watts' frame. N01638

water every day, and stir it together every day, and do this for a month.'[8] Plaster of Paris is now considered a misinterpretation of 'gesso' in the early manuscripts[9] but it was advocated in the nineteenth century as that used by the Renaissance painters, specifically Titian.[10] Watts corresponded at length with the colourmen Winsor and Newton on the matter of absorbency of grounds. He felt that getting this correct was the key to permanence and would prevent greasy paint surfaces: the gesso-like ground when bound with the right amount of glue acted like a sponge, drawing out excess oil from the paint. In further pursuit of this aim he bled excess oil from paints with blotting paper, heavily diluted his colours and on occasion applied pigment just in the diluent. Winsor and Newton also prepared special stiff paints which contained less oil; Watts stored them under water to prevent them from drying too quickly.

In 1892 after a visit from A.P. Laurie, an eminent scientist and colour theorist of the day, Watts dictated an account of his method of paint application to his wife.[11] Sic Transit, completed at this date, follows the description closely. The composition was laid on to the yellow ground with 'bounding lines' of a transparent brown paint, probably raw sienna (fig.87). This was followed by a 'first stage' of painting, involving solid colour and impasto almost sculpted on to the canvas. The paint was applied using any implement that came to hand: tools used ranged from worn down brushes, brush handles and palette knives, to agate burnishers and his fingers (fig.88). Occasionally he employed a further modification to enhance the durability of the paint layers: 'When the colour has become so dry that it is not in a state to be displaced I take a broad rhinoceros-horn palette knife and rub the whole over as if polishing it – this I know from experience makes the colour very hard.' He was also in the habit of washing down the paint surface between applications with the cut surface of a raw potato to remove any sign of greasiness. Watts's method did not lend itself to rapid execution of images. He believed that the individual drying of each paint layer was essential to ensure the truth of colours and increased permanence. With regard to the first stage he states 'This application is left to become thoroughly dry before retouching, for which purpose I expose what I have done to the strongest sunlight I can get, leaving my pictures for days, weeks and even months, under such exposure, the glass house in the garden being built for this purpose.' He also only ever worked in natural light. Finally, as in Sic Transit, the details and surface nuances were applied in subtle glazes, scumbles and watercolour-like washes. The first stage and final touches were to be repeated as appropriate but there is no extensive reworking to be seen in Sic Transit (fig.89 and fig.90).

Watts believed that all paint layers were an integral part of the final colour, and understood the visual effect of juxtaposed tonal opposites. By choosing a warm yellow ground he achieved a particular glow to the cool greys and a warmth to the browns. The bluish grey of the shroud was painted with a cold grey mixture of ivory black and lead white applied over the warm-toned, terracotta-coloured underpaint. The coarse weave was fully exploited in the final image to give light and shade. The dry paint was dragged across the high points of the weave creating fleeting highlights, the hollows of the weave allowing glimpses of the terracotta underpainting to show through. The brown curtain was created with a cool purple over a hot reddish brown underpaint, and highlights for the folds of the curtains applied on top with a warm golden yellow. The particular vibrancy in the text letters arises from the contrast given by opaque yellow ochre. The small flowers in the foreground are white with a simple glaze of pink madder, the greens of the leaves are a mixture of earth pigments and emerald green. Forms are accentuated through a mixture of glazing and dragged scumbles of dry paint; in the shield what appear to be coarse palette scrapings help give texture to the elaborately embossed front.

Watts's choice of pigments was dictated by stability. He charged Winsor and Newton 'with the strict instructions never to send him any colour, even if he had ordered it, which was not known to be absolutely safe'.[12] He listed his colours as:

Flake White and occasionally Davy's Foundation White. Lemon Yellow. Naples Yellow. Aureolin. Yellow Ochre. Raw Sienna. Light Red or Venetian. Indian Red. Vermilion (chinese). Rose Madder. Rubens Madder. Brown Madder. Raw Umber. Burnt Umber. Burnt Sienna. Burnt Terra Vert, called Verona Brown. Ivory Black. Blue Black. Ultramarine and French Ultramarine (equally permanent). Ultramarine Ash. Cobalt, Terra vert. Oxide of Chromium. Emerald Green (always pure and unmixed).[13]

(Davy's Foundation White is a lead white mixture, and Terra Vert is green earth.) Only the madders, some of

fig.87 Photograph by Frank Hollyer of *Sic Transit* at an early stage showing the bounding lines and the helmet in an earlier upright position. Mary Watts noted in her diary that the helmet was further developed directly on the canvas a year later, 24 Aug. 1892: 'As soon as it was half light he set to work to change the position of the helmet in the picture of *Sic Transit* – it had to be so carefully painted, was a fine bit of work, but he felt it was in the wrong place.' (Watts Gallery, Compton)

fig.88 Selection of Watts's painting implements at the Watts Gallery. Barrington recalled: 'New brushes were he said almost useless to him. He would wear the outside down on the background, or by merely rubbing them on a hard surface till they became a stiff little pyramid the shape of a stump used for chalk drawings and then they became great treasures. He said he believed the worst thing to paint with was a brush – except the wrong end'[14]

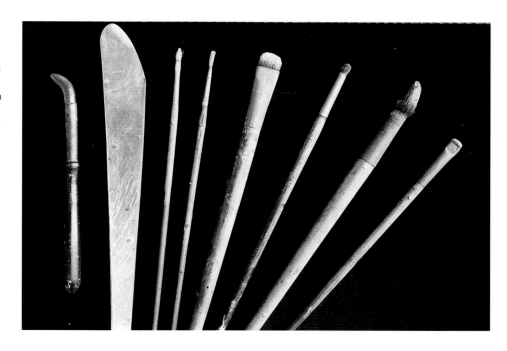

which fade in light, might be seen as less than permanent. Pigments identified in *Sic Transit* are found in this list with the addition of cadmium yellow and zinc yellow. Towards the end of his life he was increasingly concerned with keeping the true vibrancy of pigments. Mr Scott Taylor for Winsor and Newton wrote to Watts in 1896, 'I quite agree with what you say about grinding colours too finely. It has for a very long time been my opinion that in many cases modern colours have all the life taken out of them by being ground perfectly smooth and buttery, and that in this way most precious qualities of pigments are lost … I feel quite sure that the Venetians knew the value of rough colour … It seems to me that the consistent use of smoothly ground colour must necessarily result in a certain monotony and insipidity of effect and I should not be surprised if modern impressionism is not to some

fig.89 Detail showing burnished or pushed paint

fig.90 Detail showing texture of hessian, and the holes where paint has dropped into the open weave. The warm yellow preparation is visible

extent an unconscious reaction against this tendency.'[15] Special coarsely ground paints were provided for his use.

Watts's obsession with trying to establish which were the best methods and materials was not untypical for this period but his creative urge on occasion overwhelmed his knowledge of sound technique. Flaking paint is mentioned at the start of his career in correspondence with colleagues, and sinking colours seems to have been a lifelong problem. Probably a result of his excessive use of absorbent grounds and lean paint, this was a particular hazard in dark passages and may have occurred in the foreground of *Sic Transit*. Areas that sank in colour during painting, according to Watts, were resaturated by applying neat unpigmented poppy oil (it yellowed less than linseed). In addition, his struggle to capture the essence of the subject led to repeated paint applications and murky final colours. *Sic Transit* is one of the few paintings where the structure is comparatively simple and Barrington recalls that this painting was a personal triumph for the artist. She notes how he quickly achieved the desired surface and felt this was due to the picture following on from experimentation with pastels drawn on flock wall paper. She relates that it 'has in its texture much of the quality of pastel, with the suggestion of more weight and solemnity … *Sic Transit* … is so magnificently simple'.[16]

His dictated method does not mention varnishing, although we know from letters that he advised applying mastic varnish once the paint was fully dry to help protect it.[17] Recent conservation of this painting involved the removal of three thick darkened varnish layers applied since the artist's death. The layers had obscured and distorted the intended cool tone of the shrouded figure. The pastel-like texture of surface, previously choked with the thick varnish, is now more apparent.

Pigment analysis was carried out by Dr Joyce Townsend with optical microscopy and EDX. XRD was carried out by David Thickett of the British Museum.

JOHN SINGER SARGENT (1856–1925)

Ena and Betty, Daughters of Asher and Mrs Wertheimer 1901

Hylda, Almina and Conway, Children of Asher Wertheimer 1905

JACQUELINE RIDGE AND JOYCE TOWNSEND

Sargent began his series of Wertheimer family portraits with a commission to paint the parents as companion pieces, in celebration of their twenty-fifth wedding anniversary in 1898.[1] The father's portrait (fig.91) was considered particularly successful, and, over the following ten years, Sargent (who became a family friend) painted all the children, in groups of two or three or singly, with the family dogs included, and also produced a second and better-received portrait of their mother. This large series (twelve in all) of one single family has been described as representing 'almost every phase of his genius as a portrait figure painter'.[2] In contrast Fry in the *New Statesman* of 1923 relegated them to 'art applied to social requirements and social ambitions'[3] with the Wertheimers being perceived as a non-establishment, middle-class, Jewish family. When Asher Wertheimer died in 1918 the portraits were inherited by his widow, who bequeathed them to the nation in 1922 as he had wished. In the 1930s they were shown together publicly in the Sargent Room of the Tate Gallery, but with the growing interest of modernism and the waning popularity of Sargent's work they were soon removed from display.

The method used by Sargent to begin the portraits is not clear. Sketches on paper exist for the first of the parents' portraits but none, as yet, has been found for the children.[4] In unfinished works, such as *Edward Wertheimer* (whose sudden death while the picture was in progress led to its abandonment) there is no sign of a painted or drawn outline on the primed canvas, the form being defined by carefully toned washes: for example a warm brown wash, darker on the shaded side, applied round the head. Similarly in the Tate work *Study of Madame Gautreau*, although parts of the figure are complete, large expanses of canvas were left unpainted, yet there is no clear drawing other than a slight indication at the sketchy hem of the dress of a thin red pencil line.

As with all the Wertheimer portraits *Ena and Betty* was painted on canvas with a mid-toned grey priming, commercially prepared. Each priming has a different shade of grey, and this is one of the darkest. Ready-primed canvases in a range of cool greys and warm browns were readily available from all the major colourmen in London but as, somewhat unusually, none of the portraits has a canvas stamp, the supplier remains unknown. Sargent may

fig.91 *Asher Wertheimer*

fig.92 *Ena and Betty, Daughters of Asher and Mrs Wertheimer*,
oil on canvas 185.4 × 130.8 (73 × 52) N03708

have stretched the plain-weave canvas himself, since it has generous tacking margins (up to 20 cm) which would surely have seemed wasteful to a colourman. At least one of the portraits, Almina's, was eventually fastened to a smaller stretcher after painting, so perhaps this excess was to allow for size adjustments, but none, however, shows evidence of extension as the painting progressed.

Both *Ena and Betty* and *Hylda, Almina and Conway* have quite extensive alterations and reworkings by the artist which contradict the effortless manner in which Sargent is thought to have painted. A contemporary observation of changes to *Ena and Betty* when seen in the studio and then on exhibition records: 'Sargent's Wertheimer girls are changed, both appear to have been all painted over since I saw them in the studio. He [Sargent] has painted out a marble slab, put in a large vase and lightened parts here and there.'[5] Betty's slipped shoulder strap (she is in red), was also scraped out and repainted in the 'correct' position, perhaps because, as with Madame Gautreau's completed portrait, now at the Metropolitan Museum of Art, New York, it looked too daring. The gauzy white border to Betty's bodice, however, was not added for modesty: it was normal at this period for a dark gown to include more flattering white fabric next to the skin.

The darks of the background shadows are painted in lean-looking paint, as are the gowns, and do not share with other Wertheimer portraits the tendency for paint to look blanched when free of varnish. Brushwork is swift and assured, the gowns finished in crisp strokes, while finer brushes and wet-in-wet working were used to complete the faces, in particular the lips (fig.93). The details of

the vase and the gilded frames seen in the background are perfunctory and impressionistic when examined at close quarters (fig.94). In this painting Sargent has applied large brush-strokes of heavily loaded paint and has not blended the colours as he did in earlier decades.

The group portrait of *Hylda, Almina and Conway Wertheimer* cost Sargent more effort than did *Ena and Betty*. There are extensive changes in both composition and colour. On close examination, the alterations in the

fig.94 Detail of the vase in *Ena and Betty*

fig.93 Cross-section of the red paint from Ena's lips. The indistinct boundaries between the thin red paint layers indicate wet paint brushed on to wet paint. Photographed at × 250

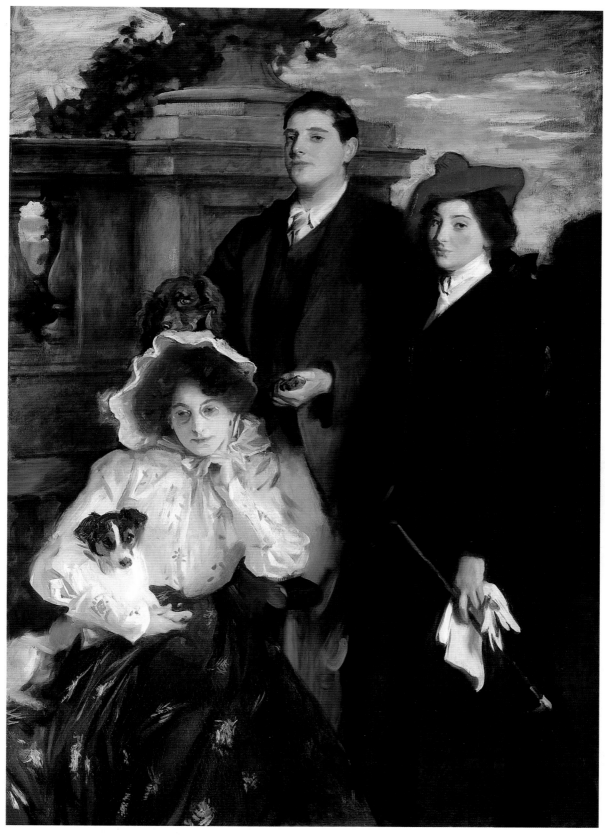

fig.95 *Hylda, Almina and Conway Wertheimer, Children of Asher Wertheimer*, oil on canvas 188 × 133.3 (74 × 53) N03712

position of the dogs (reluctant sitters, presumably, who kept suggesting new poses to Sargent as they squirmed out of position), of Hylda's hat and her arm supporting the terrier, are visible, as is the pipe which Conway originally smoked (fig.96) It became apparent during conservation that the most extensive change was to Hylda's skirt. Originally almost white, with a purple and pink pattern, the thin coat of varnish applied over it (seen in paint cross-section) indicates that this version was considered to be complete by the artist, at least initially. Sargent, however, entirely repainted the skirt in brown and added the pattern with very free brushwork, working wet-in-wet (fig.97). This change effectively disrupted the tonal balance of the composition, but by modifying Conway's grey jacket with a brown resinous wash, and lightening the sky considerably on the right, he re-established the diagonal tonal opposites in the painting. Heavily worked areas such as the sky at the upper right were worked wet with thick and opaque paint, and there is little evidence of glazing.

The background looks unresolved, with the mid-grey priming of linseed oil, lead white and bone black visible in places suggesting this was hastily applied. In areas, including beneath Almina's and Conway's heads, Sargent modified the grey priming with a thin brown imprimatura creating a much warmer hue: consequently the faces of Almina and Conway appear almost ruddy in complexion, in keeping with the outdoor setting. In contrast, *Ena and Betty*, portrayed indoors at the Wertheimers' London home, have no such underlayer. The supposed location for *Hylda, Almina and Conway* is uncertain. It may be the terrace of the house of their sister Essie after she married, but the balustrade and column could simply be props from Sargent's studio.[6]

Sargent's ability to capture detail with just a few touches of paint is exemplified by his depiction of Hylda's gold-framed pince-nez. They are indicated by a simple highlight on one side, and by the shadow they throw on to her face on the other: this works so effectively at normal viewing distance that the absence of a bridge to the eye glasses is not noticeable. Sargent's subtle use of complementary colours is also well illustrated, for example by his use of a dark blue brushstroke applied wet-in-wet next to the tan of the small terrier's ear to provide particular vibrancy and life to the paint.

The range of pigments identified in these portraits is typical of the entire Wertheimer series and corresponds, with the exception of emerald green, to those identified

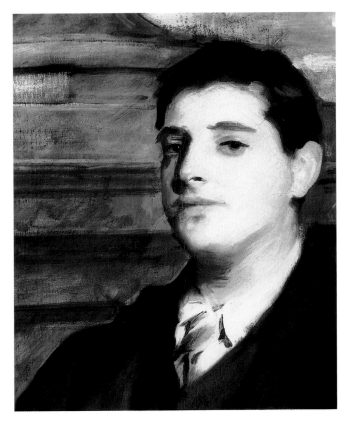

fig.96 The pipe being smoked by Conway was painted out but its texture is still visible

fig.97 Detail showing cracks in Hylda's skirt, before retouching

on six surviving Sargent palettes.[7] In *Ena and Betty* he used lead white, vermilion (glazed over several times with mastic resin, rose madder and more vermilion) for bright reds, bone black, viridian, cobalt blue and Mars brown for Betty's gown. He mixed cadmium and Mars yellows with vermilion and lead white for the flower in her hair. The flesh tones include traces of all these pigments, added to vermilion, and the floor vase includes larger amounts of viridian, cobalt blue and cadmium yellow. The same mixtures occur in the reflections on Ena's gown, with a greater amount of lead white mixed in. In *Hylda, Almina and Conway Wertheimer* the white paint is lead white, with Vandyke brown, bone black, emerald green, synthetic ultramarine, Mars yellow and red, a pink organic pigment and rose madder all identified from cross-sections. These may not be complete lists of the pigments present, but there is a distinct difference between the paintings. In *Ena and Betty* a coolness is introduced by the cobalt blue, viridian and cadmium yellow added to much of the paint, in contrast to the warmth in *Hylda, Almina and Conway* from the inclusion of synthetic ultramarine, emerald green and Mars yellow. This calls to mind Whistler's deliberate selection of only one blue, green and yellow for each of his paintings, in order to achieve a colour harmony.[8]

Analyses from various Wertheimer portraits indicate that the paint medium was primarily linseed oil for darker colours and poppyseed oil for white paint, the standard difference in preparations used by colourmen, to ensure that white paints yellowed as little as possible. There is no evidence that Sargent added extra oil to the paint, though he often thinned it.

Recent conservation of both these portraits has made a dramatic change in their appearance. Removal of several layers of yellowed varnish from *Ena and Betty* revealed the striking burgundy and white gowns worn by the sisters, and the glancing reflections of the burgundy velvet and floor vase in Ena's white silk damask gown. A 1930s photograph taken of *Hylda, Almina and Conway* implies that Hylda's brown skirt subsequently developed large numbers of cracks revealing the lighter colour and a pattern beneath, and in places even the priming and a light brown imprimatura layer. The most disfiguring cracks had been painted out in the past, and the repaints had discoloured, so that they stood out in a distracting way. During recent conservation treatment both the yellowed varnishes and these repaints were removed. New discreet retouchings over a modern, synthetic varnish now conceal the cracks from the viewer without detracting from the skirt. The conservation of these dramatic portraits has revealed the vitality, colour and movement which critics of the day recounted. The recovery of an original surface is always exciting: in portraits in particular it reveals more about both sitters and the artist. Sargent's use of cool delicately coloured yet strong brushstrokes to depict reflections in fabric, and thereby to suggest movement and form, suffer particularly badly from the reduction of contrast in hue given by yellowed varnish.

Lesley Stevenson took and prepared cross-sections during her treatment of *Hylda, Almina and Conway*. GC-MS analysis of paint media was carried out by Robert Tye of Kings College, University of London, and Dr David Rainford of FOM-AMOLF. The pigments in these paintings and in Sargent's Royal Academy palette were identified by optical microscopy and EDX by Dr Joyce Townsend.

GWEN JOHN (1876–1939)
Nude Girl 1909–10

MARY BUSTIN

Late in her career, at a time when she had practically ceased to paint, Gwen John defined six criteria for painting a portrait.

1. The strange form
2. The pose and proportions
3. The atmosphere and notes. The tones
4. The finding of the forms (the sphere – the hair, the forehead, the cheek, the eye, the nose, the mouth, the neck, the chin, the torse [*sic*].)
5. Blobbing
6. The sculpting with the hands[1]

Beneath the severe characterisation of Fenella Lovell in *Nude Girl* of 1910, this logical approach is evident. This nude study, although it was painted twenty-two years before Gwen John compiled her list, is founded upon the principles outlined above. The criteria originate in the practice and theories absorbed during her formative years at the Slade, and, under Whistler's tutelage, at the Académie Carmen in Paris.

In 1909, when settled in Paris, Gwen John employed a model, Fenella Lovell; an unfortunate choice as Gwen John came to detest her. 'It is a great strain doing Fenella. It is a pretty little face, but she is *dreadful*.'[2] For at least nine months, from the autumn of 1909, Fenella sat to Gwen John, during which time two paintings were finished: *Nude Girl*, and its pair, *Girl with Bare Shoulders* (fig.98), in which the model is clothed.[3] *Nude Girl* was painted at an important point in Gwen John's career. It illustrates the culmination of her academic period from which she set out to explore a new method of painting, the one for which she is better known, that of a fresco-like clarity and compression of hue. These later paintings are underpinned by the earlier mastery of the principles of drawing and painting exhibited by *Nude Girl*.

Gwen John employed a systematic approach to her painting, the basis of which was skilful drawing. Her key point of the 'finding of the forms' derives from Henry Tonks's teaching of drawing at the Slade. He taught

Gwen John the elements of construction: 'By mastering the direction of the bones one had (he would say) mastered the direction of a contour.'[4] Initially, Gwen John relied heavily upon line to create form in her paintings. Her *Self Portrait* (fig.100), executed soon after she left the

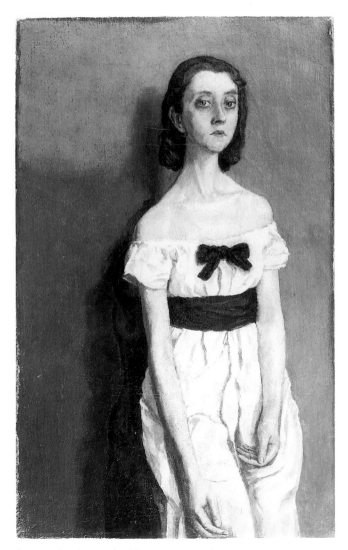

fig.98 *Girl with Bare Shoulders* (1909–10?), oil on canvas 43.5 × 26 cm (The Museum of Modern Art, New York)

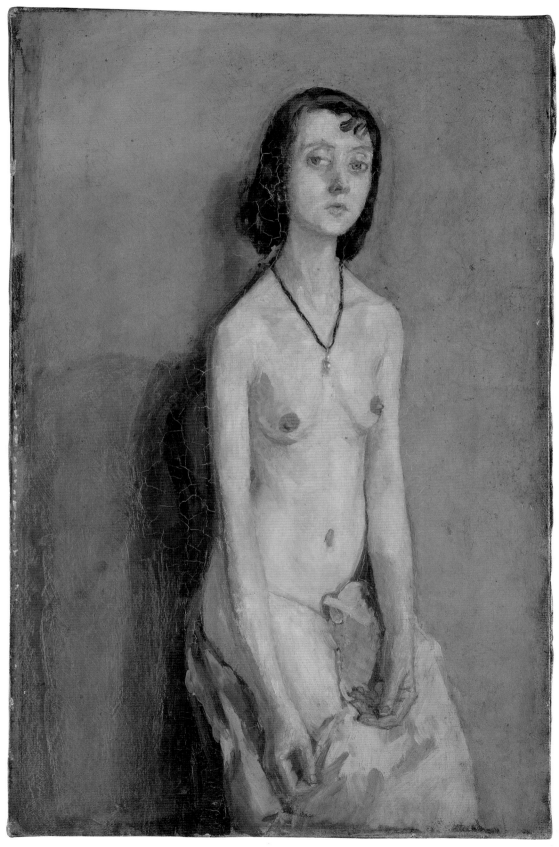

fig.99 *Nude Girl*, oil on canvas 44 × 28.2 (17⅜ × 11⅛) N03173

Slade, has an armature of drawing lines overlaid by scumbles of oil paint. By the time she was painting *The Convalescent* some seventeen years later, line was eschewed entirely in favour of tone. *Nude Girl* marks the mid-point. While the figure is strongly linear, the paint itself leaps in small tonal shifts across the canvas to create the sense of form.

Gwen John would have made many drawings of her model before starting to paint. Jean Robert Foster recalled: 'I sat for Gwen John this morning. I have been sitting for her for three days. I have posed for drawings in every corner of her studio but she has not begun to paint.'[5] She used drawings to explore the 'strange form' and the 'atmosphere' and tonal range in preparation for the oil paintings.

> I am doing some drawing in my glass [mirror],
> myself & the room, & I put white in the colour so it
> is like painting in oil & quicker ... I think, even if I
> don't do a good one the work of deciding on the
> exact tones & colour & seeing so many 'pictures' –
> as I see each drawing as a picture – & the practice of
> putting things down with decision ought to help me
> when I do a painting in oils – in fact I think all is
> there – except the modelling of flesh perhaps.[6]

Nude Girl grew from several false starts. The x-radiograph of the painting shows two images below the final version. At this stage in her career, Gwen John reused her canvases. This particular one is a section cut from a larger painting that had been abandoned. The x-radiograph (fig.101) faintly shows the figure of a penitent woman, her head back, similar to the pose adopted by Chloë Boughton Leigh in Gwen John's drawing *Etude pour Les Suppliantes* dated *c*.1910,[7] except that, unusually for Gwen John, the figure is viewed face-on. In raking light there is no trace of impasto from this earlier image, so presumably the idea was rejected before the idea had been developed, and John had adopted Whistler's technique of rubbing down rejected images before starting to paint afresh.

Before she arrived at the final image, Gwen John experimented with a different relationship between the figure and the field of view. As with *Girl with Bare Shoulders*, she started by filling the picture plane with the figure. The x-radiographs of both paintings show a larger figure beneath the final image. In *Nude Girl*, the model is centred on the long thin canvas like the supplicant beforehand. She dominates the scene, and, rather than being naked,

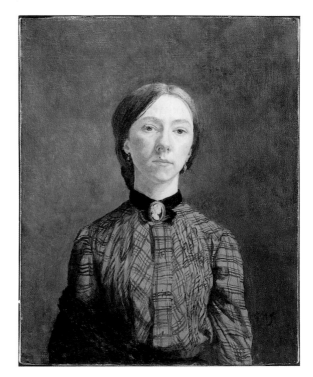

fig.100 *Self Portrait* (1902), oil on canvas 44.8 × 34.9 cm

fig.101 X-radiograph showing the larger figure clothed in white chemise, and traces of the penitent figure below

fig.102 Blue underlayers are visible in the cracks. Dabs of flesh paint cover an ochre- and sienna-coloured sketch

she is fully clothed in a chemise with a black sash in an off-the-shoulder style identical to that seen in its pair. Traces of this earlier painting along the edges show that Gwen John had laid in her preparatory blue layers of paint, and modelled the forms on top in ochres before abandoning the pose for the final version. It appears that she moved on to painting the final version before the paint was fully dry, and without rubbing it down fully, with the result that the top layers of paint slid over the underlayers on drying to form contraction cracks. In these it is possible to espy the brilliant blue first painting and traces of the early figure (fig.102).

On deciding to paint her model unclothed, Gwen John shrank the figure so that it became dominated by the background, and shifted it to the far right of the canvas so that it appeared insignificant and distant in space. Later she relented, and cropped the background to the current size, restretching the canvas on a smaller strainer, shifting the figure towards the centre once again, before completing the painting.

During this period, all of Gwen John's materials were brought ready-to-use from the colourman. In early years, this was Percy Young of 137 Gower Street, London, who supplied materials to Slade students. Presumably in 1910 she also used a local supplier, this time in Paris. The support for *Nude Girl* does not bear a canvas stamp. It does, however, display the systematic preparation characteristic of a colour merchant, from the fine linen with its open weave, heavily sized – a glint of the size may still be seen on the reverse – to its well-bodied coat of white oil priming. It would have been bought ready-mounted on a stretcher, the tacks placed at regular 10 cm intervals along the edge, and excess canvas trimmed at the reverse. It is likely that initially the canvas measured 53 × 33 cm, or a standard size 10 'marine'.[8] The mild distortion of the weave shows that the canvas was sized and primed before being cut and stretched, typical of commercially prepared canvas In her restretching of the canvas on a smaller, fixed, strainer, Gwen John's placing of her tacks was erratic, unlike the manufacturer's own carefully measured spacing. Her oil paint came from tubes. In cross-section the paint appears finely ground and the pigments are well dispersed throughout the medium.

As in *Girl with Bare Shoulders*, Gwen John started with a base coat of pale blue paint. This covered the priming. Forms were modelled on top in slightly deeper blues, and then, when this had dried, in ochres and Prussian blue. The ochre paint has poor coverage, it is thin bodied and, where scuffed across the surface with a brush, it forms a modulated and broken coating. This lets the undercolour influence the tonality through minute colour shifts in the scumbled overlying paint and sets the mood for the semi-opaque paint of the main body to follow. Vibert, the author of *The Science of Painting* defined a sketch as the 'guaranteed health of the painting; it is its under garment'.[9] The sketch had to be thoroughly dry before the

fig.103 Ultra-violet photograph showing natural resin varnish
fluorescing green, so the brushy method of application is visible.
Repainted sections show up as dark areas of low fluorescence.
The artist's fingerprints lie to the left of the figure at shoulder height

final layer of paint could be applied. Various letters from Gwen John mention delays created by waiting for her paintings to dry, a period of two weeks being the minimum between coats. Cross-sections show that she prepared the dry paint with an extremely thin rubbing of varnish before starting to paint again. This saturated the dry paint and bonded the new coat to the old.

On to this base, the pose was delineated in sienna oil paint with a fine brush, still visible in the contours of the eyes and ear. From this stage, Gwen John 'sculpted' her figure in tones; an approach derived from Whistler. He believed that 'The true understanding of drawing the figure comes by having learned to appreciate the subtle modellings by the use of the infinite gradation that paint makes possible.'[10] As his biographers, the Pennells, described:

> The student 'was taught to look upon a model as a sculptor would, using the paint as a modeller does his clay; to create on the canvas a statue, using the brush as a sculptor his chisel, following carefully each change of note, which means "form"; it being preferable that the figure should be presented in a simple manner, … and make it, first of all, *really and truly exist in its proper atmosphere*, than that it should present a brightly coloured image, pleasing to the eye, but without solidity and non-existent on any real plane.[11]

Gwen John started with the face, 'finding the forms' in sequence. Flesh is built from scumbles of thin but well-bodied paint pulled over the drawing lines with fine, stubby, brushes moving in small dabs, or 'blobs'. Although the paint is worked wet-in-wet, the tones are distinct entities, only blended at intersections when the artist 'sculpted' the forms. Each tone has a separate brush. Gwen John must have had a fist-full of brushes as she followed Whistlerian teaching. Whistler's systematic approach to his palette was adopted by her. He believed that painters should create all the tones for their picture on the palette in advance. On a small oval palette, a generous quantity of white was laid at the top with pure colours arranged around the sides. Then, as Inez Bate recorded in 1908:

> A mass of colour, giving the fairest tones of the flesh, would then be mixed and laid in the centre of the palette near the top, and a broad band of black curving downward from this mass of light flesh note

to the bottom gave the greatest depth possible in any shadow; and so, between the prepared light and the black, the colour was spread, and mingled with any of the various pure colours necessary to obtain the desired changes of note, until there appeared on the palette a tone picture of the figure that was to be painted.[12]

The portrait of Fenella extended out from its central starting-point to be worked methodically wet-in-wet, first within a feature, then in adjacent sections and merged at the boundaries by shifting the junction back and forth. The perimeter of the figure was prodded into shape by the grey background paint. The flesh was then flicked back over the edge to produce a feathered boundary. Highlights and shadows were painted in one layer. Virtually no mixing occurs on the canvas, apart from the blurring of adjacent tones, except for the deepest shadows near the hands and forearm. Drawing lines were used at intervals during this final stage of painting to redefine areas before the work continued, for example, between the arm and body, and in the hands which were remodelled while the sienna paint was still wet: the flesh colour disturbs the drawing lines, pulling them along the forms so that they meld with the new paint.

Gwen John varnished the painting using a similar lightness of touch. In ultra-violet light the thin brushy varnish appears uneven (fig.103). She concentrated on the chair (perhaps to correct sinking of medium in the dark brown paint), and neglected to cover the whole surface. She tested the varnish to see if it were dry: two finger marks are visible in ultraviolet light. Final adjustments to the image were made on top of the varnish. The model's right arm and her hands were reworked. Gwen John first rubbed down the area, possibly with a cloth dipped in solvent to break through the skin of oil and then redefined the arm with sienna lines. The new arm was repainted on top. She did not revarnish afterwards.

The final presentation of her image within a frame was also a matter for personal consideration. Gwen John spent much time searching for old distressed frames amongst the shops in Montparnasse. She preferred the 'shabby' frames because she felt that the 'bright yellow gilt made the picture look out of tone with the frame'.[13]

Pigment analysis was carried out by Mary Bustin with optical microscopy.

— 16 —

DUNCAN GRANT (1885–1978)
Bathing 1911

ANNETTE KING

'Think of it! Post-Impressionism in the neighbourhood of the Elephant and Castle …'.[1] This was the ecstatic reaction of the *Evening Standard* to a decorative scheme for the refectory of the Borough Polytechnic undertaken by Roger Fry and a group of young artists in the summer of 1911. It followed in the wake of the 'Manet and the Post-Impressionists' exhibition which was seen in London for the first time in November 1910. The scheme involved seven large canvases of which Duncan Grant's *Bathing* was one. Ridiculed and revered for its daring in equal measure, it was largely this project which launched Duncan Grant into the public eye and brought him to the attention of critics and journalists.

Roger Fry was a tireless advocate of modernism in England and his aesthetic ideas became a catalyst for change. He was central to the development of the Post-Impressionist style in England and he was one of the first to argue that painting which extended beyond the easel had a decorative and communal role, which did not necessarily have to be linked to moralistic or religious ideals, as had traditionally been the case. Fry's interest in wall painting inspired Duncan Grant (fig.104).[2]

Roger Fry was approached about the Borough Polytechnic scheme by Basil Williams, the Chairman of the House Committee. He accepted willingly and enlisted the help of Duncan Grant, Frederick Etchells and Bernard Adeney. The ideas were sketched out in June 1911, approved by the House Committee on 30 June 1911, and painting began on 1 August 1911.[3] Macdonald Gill and Albert Rothenstein were brought in to assist and the whole scheme was completed in ten days for the total fee of £100 and expenses amounting to £55.8s.[4]

The scheme was restricted in time and budget, which helped determine the use of materials and the style of the paintings. Suggestions for unity of style were made by Fry, including the flattening and unifying effect of colour graduating towards a dark outline, patterns and stripes, the simplification of forms, the abandonment of chiaroscuro and a limited palette.

The theme for the decorations was 'London on Holiday' and each artist was allowed to chose his own subject, within certain stylistic guidelines.[5] Duncan Grant produced two canvases, *Football* and *Bathing*. These paintings are early public examples of his fascination with the male body and particularly the nude. With positive attitude, he had realised at an early age that sport was a respectable way to be with other boys in a directly physical, sometimes naked way. In the case of football he made an effort to be good at it '… and I was!'[6] Erotic art in respectable forms was one outlet for his creative and sexual imagination in an age when homosexuality was illegal.

The style of *Bathing* has inspired comparisons with Byzantine mosaics, the photo series by Eadweard Muybridge of a single figure in various stages of movement and is said to show Grant's admiration for Michelangelo, as well as the Post-Impressionists. Yet whatever resonance the painting may set up, it is also startlingly original and

fig.104 Duncan Grant in 1911 at the age of 26

fig.105 *Bathing*, oil on two canvases (butt joined),
left canvas 169 (67), right canvas 137.5 (54), 306.9 × 229 (121 × 90) on
stretcher, border *c*.3 (1). One of seven canvas wall paintings for the
decorative scheme in the Borough Polytechnic on the theme of
'London on Holiday'. N04567

uncompromisingly modern for its time, alluding to all these influences, but slavishly imitating none.

There must have been considerable difficulty in obtaining large pieces of canvas for the Borough Polytechnic scheme as all the paintings have joins of two or more pieces. They were executed on canvas which was adhered directly to the wall. Remains of the original adhesive, which attached the canvases to the wall, now look like

fig.106 Back edge of *Bathing* showing red stripes which formed part of the original decorative border, now the foldover edge of the stretched painting

scraped-down plaster on the reverse of the canvas. They were found to contain lead white as well as plaster, bound in a glue medium. The two canvases for *Bathing* were butt joined on the wall, which clearly occurred before painting began as the paint bridged the gap and is now broken with jagged, overhanging edges. To help unify the scheme, each painting was enclosed in a geometrical painted border (fig.106), echoed in bands of colour which ran along the base of the decorated walls and around the doors. Part of the logic behind the use of canvas rather than painting directly on to the wall was that the paintings could be removed in the event of changes to the building structure, which was eventually what happened in 1929 when rebuilding caused the removal of the decorations. In 1931 they were purchased by the Tate Gallery for a nominal sum.

Bathing is made up of two loosely woven linen canvases of unequal size, the width of the left being 169 cm and the right 137.5 cm in their stretched form. The decorative border is folded around the stretcher on all sides and measures approximately 3 cm. The join in the canvas is now concealed on the reverse by three overlapping strips of canvas. They were applied when the painting was stretched for the first time in 1931.

The canvas is primed with a matt, absorbent, off-white priming comprising mostly chalk, kaolin extender and some ivory black pigment. The medium is casein, and it is possibly the commercially produced 'Case-Arte' casein priming, which would have been available at the time. It is water soluble and very absorbent. That in turn has leached some of the medium out of the paint and created a matt, lean paint surface, previously described as 'tempera'. But in places the paint is too thick to be tempera, even flowing a few millimetres down the canvas. In fact, analysis has revealed both poppyseed oil and linseed oil with a small amount of beeswax in different areas. It was common for poppyseed oil to be used in the manufacture of lighter colours because it yellowed less. Commercially produced tube paints were probably used for convenience, speed and cost-effectiveness. Beeswax was a common minor additive in tube paint at this time.

Key elements of the composition were drawn with pencil or charcoal, traces of which can be seen in unpainted areas of the boat and in the torso of the upper swimmer at the centre of the composition. The figures were then outlined with thin, washy viridian paint (fig.107), before being strengthened with much drier, darker green paint made up of viridian and lead white and applied in thick,

fig.107 Detail showing the butt join between the two canvases in raking light. The strip holding them together from the reverse has caused the canvas to protrude forward slightly. Grant's technique for modelling the flesh with viridian outlines and ochre inner contours is also visible in this figure. The trunks consist of the same pigment as the waves which run across them

broken brushed lines. There are many pentimenti, especially noticeable in the lower of the two diving figures, where Grant altered shapes and angles as the composition progressed.

The contours of the flesh were built up within the viridian outline. Around the inner borders of the green, yellow ochre has been brushed in thick lines to define the muscular contours of the body. Most of the pale areas of the flesh are bare priming with final highlights of chrome yellow and lead white. Grant was constantly revising the inner contours of the figures, as can be seen in places where the highlights overlap the yellow ochre and in others where the yellow ochre encroaches upon the highlights.

There has been speculation as to whether the swimming-trunks in the only clothed figure are original to the composition or a later addition for the sake of modesty, but it is clear on close examination that they are original. Breaks in the bright pink of the trunks do show green contours laid directly on to the priming but the pink paint is original. The thinner pink bands of the waves are the same colour as the paler shade in the trunks and run right across the surface of them. The pink consists of lead white, and cadmium red. The poor dispersion of red in white indicates the use of white and red tube paints mixed together by the artist, rather than a pre-prepared pink. It had been decided by Fry and the others to use a limited palette, but Adeney recalled that he insisted upon using 'vermilion' for the lips of his girls.[7] It is not clear whether he meant traditional mercuric sulphide 'vermilion' pigment or just a 'vermilion' shade of red, which could have been cadmium based. It may be that Grant took advan-

tage of this decision to add another colour to his own work and the pink areas are the last addition.

The lines of the waves were laid in sketchily with an orangey-brown colour, which is still visible unelaborated in the upper right. The other colours were then added in more fluid, opaque paint, sometimes covering the orange lines and leaving bare priming between them for defini-

tion and sometimes using the lines as borders. In places where he changed his mind, Grant erased the contours with off-white paint to resemble the priming. Several waves have been coarsely painted over to alter the final colour, leaving traces of the original colour visible at the edges (fig.108).

The whole painting seems to have been constantly in a

fig.108 Detail of the waves, showing how Grant altered their colour by covering individual stripes with another shade or erasing them with white to imitate the priming

fig.109 Detail of 'pointillist' signature incorporated into the waves at the left-hand side of the painting, which went unnoticed until pointed out by the artist many years later

state of flux without any particular need to achieve a high level of finish. For example, there is no consistency in his approach to the features of the bathers and a number of the sketched-in waves have not been developed.

Grant confessed to being interested in pointillism at the time of painting *Bathing* and this is evident in his treatment of the sky and the two somewhat uncharacteristic blue stripes of stochastic brushstrokes along the centre left edge. On a visit to the Tate Gallery in the 1970s, Grant pointed out what had previously been unnoticed, that he had signed the painting in these two lines. The dots are a barely discernible version of 'DUNCAN' top line, 'GRANT' lower line (fig.109). Grant said in an earlier interview[8] that he did not sign or date many of his early works as he did

not regard it as important and it was in fact a policy adopted by Roger Fry that this scheme should be a true collaboration, with no signed works. It is interesting therefore that Grant considered *Bathing* of sufficient importance to merit a signature, without disrupting the idea of anonymity.

The decorations at the Borough Polytechnic were above all designed to express a sense of enjoyment and gaiety by representing a light-hearted side of London life. Their lack of moralistic or patriotic sentiment led to concerns of a degenerative effect on the pupils at the polytechnic. They were, however, widely admired for their originality. The *EyeWitness* admired the achievement of *Bathing* which with its 'streaming wavy lines which symbolise water, shows how near an artist can get to suggesting reality by a convention which makes no attempt to represent it'.[9] Duncan Grant was the artist most singled out for praise, even being described as, 'the Millais of the New Pre-Raphaelites, so far as technical accomplishment counts'.[10]

The light-hearted vitality of the scheme and its refusal to pay tribute to academic traditions in art were an important catalyst in changing public attitudes towards modern art and what it should set out to achieve. Fry was hailed as a revolutionary in the *Morning Post*. Obtaining approval for his scheme was 'a triumph for Mr Fry and the principles of Post-Impressionism. If the academic Bastille has not fallen, Mr Fry is through the portcullis; there is a breach in the ramparts.'[11]

A new kind of 'journalistic' art had been accepted by the establishment and this achievement was much exalted by C. Lewis Hind:

> With the *London Amusements* frescoes, costing a few pounds a piece, the principle of journalism is at last introduced into art. Notable authors write column articles and short stories; why should … able painters think that they have come into the world solely to produce 'masterpieces' and that it is beneath them to paint 'column' pictures, or to display witty, short stories on the walls of bare classrooms, resting the tired, cheering the lonely, and making the right sort of critics urbane?[12]

The pigments were analysed by Dr Joyce Townsend with optical microscopy and EDX in 1997. Dr Brian Singer of the University of Northumbria at Newcastle used GC-MS to analyse the paint medium and HPLC to analyse the medium of the priming.

− 17 −

DAVID BOMBERG (1890–1957)
The Mud Bath 1914

TIM GREEN

David Bomberg was the fifth of eleven children brought up by Abraham and Rebecca Bomberg, Polish immigrants who lived in Birmingham, and moved to London's East End in 1895.[1] His drawing talent was encouraged by his family who arranged an apprenticeship for him in chromolithography. He did not complete this, but preferred to concentrate on drawing at night classes, and worked during the day to support himself. Some of the night classes were taught by Walter Sickert. Bomberg was encouraged by John Singer Sargent, while drawing in the Victoria and Albert Museum, who advised him that the Slade was where 'the drawing was the best in the World'.[2] Bomberg was introduced by Sargent to Solomon J. Solomon who had responsibility for recommending students to the Slade. Eventually Solomon managed to secure Bomberg financial help from the Jewish Educational Aid Society, which allowed him to enter the Slade School of Art early in 1911.

Nineteenth-century academic tradition was still casting a bituminous shadow, but, just a few months earlier, Bomberg had seen Cezanne's work for the first time in Roger Fry's influential exhibition, 'Manet and the Post-Impressionists', at the Grafton Gallery in November 1910. This was an exciting time to enlist in the avant-garde. In addition to the influence of his tutors, such as Fred Brown, Henry Tonks and William Steer, Bomberg was fortunate to join a gifted group of students including C.R.W. Nevinson, Edward Wadsworth, Isaac Rosenberg, Stanley Spencer, Jacob Kramer and William Roberts. With the emphasis on drawing, Bomberg was successful in numerous Slade competitions. He began to experiment with drawings devoid of figurative content; these evolved to the chess board 8 × 8 rectangular grid employed in *Ju-Jitsu* (c.1913) and *In the Hold* (c.1913–14)

The visual idea for *The Mud Bath* may have developed from a small oil study on a drawing board, made at the Slade in c.1912–13, *Bathing Scene*. Schevzik's Vapour Bath in Brick Lane, which Bomberg knew well, is thought to have provided the subject.[3] Certainly the clean-cut lines and tiled surfaces free from detail would have suited his purpose. The composition was developed in a number of studies.[4] Some of these cover both sides of the paper support. When viewed against a light, *Study for The Mud Bath* (1914), the watercolour composition is revealed as following exactly the charcoal drawing on the verso. The utilisation of the drawing showing through the paper to try out arrangements of colours is evident in *Gouache Study for the Mud Bath I* (recto; 1914) (fig.110), in which the reversed scene was painted in strident colours to produce a dynamic effect. The composition is incomplete. Some of the basic figure forms are evident, but, on the left side, a large area of white was poorly resolved. Various colours were tried as the shadows for the figure forms. An intense red was used for the bulk of the background colour; beside this, the dark side of the pillar was painted blue. This is confusing spatially as the red appears to be in front of the pillar. The dark green to the right of the pillar worked more happily spatially. Such experimentation with colour appears crude, but perhaps this is not surprising as Bomberg's training had consisted mostly of

fig.110 *Gouache Study for the Mud Bath I* (recto; 1914) (private collection)

fig.111 *The Mud Bath*, oil on canvas 152.3 × 224.2 (60 × 88¼) T00656

fig.112 *Gouache Study for the Mud Bath II* (recto; 1914) (private collection)

drawing. When he wanted to paint a dramatic effect to attract notice at the Chenil exhibition, evidently it proved difficult to achieve convincingly.

The drawing in charcoal, conté crayon and white heightener on the verso of the gouache shows the scene the correct way round with a much clearer depiction of form, indicating this study was completed first. In subsequent drawings the composition advanced. A second gouache (fig.112), shows a unified colour scheme quite different from the final version. Yellow ochre depicts the highlights of the limbs and maroon their shadow. The bath itself is white. Near the bottom edge, obscuring the base of the pillar, are the end parts of two prominent forms. Each is aligned on one side with the edge of the bath. The crimson coloured pavement takes an excursion from its otherwise simple rectangular shape to accommodate this.

In the finished painting, the bath is a simple rectangle with the red extending to the bottom edge. The lower form tapers and is then cut off exactly in line with the edge of the brown pillar. Surrounding this blue and white form are the other four colours Bomberg used. Here is probably the greatest spatial ambiguity. The upper form appears to hang above and in front of the lower, which almost appears to be trapped by the pillar. Its tapering end, cut off so precisely in line with the pillar, might be disappearing under the red depicting the bath. His blue and white human forms struggle mostly against a mass of

vivid red. Spatially the effect is for the abstract shapes between the forms to assert themselves.

Bomberg painted on a medium-weight linen canvas. The very thin white priming extends to the edges only, not on to the tacking edges, indicating that Bomberg prepared the canvas himself. Where unpainted at the edges, it appears to have been wiped, or scraped so that the primer fills the interstices but barely covers the raised part of the threads. By filling the canvas texture in this way, a flatter surface would have been produced. Down the left edge, graphite and a stain of red colour are just visible, spaced 19 cm apart. This points to Bomberg having transferred the drawing to the canvas using his familiar grid of 8 × 8 rectangles. Evidence that the drawing was transferred exists elsewhere on the composition, where paint-free gaps between painted shapes allow graphite lines to be glimpsed. Although the exact sequence of the many preparatory drawings is difficult to establish, one signed and dated drawing exists that Bomberg squared up into his familiar 64-rectangle grid (fig.113). It is likely a number of the sketches were consulted during the execution of the painting.

To establish the colour relationships initially, he used oil paint well thinned with turpentine or white spirit. Washes or stains of colour not related to any grid lines are present on the exposed primer in the middle area of the extreme right edge. Bomberg's colouring at this initial painting stage may well have been identifiable from the

fig.113 *Drawing Study for the Mud Bath* (1914) (private collection)

back through the insubstantial priming. However, the painting was wax-lined on acquisition at the Tate Gallery in order to treat a large tear then present in the depicted central pillar. In a lining treatment, the back of the original canvas is obscured when a new canvas is adhered to it.

By resolving the composition using preliminary studies and exploring possible colour relationships, Bomberg was well prepared as he started to paint *The Mud Bath*. Consequently he appears to have applied only one layer. Only after careful examination were two small passages found where one colour had been overpainted with another. (In a few places, two thicknesses of the same colour are also present.) A mere six colours were used, unmodified, throughout the design. By using the same colours with no modification to allow for distance, aerial perspective is ignored. Together with the annihilation of linear perspective, which he achieves by keeping parallel the long sides of the rectangle depicting the bath, flatness in the composition is strongly emphasised.

Paint was applied in a semi-fluid state. Brushmarking was retained, but not quite as crisply as if no additional medium had been employed. Bristle brushes ⅜ inch and ½ inch wide (9 mm and 12 mm) were used to apply the paint in strokes often 4 inches (10 cm) or more in length. Care was taken to prevent colours mixing at the boundary. The simplest method to avoid the problem would have been to allow each colour time to dry before painting around it. Bomberg appears to have chosen to paint wet alongside wet. He prevented the colours mixing by applying sufficient pressure to force the paint at the edges of the brushstroke up into a lip (fig.114). Sometimes the two colours at either side of the lip fused slightly along this ridge. One example of ultramarine blue mixing into lead white was found.

An idiosyncrasy was to paint a brushstroke, then lift the back part of the brush up and off the canvas. This pulled the paint up into sharp ridges. In some places, in the brown of the pillar especially, Bomberg seems to have produced this distinctive texture more directly by laying the brush flat and then lifting it off the wet paint (fig.115). Since this texturing is repeated so often across the entire painting, it is tempting to believe it was a further device to draw attention to the surface plane of the paint itself.

There was nothing revolutionary about Bomberg's choice of colours. The red of the bath was vermilion. This was mixed with lead white to form a tint, as was the synthetic ultramarine used in the blue shadow of the figure forms. Around the bath, a cream-coloured tint was mixed from chrome yellow and lead white. Chrome yellow can discolour, and possibly for this reason the cream hue exhibits the greatest variation of the six colours Bomberg employed. The column is painted with Mars brown, and its black part is probably bone black. The brown is of uneven thickness. Where it is thinnest, the white priming shows through making the colour appear appreciably redder.

fig.114 Detail showing lipped ridge at boundary between two colours

fig.115 Detail of texture produced by lifting up the flat brush from the wet paint

The canvas was inscribed on the back (fig.116), 'No.1 in the exhibition at the Chenil Gallery, July 1914'. Bomberg, in common with most twentieth-century artists, did not generally varnish his paintings. However, there appears to be some varnish residue on *The Mud Bath*. This could be a protective layer against rain, applied when he decided to exhibit the work on the outside wall of the Chenil Gallery where, as was stated in the catalogue,[5] 'it may have every advantage of lighting and space'. The *Daily Chronicle* added it was, 'on the outer wall of the house, rained upon, baked by the sun and garlanded with flags'.[6] The gallery, which also sold artist's materials, was not large. Quite possibly space was limited with over fifty works displayed inside. Implicit in the bravura of this alfresco display is a lack of knowledge concerning the vulnerability of oil paintings. A number of small losses of paint have occurred. Drip marks and a tenacious dirt layer are a likely legacy of outdoor display. As an advertisement for the exhibition, *The Mud Bath* did not succeed, with the passing public failing even to recognise it as a painting. Bomberg would tell 'how the horses drawing the 29 bus shy at it as they came round the corner of Kings Road'.[7] Sales from the exhibition were disappointing. Unsold at £50, *The Mud Bath* was stored in a garage for the rest of Bomberg's life.

The Chenil Gallery exhibition, a one-man show, was a notable achievement. Of Bomberg's circle, only Epstein had been similarly recognised. Even Wyndham Lewis, who had ousted Bomberg from a prime hanging site at the first London group exhibition earlier the same year, received far less critical notice, though seven years his senior and much more established. In the catalogue Bomberg wrote his manifesto; 'I APPEAL to a Sense of Form', 'I completely abandon Naturalistic Form, I have stripped it of all irrelevant matter', and 'My object is the construction of Pure Form'.[8] For Bomberg, aged twenty-three, the Chenil Gallery exhibition proved to be the summit of his avant-garde achievement. *The Mud Bath* has since been described as the most outstanding painting produced in this country during the pre-First World War Period.[9]

fig.116 *The Mud Bath*, detail of back

Bomberg's good luck with a storm-free July was augmented by the exhibition narrowly missing the outbreak of the First World War. *The Mud Bath* would be the last time that the machine's dynamism could inspire Bomberg to represent the movement of limbs in a completely joyous way. The red, white and blue in the painting and its display surrounded with little union jacks, indicated his patriotic feelings. Bomberg was not allowed to enlist until November 1915; then he saw the horror of front line action and was brought so low by it that he suffered a self-inflicted wound. Further active service followed his quick recovery. Richard Cork wrote:[10]

> The truth is, however, that Bomberg's prolonged and searing encounter with the armaments of modern war engendered a crisis in his way of seeing. Before the conflict, he had viewed the machine as an agent of construction and relished its precision-finish dynamism. But inventions like the rapid-fire machine-gun were deployed with such devastating consequences in battle that his attitude changed. The incessant pulverising of young men's bodies finally forced him to regard the machine as the catalyst of destruction on an obscene scale, and to recoil from his former vision of the twentieth-century world.

The pigments were identified with optical microscopy and EDX by Dr Joyce Townsend in 1997.

— 18 —

WALTER SICKERT (1860–1942)
Brighton Pierrots 1915

S t e p h e n H a c k n e y

In August 1915 Walter Sickert wrote to Ethel Sands that he intended to do some 'spiffing paintings after all this etching'.[1] During August and September Sickert stayed with his friend, the painter and collector Walter Taylor in Brunswick Square, Brighton, not far from the promenade. He visited the beach entertainments every night and made many pencil and pen sketches. As with his earlier music hall paintings he was attempting to capture the magical atmosphere of the performance. In *Brighton Pierrots*, the entertainment itself seems languid and, judging by the empty deckchairs, poorly attended, yet Sickert captures the impression of the moment when the sun's dying rays are eclipsed by the stage limelight. The stage and gaudy pink costumes are starkly lit by an eery cold limelight whereas the scene beyond is bathed in the warm glow of the setting sun. This strange scene of transient, half-hearted pleasure is more poignant in the knowledge that the heavy artillery in Flanders could be heard on such a night.

Sickert trained with Whistler, who persuaded him to abandon the Slade, and inevitably his early work is strongly derivative of the 'master'. Whistler also introduced Sickert to Degas. His fellow student Menpes joked that in response to these two influences they painted low-toned ballet girls. Much of Sickert's later development and writing reflect his struggle to evolve his own style whilst maintaining links with aspects of French methods of painting associated with these artists. He came to reject Whistler's aims and personality but continued to share many of the same technical challenges. Degas remained an inspiration to Sickert both in terms of subject-matter and technique. Sickert is best known for London scenes such as music halls and interiors in Camden Town, which can, like Degas's work, be categorised as entertainers on stage, models, portraits, intimate scenes and 'low-life'.

According to Sickert 'drawing is the extraction from nature, by eye and hand, of the limiting lines of an object'. He saw drawing as a language and a necessary preliminary to painting. He increasingly turned to Degas's methods for developing his images. Degas made many drawings of figures and other forms, putting them together to build up more complex groups, exploring their pos-

fig.117 Postcard of Brighton showing beach entertainers (*c.*1906) (Collection Peter Booth)

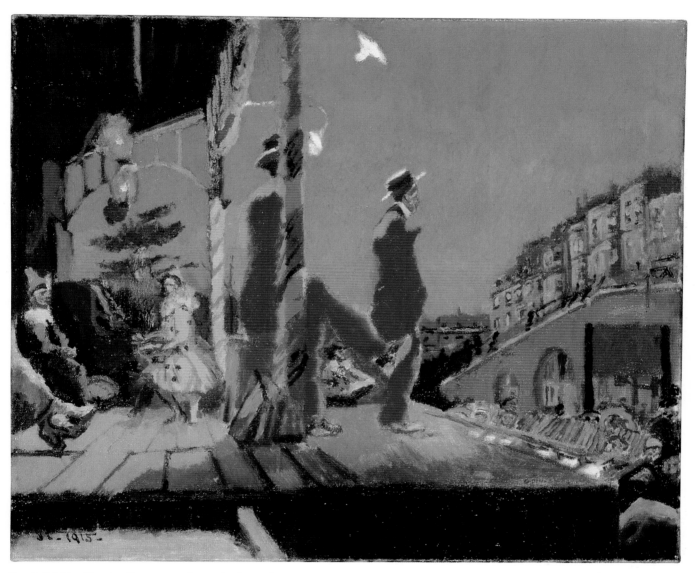

fig.118 *Brighton Pierrots*, oil on canvas 63.5 × 76.2 (25 × 30) T07041

itions and relationships.[2] Frequently he transferred images drawn in pastel by rubbing them face down on to a second sheet. In later life Sickert went a stage further, experimenting with drawing using a camera lucida and finally making extensive use of photographs as his starting-point, to be squared up for transfer to a large canvas. Throughout his career establishing a composition was a major preoccupation and he was constantly selecting images to use in his final works (fig.117). Rothenstein suggests that this is because Sickert was never a confident draughtsman.[3] Whatever the reason, these preliminary designs gave Sickert the control and versatility to create paintings with the qualities that he sought (fig.119). By contrast Whistler aspired to be an alla prima painter laying down his painting in one go, and Sickert became highly critical of the limitations of such an approach.

Sickert frequently sought technical solutions. He was proud of his knowledge and Continental connections which set him aside from his contemporaries and frequently expressed his advice in letters and published articles. His concern was less for materials than for their application, above all the belief that paint should be an opaque and lean paste (*pâte*), and that glazes were a weakness of English painting. An important technical aspect of his work that is evident in his early paintings but became highly developed during the Camden Town period is the application of oil paint in a stiff paste using a hogshair brush with the minimum of turpentine or petroleum spirit. Each area of paint was left to dry thoroughly and then, if necessary, was reworked, either modified or completely overpainted with more opaque paste. Sickert thought in terms of patches of colour rather than of lines. He advised Ethel Walker to paint fast and 'to paint across [her] forms, and not into them'. In a letter to Miss Sands he suggested the use of 'touches ranging from the size of postage stamps to the size of a pea' and not to 'fill up gaps for the sake of filling up'. 'Not till all the canvas is several times covered do you get a beginning of the quality of which everything takes.'[4] Sickert's own work follows this advice but the number of coverings may not be so great. What is evident in the surface is the stiffly applied paint in places bounced across the canvas texture and breaking up at the end of each stroke.

Although Sickert's paint was opaque, he was not simply concerned with its covering power. In *Brighton Pierrots* this is most easily observed at the bottom right side of the stage, where a pale pink coloured layer is visible beneath the dull olive brown top coat. Enlarged under the microscope it can be seen that this brown layer is applied in a broken scumble. In the previous year Sickert had begun to experiment with a method that he considered the ideal use of oil paint, and which was to form the basis of all his

fig.119 Pencil study for *Brighton Pierrots*
(Walker Art Gallery, NMGM)

fig.120 Detail of the stage showing the broken brushstrokes of dry dull-green paint over the pink camaïeu, which has been enhanced in this photograph. Sickert's advice was to 'Paint like a very stiff street sweeping machine on macadam'

future work.[5] This was termed a camaïeu preparation, and involved laying-in on top of the white priming plain areas of pale opaque colours to define the lights and shadows of the intended composition.[6] Sickert recommended white with cobalt blue for the highlights and white with three strengths of Indian red for the shadows. The exact colours were not important provided the lay-in remained light and contrasted with intended overlayers. If the shadows were too dark their effect on the next coat would be to deaden it. Those small areas of camaïeu left uncovered provide a simultaneous contrast with the final layer. In a letter to Nina Hamnett in 1918 Sickert says, 'I have certainly solved the question of technique and if you would all listen it would save you 15 years muddling … It is extraordinary how agreeable undiluted paint scrubbed hard over a coarse bone-dry camaïeu … becomes. It turns semi-transparent like a powder or a wash, and this with no dilutant: of course, this is all for the earlier coats of the true colour, as one finishes one can't scrub and, in

consequence the touches become fatter. Then in the end nothing is prettier than the non-coloured spaces semi-transparent and the laboured ones fatter and more opaque. I believe technically that is the ideal use of oil paint … All this is of course for painting from drawings. Painting from prima over and over again can only be done in the one way.'[7] The area of stage in *Brighton Pierrots* reveals the camaïeu (fig.120), a mixture of lead white and Mars red, beneath his lean, scrubbed scumble, but much of the sky is unbroken and painted in the fatter more finished paint. Small areas of camaïeu are also visible at the end of brushstrokes between patches of colour. Sickert vividly demonstrated his intention in such passages by spreading out a pack of cards on a table and scattering a pack of a contrasting colour on top.

The Tate Gallery's painting is the second of two versions of *Brighton Pierrots*, both painted after the artist had returned to London.[8] They were not done in front of the scene *en plein air* but were constructed from his drawings

fig.121 Detail of the figure of a pierrot painted very freely
in this second version

and from memory. Although the result is sketchy and incomplete it differs significantly from impressionist technique. Despite being labelled as an Impressionist and exhibiting with others under that label, Sickert thought that the term 'impressionist' was elastic. In attempting to define it, he stated that 'Surely works constructed to decorate a wall should be painted so as to appeal primarily at the distance at which they are most frequently seen' and that on closer inspection they should not reveal 'new facts about the subject of the picture'. Instead, they should reveal a 'subtle attribute which painters call quality … A certain beauty and fitness of expression in paint, apparently ragged perhaps, and capricious, but revealing to the connoisseur a thoughtful analysis of the essentials in the production of the emotion induced by the complex phenomena of vision.'[9]

Sickert's first version of *Brighton Pierrots* was immediately bought by Morton Sands, but not before it was seen in the studio by Sir Walter and Lady Jowitt who requested a second version. This second version, recently purchased by the Tate Gallery, is considered by Wendy Baron to be the more successful of the two. It is a flatter and simplified rendition; some of the detail has been omitted and the modelling of the shadows is reduced. That it is a more spontaneous work is evident from the cavalier treatment of the performer's blazer lapel and the missing collar of the seated figure (fig.121), but it is not clear why he introduced another figure to the left of the pianist, and then rubbed it out. Sickert has not even bothered to paint over the rubbed-out figure. Andrew Wilton observes that the extreme dislocation of the figures suggests a human crisis.[10] Because the amount of reworking has been kept to a minimum, there is less evidence of the struggle that is often a feature of Sickert's work.

In this painting Sickert can be appreciated as a colourist. The tonal range of his sky and background are kept low as in Whistler's *crépuscules*, but on stage the powder-pink suits and the decorated stage awnings are cool and vibrant, with the two blazered figures modelled in flat half-shadow against the light. The low-toned areas are achieved by the foolproof device, handed down by Whistler, of adding ivory black to all his colours. Where Sickert departs is in his use of pure colours, unmixed with black, for the limelit parts of the composition, for instance, the pink and lime green of the pole (fig.122). The pink consists of lead white, a red lake, vermilion and cobalt blue, and the lime green is a mixture of lead white and chrome yellow.

fig.122 Detail of the pole showing limelit pinks and greens against a darker sky

Despite starting with a pre-primed 'Winton' canvas bought from Winsor and Newton which has a lead white priming, there is little evidence of white in the finished work except for a few unpainted areas at the boundaries of forms. White paint, incompletely mixed with yellow on the brush, has been added as highlights, most obviously for the limelights and the performers' collars, but only sparingly. The painting succeeds by contrasting colours and hues; his colours deny the viewer a point of absolute reference. Sickert recollects that Degas put it succinctly, 'the art of painting is to surround a patch of, say, Venetian red so that it appears to be a patch of vermilion'.[11]

Pigment analysis was carried out in 1997 by Dr Joyce Townsend using optical microscopy and EDX.

PHILIP WILSON STEER (1860–1942)
Painswick Beacon 1915

CHRISTOPHER HOLDEN

Philip Wilson Steer was an original member of the New English Art Club. The club was founded in 1886 to exhibit work by the modern and progressive artists of the day who were unrecognised by the Royal Academy. Members of the club included many artists who became influential with established reputations – Steer became an acknowledged leader of Impressionism in England, and in 1929 he was the first living artist to have a one-man exhibition at the Tate Gallery. Steer did not think it necessary to break with tradition to paint in the modern manner; indeed many people at the time considered him to be the modern successor to Constable. He liked the move towards Impressionism, or contemporary Impressionism as he saw it, but sought to incorporate into it the traditions of British painting as he perceived them.[1]

In a lecture at the Art Workers' Guild in 1891 Steer expressed his view on Impressionism:

I have both read and heard it stated that Impressionists ignore tradition. Now, I propose to show that so far from ignoring tradition they follow the highest tradition of all time that is inspired by nature and nature only. Impressionism is not a new thing created by my generation. The word is new, I grant, and herein lies the trouble. Everyone seems to put their own construction on the word. For the sake of simplicity, let us substitute the word Art for Impressionism – there can only be two things, Art or no Art. I think the definition that someone has given that art is the expression of an impression seen through a personality, sums up the question of what art is, very concisely.

I think that it may not be out of place if I read you one or two short extracts from the *Discourses* of Sir Joshua Reynolds that will show you that he, himself an Impressionist, held, over a hundred years ago, precisely the same views which are held by the most advanced Impressionists of today. We are told that Impressionism is a passing craze and nothing but a fashion. Is there any fashion, I would ask, in painting a grass green instead of brown; making a sky recede and hold its place in the picture instead of hitting one in the eye? Is it a craze that we should recognise the fact that nature is bathed in atmosphere? Is it fashion to treat a picture so that unity of vision may be achieved by insisting on certain parts more than others? No! It is not fashion, it is *law*.

There are pictures painted nowadays, welcomed in high places and sold for large prices that have no unity of vision. They are like worms which, if you cut them up into half-a-dozen pieces, each bit lives and wriggles; so with tiresome exercises of misguided industry you may make six pictures out of one and each is finished and as badly composed as the others. The impressionist is inspired by his own time because his art is inspired by nature; he finds his pictures in the scenes that surround him, and although he works on the same principles as did the ancients he is not satisfied to produce rechauffés of the past Art but rather he tries to dignify the subjects he deals with (commonplace and ordinary though they may be) with the principles that have actuated the production of great Art in all time.

Impressionism in Art has always existed from the time when Phidias sculptured the Parthenon frieze … Reynolds and Gainsborough dignified their sitters till they became goddesses. So impressionism is of no country and of no period, it has been from the beginning; it bears the same relation to painting that poetry does to journalism. Two men paint the same model; one creates a poem, the other is satisfied with recording facts.[2]

He visited Painswick, near Stroud in Gloucestershire, in 1915 (fig.124).[3] *Painswick Beacon* is painted on a stretched canvas support, prepared by the artists' colourman, Newman of Soho Square in London. (This is known from a stamp on the reverse). D.S. MacColl, his friend and biographer, records that most of his canvases were Newman's. They were of a type known as 'half primed', a near

fig.123 *Painswick Beacon*, oil on canvas 61 × 91.5 (36 × 24) N03884

fig.124 Cartoon drawing of Coles, Steer, and Brown setting out to paint. Steer was nearly always accompanied by artist friends on his painting trips. They were usually W.C. Coles, master of Winchester School of Art, and Frederick Brown, professor of painting at the Slade School

fig.125 Steer painting 'on the spot' at Bosham, near Chichester, Sussex, in 1914

white with a 'tooth to them'[4] (see pages 76 and 80 on the subject of primings). The canvas is closely woven from fine linen threads (20 warp and 17 weft threads per square cm) and is stretched with tacks on the sides and on the flaps at the back. The analysis of the priming shows that it consists of a single layer of lead white in oil medium. There is a thick glue-size layer present beneath this on the canvas, possibly applied cold as it did not soak into the canvas threads. The surface of the priming retains the texture of the canvas.

D.S. MacColl also records that Steer's oil paint medium was simple and straightforward. Turpentine and linseed oil were his staple medium with occasional use of poppy oil. Examination of paint samples from *Painswick Beacon* shows the medium to be consistent with unmodified oil. The paint has been applied in all directions with rapid, vigorous and spontaneous brushstrokes that have retained their texture (fig.126). Generally it is opaque. This Impressionist style of oil painting was influenced by the growing number of watercolours he was producing by this time. Steer's handling became increasingly fluid and spontaneous. Watercolour gave him an alternative to the heavy impasto which is characteristic of many of his earlier oil landscapes paintings (he used to joke that he could tell when a painting was finished by its weight!).[5] From examining *Painswick Beacon*, it can be seen that he used a flat brush of about 1 inch (25 mm) thick, and a ¼ inch (6 mm) or ½ inch (12 mm) filbert brush and in places his finger. When talking about brushes, he said, 'He couldn't think why fellows used so many. He found washing them such a nuisance that he only used two, one for light and one for dark colours.'[6]

It was Steer's practice at this time to paint his oil landscapes in two distinct stages. The first stage was done 'on the spot' (fig.125) and the second stage was to rework them away from the subject. Circular impressions (of diameter 1.5 cm) in the paint with pin-sized holes in their centres at all four corners and at a point in the top and bottom edges, show the use of canvas spacers. These are small circular pieces of cork with a pin at their centre, used to separate the surfaces of wet paintings while being carried. This confirms that the painting was worked on out of doors. The two stages are a main feature of the painting. The first stage, which can still be seen, consisted of applying an ultramarine blue sky with some pink clouds and then applying the outline of the hill as a single horizontal sweep of yellow paint over the sky. The second stage was done after the first stage was well dried and con-

fig.126 Detail of the lower left showing the thick vigorous
brushstrokes of the second stage of painting

sists of thick paint covering most of the landscape below
the hill and the sky. Steer told D.S. MacColl that he had
'rehandled the whole land and sky and the result was
excellent'.[7] In the foreground there are some textured
areas formed by broken horizontal brushstrokes and also
a similar area of white cloud directly above the centre of
the hill. Tall trees reaching above the horizon, some
below it and a number of other sketched forms, have been
mostly obliterated (fig.127). All the changes can be seen
from looking at the painting without a microscope, and
from examining the cross-sections. All the cross-sections
show that Steer was working new brushloads of paint
into still-wet paint, especially in the second stage. Some of
the sections show the division between the two stages,
with thin layers of paint worked wet in the initial stage,
dried out, and then overlain by much thicker paint,
followed by a further application of wet paint in the
reworking (figs.128a and b). An x-radiograph taken of the

painting did not help to clarify the first stage, since in the
lower half of the painting, the thick, lead-rich paint com-
pletely obscures the brushstrokes beneath. In thinner
areas, such as sky, it is possible to see brushstrokes under-
neath which are not concealed by later ones.

In the analysis, most of the cross-sections include a few
of the following pigments, and traces of nearly all of
them; viridian, cadmium, chrome and strontium yellows,
chrome orange, chrome red, cadmium red, a pink organ-
ic pigment, cerulean blue, synthetic ultramarine, ultra-
marine ash, Mars yellow, two shades of red and brown
sienna, lead white, ivory black. Emerald green, Prussian
blue, vermilion, a second pink organic pigment and zinc
white were less common, but were seen in at least one
sample. The zinc white was always associated with lead
white. One highlight of white paint analysed included
only lead, not zinc. This suggests that the zinc white must
have been present in some of the paint tubes rather than

fig.127 Detail showing trees above and below the horizon, painted
during the first stage of painting and partially painted out during the
second stage

fig.128 a and b Cross-section, photographed at × 100, taken from the foreground near the lower left edge, showing the two distinct stages of the painting (marked by a dotted line in the diagram), and a range of pigments

1st stage (lower): thin layers of paint worked wet in wet and dried out before application of the 2nd stage
2nd stage (upper): much thicker layer worked wet in wet

deliberately selected by Steer for pure white. Viridian was present in nearly every sample examined. The presence of nearly all the pigments found in most of the sections is probably due to the use of a few and only partially cleaned brushes.

It is not known whether Steer originally varnished the painting. It was unusual for the Impressionists to do this. However, it was not unusual for their paintings to be varnished by their dealers and galleries. At some time after the painting was finished, two layers of a natural resin varnish (mastic) were applied generally over the paint film. The top layer of varnish was applied when the painting was in a frame. Substantial runs of varnish on the lower side, smaller ones on the vertical ones and none on the upper side, show that the varnish(es) were applied with the painting in the upright position or on a steeply sloping easel. The varnishes had yellowed with time. Because of this, they were removed in 1996, during a programme of restoration of Steer's paintings, and replaced with several layers of non-yellowing acrylic resin (Paraloid B-72).

Pigment analysis was carried out by Dr Joyce Townsend in 1996 with optical microscopy and EDX. The varnish was analysed with DTMS at FOM-AMOLF by Gisela van der Doelen.

STANLEY SPENCER (1891–1959)
The Resurrection, Cookham 1924–6

STEPHEN HACKNEY

Spencer returned to the subject of the Resurrection several times during his life, 'back to the bottle' as he put it, but 'never [again] got a comprehensive "setting" or framework such as I found in the subject of *The Resurrection, Cookham* which held me firmly while I viewed the world. I wanted to see all these things through eyes such as that subject gave me.'[1]

This enormous painting was the centre of attention at Spencer's first exhibition at the Goupil Gallery in 1927, giving the artist his first public success. *The Times* called it the 'most important picture painted by an English artist in the present century … what makes it astonishing is the combination on it of careful detail with modern freedom of form. It is as if a Pre-Raphaelite had shaken hands with a cubist.' Even the influential but unsympathetic critic, Roger Fry, willingly admitted that *The Resurrection, Cookham* 'is highly arresting and intriguing. It is no perfunctory sentimental piece of story-telling, but a very personal conception carried through with unfailing nerve and conviction'.[2]

While he was painting *The Resurrection, Cookham*, Spencer was also preparing to paint his major series of murals for the Sandham Memorial Chapel at Burghclere. This work was based on sketches and paintings that he made on return from his military service in Macedonia. One of Henry Tonks's criticisms was that Spencer suffered from an overcrowding of ideas. These two major undertakings embody an enormous number of different images and are the culmination of Spencer's religious thoughts and feelings at this period.[3]

Spencer trained at Maidenhead Technical Institute for one year and then at the Slade School, University College, under Henry Tonks from 1908. He had several notable contemporaries at the Slade (see page 114). Spencer's limited experience and confined upbringing kept him apart from his more sophisticated colleagues, made worse by his daily commute to Cookham. He was soon given the nickname Cookham. During his first year Spencer drew from the 'antique' under Walter Russell. Later he drew in

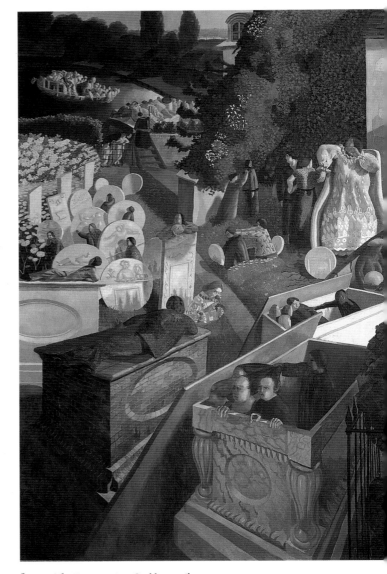

fig.129 *The Resurrection, Cookham*, oil on canvas
276 × 552.3 (108¼ × 216⅝) N04239

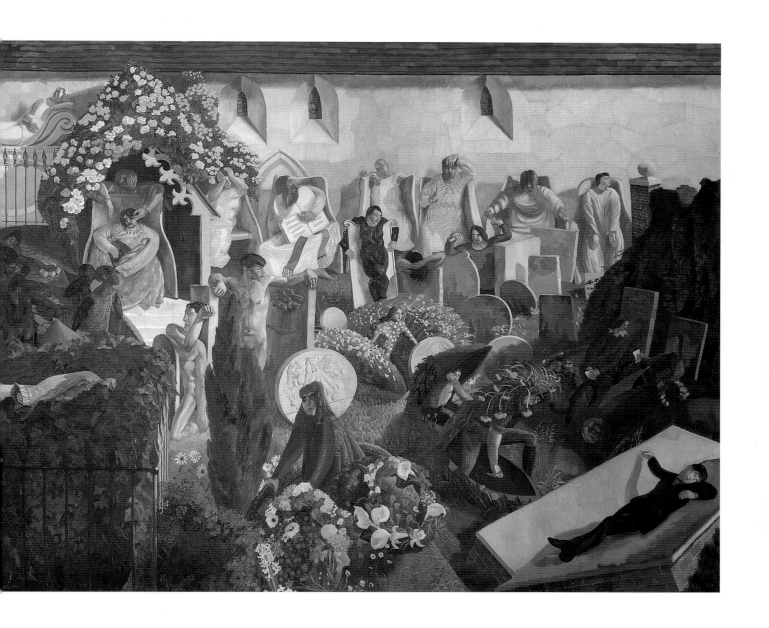

fig.130 Preparatory drawing (National Museum of Wales) showing squaring up and enlargement of the sheet (31.3 × 63.3 cm)

the life room where throughout the week the nude model retained the same pose during the morning and afternoon sessions. In the late afternoon the model took short poses but Spencer missed these sessions to catch the 5.08 from Paddington to Cookham.

The emphasis was on drawing. Tonks's advice was 'Don't copy, but try to express the shape you draw; don't think about the paper and the flatness of it; think of the form and the roundness of form … Think of those bones, those beautiful sweeps and curves they have … don't think about style. If you express the form, the "style", as some people call it, is there.' His criticism could be hard and on one occasion Spencer recalls him saying 'Photos don't express anything and your drawing is too much of a photograph.'[4] Through a combination of Spencer's natural talent and Tonks's criticism he became a highly competent draughtsman.

Training in painting was more limited. 'In the four years I was at the Slade I did about three days' painting from one model – three days out of four years.'[5] Spencer's first paintings in oil were on paper using tubes bought from another student. Essentially, like many of his contemporaries who had learned to draw proficiently at the Slade, he taught himself to paint and in the process developed his own peculiar traits.

Spencer had planned to paint a Resurrection for a number of years. An early oil sketch on the subject was done around 1912 but this was overpainted by Spencer when he reused the canvas for *The Apple Gatherers* in 1912–13. X-radiography did not reveal the underlying image but a raking light photograph indicates an earlier subject. A diptych, *The Resurrection of the Good and the Bad* (1915), was the source of two figures. A further small study on millboard, made in 1920–1, has resurrecting figures pulling themselves out of graves with synchronously raised arms. More directly, a sketch of *Bonds Launch, Cookham* was done in 1920. This image is very close to the boat in the top left corner of *The Resurrection, Cookham* and was used directly as a source.

Spencer started with the all-important drawing. His working practice began with small preparatory sketches in pencil, pen and brown wash on paper to be squared up for transfer to a larger canvas. The sketch, or cartoon, for *The Resurrection, Cookham* (fig.130) is in the National Museum of Wales.[6] It is in pencil and wash on six sheets of paper laid down (later) on card. It was done when Spencer was staying with Henry Lamb in Poole in 1922. The sketch (31.3 × 63.3 cm) is the same format as the painting (a ratio of 1:2). Spencer has enlarged his paper as he developed his composition for the final image. It was then

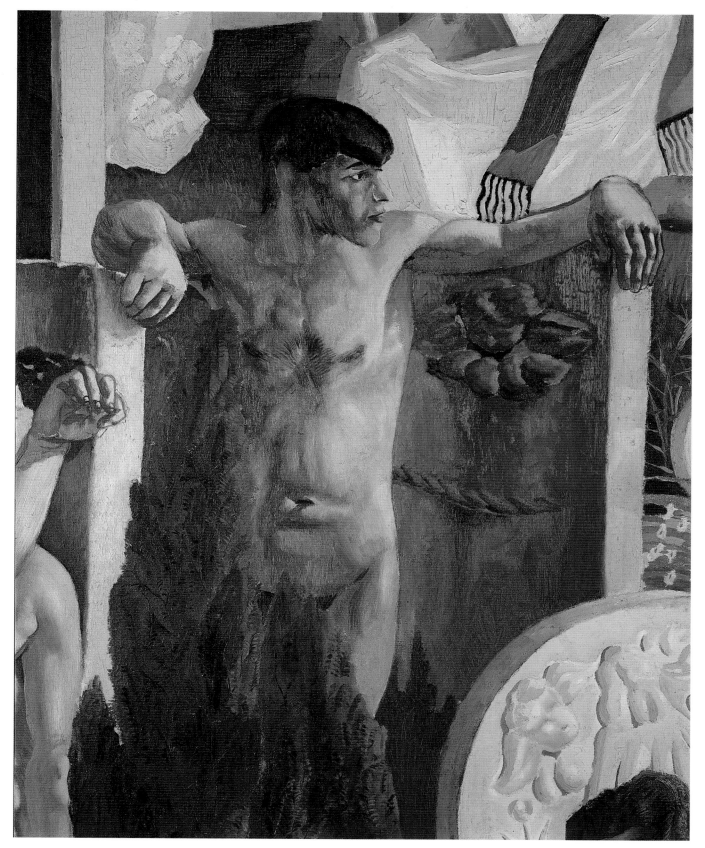

fig.131 Detail of the figure of Spencer with hands reinforced
in pencil over the paint

squared up for transfer. Sometimes Spencer also did small oil sketches overlaid with squares and diagonal lines, before he embarked on the main canvas.

He bought his canvas and paints from Bryce Smith, who sold Winsor and Newton materials among others.[7] The canvas and priming appear to be commercially prepared with an initial layer of lead white and chalk followed by a lead white layer. Analysis also revealed the unexplained presence of magnesium sulphate, detected in parts of the priming, one sample of green paint and in some white spots on the surface of the paint. The final drawing was done in considerable detail in pencil on the lead white oil-priming of the squared-up linen canvas. It is still possible to see lines from the squaring up that correspond with those in the sketch, more closely grouped around the church door.

Spencer then painted each section of his drawing, methodically colouring them in area by area, painting up to the drawing line which often remains visible, occasionally with a patch of unpainted white exposed. Indeed in one of his last, unfinished, works he had literally started at the top of the composition and was working his way down. John Rothenstein observed, 'The great canvas which I had seen blank except for a few minutely finished islets, and – at longish intervals – seen fill gradually with figures resurrecting among gravestones and tombs.'[8] On one occasion in 1926 when *The Resurrection* was almost complete Rothenstein recalls the scene of domestication around the working artist: 'Mrs Spencer was bathing Shirin, [their daughter] … a boiling kettle which stood on a small iron stove filled the room with steam, which condensed and streamed down the spacious surfaces of the canvas.'

It was painted in Henry Lamb's studio in the Vale Hotel, Hampstead, where it stretched the entire length of the room. Because of its height the artist had to stand on a box placed on a table to paint the upper part of the canvas. A friend, Kate Foster, described the artist at work 'teetering on a box while painting white roses in a corner, just a patch at a time, and holding forth from his elevation on Tonks and the Slade'.[9] In his later, even larger, *The Resurrection, Port Glasgow* (1947–50) – eventually 215 × 665 cm – he was unable to unroll the work to see it in its entirety until it was removed from his studio; at times he was standing on the lower edge in his stocking feet. Removing *The Resurrection, Cookham* from Lamb's studio was no easy job. It had to be lowered from a first-floor window.[10]

Spencer was undisturbed by these inconveniences and had a remarkable capacity to maintain a consistent approach to his work across a wide expanse of canvas and a long period of time. His colours remain consistent even though at times he was working by yellow incandescent light or even candlelight. Spencer observed that 'the effect in the morning is sometimes tremendous'.[11] Much later in 1952 he was able to use blue daylight bulbs for painting after dark.

In much of the composition of *The Resurrection, Cookham* Spencer's application of paint is unexceptional.

fig.132 Detail of flowers

fig.133 Detail of girls held by their hair, showing changes to composition at painting stage

He was exploring the flat unmodulated forms influenced by the Post-Impressionists and was enthusiastic about Giotto's frescoes. 'I want especially to do the resurrection in oils as the paint is to be thick and solid like my Apple Picture.'[12] His lights are usually matt, often opaque from mixture with white, and have roughly brushed impasto whereas his shadows are usually glossy from the addition of extra medium or retouching varnish. In places he has continued to draw further details in pencil over the paint; he appears to have found that he could reinforce the form of hands and other details more successfully in pencil than in paint (fig.131). Such a pragmatic approach did not lend itself to painterly expression, although several of the more important figures are painted more strongly. Flourishes of a freer style of painting can be seen in the depiction of surface textures and details of grass and flowers painted within defined areas that had not previously been assigned much detail at the drawing stage (fig.132).

The setting of the painting is Cookham churchyard at 2.45 in the afternoon of a Tuesday in May with the Thames in the background. Work on the canvas began in February 1924 and was completed in March 1926.[13] The recently resurrected emerge in a leisurely fashion to experience the joy of judgement day which Spencer imagined to be without serious punishment for sinners. The representation of Cookham churchyard is not precise, although many of the elements in the picture exist; Spencer incorporated his childhood memories of playing in the churchyard and its stillness on a spring afternoon. He has painted himself on the 'open book' created by two listing graves, and again, nude with head in profile, to the right. Richard Carline, his brother-in-law, also as a nude, kneels beside him. Spencer's wife, Hilda Carline, appears three times, smelling a flower, reclining in the ivy-covered tomb, and climbing over the stile which leads to the boat. Sir Henry Slesser, a local judge and early patron of the artist, is seen emerging in the foreground, wearing a wig. It was clearly important to Spencer to include all his friends and no doubt convenient for his painting to have readily formed images of them and for some to sit as almost academic studies.

The composition is contrived to make the viewer feel close to the subject. The perspective is that of a wide-angle lens photograph with strong diagonal recession lines, despite the differences in scale of groups of figures. The images are cut off, particularly at the top and bottom,

leaving no idea of a world above or beyond the church-yard and river. Despite the well-developed preliminary drawing a few alterations in the composition are clearly visible as brushmarks under the paint surface, such as those around the heads of the girls who are being held by their hair (fig.133).

Spencer did not varnish *The Resurrection, Cookham*. The surface retains the variations in gloss and impasto that the artist left.[14] Some areas are strongly brushmarked but in general the paint is not excessively thick, which is not surprising on a work of this size. Mostly it is matt with some gloss in the darker areas where Spencer has applied more medium or retouching varnish to wet the surface. Some areas of green in particular are dry and remain unconsolidated (underbound). The difficulty of protecting such a large surface from the accumulation of dirt has not yet been entirely solved. Repeated surface cleaning of underbound surfaces is not advisable. The greens appeared soapy when cleaned with water and this suggests that this pigment could have included stearates. Analysis reveals that they contain many extenders, typical of inferior grades of artists' paint or household paint. Spencer claims not to have tampered with his paint, simply to have purchased and used artists' oil paint unmodified. There seems to be no reason to doubt his word in general since his paintings do not suggest an experimental approach and therefore any problems with the green may be a result of its formulation.

Andrew Causey observes that 'even now it is not altogether easy to look back across the thirties and appreciate how precisely this strange picture satisfied the taste of its time ... it had a quirkish individuality which has often found favour with English taste'. Perhaps this is because, as Mary Chamot has pointed out, Spencer's paintings 'magnify reality rather than accommodating themselves to conventions'.[15]

Pigment analysis was carried out in 1997 by Dr Joyce Townsend using optical microscopy and EDX.

PART II
Paintings on Panel or Board

BRITISH SCHOOL
An Allegory of Man 1596 or after

RICA JONES

The painting is an allegory of Christian faith, depicting Man at the centre being assailed by the vanities and temptations of the world. Above him, Christ the Saviour and a heavenly host offer salvation.[1] It is on an oak panel composed of three vertical boards of unequal width, held together with animal glue at butt joins. The grain of the wood runs vertically. Each board is about 9 mm thick and the perimeter edge of the panel is bevelled at the back. Some time in the past the join between the left and central boards failed and had to be reset. Now both joins and an old vertical crack in the bottom of the left board are reinforced at the back with wooden buttons, which are

fig.134 The back of the panel showing modern oak buttons reinforcing both joins and an old split, and the marks of an earlier set

replacing earlier ones (fig.134). Examination and dating of the boards by analysis of their tree-rings (dendrochronology) was carried out in 1997. The oak is of Baltic origin, which is in keeping with the practice of the times, its straighter grain compared to English being preferable for paintings; there was a thriving import trade in it.[2] The earliest felling date of these boards is 1588, though some time during the first half of the 1590s is more likely. An allowance of two years' minimum for seasoning gives us a probable earliest dating of around 1596 for the painting.

This discovery proved very surprising in relation to the style and subject of the image. From its similarity to works by the Netherlandish artist, Hans Eworth, who worked in England from about 1549 to about 1574, it had previously been placed tentatively in the 1570s. Comparison with a signed painting by Eworth (fig.136) shows several stylistic similarities.[3] The disparity between the style and the date might be attributable to England's largely conservative artistic taste, with the interesting corollary that Eworth would appear to have left behind him a significant school or studio, whose work maintained a recognisable standard some twenty years after he had apparently ceased to paint there. Alternatively, however, the picture may be a copy from the 1590s or later of an original from the 1570s. This plausible interpretation by Karen Hearn depends principally on the lady's costume, an elaborate gown of a style fashionable around 1567–9.[4] Being a symbol of gluttony, sloth and lechery, the lady surely would be wearing the latest style in order to reinforce the emblematic point and modish dress in the 1590s was very different from this.

The joined panel was first prepared with a white priming composed of chalk bound in animal glue, possibly one derived from fish. The painting gives us very few clues about its evolution on the prepared panel. Hardly any linear underdrawing is visible with either the binocular microscope or with infra-red reflectography. Templates existed for the multiple production of portraits,[5] for example, and, if the painting were an example of a retro-

fig.135 *An Allegory of Man*, oil and oil-and-resin on oak panel 67.3 × 52.3
(26½ × 20⅝). After restoration at the Tate Gallery in 1995. T05729

DVM STERTVNT FATVÆ MEDIA DE NOCTE, PVELLÆ. VOX SONAT E CŒLO, SVRGITE, SPONSVS ADEST.
PRVDENTES, QVARVM RVTILA LVX LAMPADE FVLGET, OCCVRRVNT HILARES, ET COMITANTVR EVM.
PANDITVR EXCELSI, SVBLIMIS IANVA CŒLI, ET SVBEVNT SVMMI, SPLENDIDA TECTA DEI,
ACCVRRVNT FATVÆ, SED IANVA CLAVDITVR ILLIS, QVI SAPIT IS SEMPER LAMPADE LVMEN HABET.

fig.136 Hans Eworth, *Allegory of the Wise and Foolish Virgins* (1570), oil on panel (Statens Museum for Kunst, Copenhagen)

spective style being produced in a studio, one might expect their use here. The evidence would be in the form of dotted lines from 'pouncing' or continuous lines from tracing. But apart from a line of drawing off-set from the final painted one in the archer's arm and what might be three marker dots and a drawing line in the profile of the lady's face, all visible in infra-red reflectography, and what might be a trace of black drawing in a cross-section taken from the devil's flesh tones, no preparatory design is visible. Yet the putti, for example, are not painted on top of the sky but directly on to the ground in the same phase as the clouds, which would argue for a detailed preconception of their positioning. Again this seems to indicate that the painting is a copy.

Some of the cross-sections show the presence of thin underpainting in some areas. The once-green landscape behind the lady and in the grass at her feet (fig.137) were first painted with opaque, light green mixtures containing lead white, azurite and yellow ochre. After this paint had dried it was glazed over with the brilliant, translucent green, copper resinate. It must have looked jewel-like and

very beautiful. Now, however, its brown hues belie the vista; the paint has discoloured permanently as a result of exposure to light. The brown cave-like area behind the skeleton has a thin, pale grey, slightly gritty-looking underpaint, which appears to be present beneath the black inscription also. The figures of Christ and the putti appear to have been sketched in first very thinly with pale grey paint, which has lead white as its principal component. The visible colours were mixed on the palette and applied mainly wet-in-wet to the panel. Details such as lettering, highlights and embroidery were then applied on top, as were the glazes of lake in the shadows of the angel's robe and in the scrolled banner next to Christ. The yellow sky is lead-tin yellow and the bluish grey areas contain lead white, black and smalt. The putti were made from mixtures of lead white with some earth pigments, red lake, ivory or bone black and vermilion. Only lead white and an organic lake appear in the angel's flesh tones. Down in the terrestrial regions the lady's petticoat consists of ochres with ivory or bone black, the detailing applied on top in lead white and lead-tin yellow. Vermil-

fig.137 Detail of the discoloured grass and foliage. The top layers
of copper resinate have turned brown, leaving the solid green
underpainting beneath them as the only source of green
colouration in the landscape

fig.138 The painting in 1995 after removal of varnish and all old
restorations. Paint losses associated with old splitting and damage at
the corners show as white patches, where they have been filled ready
for retouching. Old abrasion in the sky is most visible in the clouds
and putti on the left. Patchiness behind the skeleton is caused by the
small circular losses of paint

fig.139 Detail of the circular paint losses near the skeleton before restoration. Both layers of paint have fallen off, allowing the ground to show through. Photographed by Angela Geary through the binocular microscope at × 30 magnification

ion appears in all the flesh tones in this region and in the lettering around Man and is mixed with red lake for the archer's sleeves. The dark brown, shadowy areas behind the skeleton contain ivory or bone black and vermilion. Apart from the discoloured green area, the black inscription and the brown behind the skeleton, which are all in a resinous or oleo-resinous medium, the painting appears to be painted in linseed oil.

For an English panel painting of this period, *An Allegory* is in reasonably good condition, though it has suffered as a result of external and internal factors (fig.138). Apart from the old splits and the discoloured green, two areas have suffered noticeable change. The grey clouds and all the putti have been overcleaned in the past, leaving the paint looking worn in places and lacking in subtlety. No other part of the picture has been so badly affected. The cross-sections indicate that the absorbent ground has leached out a lot of the oil from this area, resulting in a weakened paint film, more vulnerable to cleaning action than the thick, lead-rich yellow around Christ, where the presence of so much lead has produced a strong paint. The second type of damage is of internal origin and has affected the shady region behind the skeleton and the

black inscription; the paint has developed a rash of very small, circular eruptions in the black and the underpaint, allowing the ground to show through (fig.139). This phenomenon is found fairly often in dark passages on sixteenth- and seventeenth-century panel paintings. While we do not know the exact cause, it seems likely that the catalyst is strong sunlight, the dark areas of necessity absorbing more heat than the lighter tones. After the painting was treated at the Tate in 1995 (in order to remove a varnish of soluble nylon which had been applied before the painting was acquired), these damaged areas were retouched locally to reduce the appearance of wear. The painting was varnished with non-yellowing, synthetic resins.

Preparation and some analysis of the cross-sections were carried out in 1995 by Angela Geary when she treated and restored the painting. Microscopical examination of the painting was done by Angela Geary and Rica Jones. Analysis of the pigments was done with optical microscopy by Dr Joyce Townsend and Rica Jones and with EDX by Townsend. Dr Marianne Odlyha of Birkbeck College analysed the binding media in the paint and ground layers with FTIR. Dr Sarah Vallance of the University of Northumbria at Newcastle analysed the ground with HPLC. Dendrochronology was done by Dr Peter Klein of Hamburg University.

— 22 —

SIR JOSHUA REYNOLDS (1723–1792)
George IV when Prince of Wales 1785

RICA JONES

The painting is on a mahogany panel. Mahogany became popular for furniture in England early in the reign of George II, being imported from Cuba and the West Indies, but was seldom used for paintings during the eighteenth century. It did not become fashionable to paint on mahogany until the early decades of the nineteenth century.[1] Yet, as a tropical hardwood, it is much less likely to warp and split than oak, thus making an admirable solid surface to paint on, and its dimensional stability must have been long known to the makers of furniture. The whole concept of finished paintings on panel must have seemed archaic to most artists and patrons during the eighteenth century and examples are few; Canaletto did at least two paintings on mahogany panel during his stay in London between 1746 and 1755 and George Stubbs, never a slave to convention, began using wooden panels (mainly of oak) in the late 1760s, perhaps initially as trial paintings for his enamelled works on copper.[2] He continued off and on into the 1780s and perhaps it was his example that inspired other artists to try painting on solid supports. Wright of Derby did a few landscapes on wood during the 1780s but, ironically given the prevailing history of panels, there was no general move towards reinstating them for portraiture, the practical advantages of canvas presumably being too deeply engrained. 'The smooth surface [of panels] is not calculated for expedition', observed Wright in 1792.[3]

So, is it noteworthy to find Reynolds using a wooden support for a royal portrait in 1785? Panels are rare in his finished paintings and may have some slight symbolic value. It is tempting to imagine him using panel for the wayward, pleasure-loving Prince of Wales as a wry conceit, linking his sitter to a distant period when the self-indulgence of princes was well established and inclined to get out of hand; but he painted several portraits of the Prince on canvas around this time and it is therefore more likely that the terms of reference are set within his own practice. In about 1780 he had painted two portraits on panel for presentation to the Royal Academy, one of its

Treasurer, Sir William Chambers, the other the Self Portrait in Doctoral Robes, which has been noted as being painted 'in the manner of Rembrandt'.[4] The use of panel in these paintings, as in George IV when Prince of Wales, is probably a deliberate continuation of the stylistic reference to Rembrandt. The three-quarter profile of the head and shoulders seen in George IV is one found frequently in Rembrandt's œuvre.

Analysis of the paint from several areas of the picture revealed that the binding medium is a mixture of beeswax and a natural resin, probably mastic. Some oil is present but in barely detectable quantities. Fig.142, a cross-section through the jacket viewed in ultra-violet light, shows the wax-resin mixture as a milky fluorescence in both layers of paint. Reynolds may have been using wax in paintings some years before the first reference appears in his technical notes, for a portrait of Kitty Fisher in 1766/7 (the notes date from 1766).[5] Interest in wax as a binding medium was very much part of the spirit of antiquarianism that flourished in the eighteenth century, fuelled by such enterprises as the excavation of Herculaneum, begun in 1738; the speculation about the methods and materials used to create the wall paintings found there centred on a reference in Pliny that the ancients painted with 'burned-in wax'.[6] The first literary discourses on wax as a painting material appeared in French around the mid-century, most notably in the Comte de Caylus's Mémoire sur la peinture à l'encaustique et sur la peinture à la cire.[7] It was published in 1755 and there was a partial translation into English by J.H. Müntz in 1760.[8] Reynolds may have become aware of the growing discussion on wax in painting during his sojourn in Italy from 1750 to 52 or during the return journey through France later that year; but until more of his paintings from the early 1750s are analysed, Caylus's book must remain the strongest candidate as the source of his waxy media.

The first part of the book describes experiments with encaustic painting, that is, with heated wax as the only significant binder. The method Caylus found most

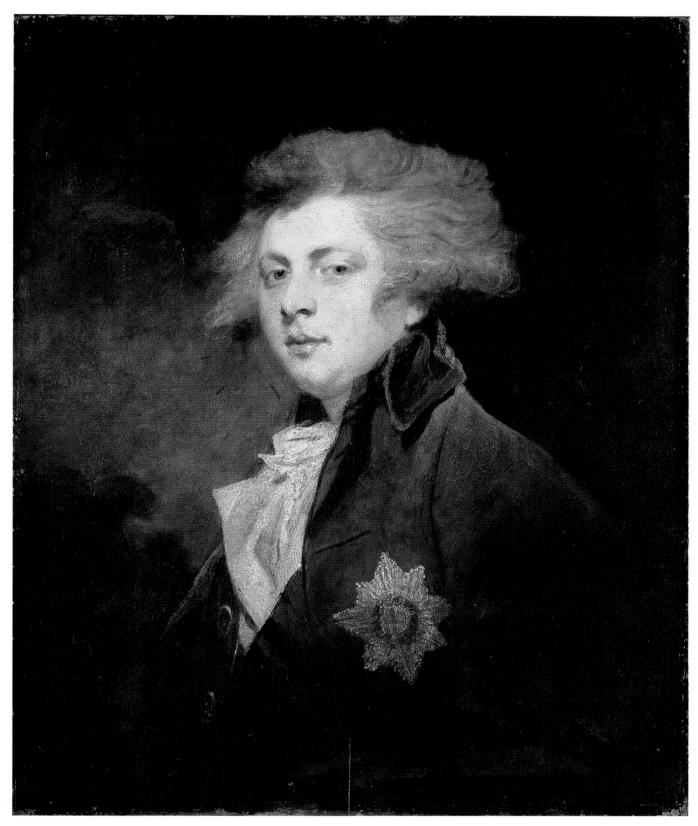

fig.140 *George IV when Prince of Wales*, beeswax and mastic resin with
traces of oil on mahogany panel 75.7 × 61.7 × 1.5 (29⅞ × 24⁵⁄₁₆ × ⅝).
The discoloured varnish makes the blue jacket appear green. N00890

fig.141 Cross-section from the bottom edge at a crack in the centre of the panel, showing the blue coat with its original scarlet colour underneath. In 1785 the *Morning Herald*, discussing a portrait of the Prince of Wales by Reynolds, noted that 'The drapery of this portrait, while it stood in Sir Joshua's gallery, consisted of a scarlet great coat. The artist has in consequence of an intimation given in the *Herald* a few weeks since, changed it to a close dress, which is, no doubt, an improvement.'[9] Sample photographed at × 250 magnification

fig.142 The same cross-section photographed at × 250 magnification in ultra-violet light. The wax-resinous medium can be seen as the milky fluorescence surrounding the pigments and there are two layers of brightly fluorescing varnish on top. The right edge of the sample lay on the edge of the crack in the panel; the varnish flowing over this area cannot, therefore, be original. The vertical cracks in the varnish occur all over the surface

fig.143 Top edge of the panel where the paint thins out to expose the wood, showing superimposed layers and a very thin white ground in the grain. Photographed at × 12 magnification

successful was as follows: rub the front of the support with wax until the whole surface is covered with a thin, even film. Then rub fine chalk or whiting into the waxed surface. Paint on to this with pigments ground in plain or lightly gummed water. When the painting is finished, take it to the fire and gradually warm it up until the wax infuses itself into the colours, thus fixing them and producing an attractive, matt and very stable surface.[10] In the second part he describes methods of painting with wax, that is using a cold, wax-based paint applied more conventionally. His recommended binders vary according to different pigments and are made from either mastic or pre-heated amber resin dissolved in turpentine and mixed with beeswax and a little boiled olive oil. Combined with dry pigment, they are to be applied with brushes to supports prepared with several coats of unpigmented wax dissolved in turpentine or with one of the varnishes used in the paint medium. Although Caylus prefers encaustic, he admits that all the artists he has consulted about his experiments prefer the second method. He lists its desirable properties: it is uniformly matt, may be varnished with egg white or with mastic in alcohol, may be retouched with colours prepared in the recommended varnishes, is itself suitable for restoring old paintings, is easily integrated into a picture being painted over a period of time, and, over nine or ten months' assessment of the samples, alters less than oil paint.[11] Müntz does not describe this technique of painting with wax at all, con-

centrating instead on his own modifications to the methods of encaustic painting. In his introduction he makes a reference to Reynolds: 'I am not self-conceited, or foolish enough to believe that Rynolds or Ransey, Scott or Lambert, etc. etc. will take up at once and prefer my new system to that they practised for many years with success and applause – they and every body else may try',[12] but there is no reason to believe he was in touch with Reynolds. There is a degree of name dropping in the book; for example, despite the title, *Count Caylus's Method of Painting*, fewer than 10 out of 139 pages refer directly to Caylus's work, the rest being about Müntz's, which probably, indirectly, gives us an indication of how well Caylus's name was known in England.

The analytical results indicate that Reynolds used a technique similar to Caylus's second method in this painting, possibly incorporating aspects of encaustic in the preparation of the panel. Fig.143 shows the paint where it thins out just before reaching the top edge. Between the layers of coloured paint and the bare wood beneath them is a very thin, streaky white layer which might be white wax (or perhaps wax treated with chalk) rubbed into the grain of the mahogany. This is the only hint of an overall preparation in the painting; nothing resembling a ground of normal thickness emerged from any of the cross-sections. A minimal preparation would be consistent with another of his paintings in which a principal ingredient of the binder has been found to be beeswax, *Mrs Hartley as a*

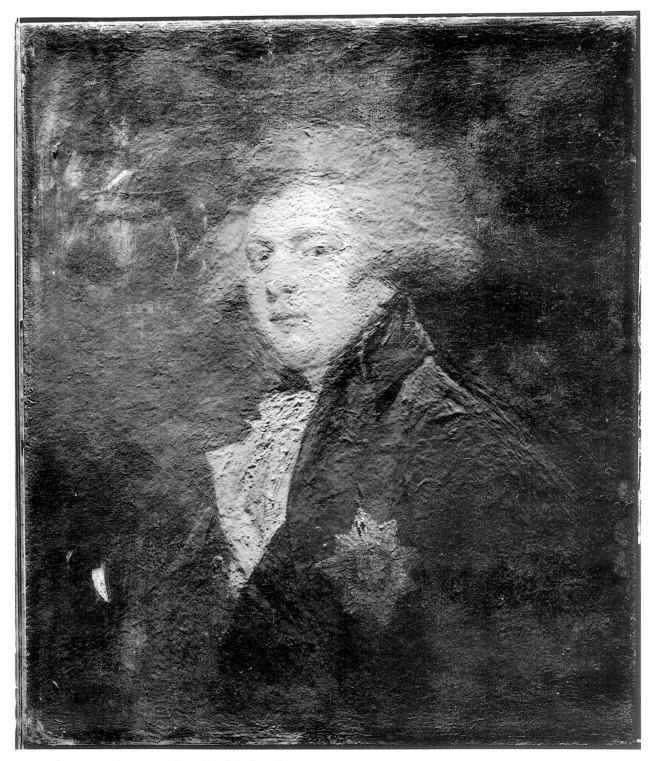

fig.144 The painting photographed in raking light from the top to show the different textures within it. Old flaking of paint in his left cheek has been treated in the past, perhaps flattening the impasto slightly, but otherwise the surface topography is as Reynolds intended it, a rare survival in his otherwise much-altered œuvre. Note how few drying cracks are present; in this respect wax resin appears to be a very stable medium

Nymph (the support is canvas).[13] His technical notes contain several references to painting with wax on unprimed canvas, for example this entry dated May 1770: 'My own Picture Canvas unprimed – Cera – finito con vernicio [Wax – finished with varnish],[14] and it is interesting that George Stubbs, when he painted with mixtures of beeswax and natural resin on panel, appears not to have applied a conventional ground either.[15]

Fig.144 shows the textures achieved as Reynolds built up the painting. Although it has not been possible to sample from the face (there being no significant, unrestored damages), very close examination with a binocular microscope suggests that he might have used his well-tried method of laying down a white opaque couch of paint and then working it up with thin scumbles and glazes of colour to produce the features (see pages 60–5). Talley notes that one of Reynolds's sitters reported that 'Sir Joshua dabbed on a quantity of stuff, laid the Picture on its back, shook it about like a batter pudding, and then painted away'.[16] Comparison with the x-radiograph (fig.145) indicates that the face contains a significant proportion of chalk as well as lead white, as it has very little density compared to the shirt-front, which is composed of pure lead white. Elsewhere the structure varies: the blue jacket seems straightforward enough – opaque, tonal mixtures of Prussian blue worked into one another on top of the red; fig.143 shows the complexity of structure at the top left edge.

'Damn him, how various he is!',[17] Gainsborough is reported to have said of his great rival, referring to the enormous invention Reynolds applied to the iconography of portraiture, but the same could be said of him as a technician. No two areas of one painting can be assumed to be composed of similar materials, let alone two whole pictures, and this has made restoration of his work in general particularly hazardous. The examination of this painting, sponsored by the Getty Grant Program, was designed principally to establish the feasibility of removing the varnish. As shown in fig.142, the paint is covered by at least two thick layers of natural resin varnish separated by a layer of dirt. This coating is now very brown and is also shot through with a dense network of sharp cracks (fig.143), which scatter the light, making the discoloured varnish appear hazy and even more noticeable

fig.145 X-radiograph. The white blotches in the face are the blobs of sealing-wax holding a label on the back and the figures relate to the numbering of the x-ray plates. The bold, diagonal streaks are in a layer of brown paint applied to the back of the panel. The 'dabbing' effect in the face and hair is typical of his work, regardless of the medium

in general viewing. No part of the varnish is original, since in cross-section it can be seen to lie on top of old damage (fig.142). Tests are under way to reduce its thickness, removal being very unlikely given the high solubility of the waxy paint, but the exercise is complicated by the network of cracks in the varnish, which allows easy penetration by any cleaning-agent. It may be then, that, with the methods of cleaning currently available, this painting has to be left as it is.

Identification of the medium was done by Dr Jaap Boon and Jos Pureveen of the FOM-AMOLF, Amsterdam, in 1997 using DTMS. Examination of the painting and its cross-sections was done by Arabella Davies, Rica Jones and Dr Joyce Townsend, who also analysed the pigments with EDX.

— 23 —

JAMES ABBOTT McNEILL WHISTLER (1834–1903)
Nocturne in Blue-Green 1871

STEPHEN HACKNEY AND JOYCE TOWNSEND

This example of Whistler's Thames Nocturnes, *Nocturne in Blue-Green*, was labelled 'Nocturne Blue and Green' in Whistler's hand, and is a moonlight scene.[1] It differs from *Nocturne in Blue and Silver: Cremorne Lights* by being on a tropical hardwood, probably mahogany, panel. Tropical hardwoods have a very fine grain, and when they are primed thinly they provide a support with less texture than a canvas primed in the same way. On the reverse this panel was lightly primed with grey oil paint, then scraped down, a proceeding which would protect the panel against changes in relative humidity. Whistler bought panels and commercially prepared, white-primed canvases from a variety of colourmen, both English and French, and some of his grounds were prepared by the Greaves brothers. In some of his earlier works Whistler applied his own ground colour on top of a commercial priming. Walter Greaves prepared a range of lean distemper grounds from which Whistler selected his ground colour, just as carefully as he selected fine old papers for his etchings or colour washes for his interior designs. His later grounds were more consistently dark grey.

Nocturne in Blue-Green is one of the few nocturnes or harmonies of this decade for which Whistler selected a panel support. Most importantly, over the light commercially applied priming there is a dark grey oil ground applied by the artist. In other respects the painting process would have been very similar to *Nocturne in Blue and Silver: Cremorne Lights*, except that the dark buildings on the wharf of *Nocturne in Blue-Green* are not painted in but are essentially exposed ground (fig.148)

This is an extremely economical way of producing an image and the painting could certainly have been completed in a very short time (fig.146). Indeed the main activity would have been preparing the sauce, as Whistler called his medium, on the palette. Along the edges of the panel, finger marks are visible in the paint where the artist touched the wet painting presumably when placing it flat to dry. When these two paintings are compared it is noticeable that the brushmarks are more apparent on *Nocturne in Blue-Green*. Despite being a mixture of lead white and ivory black, where it is exposed it contrasts with the blue, thus the grey ground appears warm coloured. In contrast, the pale blue over the dark ground is cool in hue. This is an example of the turbid medium effect: blue light, which has a short wavelength, is scattered more than longer-wavelength red light by the paint medium. When the ground is dark, neither red nor blue light is reflected strongly from it, and the surface colour is perceived as blue from the scattered light. A white ground would allow the red light to be reflected back to the viewer as well, swamping the scattered blue light, and giving the appearance of a warm-toned paint surface. Blue paint over a dark ground thus looks a cooler blue than it ever could over a white ground.

There are two basic colours of sauce in this work: the darker blue scumble applied over the background and foreground and the lighter colour over the sky and midground. The darker colour was applied first, followed shortly after by the lighter blue. Variations in thickness and merging of the layers provide most of the image. Hence, the harmony was created by tonal variations on a single hue based on a mixture of Prussian blue and ultra-

fig.146 Whistler sketching in a boat on the Thames by Walter Greaves

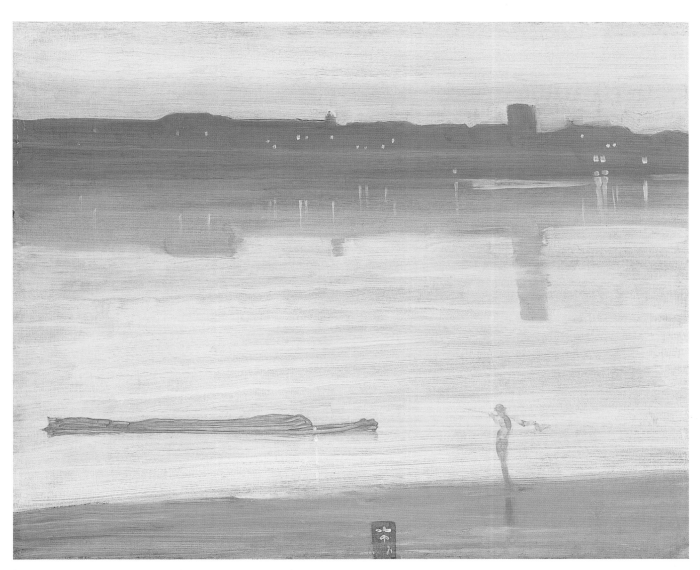

fig.147 *Nocturne in Blue-Green*, oil and mastic resin on tropical
hardwood panel 50.2 × 59.1 (20 × 23) T01571

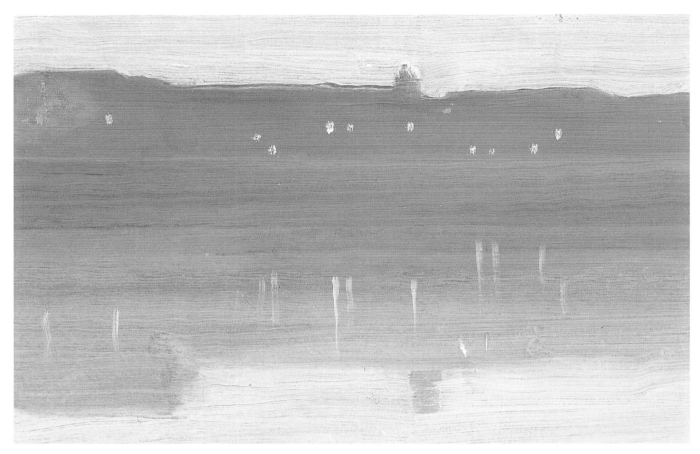

fig.148 Detail of brushmarks and visible ground used for wharves

marine. The barge, lights and signature were applied on top of the sauce a little later, when the paint was partly dried and less easily disturbed. A stiff short-bristled brush was used for the barge, forcing paint to its edges to produce a very stylised result. A thin glaze layer, unusual for Whistler, was applied to the shore in the foreground, and for the figure. This is now relatively yellow in hue. Except for this added glaze, by preparing his palette with hues mixed from the same range of pigments and by exploiting the unifying effect of the dark ground Whistler has created a harmony. Whistler's consistency in choosing pigments for harmonies and nocturnes is hardly surprising. He himself described his 'symphonies' as 'the complete results of harmonies obtained by employing the infinite tones and variations of a limited number of colours'.[2]

Whistler's paint medium is of great interest. It is evident that he used a very liquid medium for both nocturnes, his sauce. Sometimes the medium dripped off the canvas to such a degree that the panel or canvas had to be laid flat.[3] Such drips can be seen on the edges of this panel. According to Walter Greaves, he used linseed oil and turpentine as the medium for both paint and ground, and a mixture of copal and mastic resins with turpentine, by implication for the sauce.[4] Copal resin tends to make paint look glossy, not a characteristic of much of Whistler's work, and it was not found during detailed analysis, which did, however, show the presence of a network of heat-bodied oil (stand oil), a lead drier, mastic and a second oil type. The second oil would have come from the tube paint which Whistler mixed into the sauce. It is known that in 1881–2 Whistler was purchasing linseed oil and both light and dark drying oil.[5] The amount of lead drier must have been small, because the paint does not show major drying defects. From the appearance of his nocturnes there must have been a thinner such as turpentine as well: this also figured in his purchases of 1881–2.[6]

Changes in appearance have occurred on many of his

works, and minor adjustments to compositions are now evident. Significantly, most nocturnes have become darker and cooler, as the thin paint has increased in transparency over the dark ground. Similarly, his small sketches with medium-toned grounds have lost contrast in the mid-tones. His earlier, more thickly painted and decoratively colourful work on light grounds, although flawed in detail, has preserved its appearance much better and now can be more readily appreciated than his dark ground sketches.

Cross-sections confirm that the medium of both paint and artist's ground has darkened in many of his paintings. It has been suggested that Whistler experimented with unusual paint thinners such as petroleum, which could well have improved short-term handling properties, but not the long-term tendency of the paint to yellow. Petroleum-based products were available in Britain by the mid-1850s. However, there is no evidence for any British artist using them until they were incorporated in artists' tube paints in Germany in about 1887, when the colourman Schönfeld of Düsseldorf was advertising them for sale.[7] Whistler bought tube paints from the firm – they survive

fig.149 Whistler's table palette

fig.150 Whistler's painting materials
(Hunterian Art Gallery, Glasgow)

fig.151 Detail of the frame, designed by Whistler

in the archive at the Hunterian Art Gallery. It seems unlikely that Whistler used petroleum spirits for the nocturnes, since Sickert wrote a letter to Whistler, recommending him to try petroleum much later, in 1885.[8] A drying defect which may be caused by a thinner can be seen in some of the lights and their reflections in *Nocturne in Blue-Green: Chelsea*, where the paint has formed a surface texture reminiscent of orange peel.

One of Whistler's 'palettes' is now in the Tate Gallery Archive (fig.149). It provided a surface for mixing and storing colours, and was designed to fit on a table. A similar example was described by the Pennells as being in use in 1886,[9] and another was described by Menpes.[10] It consists of a flat mahogany-type base the size of a writing desk, with 'pigeon-holes' or 'ink-wells' of various sizes arranged in a row round three sides. The flat middle area could have held a flat palette or a selection of fairly long brushes. Whistler's butterfly signature is painted on this surface. Regrettably, there is no other paint on the palette! The Pennells also described a palette 'with raised edges to keep the liquid colour from running off',[11] which would have been necessary for the painting of *Nocturne in Blue-Green: Chelsea*. Paint which had been successfully mixed was kept under water, so that Whistler could continue with it on another day.[12]

Several other Whistler palettes are now in the Hunterian Art Gallery, University of Glasgow, with a selection of tube paints (fig.150), all presumed to date from the end of his life. They have been analysed for this study.[13] Whistler's paintbox in the Pennell Collection of the Library of Congress, Washington DC, containing thirty-four tubes of paint has been analysed by others. In the case of the nocturnes, the range of pigments for a given painting is quite restricted and carefully chosen.

Whistler had a lifelong interest in frames. He designed and painted a frame for this nocturne, with a painted flat set within reeded mouldings (fig.151). The basic design, with reeded mouldings but no flat, is known to this day as a 'Whistler frame'. The reeded mouldings were oil-gilded with a warm reddish gold applied to a white gesso, while the background of the flats looked cooler because it was gilded over a transparent dark brown material. The pattern of fish-scales, each scale made from three curving lines, was then painted on in greyish paint mixed from Prussian blue and lead white. The flats have since been regilded and repainted, either by Whistler or according to his instructions, and presumably the original design was copied faithfully. The blue paint was greyer than that on other Whistler-designed frames from this decade which are now at the Tate Gallery. Whistler would have chosen the colour to complement the moonlit scene in *Nocturne in Blue-Green: Chelsea*. The paint on the flat has now discoloured, and looks more brown than blue.

DTMS analysis was carried out by Dr Jaap Boon of FOM-AMOLF. Pigment analysis with optical microscopy and EDX was done by Dr Joyce Townsend. Information from the Roberson Archive is published by permission of the Syndics of the Fitzwilliam Museum. Elizabeth West Fitzhugh of the Freer Gallery of Art made the report on Whistler's pigments available.

BEN NICHOLSON (1894–1982)
1935 (white relief) 1935

ANNETTE KING

Ben Nicholson's 1930s *white reliefs* developed out of a passionate commitment to modernity and abstraction which had begun with his first abstract painting in 1923. He had experimented with the liberation of colour and form from the constraints of representational painting, at first applying different colours to a recognisable form until eventually he could 'discard altogether the forms of even the simplest objects as a basis and work out ideas not only in free colour, but also in free form'.[1] Nicholson's work in relief began in earnest in 1933. It was, he claimed, an accidental breakthrough, although there is no mention of the accident in letters to Hepworth at the time of the first relief.[2] The accidental nature of the breakthrough may be nothing more than a colourful, retrospective narrative. He had begun experimenting with incised lines as a means of creating contrast and as an alternative to the juxtaposition of dark and light. He claimed he was following his usual practice of incising the surface, but, at the intersection of two lines, a chip fell out. He began to exploit the accident and found himself working in relief (fig.152).

Accidental or not, the development was also a natural progression. Nicholson had been inspired by the 'free

poetic' reliefs of Arp, by Giacometti's sculptures and by Calder's mobiles. He and Hepworth had already been experimenting with linocuts and an increasingly sculptural approach had opened up new possibilities for the liberation of colour and form. According to Henry Moore, who lived close to Nicholson and Hepworth in Hampstead, 'It may have been that having a few sculptors around indirectly prompted him to translate the Mondrian influence into carving, but he has always been a very good craftsman and to do that kind of thing would have been a quite natural direction.'[3]

The first white reliefs were carved freehand, echoing the interest in natural forms shown by Moore and Hepworth. However, Nicholson soon began to regularise his compositions by using ruler and compass. Proportion began to play an increasingly important role, and frequently the principal elements were located in either a calculated or intuitive way on the Golden Section. His aim in *1935 (white relief)* was, in his own words, to create 'space. The awareness of it is felt subconsciously and it is useless to approach it intellectually as this, so far from helping, only acts as a barrier.'[4]

Nicholson created the relief from two panels. An inscription on the reverse in Nicholson's own hand confirms that it is 'carved in mahogany and mounted on ply'. The carved panel is made from a mahogany table top which Nicholson bought in Camden Town and brought home on the no.24 bus. The 2.2 cm thick mahogany panel was cut to size along the right vertical edge as evidenced by striations from a saw (fig.154). It has at least five different levels carved into its surface, all clearly defined, apparently precise geometric shapes fixed in relation to one another, yet in motion with changing shadows and the play of light.

This work is significant in that it marks a transition between freely drawn organic forms and more mechanical geometrical shapes. In a letter to the Tate Gallery Nicholson wrote that one of the circles was drawn by hand and the other using compasses.[5] This is evident

fig.152 Ben Nicholson's hands smoothing the painted surface of a white relief with a razor blade. A similar technique to that employed in *1935 (white relief)*

fig.153 *1935 (white relief)*, oil on carved mahogany, mounted on plywood: mahogany panel 80.4 × 146.7 (31¾ × 57¾), plywood backboard 101.6 × 166.5 (41¾ × 65½). The overall dimensions of the ply backboard correspond to the Golden Section ratio of 8:13, i.e. height to width. T00049

fig.154 Detail viewed from the right-hand side showing striations along the edge of the carved mahogany panel where it has been cut down with a saw. The depth of the mahogany panel (2.2 cm) and the height of the lowest step (1.3 cm) correspond approximately to the Golden Section ratio of 8:13

fig.155 *1935 (whtie relief)* in raking light from the left. This shows the changing character of the work in different lighting conditions and the texture of its surface, with its prominent brushstrokes and pits from 'rubbing down' with a razor blade

upon close inspection, the right-hand circle being slightly elliptical and irregular in comparison to the left. Both circles are nevertheless carved out with extreme dexterity, the sides remaining absolutely vertical with a clean 90° angle at the base of the wall. The straight lines were plotted with a ruler and the carving was carried out with sculpting tools from the studio and fine-tuned with a razor blade (fig.155).

The link with sculpture and architecture meant that the creation of space was of paramount interest to Nicholson. The reliefs were a means of playing out his 'poetic idea' in more geometrical form. He describes this development:

At first the circles were freely drawn and the structure loose with accidental textures, later I valued more the direct contact that could be obtained by flat planes of colour made and controlled to an exact pitch and the greater tension obtainable by the use of true circles and rectangles – the superficial appeal became less, but the impact of the idea more direct and therefore more powerful. The geometrical forms often used by abstract artists do not indicate, as has been thought a conscious and intellectual mathematical approach – a square or a circle in art are nothing in themselves and are alive only in the instinctive and inspirational use an artist can make of them in expressing a poetic idea.[6]

The painting process began once the mahogany panel was mounted on to the plywood backing. This was done with steel screws from the reverse, avoiding the vicinity of the circles. Nicholson wanted to negate the concept of a surface coating and create colour which 'runs right through the material and comes out the other side'.[7] The surface of the work has a lively texture in raking light, showing not only sweeping brushstrokes, following the contours of the circles and straight lines, but also small pits and grooves in the layers beneath. Wilhelmina Barns-Graham describes Nicholson's technique in a letter:

I remember well Ben called me in to see the 1935 White Relief, of a single square and circle I had so much admired, and remember him standing with hands on his hips saying 'You wouldn't guess how many coats are on THAT'! & I said 4 or 5?' & he replied '4 or 5? there are numerous coats, put on and rubbed down – when quite firm and dry and then rubbed down – again and repeated again and again' – 'But – I inquired – 'how do you get them so dry & white?'

'I use the best flat white (& I think he said no oil – & I am under the impression he inferred it was undercoat …
P.S. I omitted to mention Ben used razor blades as part of the process of rubbing down.[8]

Nicholson appears to have used a stiff hogshair brush and to have employed a similar rubbing down technique between layers in this work. On the reverse of the panel Nicholson has written '(final coat of white FLAT RIPOLIN)' (fig.156). Ripolin was a trade name for a French household paint, much used in the first half of this century by artists including Picasso. Nicholson had visited the studios of Paris artists such as Picasso and Braque, and it is possibly under their influence that he chose this particular make of paint as he could see the effects it was able to achieve (fig.157). Christopher Wood may also have introduced Nicholson to Ripolin, as he had close contact with Picasso. The reference to 'no oil' presumably means no additional oil added to the paint mixture to make paint more transparent and glossy.

The medium of the paint used by Nicholson is oil. The 'final coat' referred to is the 1935 coat, but Nicholson repainted the work in 1955 when it was acquired by the Tate Gallery directly from him. In a letter received by the Tate on 1 September 1955 Nicholson writes: 'I have been giving coats of white to the relief – it takes time as each coat has to dry hard but it should be ready soon.'[9] The final 1955 coat was applied between 1 September and another letter dated 15 September, when he tells Norman Reid that, 'The White Relief is being despatched to you today' but that 'it is not "hard-dry" yet (indeed I suppose it will not be really hard-dry for several months)'.[10]

In 1935 Ripolin would have been based on thickened oil. By 1955 alkyd resins were commonly used in household paint, but no traces were found in the samples from this painting. Possible reasons for their absence are that either the manufacturer was very slow to adopt alkyds, or that Nicholson used an old tin of paint for the 1955 repaint. When sealed, oil can remain fresh for many years. The paint is composed of a mixture of white pigments, predominantly lithopone with kaolin, chalk and talc extenders. These components are common in household paint such as Ripolin.

The fact that Nicholson repainted the panel twenty years after its completion demonstrates his continuing interest in the welfare of his works. Framing was an issue about which he felt particularly strongly:

fig.156 Detail of the reverse with inscriptions by Ben Nicholson.
The line on the right-hand side is the shaft of an arrow added by the
artist to show the orientation

If a painting is worked out within the terms of its
medium then its edge, the outside edge of the form
on which it is painted or worked has a vital
importance … the entire form of a painting must be
considered just as the entire form of a sculpture has
to be considered.[11]

Nicholson sets out in very definite terms the form that
frames for his works should take:

I have always considered the frame which surrounds
a work of mine as a vital part of its presentation.
Therefore, I have always seen to the framing of my
work myself …
1. Frames should be made of natural wood with
little graining and of a colour which is not too hot,
nor too yellow, and which is not stained or
varnished.
2. The corners of the frame should not be mitred
diagonally. The four sides should abutt each other,

aligned so that the top side extends over the left-side
vertical and that the right-side vertical rises so as to
extend over the side of the top lateral. Similarly, the
left-side vertical is to extend across the end of the
bottom lateral while the bottom lateral is to extend
across the end of the right-side vertical.[12]

The frame around *1935 (white relief)* also dates from 1955.
Nicholson wrote to Norman Reid in 1955:

I found that it was better to get the carpenter to
make a new frame out of what I feel is a nice-looking
wood – the right colour and texture for the relief –
I hope you will like it. Planing off the paint on the
old frame could have revealed wood that is not
satisfactory and the slightly glazed raw wood seems
to me altogether more satisfactory than the p[ain]ted
wood.[13]

In the same letter he wrote, 'I think in that greasy, dirty, London atmosphere it should be glazed (it is intended to be glazed) – really with that new *non-reflecting (perspex?)* material which is now used in the USA.'

He took a passionate interest in the conditions in which a painting was kept and decreed that 'the wooden white reliefs should *never travel* … In these days of flying anyone who's interested can *come to the Tate* & large works travelling tend to become injured – & in the USA the glasses are *frequently removed* – if perspex is used then this should not be removed from any work of mine large or small.'[14] This decree may be the result of experience as his paintings certainly travelled frequently all over the world, before this statement was issued. There is an exhibition stamp on the reverse of this panel in two places: 'San Francisco Bay Exposition, San Francisco, Cal. U.S.A.' These were the sponsors of the Golden Gate International Exposition in 1939, at which *1935 (white relief)* was exhibited and did not return to England until after the war.[15]

The *white reliefs* were Ben Nicholson's principal contribution to the modern movement in Britain. Nicholson's use of pure white for the reliefs was in keeping with modern ideas. The constructivist movement, in which he was a leading participant, sought to establish unity in painting, sculpture, architecture and life, observing in all areas of life and nature a series of common forms. It was an era of slum clearance and the encouragement of health and cleanliness.[16] It has been noted that during this period white had become a symbol of the new. But it was Kandinsky who described white as 'a symbol of a world from which all colour as a definite attribute has disappeared'[17] – a world where colour, or rather its absence, joins forms together instead of separating them. White was pregnant with possibilities because it was unifying, capable of being nothing and everything and Nicholson's use of white in the reliefs was consistent with his personal theology: .

fig.157 Ben Nicholson in 1969, with a pot of white Ripolin commercial paint on his workbench, the same make as used for *1935 (white relief)*

As I see it, painting and religious experience are the same thing, and what we are all searching for is the understanding and realisation of infinity – an ideal which is complete, with no beginning, no end and therefore giving to all things for all time.[18]

Dr Tom Learner analysed the paint medium with Py-GC-MS. Pigment analysis was carried out by Dr Joyce Townsend with optical microscopy and EDX

— 25 —

ALFRED WALLIS (1855–1942)
Wreck of the Alba c.1938–40

MARY BUSTIN

In the stormy winter of 1938, Porthmeor Beach, St Ives, witnessed one of the most dramatic wrecks of this century when a Panamanian steamer, the 3,700 ton *Alba* ran aground in heavy seas. St Ives's lifeboat, the *Caroline Parsons*, was launched and the Hungarian crew of twenty-three was taken off. As the lifeboat 'rounded the bow of the wreck on the return journey, a huge wave struck her broadside on', capsizing the lifeboat, throwing the men into the water, and tossing the craft on to the Island. 'Hundreds of St. Ives people scrambled over dangerous rocks to help the men'[1] with the result that the majority of the mariners were saved.

For several months the *Alba* lay 'firmly embedded in the sand, her stern in the grip of the rocks at the Island head'.[2] She was abandoned to the Cornish Marine Salvage Company, which had the task of dismantling the great ship. By October much of the wreck had gone (fig.158). It had drawn numerous sightseers. Among these would have been Alfred Wallis, then in his eighty-third year, who lived nearby in Back Road West. He painted several versions of the wreck from memory at the table in his cottage. For this, the most painterly of these narrative pictures, he selected a long rectangular board to accommodate the span of the tragedy.

As a former 'Dealer in Marine Stores' (fig.159), or rag-and-bone man, Wallis continued the ethos of recycling materials when he took up painting at the age of 67. He derived his supports from a wide variety of sources including artists, his grocer Mr Baughan, and a friend Joe Burrell, who sold decorator's materials. His favoured support was cardboard. This could be had in a wide variety of colours and surfaces, which enabled him to extend the range of his technique.[3] Joe Burrell recalled in the 1960s: 'Course we used to give him lots of cardboard and 3-ply there weren't no hardboard in them days. He had lots of tea boxes.'[4]

The 4 mm thick, three-ply wood panel used for *Wreck of the Alba* was probably originally the lid of a box or shipping container. In the 1930s plywood boxes were

fig.158 The engine block of the *Alba* can still be seen. During the exceptionally low tides of 1996, the wreck once again drew sightseers. At high tide, it becomes useful to surfers for the 'boiler effect'

fig.159 St Ives harbour *c.*1900. Alfred Wallis's Marine Stores were on the far side of the harbour. Wallis had been a mariner until his early thirties, after which he set up his salvage business in St Ives. He made a reasonable living, buying and selling scrap – iron, rope, sails, and odds and ends, until the crash of the fishing industry in St Ives brought an end to his business just before the first world war. He took up painting in 1922 when his wife died

fig.160 *Wreck of the Alba*, oil on plywood 37.7 × 68 (14⅞ × 26⅞).
Porthmeor Beach lies to the left of the 'Island', a neck of land that
juts out into St Ives Bay. Godrevy Lighthouse, whose lamp was too
weak to guide the *Alba* to safety, is depicted top right. T06871

becoming increasingly popular for the transportation of a wide variety of goods, three-ply birch being a common material. Construction depended upon the nature and weight of the commodity but in general comprised sheets of plywood strengthened by battens. The earliest boxes were tea chests and rubber chests but these had a standard size of 48 × 48 × 61 cm[5] unlike the board used for *Wreck of the Alba* which was originally 38 × 67 cm but has now shrunk slightly, and expanded in thickness at the edges from 4 to 8 mm.

By the time he started to paint, the panel had been stripped of its battens, leaving only the nails around the perimeter, the tails of which were hammered flat on the

fig.161 Alfred Wallis painting on a board at the table in his cottage in the 1930s. In his left hand he holds a second brush. Nearby are two tins of paint

back. There were two holes at the top, possibly for a rope handle. The edges were feathered and worn; the wood had split into 'checks' (short vertical splits running parallel with the uppermost grain of the ply) and the nails had rusted. He made no attempt to cut down the board, extract the nails, or fill the holes.

Most of Wallis's supports are unprimed despite visual interference from printed words on the cardboard. *Wreck of the Alba* is unusual in that it has a grey ground; possibly applied before Wallis received the board. The grey paint is based on chalk or barytes, tinted with ivory black and a reddish brown ochre. Its thinness and dull surface resemble a decorator's undercoat. The paint was applied over the whole surface, including nails, a discontinuous layer of black paint, wax drips, splintered edges and reverse. This 'undercoat' served to 'prime' the plywood, which, if it had been used in a weathered state would have been very porous or 'thirsty'; it sealed the wood and created a semi-absorbent surface on which to paint.

Stories of Wallis's exclusive use of ready-mixed, household paint or ships' paint rather than the 'muck they [artists] use'[6] were perpetuated by Ben Nicholson. He recalled that Wallis asked specifically for 'enamels', sixpence each.[7] Artist's oil paint has been found in *The Blue Ship*, but not in *Wreck of the Alba*. Household paint is a complex balance of pigments, extenders, oils, driers and sometimes natural or synthetic resins that are formulated by the manufacturer to create particular flow, covering power and drying times suitable for the home decorator. Hard gloss paint or 'enamel' is more fluid, more glossy, and faster drying than artist's paint, which is paste-like on expulsion from the tube. On his chosen surface of absorbent card, or, in this case, a lean undercoat, household paint would be absorbed initially then become glossier with successive coats. The first application could be tighter, and subsequent coats, looser and more mobile.

Christopher Wood wrote to Winifred Nicholson of Wallis: 'both he and Picasso mix their colours on box lids!'[8] In fact this mixing was probably as minimal as adjusting the amount of paint on the brush, for the cross-sections reveal well-dispersed pigments in a matrix indicative of machine-ground paint rather than the irregular mixing generated on an artist's palette. The whites exhibit a complex balance of pigments. For instance, zinc, titanium and antimony whites with small amounts of kaolin extenders have been identified in the surf. Combinations of white pigments are used by commercial

fig.162 The sea. Stipple brushmarks imitate sea spray over the grey undercoat

manufacturers to tailor the handling characteristics and longevity of the paint: zinc oxide adjusts the elasticity of the dry film, titanium improves the hiding power and the resistance to impurities in the air and antimony is used for its fineness and opacity which make it suitable for full gloss paint.[9]

With the board propped up on a table (fig.161), Wallis first established the position and bulk of the ship in pencil then in black gloss paint. He selected specific pre-mixed colours from the local decorators' shop, to match the colours that he observed around him, for example, the reddish brown Cornish earth and vivid green grass studded with black granite rocks of the Island. Texture is created by the variety of brushstrokes: stippling and dabs for the rocks and grass, sleek alla prima strokes for the bulk of buildings and ships, while the sea has a multitude of smooth undulating lines and short pulled touches of a well-laden brush.

With a subject calling for a range of sea moods, including forty-foot waves, Wallis was in his element. His unfettered observation of the changeable colours of the sea in St Ives Bay that shift from white, grey and pale green to intense greenish blues were captured in paint. 'Wallis could stir up his paint into a boiling, frothy substance to suggest a storm. It could be as thick as cement, as sharp as scythes flailing up over a boat's prow or brown and sluggish as beer.'[10] His choice of paint was critical to his ability to depict the sea. Aware of the drying time of his

paint, which could be as fast as a few hours, he formed the sea with trailing sinuous strokes leading in a rhythmic flow across the board. Initially the paint was applied thinly; its transparency allowing the dabs to be built up into shifting pale green and ochre shades. It dried fast so neighbouring brushstrokes barely intermix.

With staccato movements of the brush, he dabbed breakers into the image, flicking up the brush to leave tufts of hair trails that imitate the spray of the surf. By subtly altering the white each time, he distinguished each wave from its neighbour. The method may have been as simple as to dip his brush into both white and grey pots to charge it. By restrained action of the brush, he created an incomplete mixing of the two colours to form watery swirls of microscopic detail (fig.162). By slanting his board, he could encourage the paint to flow into languid drips to imitate the crest of a wave.

When water whips up into a stormy sea, the waves pick up the sand making the sea boil with a brown frothy texture. The effect is captured in paint in *Wreck of the Alba*, whether intentionally or fortuitously is unclear, it being dependent upon the disparate drying time of two layers. Fast-drying cream-coloured paint was painted over tacky white dabs. The top coat slumped slightly but dried relatively quickly, forming contraction crackle as it shrank on losing its solvent, and split into minute islands. The thicker the white paint beneath, the worse the drying cracks with the result that the large waves sweeping into

fig.163 Brushmarks replicate the crash of surf over the decks of the
steamer. A band of unfaded chrome yellow is visible along the edge.
Brown lumps in the sand are friable clumps of nicotine

St Ives Bay in the lower right form wide spume, as do the waves pouring over the deck and those forced on to the beach.

Household paint is not designed for permanence of colour, with the result that *Wreck of the Alba* has altered in the sixty years since it was painted. Exposure to light has accelerated ageing of both the oil/resin medium and a pigment. The medium has darkened, shifting the whites down a tone, and the chrome yellow in the sand has turned brown (fig.163). Unusual ingredients have been found in his paintings, from the accidental – a flea caught in the paint on *Schooner under the Moon* (Margaret Mellis gave a graphic description of the infestation she found in Wallis's cottage in 1942),[11] to the deliberate – nicotine found in the sand paint on *Wreck of the Alba*. This flaky brown substance, caught in pockets in the paint, which imbues the sand with a rough, crackled texture, could be a spillage of tobacco employed to advantage. George Farrell recollected that Wallis 'smoked a pipe. Black Twist! Fly Killer!'.[12]

Wallis varied the marks made by his brush as far as the tool would permit. While the steamer heading in from the top left corner is densely painted in black gloss paint using a well-charged brush, the masts are more delicate, being added in light touches of a scruffy uneven-haired brush so that the paint skips across the surface as the artist's hand moves slowly, shaking slightly as he controls the strokes. Joe Burrell recalled that 'he'd only buy the little cheap camel hair brushes, you know, you can't press on them or anything'.[13] Camel hair brushes were so named for Camel, a nineteenth-century brushmaker who was secretive about the exact blend of hair in his brushes.

Today they are commonly a mixture of squirrel and pony or other less expensive cylindrical hairs.[14] The poorer grades do not form a fine point, and Wallis would not have found fine detail easy with these brushes because the hairs fork when full of paint. The finest lines he could achieve are 5 mm wide. For more subtlety in line and shade, he resorted to the pencil: here an uncommonly hard grade for him. In the chapel, which Wallis has amalgamated with the Coastguards' hut, the simple building was painted roughly in sand colour with accents of dark blue for the door and windows. Wallis then tightened the lines using a pencil. The paint had half-dried when he added the amendments: the subtle shadow at the front steps, and toning for the wall on the left, scribbling lines to form a dense pale shadow, disturbing the paint slightly. The mast also is drawn in pencil on top of partially dry sea paint using a fairly hard grade of graphite.

Wallis signed his painting in the top left corner on a remaining scrap of grey ground. When he thought the painting was dry, he protected it with newspaper, remnants of which are stuck to the top right corner. The first owner of *Wreck of the Alba* recalled visiting Wallis on 7 May 1940, one of the annual spring show days when most St Ives artists opened their studios to the public in anticipation of submitting their work to the Royal Academy summer show. He found *Wreck of the Alba* with *Brown Schooner*[15] propped outside the artist's cottage in Back Road West. He bought them both.

Pigments were analysed in 1995 by Dr Joyce Townsend using EDX. Dr Tom Learner analysed the nicotine in the binding medium in 1995 using FTIR.

EDWARD WADSWORTH (1889–1949)

Bronze Ballet 1940

ROY PERRY

When Edward Wadsworth presented *Bronze Ballet* to the Tate Gallery in 1942, he wrote to the then Director, John Rothenstein 'it is painted with yolk of egg (and powder colour) on a gessoed panel and was painted in April and May 1940 at Maresfield, Sussex – to the somewhat noisy accompaniment, as far as I can remember, of the bombardment of Abbeville, Boulogne and Calais – all mingled with the call of the cuckoo! It is one of a series of many paintings done as a Le Havre series, it is in no sense a topographical view of any particular scene but all the motifs or design elements are to be found in that part and the two jetties "place" it more or less …'.[1] This was his second version of the composition. He had painted a slightly larger, more complex version during March and April 1940, which he sold to Sir Arthur Bliss and which is now in the collection of Eastbourne Art Gallery.

Wadsworth was highly critical of his own work. He was dismayed at the Tate's acquisition, by bequest, of an experimental still life painting, made to instruct Pierre Roy in tempera. This prompted him to offer *Bronze Ballet* as an exchange for it. He wrote to Rothenstein in 1942 about the still life: 'If I were in your position, in charge of the Tate, I should secretly destroy it – and with great enthusiasm! In these days of fuel economy it is only fit to contribute to the central heating of the Tate!' The Tate accepted *Bronze Ballet* but did not destroy the still life. However, Wadsworth was satisfied that he could 'look the Tate in the face once more!'.[2]

Wadsworth adopted pure egg tempera as his painting medium in *c*.1923–4 having used commercially produced tempera paints, made from an emulsion of egg and oil, since 1922. His first practical experience of the medium was probably in 1912–13, when he worked as an assistant to Roger Fry on the restoration of the Mantegna cartoons at Hampton Court Palace that were retouched in tempera. Wadsworth's dedication to his craft is revealed in his correspondence, between 1929 and 1949, with Maxwell Armfield, who was equally obsessed with the craft of egg tempera painting.[3] He admired Armfield's *A Manual of*

Egg Tempera Painting,[4] but it was to Cennino Cennini's *Il Libro dell'Arte*, available in several translations, that he repeatedly returned for guidance. His wife told John Rothenstein: 'As for Cennino Cennini's treatise he read it again and again – he was always reading it.'[5] Although Wadsworth's technique is profoundly indebted to the practice recorded by Cennini in late fourteenth-century Italy, it is also very much a part of the first half of the twentieth century in his use of modern materials from his choice of panels to pigments.

Wadsworth's attention to detail began with his panels, which he prepared himself. In place of traditional timber panels, he chose to paint on plywood for its stability and strength. Laminating layers of wood has been practised since the ancient Egyptians. However, it was not until towards the end of the nineteenth century that sheets of plywood were produced on an industrial scale for the manufacture of tea chests and furniture. The common form of plywood is made from three veneers of equal thickness cemented together under pressure with the grain of the two face veneers at right angles to the core veneer. Thicker boards have five, seven or more plies. Waterproof cements based on synthetic resins came into use during the 1930s, replacing those made from natural glues. A type of thick plywood, called Laminboard, even less prone to warping, was developed during the first decades of the twentieth century. The thick core of Laminboard is sawn from a block made from timber slats or rotary cut veneers cemented together. The core is faced with thinner, rotary cut veneers, with their grain direction set at right angles to the grain of the core (fig.165).[6] Wadsworth used ½ inch (12 mm) thick Laminboard, with a ¼ inch (6 mm) core and ⅛ inch (3 mm) face veneers for *Bronze Ballet*. The panel has retained a flat plane for more than fifty-five years, although he did not add any supporting battens or seal the back.

The preparation of the panel for painting follows Wadworth's well-tried procedures (fig.166) which he ummarised in an inscription on the back of *Dunkerque*

fig.164 *Bronze Ballet*, egg tempera on plywood panel
63.5 × 76.2 (25 × 30) N05380

fig.165 The construction of Laminboard

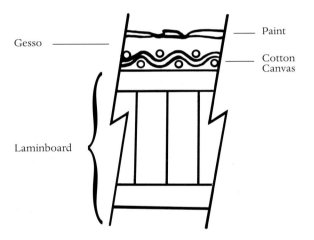

Paint

Gesso

Cotton
Canvas

Laminboard

fig.166 Diagram showing the structure of
Bronze Ballet

painted in 1924 – 'Size, cover it over with linen, stick with size and gesso surface – white gesso 2 or 3 coats'. Size is a dilute solution of glue prepared from the gelatinous parts of animal waste dissolved in hot water and applied in a warm, fluid state. The best grades are made from skins and often sold as 'rabbit-skin' glue. After sealing the panel with size, a canvas was glued down over the whole face of the panel, folded around the sides and neatly trimmed off at the back edge. The fabric used for *Bronze Ballet* is an open, plain-weave, cotton canvas rather than a linen. It provides a good mechanical key to hold the layers of gesso and prevents any splitting in the veneer from penetrating into the priming and paint. This is important with plywood. Rotary cut veneers are prone to developing fine, superficial splits along the grain, called checks. A few are visible on the back of the panel. They result from the internal stresses induced by flattening the veneer from its natural curved shape which is produced as the veneer is sliced from the rotating log.

Wadsworth made his gesso by mixing pure chalk into a warm solution of size. The gesso is prepared to a creamy consistency, free of air bubbles, and applied warm. This has to be done carefully but swiftly to achieve an even layer, free of defects, before the gesso cools and sets. The first layer was worked well into the surface of the canvas and remains visible around the sides of the panel where no further layers were applied. The face of the panel was then coated with further layers of gesso, brushed on to underlying layers that had set but not dried. The canvas texture was totally obliterated. It was then allowed to dry for a day or two. Wadsworth, like the early Italians, would sometimes expose his panels to sunlight and fresh air to speed the process.[7] After drying, the surface of the gesso was smoothed by scraping but traces of the final horizontal brushstrokes in the gesso remain visible.

The composition was carefully drawn on the gessoed panel with graphite pencil and then fixed. A working drawing exists for *Bronze Ballet* in the Middlesborough Museum and Art Gallery. Marks, typical of those left by thumb tacks, are visible beneath the paint in each corner, which could have held a cartoon in position for tracing. To fix the drawing Wadsworth was in the habit of washing over the panel with dilute egg. In a letter to Armfield of 14 August 1942 he wrote of going 'over the panel with dilute egg wash (which fixes the drawing and makes the gesso rather more amenable)' after tracing the cartoon.[8]

Although Wadsworth experimented with emulsions of oil in egg and water, he stated that the majority of his

tempera paintings after 1924 are in 'egg-egg-egg and nothing but egg'.[9] Pure egg tempera technique consists of grinding pigment powder into water to form a paste and mixing (tempering) the paste with a medium of hen's egg yolk thinned with water, during painting. In her biography of Wadsworth, his daughter Barbara Wadsworth recalled how as a child she would help prepare the pigments, mixing them with water with a palette knife on a sheet of plate glass (fig.167).[10] Wadsworth selected his pigments for their permanence as well as their colour, using the traditional pigments of early Italian tempera paintings and more recent additions to the range of artist's pigments, e.g. zinc white, viridian, cadmium yellows and pthalocyanine blue and colours used by potters such as black oxide of cobalt and Potter's coral. Analysis of the blue sky of *Bronze Ballet* revealed that the predominant cerulean blue was pre-mixed with white extenders of low to moderate refractive index, such as barytes and kaolin and a small proportion of natural ultramarine (lapis lazuli) had also been added.

Barbara Wadsworth recalled his consummate skill in separating the yolk from the white of the egg when preparing the medium.[11] To free the yolk in its sac from any contamination by the egg white, he transferred it from one hand to the other, repeatedly wiping the palms of his hands on his trousers until 'not a smear of white' remained on the yolk. Once this had been done, the sac would be pierced and the fluid yolk run into a container to be thinned with water. Egg yolk is a complex emulsion of oils and proteins in water intended to nourish the growing embryo. It makes a suitable binder for paint because when dried it forms a stable, adhesive and water-resistant film. It dries initially by loss of water which allows the oily components to coalesce. They continue to harden over a long time as larger molecular structures are formed by crosslinking. Because egg yolk is only about 50 per cent water, it requires the addition of more water to produce a paint with sufficient fluidity to manipulate. It can be thinned considerably and still form a viable film. Judging the correct proportion of egg medium required for each pigment is at the heart of the craft of tempera painting. Too little egg in the medium and the colour will rub off while too much produces a paint impossible to handle. The hand-mixed quality of the paint is visible on *Bronze Ballet* in the granular clusters of pigment in some colours and broken craters left by burst air bubbles in a few of the more viscous brushstrokes.

At the period *Bronze Ballet* was painted, Wadsworth was

fig.167 Wadsworth mixing his egg tempera paints

making extensive use of diagonal, crosshatching developed from his pointillist technique of the late 1930s. Wadsworth developed the painting in stages, moving from one area to another at each stage of completion. After completing the outline drawing, the initial paint layers were applied in thin washes and open hatching. Each part was then gradually built up, layer by layer, with increasingly precise hatching and occasional washes, using soft pointed brushes, such as sables. His brushwork is never mechanical. It is vigorous and sinuous, changing in direction and density to draw the planes and enliven the surface (fig.168). The technique of egg tempera allows for repeated overpainting, without disrupting earlier work. Each brushstroke remains undisturbed. This produces a dense accumulation of small brushstrokes, as in the sky. The rhythmic crosshatching in the sky becomes tighter towards the horizon, its vertical emphasis contrasting with the agitated, horizontal hatching of the narrow ribbon of sea. Wadsworth used other methods to achieve particular effects, such as the reflected lights on the curves of the propellers in shadow. He scratched through the initial red paint into the white gesso below, then rubbed over the area with a steel blue tint. The blue is worked into the scored surface to produce the sense of a cool, diffuse light.

Wadsworth applied his paint in clear, pre-mixed

fig.168 Wadsworth's use of hatching to produce
an optical mix of colours to describe forms and
enliven the surface of the painting

colours, whether containing a single pigment or complex mixture. The colours were not blended on the painting. He produced his subtle modulations of hue and tone by creating optical mixtures. Different coloured strokes of paint are juxtaposed in a pointillist manner; as in the combination of blues with delicate touches of cream, ochre and crimson in the crosshatching of the sky. The viewer perceives the optical mix of colours at a distance while still remaining aware of the brushstrokes.

The vibrant colouring of the strong, midday shadows cast by the propellers is perhaps the boldest optical effect in the painting. Wadsworth covered a broken layer of dull green brushstrokes with a translucent wash of rust red. Glazing over the green with the complementary colour of the red blackens the green brushstrokes while producing a fiery sparkle in the gaps between them (fig.168).

The carefully designed composition, delight in maritime motifs and attention to technique of *Bronze Ballet* are hallmarks of Wadsworth's tempera paintings. In egg tempera he discovered the medium perfectly suited to his temperament, finding within the confines of the craft the inspiration to refine his art.

Pigment analysis by EDX and optical microscopy was carried out by Dr Joyce Townsend. Protein analysis of the priming by HPLC was carried out by Dr Brian Singer of the University of Northumbria at Newcastle.

— 27 —

FRANCIS BACON (1909–1992)
Three Studies for Figures at the Base of a Crucifixion c.1944

STEPHEN HACKNEY

Bacon received no formal training in painting, and indeed virtually no formal education at all, but his art had a long gestation period. During the thirties he made a living as a furniture designer and in 1933 and 1937 had some critical success as a painter. Little of his early work survives since Bacon destroyed much of it. It was not until 1944 that Bacon was sufficiently satisfied with his work and in a position to submit paintings for exhibition (in 1945). *Three Studies for Figures at the Base of a Crucifixion* established his reputation. Instead of suggesting the new spirit of optimism that existed in some quarters at the end of the war, this powerful work rekindled thoughts of anguish and horror, addressing painful aspects of the human condition. It derived from Bacon's own difficult life and contained many of the elements that were to characterise his subsequent paintings.[1] Towards the end of his life in 1988, he painted a second larger version, now in the Tate Gallery (each panel 198 × 147.5 cm).

Talking in interviews with David Sylvester between 1962 and 1979, Bacon described his attitudes and working methods.[2] These relate more to his later more fluid work but provide valuable insights into the man who created *Three Studies for Figures at the Base of a Crucifixion*. He described his great interest in photographs and stills from movie films and how he used them to establish images in his mind. In this case the original image was of figures from the crucifixion transformed into Eumenides (*Erinnyes* or Furies). This work is not *the* Crucifixion but a crucifixion and in that sense Bacon implies a personal, even mundane, tragedy. He considered it close to self-portraiture. Each figure is isolated in its own space, on a separate panel, the space behind is simply depicted with a few painted lines. Although the vivid cadmium orange colour of the background and their size unite the panels, there is no continuity of space or narrative. Bacon was emphatic in his intention not to tell a story nor to be illustrative. Instead, his paintings represent his response to images in his head suggested by his experience.

In conversation, he explained his view on the purpose

fig.169 General view of triptych *Three Studies for Figures at the Base of a Crucifixion*: (a) left panel; (b) middle panel; (c) right panel, triptych in oil on Sundeala compressed wood fibreboard, each panel 97 × 74 (37 × 29) N06171

of painting. Recognising the predominance of mechanical methods of recording, such as film, camera and tape recorder, he thought the role of painting to be something more basic and fundamental. 'Where you unlock the areas of feeling which lead to a deeper sense of the reality of the image, where you attempt to make the construction by which this thing will be caught raw and alive'.[3] He went on to observe that 'What has never yet been analysed is why this particular way of painting is more poignant than illustration ... Why some paint comes across directly onto the nervous system and other paint tells you the story in a long diatribe through the brain'.[4]

In describing one such struggle he said, 'I used a very big brush and a great deal of paint and I put this on very freely and I simply didn't know in the end what I was doing and suddenly this thing clicked, and became exactly like this image I was trying to record. But not out of any conscious will, nor was it anything to do with illustrational painting.'[5] But it 'probably only happen(s) in oil paint, because it is so subtle that one tone, one piece of paint, that moves one thing into another completely changes the implications of the image'. Sometimes this leads to 'a moment of magic to coagulate colour and form so that it gets the equivalent of appearance'. On other occasions 'it disappears completely and the canvas becomes completely clogged, and there's too much paint on it ... and one can't go on'.[6]

Bacon's description of his tortured act of painting, then, does not suggest the possibility of conscious decisions about technique. Indeed, while painting he deliberately freed himself of such constraints. Yet to do so an artist must have established some basic working methods and, through practice, have some highly developed skills, not least of which is the ability to recognise a successful outcome. While painting *Three Studies for Figures at the Base of a Crucifixion* Bacon was developing such methods and defining an approach to painting that recurs consistently in his later works. He talked of working in other ways and even contemplated making sculpture, noting the sculptural forms in *Three Studies for Figures at the Base of a Crucifixion*, but remained committed to painting.

As soon as he could afford to, Bacon painted on canvas. In 1947–8, while reusing an old canvas, he resorted to painting on the back and discovered that he preferred the absorbency of the unprimed back of the canvas. This raw surface was a more sympathetic starting-point; it became his working method to stretch his commercially primed canvas back to front on the stretcher and to paint directly

on the canvas. However, *Three Studies for Figures at the Base of a Crucifixion* is painted on ¼ inch (6 mm) fibreboard, a material that is thicker and softer than hardboard or Masonite, called Sundeala Board. This board was popular with artists in the forties at a time when canvas was in short supply. It is rough and absorbent, but unlike canvas resists the pressure of the brush. Bacon noted that it held pastel well. The background of *Three Studies for Figures at the Base of a Crucifixion* is thicker than his later normal practice and extremely lean. Bacon has applied layers of lean oil paint, and possibly other lean media, which have soaked into the absorbent support. The brittle and underbound film that results is very fragile and the cracks that have appeared in it would surely have been much more serious on a flexible canvas support. Bacon's later work on canvas is therefore very different in this respect.

In painting the main images of the Furies Bacon worked directly on the support, drawing with a pastel and a paint brush. He used artists' oil paint, without the addition of more medium or varnish and frequently straight from the tube, well diluted with turpentine and brushed on to the absorbent support. He has also used unbound media on top of his paint, reworking and redrawing the images, for example in the hair of the left figure. This appears to be pastel. Unfortunately analysis of such a lean medium as pastel is not easy at present particularly in combination with lean oil paint.

The ambiguous figures, part human and part beast, were influenced by surrealist images of the thirties, particularly those of Picasso.[7] Bacon was exploring such figures in several surviving works which are precursors of

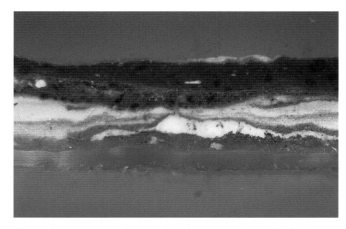

fig.170 Cross-section, photographed at × 125 in ultra-violet light shows much reworking of paint wet-in-wet in the area sampled (the wrap in the left panel)

this triptych.[8] In a sense, implied in the title, the triptych remains a study that has reached a certain stage of resolution. One earlier study, *Figure Getting out of a Car*, based on an image of Hitler, contains elements developed in the central and right panels.[9] It was photographed during painting, then in its final state. Bacon has placed this figure in complex surroundings with spiky foliage in the foreground reminiscent of the work of Graham Sutherland. Another study (fig.171, *Study for a Figure at the Base of a Crucifixion* (1943–4), also on Sundeala board and the same dimensions as the Tate panels, relates directly to the right panel. But cross-sections reveal many alterations and repainting of the background. Bacon must have been dissatisfied with this overworked background and the flowers in the mouth of the Fury, and therefore started another study which became the present version of the right panel. The background colour in this version is a slightly lighter orange than the two other triptych panels and in contrast to the earlier study the black lines are placed in a premeditated reserve in the orange. There are also changes to the Fury: the ribs are drawn over the white in the earlier study but in the triptych they are drawn in first, and the legs and black shadow have been altered. The evolution of the right panel demonstrates the artist's struggle to capture an extraordinary image in his head and to represent it in a satisfactory way. It shows the deliberate introduction of new forms that were eventually rejected and the modification of the remaining image of the Fury. The final version is more confidently executed but lacks some of the struggle that is evident in the earlier studies.

A similar struggle took place on the other panels, some of which is still visible through the paint films and by infra-red light. Numerous changes to the backgrounds and some modification of the positions of the Furies are evident (fig.170). In the central panel around the rear of the Fury are small tulip-like shapes that have been overpainted. Within the receding screen-like forms there are further examples of obliterated distant vegetation. The pedestal legs below the figure merge into a seemingly unresolved curved shape to the right. Here the paint is at its thinnest and underdrawing in charcoal or pastel is visible (fig.172).

The left panel has the most obvious examples of unfixed pastel on the surface. In the background, particularly to the right of the Fury, there are brown patches of surface discoloration on the orange. These are more evident now than in older photographs. The paint film is

fig.171 *Study for a Figure at the Base of a Crucifixion* (1943–4) oil and Sundeala board (private collection), an earlier version of the right panel showing a stage in the development of the Fury

fig.172 Detail of the centre panel. The barely resolved legs of the figure are indicated by painting round the drawn shape and leaving the support largely uncovered

largely cadmium orange, but in the brown patches it includes vermilion which can darken when it is not well bound in a medium. The eventual resolution of the problem of the background in this work by simplification of the space became incorporated in Bacon's methods. In later works his backgrounds, although important in setting the context for the figures and their actions, technically are often a minimal identification of the space around the figure with no insignificant detail. In addition, the panel and painted frameworks that surround the figures further define their space. Backgrounds are frequently painted thinly and relatively evenly perhaps using well-diluted oil paint or, in some later works, artists' acrylic paint. They normally did not involve the intense working methods associated with his figures, but they might be completely changed during painting. In making a triptych he would work on each panel separately with the canvases upright until they had reached a certain advanced stage, then he would lay out his panels across the room to work on them together.

In later works his application of paint was in every sense expressive. He delighted in the subtlety and malleability of his medium.[10] He manipulated the paint, throwing it by hand, using a rag and scrubbing brushes, and even sweeping brushes. He impregnated rags with paint to create a network of colour across the image and used all sorts of other practices to disrupt the painting surface. 'You don't know how the hopelessness in one's working will make one just take paint and just do almost anything to get out of the formula of making a kind of illustrative image – I mean, I just wipe it all over with a rag or use a brush or rub it with something or anything or throw turpentine and paint and everything else onto the

thing to try to break the willed articulation of the image, so that the image will grow, as it were, spontaneously and within its own structure, and not my structure.'[11]

For Bacon painting was an intense and private activity. In some cases he could not leave his paintings alone and was glad when people took them away.[12] He felt there were very few people who could help with their criticism and therefore in painting and, most importantly, settling on the final image he was alone. Even when painting portraits of friends he thought that working from photographs and other images was easier than having their presence in the room.[13]

His work was never varnished. The surface incorporated all the chance accidents and alterations that his painting had suffered. In parts it remains matt, for instance, in the background of *Three Studies for Figures at the Base of a Crucifixion* where the paint was applied well diluted over pastel and an absorbent ground, and elsewhere it may be thick and glossy, where paint has accumulated by frequent reworking. This is important to retain. Bacon often chose a bright gold frame for his finished work, with each panel of his triptychs framed separately. The frames on this triptych were probably chosen by the artist.[14] Instead of varnishing, to protect their surface Bacon glazed his works either with glass or acrylic sheeting. He did not like the reflections but noticed that the glass helped to unify the paintings and also created a distance between the onlooker and the work. He looked forward to glass which did not reflect.

Pigment analysis by optical microscopy and EDX was carried out by Dr Joyce Townsend.

PETER LANYON (1918–1964)
Zennor Storm 1958

ROY PERRY

Peter Lanyon was born in St Ives, Cornwall, in 1918 and lived there for most of his life. Lanyon's painting is an empirical response to his native landscape while also reflecting the influence of avant-garde artists working in Cornwall and his contact with the abstract expressionists in the USA during the 1950s.

He spoke eloquently of his approach to painting in a talk, 'Landscape Coast Journey and Painting', given in 1959, a year after *Zennor Storm* was painted. He said 'painting is much more an evocation of experience, an emergence rather than a statement, a revelation more than an art. There is no right or wrong way to paint. I merely state my preference for painting as being a re-creation of experience in immediacy, a process of being, made now.'[1]

Zennor Storm exemplifies this 'evocation of experience' in paint (fig.173). His wife, Sheila Lanyon, believes that the storm referred to in the title may have been over Carn Galva, a hill close by to Zennor.[2] The painting is not a recognisable portrait of a location made from one viewpoint at one point in time, but re-creates Lanyon's experiences during the storm. It was not painted directly from nature but in recollection, working in the garage of his home, Little Park Owles, at Carbis Bay, St Ives, which served as his studio (fig.174).

fig.173 Lanyon at work (undated)

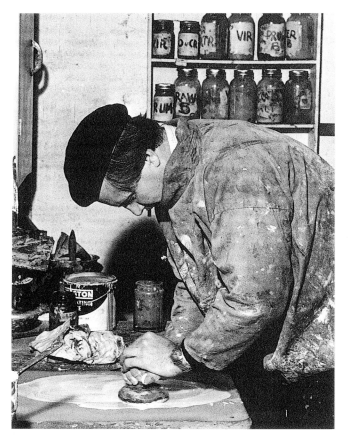

fig.174 Peter Lanyon grinding his paints in the garage that served as his studio at Little Park Owles *c.*1951–2

fig.175 *Zennor Storm*, oil on hardboard panel
121.9 × 182.9 (48 × 72) T03209

Although he describes the process of painting as 'an emergence', Lanyon did not hold the view that the image was somehow inherent in the materials waiting to be revealed by the artist. He said 'the revelation is a result not of the material but of the intention of the artist ... I don't believe there is any truth in materials.'[3] He believed that the particular properties of materials which are used to create the image are chosen by the artist not dictated by the material.

His careful choice of materials and techniques, from the preparation of his supports to the application of paint, evolved over many years. As with most of his paintings of 1958, the support for *Zennor Storm* is a standard hardboard panel, 4 × 6 ft (121.9 × 182.9 cm) and ³⁄₁₆ inch (4 mm) thick. Like many other artists working in Cornwall and elsewhere, Lanyon habitually used hardboard as a painting support. Readily available and economic, it is easily cut to any desired size and simply prepared for painting. Lanyon regularly used the board in its 6 × 4 ft size as supplied, his preference being for Masonite Presdwood, an untempered hardboard which he bought from Lanhams in St Ives. Established in 1869, Lanhams had developed a healthy trade in supplying local artists with artist's materials, board and wine. An order from Lanyon of 1958 included fifteen, 6 × 4 ft, sheets of Masonite. Many artists prefer to paint on the seductively smooth face of the hardboard, but Lanyon preferred the face embossed with the mechanical texture of wire mesh. This provided him with a good key for his ground and paint as well as a certain resistance to the passage of the brush reminiscent of painting on canvas.

Hardboard is a modern material.[4] Its manufacture was developed in the USA by W.H. Mason in the 1920s using the type of processes used since the 1880s for producing low density boards. Commercial production began in 1926 and although available in the UK from the 1930s it was not until the 1940s that hardboard became a popular painting support for British artists. Masonite is made from wood fibres coated in naturally occurring lignin, produced by exploding timber with high pressure steam. A slurry of the wood fibres in water is formed into sheets and excess water drained off. The partially dry sheets are then heat pressed, producing the different face textures of the board. One side is smooth from the smooth, heated plate while the other retains the impression of the wire mesh, which forms the bottom of the tray through which the remaining water is expelled.

Peter Lanyon prepared the Masonite for painting him-self. His normal practice was to degrease the surface by washing it with diluted ammonia and to apply up to three coats of gesso made from rabbit-skin glue, chalk (whiting) and a little zinc oxide.[5] The zinc oxide enhances the cool whiteness of the gesso and acts as a biocide. Examination and analysis carried out on *Zennor Storm* also reveals the presence of a sizing layer of unpigmented glue (probably rabbit-skin glue) applied to the board before the gesso. This is common practice when priming a panel with gesso. It seals the board reducing its absorbency. The gesso on *Zennor Storm* is thin and probably does not consist of as many as three layers.

Lanyon had used Masonite for many years partly as a result of problems he had encountered when painting on canvas which could not take his robust scraping and handling of paint. However in 1959, the year after painting *Zennor Storm*, he suddenly changed back to painting almost exclusively on stretched canvases. Sheila Lanyon attributed this change to problems he had encountered with his paintings on hardboard in New York, which warped badly in the central heating. This was probably because he did not prime or seal the back of his boards, the exposed backs losing or gaining moisture rapidly while the painted fronts remained relatively impervious. *Zennor Storm* was exhibited at the Catherine Viviano Gallery, New York, in early 1959 and probably stayed in America until presented to the Tate Gallery by Catherine Viviano in 1981. During that time it had developed a gentle warp convex to the face but was quite secure, being supported in its frame by a wood framework inserted behind it but not attached to it.

Lanyon painted directly on to the primed board without any preparatory drawing. No sketches or preparatory works like the constructions he made to explore his ideas for *Porthleven* (1951), are known for *Zennor Storm*. The image evolved directly on the board as he painted, the history of its evolution being encapsulated within the structure of the work (fig.176). He worked constructively, adding layer upon layer of paint as the image emerged. There is little evidence of scraping back visible on the surface.

The paints he used are traditional, commercially prepared artist's oil colours, and oil paints that he mixed himself from dry, powdered pigments and oils. Surviving bills from Cornelissen the colourman and Lanhams show some of the materials he purchased in 1958. He purchased turpentine, linseed and stand oil from Lanhams and the pigments coerulean blue (cerulean blue), French ultra-

fig.176 Detail of calligraphic black strokes over
green and white scumble over blue paint

fig.177 Detail of the signature

fig.178 Cross-section from right edge photographed at × 250, showing several thick applications of paint, and wet working of the topmost layer of blue

fig.179 A splash of thick paint which landed on the reverse of the panel during painting, showing a mixture of several pigments. Photographed at × 100

marine, Mona blue (phthalocyanine blue) and cadmium yellow light from Cornelissen. All these colours were found by analysis in *Zennor Storm*. Lanyon ground the pigments in a mixture of stand oil and turpentine (Winsor and Newton's) to produce paints with exactly the handling properties he required.[6] By using stand oil (partly polymerised linseed oil) instead of the normal, refined linseed oil, he produced paints which dried slowly to a relatively glossy, enamel-like finish, which allowed some of the brushmarking to flow out before setting and were less prone to yellowing with age. The turpentine was added to reduce the viscosity of the stand oil and help wet the pigment. Lanyon's understanding and mastery of his paints is shown in his ability to retain the legibility of the image created from such a complex accumulation of many layers (fig.177). The correct balance of medium to pigment avoided uneven sinking of his colours or the development of disfiguring drying defects. He certainly purchased picture and retouching varnishes, often used to resaturate sunken passages of paint as well as to protect the surface, but there is little evidence of their use on *Zennor Storm*.

The range of colours in the painting is limited, consisting predominately of blues, dark greys and white off-set with warm earthy green, sienna and an accent of red that breaks though from below near the signature. Lanyon had employed all the blues purchased from Cornelissen to achieve the range of warm and cool blues which dominate the painting. Examination of the cross-sections (fig.178, for example) and the surface of the painting shows that he has used a combination of ready-prepared artist's paints and those he ground in the studio, often mixed together. Whereas many of the blue pigments are unevenly dispersed in the oil, as with hand grinding (fig.179), other colours, including the whites, have the even, fine dispersal of machine-ground paints. The artist's titanium and zinc whites from tubes have a buttery consistency revealed in the sharper impasto of the brushwork. The cross-sections also show the complexity of the work in depth and the considerable number of layers superimposed to achieve the visible surface. Each successive layer obliterates or modifies previous work until the final image emerges from the accumulated experience of the painting.

Lanyon gave an insight into his working methods and the emotional charge he felt in the act of painting when discussing his work *Offshore* in 1959.

The final process of the painting, the action, the painting itself is the most certain, the most definite and very often the most unconscious part of one's whole procedure in the construction of a painting of this sort. I'm finding, for instance, that I become familiar with my paint-slab and my muller and my pots of paint and powder-colours and so on, that as I'm getting closer towards the end of the painting, these objects, these paints, the oils, substances, have the same extreme appearance about them, the insistence about them that I referred to in the subject, when I first noticed that I was, as I say, almost as if under the influence of drugs, when I was seeing flowers looking at me, a car sitting, a gate arguing with itself, grasses blowing. The actual materials, the things which I use, the brushes, the knife, the tubes of paint, and so on, they all have an extreme sudden presence or awareness and I know exactly what quality of paint, what degree of turpentine oil, for instance, what sort of stroke, what sort of brush I'm going to use, what the area of paint will be. I know this, not at the same time as I'm putting it down, but I know it beforehand when I have to, for instance, make the paint itself. I do that by grinding colour, of course, making it up with the oils. I get to know exactly the sort of drag or the sort of smoothness or liquidness of certain parts of the painting. I even know, for instance, perhaps two hours before, that I shall eventually come down the centre across a piece of white with a rag. I even will put that rag aside and wait for that moment to occur. That sort of certainty is not anything magical or unusual.[7]

Visually the surface of *Zennor Storm* appears to change continually as one set of relationships after another catches our attention. There is no rest for the eyes or brain. The viewer is drawn into both the experience of a storm and the creation of the painting. The apparent still of the earthy green, left of centre, is rapidly crossed by a final, downward, calligraphic stroke of black (see fig.176) applied with total assurance. Each movement can be followed as the brush changed direction with a twist, unloading less black and picking up more green from below as the pressure on the brush altered and the paint ran out. The physical and visual blending of colours occurs in many passages of the painting painted wet-in-wet; bringing unity to the surface along with a complex and subtle illusion of space and movement through it. In other areas Lanyon had waited until the paint was sufficiently dry to allow another layer of broken colour to be dragged over picking up the textures of the underlying paint. The spatial illusions created in such passages are often stark and create the illusion of sudden and deep recessions. The textures, which contribute so much to the energy of the surface, are the result of the agglomerated paint layers which have obliterated the texture of the hardboard in many areas. The regular rhythm of the mesh does occasionally appear as a faint echo amongst other more robust textures, but it is only clearly discernible towards the edges, where there are fewer layers of paint.

Zennor Storm shows Lanyon at a period in his art when he had achieved mastery of his materials in producing densely worked paintings. He said, 'I think it is the logical result of this constructive process which, starting in an extreme awareness of oneself in a place, ends in an extreme awareness of oneself in painting.'[8]

Pigment analysis with optical microscopy and EDX was carried out by Dr Joyce Townsend.

PART III

Paintings on Paper

— 29 —

THOMAS JONES (1742–1803)
Naples: The Capella Nuova outside the Porta di Chiaja 1782

JACQUELINE RIDGE

Thomas Jones was born the second son of a local landowner in Pencerrig, mid-Wales. His search for 'a proper master, under whom I wished to pursue my future Studies'[1] was initially aimed at learning the art of portraiture, but when he failed to find an affordable and appropriate position he decided he was more suited to landscape painting. He thus undertook a two-year apprenticeship with the classical landscape painter Richard Wilson (1763–5). He was to have doubts at first about Wilson's ability, 'The Characteristick Beauties of this great Master I was quite blind to – And I looked upon his pictures as coarse unfinished sketches',[2] and although Jones's formal paintings were to be strongly influenced by Wilson, through his drawings, watercolours and small oil studies, Jones developed a distinct style of his own.

Jones travelled in Italy between 1776 and 1783 and recorded in detailed diaries and subsequent memoirs his activities and lifestyle. This small finished oil study is one of several from his second stay in Naples. As with most of his works on paper he has written the date and location on the back in pencil: 'The Capella nuova fuori della porta di- / Chiaja Naploli / May 1782 TJ' (fig.181). From his memoirs we can almost certainly determine the view was that seen through the window of his ground floor studio. On 3 May 1782 he wrote:

The Term being expired this day, for which I had taken my house I sent all my Furniture to Anastasia, my Nurse's house on the *Molo piccolo*, and removed to Mr Thomas Francis, the English Taylor's without [outside] the porta di Chaja who had fitted us up an Appartment to sleep in – and at the same time D. Antonio Pellegrini, the Neapolitan painter, who lived in the Other Quarter, removed into that which I was now quitting – As for a Room to paint in, I procured one in a little Convent adjoining, called the Capella Vecchia, situated in the Borgo of the Chaja & very near Sr W'm Hamilton's palace, paying beforehand a Ducat and a half which was One Month's Rent, and I took possession on the 9th.[3]

On 12 May he wrote:

The Room which I was in possession of at the Convent, was large and commodious for such a place, and as it was on a ground floor and vaulted above, very cool and pleasant at this Season of the Year – The only window it had, looked into a Small Garden, and over a part of the Suburbs, particularly the *Capella nuova*, another Convent, the *Porta di Chiaja*, Palace of Villa Franca, and part of the Hill of Pusilippo, with the Castle of S. Elmo & convent of S. Martini &c. all of which Objects, I did not omit making finished Studies of in Oil upon primed paper – I likewise went on with my large View of the Lake of *Nemi* for Lord Bristol.[4]

Jones recorded, on his outward journey, buying painting implements and other travel essentials. Tuesday 29 October 1776: 'As Lyons is famous for these Articles I bought 2 dozen painting Tools – 6 Livers and one Dozen pencils – 1L. 16 Sous many of which Tools I have still by me in the Year 1794 – I likewise purchased a French Grammar for 2 Livers 4 Sous – but the Blunder was – that this Grammar was for the purpose of Teaching *a Frenchman English*, & not an *Englishman French*.'[5] Some of his notebooks are inscribed 'purchased in Rome' or 'purchased in Turin'.[6] The handmade paper for this work is probably from Northern Italy or possibly France.[7] There is no maker's name or watermark, but from the back, the chain and laid line imprints from the making process can be seen. The flattened slubs indicate that the rags, from which the paper was made, were stamper beaten to break up the fibres; this was a method still used at this date in Northern Italy and France but largely replaced by the mechanised Hollander beater in Britain. This piece was cut from the middle of a much larger sheet, shown by the wrinkling on the back left-hand side where the surface of the full sheet was compressed as it draped over ropes in the drying lofts during manufacture. The paper was originally white but is now yellow from natural ageing (fig.181).

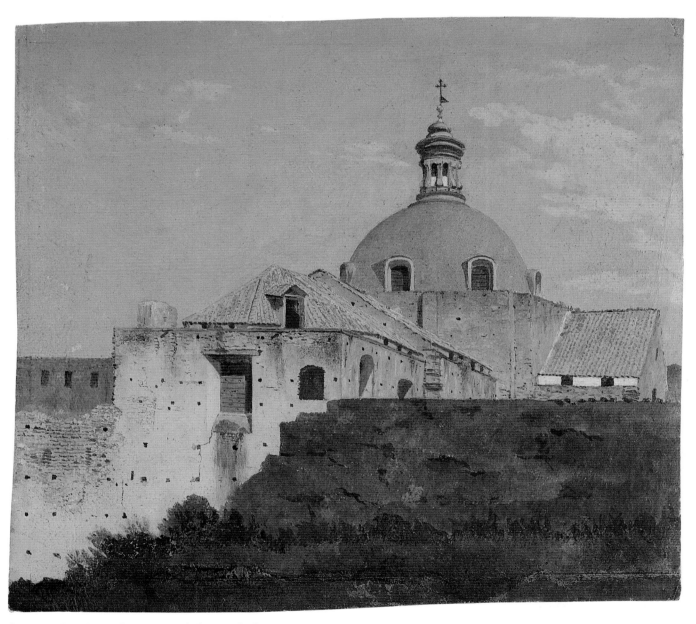

fig.180 *Naples: The Capella Nuova outside the Porta di Chiaja,*
oil on paper 21.1 × 23.3 (8¼ × 9⅛). The church was demolished
in the nineteenth century and this appears to be the only visual
record remaining.[8] T03545

fig.181 Reverse of painting in slight raking light showing the
surface texture of the paper. Chain and laid lines are visible from
the manufacturing process (chain line 25 mm variable, laid line
frequency 1 mm). On the right edge, compression wrinkles from
the drying process can be seen. The stain marks on the back are
from oil soaking through from an early painting stage. The
inscription reads: 'The Capella nuova fuori della porta di- /
Chiaja Naploli / May 1782 TJ'

Whilst abroad, Jones seems to have bought materials that were ready for use. He told a prospective patron that 'I bought my Cloths & Colors ready prepared at the Colorshops, & [that they] were the same that all other painters used'.[9] This contrasts with diary entries made after his return to England where he mentions priming canvases himself.[10] This paper was probably bought ready-prepared with its orange brick-coloured priming on the front surface: it includes a material which may be chalk, with kaolin extenders and red earth pigment bound with glue (fig.182). The priming is thick enough to cover the texture of the paper fibres and gives a fairly smooth surface. On to this Jones drew an outline, in pencil, of the view seen up through his ground-floor studio window. Some of the lines are visible by eye. The pencil line is firm and in raking light a fine groove can be seen where it has dug into the priming. As with his watercolours, the drawn line is used to define form and shadow in the final image. This is particularly effective for the cross on the dome (fig.182). Jones added further pencil lines during the painting process as compositional elements developed. Some painted-out lines are detectable with infra-red reflectography: these include in the sky an outline of billowing clouds or a tree that Jones did not paint in and a ruled centring line through the dome to keep it symmetrical (fig.184).

Having drawn in the shapes Jones filled in selected areas with distinct hues of grey or olive-coloured paint, leaving exposed only selected areas of the brick-coloured priming. These flat undercolours have a direct bearing on the final hues of the picture. The buildings and roofs in bright sunlight were painted directly on to the warm brick-coloured priming, whereas areas in partial shade are over the olive paint. Most of the blue sky is painted over a light grey undercolour. For the deepest shadows of the buildings, a cool grey paint was locally adjusted with a darker grey. A similar colour is seen through parts of the bushes and trees, again, to help introduce shadow and depth. These undercolours extend up to, but leave visible, most of the drawing lines. Stain marks seen on the back of the paper are from the oil soaking through from this stage of painting. The diagonal stain running through the area of bushes contradicts the final image and suggests that Jones had a slightly different feel for the composition at this early stage (fig.181). The colours of the final image were applied over the undercolours and finished with an array of surface details. The brick texture was almost splattered on. Roof tiles consist of droplets of paint care-

fully applied one by one and green plants and ivy are rivulets of colour (fig.183). Small areas of the brick-coloured priming still remain visible and form a part of the final coloured image (fig.182).

The sampling of pigments was limited due to the excellent condition of the paint surface. Those identified include lead white, Prussian blue, Naples yellow, ivory black, red/brown ochre and a red lake pigment. Jones recorded using these specific colours in diary entries of the 1780s. He also listed various pigments to buy on leaving Naples: these include Vermilion at 2 carlines an ounce, Roman brown [ochre], Naples yellow as [gouche], black or Cologne earth and 4 pounds of [lead] white.[11] The medium has not been analysed but in his diary of the 1790s he recorded using drying oil, nut oil and on occasion additions of mastic resin and megilp.[12] All paint applications appear to have been made with a brush, each stage seemingly left to dry completely. There is little evidence of working wet-in-wet. As with most of the oil studies no varnish was applied. Jones's small works in oil on paper contrast with those on canvas by being devoid of cracks, reflecting the dimensional stability of paper as a support.

The method used here by Jones combines both oil and watercolour painting techniques. The structured build-

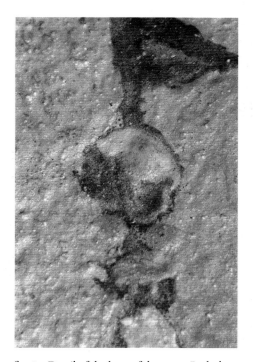

fig.182 Detail of the base of the cross. Both the drawing lines and the orange brick-coloured priming are used as part of the image

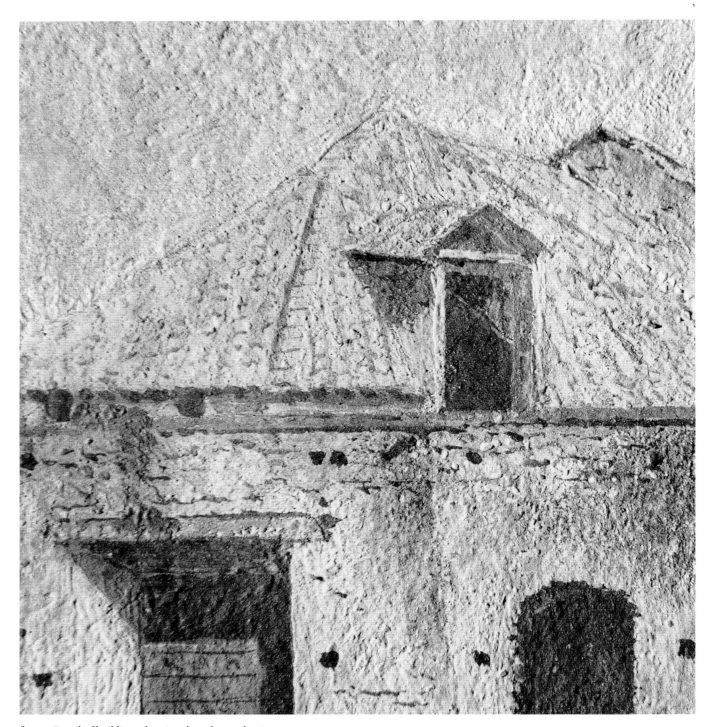

fig.183 Detail of buildings showing the splattered paint
used to create the effect of bricks and the droplets of colour
used for the roof tiles

fig.184 Infra-red reflectograph showing the extent of drawing. On the right, in the sky, an early idea of billowing clouds or possibly a tree can be seen. The dome of the Capella has been drawn using a geometric centring line, and there are changes to roof outlines. Drawn lines round the perimeter of the paper define the size

up of layers shows Jones's familiarity with oil paint and his understanding of the effect of layering relatively opaque colours one over another. In contrast, the filling in of areas demarcated by drawing lines, the extent to which drawing has been used, and the small scale of the work is more analogous to his watercolour method.

Jones was already executing finished oil studies of views in Wales prior to his departure to Italy and continued to do so after his return. Neither the Italian nor Welsh oil studies were used by him as preparation for larger scale formal oil paintings and are notable as examples of *plein-air* technique: that is the capturing of an image from nature seen directly in front of the artist. The Welsh works, literally painted in the field, appear to have no underdrawing and the paint application is less structured, as if done on the spot. The structured approach of the Neapolitan works, though still recording the view as seen, reflects the relative comfort of painting a view from a studio window rather than in the mid-Wales countryside. Contrasting with his contemporary Valenciennes who advocated painting from nature as a means of developing painting skill and eye,[13] these small works appear to be a means by which Jones registered his own personal experiences. Though they were admired by prospective patrons no reference is made in his memoirs to their being sold or his attempting to sell them. This work, along with other Neapolitan views, must have been a precious memento after his return to Britain.

Pigment analysis by optical microscopy, EDX and microchemical analysis was carried out by Dr Joyce Townsend in 1997.

JOHN CONSTABLE (1776–1837)
Beaching a Boat, Brighton 1824

RICA JONES

In 1825 Constable sent his friend, John Fisher, a package containing amongst other things 'a dozen of my Brighton oil sketches … they were done in the lid of my box on my knees as usual'.[1] Fig.185 shows the way Constable would have used his box, sitting in front of the motif and responding directly in paint to what he saw. These documents of his involvement with nature were never exhibited during his lifetime; occasionally he would lend them to close friends who could be trusted but even then it was with caution. 'Will you be so good as to take care of them', he instructed Fisher. 'I put them in a book on purpose – as I find dirt destroys them a good deal. Will you repack the box as you find it. Return them to me here at your leisure but the sooner the better.' Most of the sketches, *Beaching a Boat* amongst them, remained in the possession of Constable's children and were dispersed only after the death of the last of them in the late nineteenth century. He began doing oil sketches from nature in about 1810. This one dates almost certainly from June 1824, during Constable's second visit to Brighton.[2] Two

similar sketches in the Victoria and Albert Museum, one of them sharing the same double priming as the Tate's, are dated 10 and 12 June respectively. The scenes depicted eventually found their way into *Chain Pier, Brighton* (fig.187), a 'six footer' on canvas which was exhibited at the Royal Academy in 1827.

The paper support used for this and his other oil sketches was probably prepared in his studio. Sarah Cove, in her extensive studies of Constable's painting techniques,[3] has described the process he used to make cheap, lightweight, durable painting supports to use outdoors. They generally consist of two sheets of paper placed one on top of the other and stuck together firmly with glue. The upper sheet could be a rough 'wove' paper or a thin tissue-type paper which gave a smoother painting surface. The back of this painting is now obscured with canvas, and the paper so infused with the glue used in this later remounting, that it is not possible to discern the exact types of paper chosen, except to note that the upper sheet is thinner than the lower. He usually primed his paper with a single layer of opaque pink or brown paint, bound in oil or glue. A stretching frame was used to hold the laminated sheets flat during drying. When thoroughly dry the primed laminated sheets were cut into fractions (quarters, as in *Beaching a Boat*, eighths or sixteenths) of the original 20 × 24 inch (50.8 × 61 cm) sheet. Unusually, *Beaching a Boat* has two layers of priming, the first being a coat of opaque pale blue paint consisting of lead white tinted with Prussian blue and very small amounts of red lake, yellow ochre, black and gypsum. The binding medium is probably oil. The next coat, applied after the first layer had dried, is oil-bound. It is a semi-translucent, purplish brown paint made up of yellow, red and brown ochres with smaller amounts of umber, black, vermilion, lead white and cobalt blue. Once mixed up, it was brushed on to the pale blue surface with broad vertical and diagonal strokes, its liquid consistency allowing the underlayer to modify its hue. Cove has suggested that this brown second layer, also found in several other Brighton

fig.185 Christen Kobke (1810–48), *Eckersberg and Wilhelm Marstrand on a sketching Tour* (1832). Pencil on paper, 14.7 × 18.4 cm (Statens Museum for Kunst, Copenhagen)

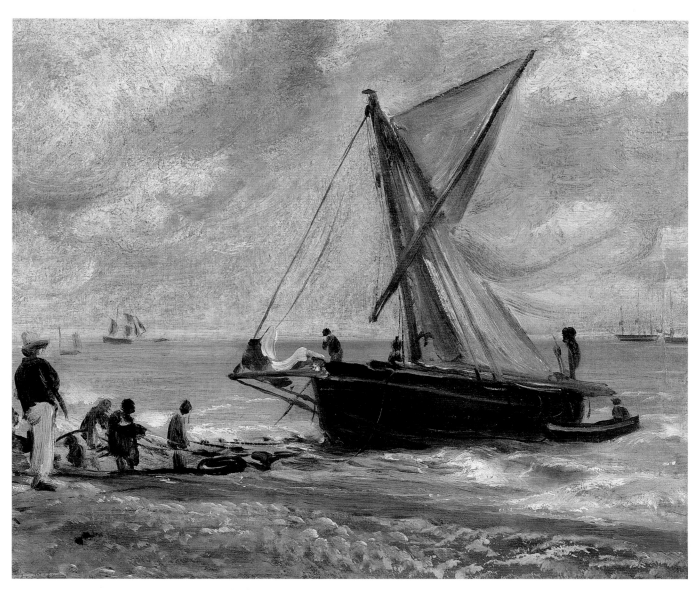

fig.186 *Beaching a Boat, Brighton,* oil and egg-and-oil on paper
(laid onto canvas) 24.8 × 29.4 (9¾ × 11⁹⁄₁₆) T04135

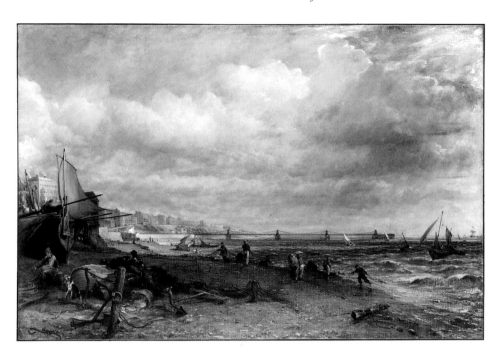

fig.187 *Chain Pier, Brighton.* Oil on canvas, 127 × 182.9 cm. The man in the straw hat has been placed in the centre of the composition and the fishing boat is on the right

sea sketches, represents his adaptation of some blue-primed paper left over from recent sketching in Hampstead. Whatever their origins, the coloured primings in this and all his other sketches are profoundly important, being left visible in places in order to play a part in the composition and help create the overall mood of the picture.

This prepared support then, fully dry and cut to fit into the inner lid of his sketching box, is what Constable would have placed before him one blustery day on Brighton beach when he decided to record the fast changing scene of nets being drawn in from the approaching boat. Inside the box his paint, as we know from surviving examples, would have been ground in oil and stored in bladders. At least one of the surviving paint boxes also contains dry pigments in glass phials, which could have been mixed into the ready-bound paint as desired – but we cannot be sure whether these bottles belonged to Constable or to one of his descendants. There is no preparatory drawing of any kind. The whole image was worked up in paint at what looks like a rapid pace. The three main areas of the scene – sky, sea and sandy foreground – appear to have been put in first, different types of brushes being used for each. In the sky mixtures of lead white with ochres, black, vermilion and umber were almost scrubbed on with a very stiff, smallish brush; the purplish brown priming, which is visible in the troughs of the brushstrokes, helps create the impression of wind and

speed (figs.188 and 189). For the sea he used a larger, softer brush. The paint mixture is mainly lead white with varying amounts of Prussian blue, black, yellow ochre, patent yellow and a granular, colourless material (fig.190). It is an extender of some sort but its gritty presence would also have provided an extra degree of 'tooth' and control for the brush. The beach was done with mixtures of ochres and umber with lead white which were applied in sweeping strokes with a stiffish brush.

So with the main spatial divisions laid in with broad tonal modelling, Constable could begin to add details. A few slight disturbances in the strokes of the sea around the hull of the central boat suggest that he wiped out a space for it, rather than pick up the underlying wet paint in this comparatively large area. All the rest – figures, distant boats and tonal modifications in the foreground sea and beach – were done wet-in-wet with brushwork descriptive of the shapes or textures required (fig.188). Finally he applied the thick, sharply delineated highlights on the sand and on the waves breaking near the shore (figs.188, 189 and 190). The crisp impasto of this paint suggests that it is an example of the egg-oil binding medium that Sarah Cove has identified in the white highlights on several Constables. The presence of egg was identified in a small sample and an emulsion of this sort would produce a light impasto which would retain the brushmarks in this precise way. His usual binding medium at this period was heat-treated linseed oil and the paint was

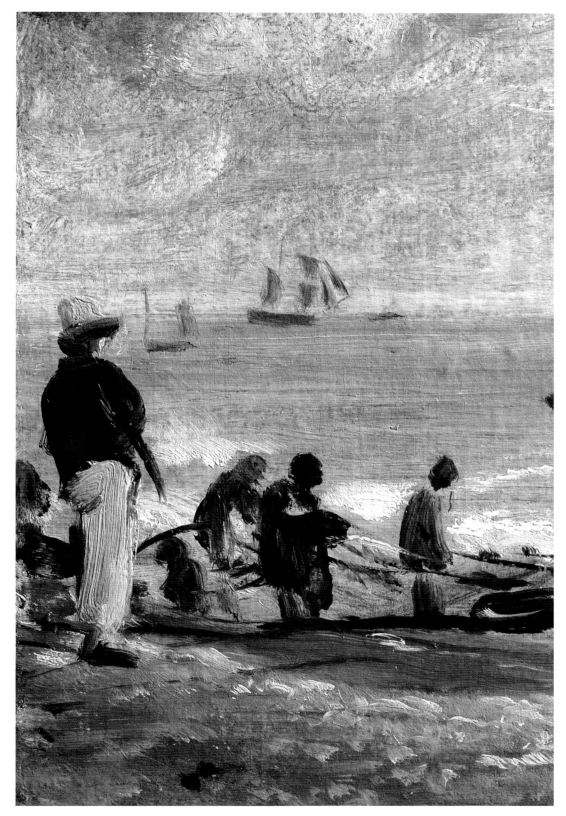

fig.188 Detail of the sky, sea and figures in *Beaching a Boat*,
photographed in slightly raking light from the top to show
the different types of brushwork and thicknesses of paint.
The purplish brown imprimatura is visible in the sky

fig.189 Detail of the lower right corner, photographed in slightly raking light from the top to show the impasto on the waves and shore. The crease running down the right edge was caused by the stretching frame employed while the support was being laminated

fig.190 Detail of the sea just below the hull, photographed in slightly raking light through the binocular microscope set at × 3.5 magnification. Different types of white paint were used for the two types of foaming sea illustrated. The dots in the upper half of the image are the colourless, granular substance mixed into the green sea paint

normally kept lean. The pigment in the impasto is lead white tinted with very small amounts of black, umber and ochres but it is a different lead white from that used elsewhere in the painting. In the sky and sea the particle sizes vary from very large to very small; here, however, the lead white is ground extremely finely and homogeneously, another reminder of Constable's attention to the characteristics and quality of his materials.

As is evident in this painting and has been amply borne out by Cove's research, Constable was a sound technician who combined great sensibility of the working properties of pigments and oils with more regard for durability than was current at the time. This did not prevent him, however, from using some of the newly invented pigments that became available in the early nineteenth century, most notably the strongly coloured chrome yellows and greens. For this sombre-toned scene, however, he kept his palette in a lower key, using ochres, blacks, umbers, vermilion and Prussian blue (which was more durable in this period than it had been in the eighteenth century) with lead white. The only comparatively new pigment in this painting is patent yellow or Turner's yellow as it was sometimes known, having been patented and first manufactured in England by James Turner in 1781.[4] Constable's friend the colour chemist, George Field, wrote of patent yellow : 'it is a hard, ponderous, sparkling substance, of a crystalline texture and bright yellow colour ... It has an excellent body, and works well in either oil or water, but is soon injured both by the sun's light and impure air ...'.[5] As the oil sketches were rarely exposed and the pigment therefore not put at risk, Constable took advantage of its bright, crusty nature and used it unmodified for the straw hat and for the curve of the dinghy (figs.188 and 189). As noted above, he also mixed small amounts into areas of the sea. The stability of these pigments has ensured as little tonal change as is possible in oil painting. One inevitable alteration has been in the sky, where the purplish brown imprimatura, although always intended to play a significant role in the lowering clouds, must now be more apparent because of the tendency of oil paint to become more translucent with time.

Two factors indicate that Constable did not varnish his oil sketches: firstly we have his own reference that dirt destroys them and secondly the majority of those given to the Victoria and Albert Museum by his daughter Isobel remain in their original unvarnished state. When this painting was acquired by the Tate in 1986, it had been previously coated with a thick layer of modern synthetic resin varnish and had also, some time in the late nineteenth or early twentieth century, been lined on to canvas and stretched up like a conventional easel painting. As the lining glue is still very strong (too strong to make its removal from fragile paper feasible), the lining has been retained. The varnish, however, was removed and not replaced. Its effect had been to saturate the hues, taking away the dry, sparkly surface evident in the unvarnished examples and masking the many changes of texture within the painting. Although we can never now regain the original unvarnished effect, varnish removal has brought us closer to it. The few, very small losses of paint (around the edges, along the gunwale of the large boat and down the crease caused by the stretching frame parallel to the right edge) were retouched with pigment bound in a modern synthetic resin.

Analysis of pigments was carried out as follows: with XRF by Graham Martin at the Victoria and Albert Museum in 1986; with optical microscopy by Rica Jones at the Tate in 1997; the medium in the white waves was analysed with GC-MS by Dr Brian Singer at the University of Northumbria at Newcastle in 1997.

NOTES

Place of publication is London unless otherwise stated.

TGA refers to Tate Gallery Archive.

Introduction

1. D.V. Thompson, *The Materials and Techniques of Medieval Painting*, 1936, repr. 1956, p.7.

2. Few technical studies in English written in the last thirty years would have got far without the publications (and very often practical help) of the Scientific and Conservation Departments at the National Gallery, London. Their work is cited in the notes throughout this book. References for the exhibition catalogues are as follows: D. Bomford, C. Brown, and A. Roy, *Art in the Making: Rembrandt*, 1988; D. Bomford, J. Dunkerton, D. Gordon, and A. Roy, *Art in the Making: Italian Painting before 1400*, 1989; D. Bomford, J. Kirby, J. Leighton, and A. Roy, *Art in the Making: Impressionism*, 1990.

3. See, for example, *Appearance, Opinion and Change: Evaluating the Look of Paintings*, ed. L. Carlyle and S. Hackney, 1990.

4. S. Hackney (ed.), *Completing the Picture: Materials and Techniques of Twenty-Six Paintings in the Tate Gallery*, 1982. It was produced in conjunction with *Paint and Painting*, the record of an exhibition and working studio sponsored by Winsor and Newton to celebrate their 150th birthday.

5. J. Crook and T. Learner, forthcoming.

6. L. Campbell in *Renaissance Portraits: European Portrait-Painting in the 14th, 15th and 16th centuries*, New Haven and London 1990, refers to a portrait of a duke, 'steyned upon cloth of silver', given by the Florentine Serjeant Painter, Anthony Toto, to Edward VI in 1552 and also mentions canvas portraits done in Italy being rolled for transport in the late fifteenth century (p.65 and notes). See also D. Bomford, A. Roy and A. Smith, 'The Techniques of Dieric Bouts: Two Paintings Contrasted', in *National Gallery Technical Bulletin*, vol.10, 1986, pp.39–57 for early use of canvas in Netherlandish painting.

7. C. Proudlove, 'The Early Norwich Artists: Their Techniques and the Dutch Example', in A.W. Moore, *Dutch and Flemish Painting in Norfolk*, 1988, pp.151–6, and A. Southall, 'Turner's Contemporaries: Their Materials, Practices and Opinions', in *Turner's Painting Techniques in Context*, ed. J.H. Townsend, 1995, pp.12–20.

8. S. Cove, 'Constable's Oil Painting Materials and Techniques', in L. Parris and I. Fleming-Williams, *Constable*, exh. cat., Tate Gallery 1991, pp.498–9.

9. N. Pevsner, *Academies of Art Past and Present*, Cambridge 1940, pp.82–92.

10. W.A.D. Englefield, *The History of the Painter-Stainers Company*, 1923, pp.65–161.

11. S. Foister, 'Foreigners at Court: Holbein, Van Dyck and the Painter-Stainers Company', in *Art and Patronage in the Caroline Courts*, ed. D. Howarth, Cambridge 1993, p.41.

12. Englefield 1923, pp.65–161.

13. Foister 1993, pp.32–50.

14. Englefield 1923, p.161.

15. R. Jones, 'The Artists' Training and Techniques', in *Manners and Morals: Hogarth and British Painting, 1700–1760*, exh. cat., Tate Gallery 1987, pp.19–28.

16. E. Einberg, 'Introduction', in *Manners and Morals*, 1987, pp.11–17.

17. M. Faidutti and C. Versini, *Le Manuscrit de Turquet De Mayerne*, Lyons c.1970, p.101.

18. M. Beal, *A Study of Richard Symonds*, New York and London 1984, p.311. Fenn also had 'a faculty of smoothing old and tattered wrinckled pictures'.

19. W. Whitley, *Artists and their Friends in England, 1700–1799*, 1928, I, p.331.

20. M.K. Talley, 'Extract from Charles Jervas's "Sale Catalogues" (1739): An Account of Eighteenth-century Painting Materials and Equipment', *Burlington Magazine*, vol.120, no.898, Jan. 1978, pp.6–11. The long list includes primed and unprimed canvases and dry colours in papers and boxes.

21. E.K. Waterhouse, *Painting in Britain, 1530–1790*, Pelican History of Art, 1969, p.101.

22. Andre Rouquet, quoted in Jones 1987, p.25.

23. M.K. Talley, *Portrait Painting in England: Studies in Technical Literature before 1700*, New Haven 1981.

24. T. Bardwell, *The Practice of Painting and Perspective Made Easy*, 1756.

25. Waterhouse 1969, pp.90–101, 139–40.

26. See pp.146–51 for wax painting. See also H. Dubois, 'Aspects of Sir Joshua Reynolds's Painting Technique', unpub. thesis, Hamilton Kerr Institute 1992–3, and A. Massing, 'From Books of Secrets to Encyclopaedias: Painting Techniques in France between 1600 and 1800', in *Historical Painting Techniques, Materials and Studio Practice*, ed. A. Wallert, E. Hermans and M. Peek, Leiden 1995, pp.20–9.

27. See p.151 and also J. Mills and R. White, 'The Mediums used by George Stubbs: Some Further Studies', *National Gallery Technical Bulletin*, vol.9, 1985, pp.60–4. For enamelled painting see Hackney 1982, pp.26–9.

28. T. Wright, *Some Account of the Life of Richard Wilson, Esq., R.A.*, 1824, p.20, and quoted in L. Carlyle and A. Southall, 'No Short Mechanic Road to Fame: The Implications of Certain Artists' Materials for the Durability of British Painting: 1770–1840', in *Robert Vernon's Gift*, 1993, p.24. The major source of technical information in this paper is a Ph.D. thesis by L. Carlyle, 'A Critical Analysis of Artists' Handbooks, Manuals and Treatises on Oil Painting published in Britain between 1800–1900', University of London 1991, pub. as *The Artists' Assistant*, 1998.

29. Carlyle and Southall 1993, p.24, quoting M.K. Talley, '"All Good Pictures Crack": Sir Joshua Reynolds's Practice and Studio', in *Reynolds*, exh. cat., Royal Academy of Arts 1986, p.62.

30. J. Gage, 'Magilphs and Mysteries', *Apollo*, July 1964, p.38.

31. Ibid, pp.38–41.

32. Carlyle and Southall 1993, pp.21–6.

33. J. Townsend, *Turner's Painting Techniques*, 1993, pp.67–79.

34. Quoted in J. Townsend, 'The Materials and Technique of J.M.W. Turner, RA, 1775–1851', unpub. Ph.D. thesis, University of London 1991, pp.31–2.

35. R. and S. Redgrave, *A Century of Painters of the English School*, 1866, II, p.90.

36. Carlyle and Southall 1993, p.24.

37. Ibid.

38. *Ruskin's Collected Works*, III, 1903, p.249.

39. L. Carlyle, 'A Critical Analysis of British Handbooks, Manuals and Treatises on Oil Painting Published in the Nineteenth Century', in *Preprints for the UKIC Thirtieth Anniversary Conference*, 1988, p.55 and note. Some of the artists who subscribed to the first edition of Field's *Chromatography* in 1835 were Beechey, Calcott, Constable, Cope, Eastlake, Etty, Lawrence, Landseer, Mulready, Shee, Turner, Westall and Wilkie. See also, Southall 1995, pp.12–20.

40. Jones 1987, p.27.

41. Ibid., pp.25–6.

42. A. Jal, *L'Artiste et le Philosophe, entretiens critiques sur le Salon de 1824*, pp.292–5, in the Beckett Papers, Tate Gallery Archive 9030. I am very grateful to Leslie Parris for photocopying these references for me and to Annette King for help with the translation: 'AR. Je vois que M. Gassies a voulu imiter les peintres anglais, et qu'il n'a prodigué, sur ses premiers plans, les épaisseurs de couleurs que pour essayer la manière sauvage et bizarre de John Constable. PH. J'ai lu dans un journal que ce John Constable … avait envoyé a Paris des tableaux qui avaient troublé le repos de tous nos peintres de paysage … AR. … Tenez les voici. PH. Mais, mon ami, savez-vous que cela est fort bien. C'est la nature même … Je ne sais si, comme peinture, ces tableaux peuvent être estimés; mais, pour moi, je les prise fort, je les trouve d'une naiveté merveilleuse. AR. Ils sont extraordinaires, en effet, sous le rapport de ton. C'est bien l'aspect de la compagne. Ces compagnes sont vraies; cette charette est vraie; ces bateaux sont vrais; mais le procédé qui mene a cette expression de la verité est tout près de la *manière*. On dirait d'un tatonnement perpetuel. Ce travail en relief, ces masses de brun, de jaune, de vert, de gris, de rouge et de blanc, jetées les unes sur les autres, remuées a la truelle, coupé avec le couteau à palette et glacées ensuite, pour les faire rentrer dans l'harmonie et dans le mystère; ces choses, dis-je, sont moins de l'art que du mécanisme; et, encore, ce mécanisme est-il sans grace. PH. Qu'importe s'il me conduit a une illusion parfaite? AR. Mais cette illusion cesse, si vous approchez

un peu; et comme les tableaux de paysage sont faits pour être vus a une distance peu considérable, le but du peintre est manqué, parcequ'il a calculé son effet comme celui d'une décoration, dont les lignes, les tons et les détails n'arriveraient a l'oeil qu'en traversant de grands espaces d'air.'

43. See C. Cennini, *The Craftsman's Handbook 'Il Libro dell'Arte'*, ed. and trans. D.V. Thompson, 1933, republished New York 1960, for other translations, pp.ix–xx.

44. Sir C.L. Eastlake, *Materials for a History of Oil Painting*, 1847, republished as *Methods and Materials of Painting of the Great Schools and Masters*, 1960.

45. Carlyle, 1988, pp.54–8.

46. S.A. Woodcock, 'The Roberson Archive: Content and Significance', in Wallert, Hermans and Peek 1995, pp.30–7, and M.R. Katz, 'William Holman Hunt and the "Pre-Raphaelite Technique"' in ibid., pp.158–65.

47. Tube colours were introduced in the 1840s, though oil paint in less practical and more expensive glass or metal syringes had been available since the 1820s. See *Paint and Painting*, ed. L. Fairbairn, I, 1982, pp.67–9, and also J. Ayres, *The Artist's Craft*, Oxford 1985, pp.114–15.

1 Marcus Gheeraerts

1. Els Vermandere, *The Dictionary of Art*, ed. J. Turner, 1996, XII, pp.514–15.

2. K. Hearn, *Dynasties*, exh. cat., Tate Gallery 1995, pp.176–7.

3. J. Stephenson, *The Dictionary of Art*, V, pp.653–8.

4. e.g. Simone de' Crocefissi (documented in Bologna from 1355 to 1399), *Sant'Elena adora la croce*, c.1370, Inv.242, Pinacoteca Nazionale di Bologna. C. Villers, 'Painting on Canvas in 14th Century Italy', *Zeitschrift für Kunstgeschichte*, 58, 1995, pp.338–58.

5. D. Bomford, A. Roy and A. Smith, 'The Techniques of Dieric Bouts: Two Paintings Contrasted', *National Gallery Technical Bulletin*, vol.10, 1986, pp.39–57.

6. Hearn 1995, *passim*.

7. R. Jones, 'The Methods and Materials of Three Tudor Artists: Bettes, Hilliard and Ketel', in Hearn 1995, pp.231–40.

2 John Michael Wright

1. National Library of Wales (NLW), Bachymbyd Letters, 299A (9 Dec. 1675). Letter reproduced in W.J. Smith, 'Letters from Michael Wright', *Burlington Magazine*, July 1953, pp.233–6.

2. K. Hearn, 'Portrait by John Michael Wright', *tate: the art magazine*, no.3, Summer 1994, p.m6.

3. NLW, Bachymbyd Letters, 299 (27 July 1676).

4. Ibid., 316 (25 July 1676/7).

5. J. Sharp, 'The Midwives Book', 1671, pub. in A. Buck, *Clothes and the Child*, Bedford 1996, p.24.

6. Diana Scarisbrick has suggested that this may be a bezoar stone, found in the intestines of ruminant animals, and believed to have health-giving properties. With thanks to Karen Hearn for this information.

7. NLW Bachymbyd Letters, 304 (24 Oct. 1676).

8. Act of Charles II Parliament 1, Session 1, cap.43. quoted in J. Horner, *The Linen Trade of Europe*, Belfast 1920.

9. A. Wilton, *The Swagger Portrait*, exh. cat., Tate Gallery 1992, pp.92–3.

10. Anon., *The Excellency of the Pen and Pencil*, 1668, p.94.

11. Analysis of the pigments is ongoing.

12. NLW Bachymbyd Letters, 329 (15 Mar. 1676/7).

13. Ibid., 316.

14. Recorded in the Executor's Account Book 169–1691 BM MS Additional 16,174 published in M.K. Talley, *Portrait Paintings in England: Studies in the Technical Literature before 1700*, New Haven 1981, pp.364–5.

15. NLW, Bachymbyd Letters, 329.

16. MS Egerton 1636 fo.135 in M. Beal, *A Study of Richard Symonds*, New York and London 1984, p.279.

17. NLW, Bachymbyd Letters, 329.

18. Ibid., 299.

19. J. Simon, *The Art of the Picture Frame*, exh. cat., National Portrait Gallery 1996, p.58.

20. NLW, Bachymbyd Letters, 304.

3 Jan Siberechts

1. K. Hearn, 'Acquisitions of Seventeenth-Century Painting at the Tate Gallery', *Apollo*, vol.144, Dec. 1996, p.22.

2. D. Bomford, C. Brown and A. Roy, *Art In The Making: Rembrandt*, 1988, p.92 and *passim*.

3. R. Woudhuysen-Keller, 'Aspects of Painting Technique in the Use of Verdigris and Copper Resinate', in *Historical Painting Techniques, Materials and Studio Practice*, ed. A. Wallert, E. Hermans and M. Peek, Leiden 1995, pp.65–9, and A. Roy, 'The Physical Structure of *The Ambassadors*', in *Making and Meaning: Holbein's Ambassadors*, exh. cat., National Gallery 1997, p.97.

4. Z. Veliz, *Artists' Techniques in Golden Age Spain*, Cambridge 1986, pp.4, 72, 157, 167. See also G. McKim-Smith, G. Andersen-Bergdoll and R. Newman, *Examining Velazquez*, New Haven and London 1988, pp.89–90. Ground glass is present in the ground of Velazquez's *Forge of Vulcan*.

5. Bomford, Brown and Roy 1988, p.76 and *passim*. See also *Art and Autoradiography: Insights into the Genesis of Paintings by Rembrandt, Van Dyck, and Vermeer*, New York 1982, pp.100–3.

6. E.M. Gifford, 'A Technical Investigation of Some Dutch Seventeenth Century Tonal Landscapes', *A.I.C. Biennial Conference* preprints, Baltimore 1983, pp.39–49.

7. Ground glass is present with yellow ochre on painted necklaces in several portraits of *The Smythe Family*. See, R. Jones, 'The Methods and Materials of Three Tudor Artists: Bettes, Hilliard and Ketel', in K. Hearn, *Dynasties*, exh. cat., Tate Gallery, 1995, p.238.

8. M. Smith, *The Art of Painting According to the Theory and Practice of the Best Italian, French and German Masters*, 1692, p.73. See also M.K. Talley, *Portrait Painting in England: Studies in the Technical Literature before 1700*, New Haven 1981.

4 William Hogarth

1. E. Einberg and J. Egerton, *The Age of Hogarth: British Painters Born 1675–1709*, 1988, pp.104–6, and E. Einberg, *Hogarth The Painter*, exh.cat., Tate Gallery 1997, pp.38–9.

2. J. Burke (ed.), 'The Autobiographical Notes', in *The Analysis of Beauty*, Oxford 1955, p.202.

3. Ibid., p.204.

4. Einberg 1997, p.9.

5. R. Woudhuysen-Keller and K. Groen, 'The Restoration of William Laud, Archbishop of Canterbury', in *Hamilton Kerr Institute Bulletin*, no.1, 1988, and also C. Christansen, M. Palmer and M. Swicklik, 'Van Dyck's Painting Technique, His Writings and Three Paintings in the National Gallery of Art', in *Anthony Van Dyck*, ed. A.K. Wheelock and S.J. Barnes, exh. cat., National Gallery of Art, Washington 1990, pp.45–52.

6. T. Bardwell, *The Practice of Painting and Perspective Made Easy*, 1756, p.6.

7. R. Jones, 'The Artist's Training and Techniques', in *Manners and Morals: Hogarth and British Painting 1700–1760*, exh. cat., Tate Gallery 1987, pp.19–28.

8. I am grateful to Elizabeth Einberg for this information.

9. M. Kitson (ed.), 'Hogarth's "Apology for Painters"', *Walpole Society*, vol.41, 1966–8, p.98.

10. G. Vertue, 'Notebook III', *Walpole Society*, vol.22, 1934, p.96.

11. A. Roy, 'Hogarth's "Marriage à la Mode" and Contemporary Painting Practice', in *National Gallery Technical Bulletin*, vol.6, 1982, p.65.

12. R. Jones, 'Drying Crackle in Early and Mid Eighteenth-Century British Painting', in *Appearance, Opinion and Change: Evaluating the Look of Paintings*, 1990, pp.50–2.

5 Thomas Gainsborough

1. *Tate Gallery 1984–86: Illustrated Catalogue of Acquisitions*, 1988, pp.68–9.

2. R. Jones, 'The Artists' Training and Techniques', in *Manners and Morals: Hogarth and British Painting 1700–1760*, exh. cat., Tate Gallery 1987, p.24.

3. W. Thornbury, *The Life and Correspondence of J.M.W. Turner, R.A*, 1877, repr. 1970, p.247. Thornbury's source of this information, 'Mr.Trimmer', was Joshua Kirby's great-grandson.

4. Jones 1987, pp.23–4.

5. R. Jones, 'Gainsborough's Materials and Methods', in *Young Gainsborough*, exh. cat., National Gallery 1997, pp.19–26, repr. in *Apollo*, Aug. 1997, pp.19–26.

6. A. Corri, 'Gainsborough's Early Career: New Documents and Two Portraits', *Burlington Magazine*, vol.125, 1983, pp.212–16.

7. S. Foister, 'Young Gainsborough and the English Taste for Dutch Landscape', in *Young Gainsborough*, exh. cat., National Gallery 1997, pp.3–10, repr. in *Apollo*, Aug. 1997, pp.3–10. The author cites the pioneering work of John Hayes in this context.

8. Ibid., pp.7–9.

9. Colourless glass has been found in the priming of Velazquez's *Forge of Vulcan*, see G. McKim-

Smith, G. Andersen-Bergdoll and R. Newman, *Examining Velazquez*, New Haven and London 1988, pp.89–90.

10. Jones 1997, p.25. Ground glass was used in various propriatory media for painting in the nineteenth century. See L. Carlyle, 'A Critical Analysis of Artists' Handbooks, Manuals and Treatises on Oil Painting published in Britain between 1800–1900', Ph.D. thesis, University of London 1991, pub. as *The Artists' Assistant*, 1998. See also C. Proudlove, 'The Early Norwich Artists: Their Technique and The Dutch Example', in A.W. Moore, *Dutch and Flemish Painting in Norfolk,* 1988, pp.151–6.

11. Analytical work in progress, Tate Gallery.

12. J. Kirby, 'Fading and Colour Change of Prussian Blue: Occurrences and Early Reports', *National Gallery Technical Bulletin*, vol.14, 1993, pp.62–71.

13. Ibid., p.67.

6 Joseph Wright of Derby

1. B. Nicolson, *Joseph Wright of Derby, Painter of Light*, 1968, vol.1, p.2.

2. J. Egerton, *Wright of Derby*, exh. cat., Tate Gallery 1990, pp.102–3.

3. R. Jones, 'Wright of Derby's Techniques of Painting', in Egerton 1990, pp.263–71, and R. Jones, 'Notes for Conservators on Wright of Derby's Technique and Studio Practice', *The Conservator*, no.15, 1991, pp.13–27. All other comparative technical information is from these studies.

4. Jones 1990, p.268.

5. Wright of Derby's Sitter Book in the Library and Archive of the National Portrait Gallery.

6. Egerton 1990, pp.168–9.

7. Nicolson 1968, II, p.269.

8. Ibid., I, p.116.

7 Sir Joshua Reynolds

1. N. Penny (ed.), *Reynolds*, exh. cat., Royal Academy of Arts 1986, pp.317–18.

2. J. Ingamells, *The Wallace Collection Catalogue of Pictures: I, British, German, Italian and Spanish*, 1985, pp.151–3.

3. Sir C.L. Eastlake, *Methods and Materials of Painting of the Great Schools and Masters (Materials for a History of Oil Painting)*, New York 1960, repr. of 1847 ed., II, p.207 n.

4. M.K. Talley, '"All Good Pictures Crack": Sir Joshua Reynolds's Practice and Studio', in Penny 1986, pp.55–70.

5. H. Dubois, 'Aspects of Sir Joshua Reynolds' Painting Technique: A Study of the Primary Sources with Reference to the Examination of Paintings', unpub. thesis, Hamilton Kerr Institute 1992–3. The first technical examination of this painting was done by Hélène Dubois and Rica Jones in preparation for this unpublished diploma thesis, which has been a major source of information during the current study of Reynolds, both for documentary and material evidence. See also B.A. Buckley, 'Sir Joshua Reynolds, The Ladies Amabel and Jemima Yorke', *Bulletin of the Cleveland Museum of Art*, vol.73, no.9, 1986, pp.350–71.

6. Transcribed in Dubois 1992–3 and also in M. Cormack, 'The Ledgers of Sir Joshua Reynolds', *Walpole Society*, vol.42, 1968–70, pp.105–69.

7. Talley 1986, p.67.

8. I am grateful to Hélène Dubois for this reference from B.R. Haydon's *Diary*, ed. W.B. Pope, Cambridge, Mass., 1960–3, V, p.578. Reynolds's influence on Haydon's technique is discussed in Talley 1986, pp.63–4.

8 William Blake

1. A. Gilchrist, *Life of William Blake*, London and Cambridge 1863, I, pp.36, 369.

2. Ibid., p.8.

3. Ibid., p.368.

4. Ibid., pp.368–9.

5. Ibid., pp.69, 368.

6. A. Maheux, 'An Analysis of the Watercolour Technique and Materials of William Blake', *Blake: An Illustrated Quarterly*, Spring 1984, pp.124–9.

7. R.N. Essick, *William Blake: Printmaker*, Princeton 1980, App. II.

8. Gilchrist 1863, I, p.38.

9. Maheux 1984, pp.124–9.

10. Gilchrist 1863, I, p.358.

11. S. Vallance, B. Singer, S. Hitchin and J. Townsend, 'The Development of Chromatographic Techniques for the Analysis of Artists' Paint Media', *Conservation Science 95*, postprints, 1998; S.L. Vallance, B.W. Singer, S.M. Hitchin and J. Townsend, 'The Analysis of Proteinaceous Artists' Media by High Performance Liquid Chromatography', *LC-GC International*, vol.10, no.1, 1996, pp.48–53; S.L. Vallance, B.W. Singer, S.M. Hitchin and J.H. Townsend, 'Development and Preliminary Application of a Gas Chromatographic Method for the Characterisation of Gum Media', *Journal of the American Institute for Conservation*, 1998.

9 J.M.W. Turner

1. M. Butlin and E. Joll, *The Paintings of J.M.W. Turner*, rev. ed., New Haven and London 1985 p.225.

2. Ibid., p.224.

3. Ibid.

4. J.H. Townsend, *Turner's Painting Techniques*, rev. ed., 1995

5. J.H. Townsend, 'The Materials of J.M.W. Turner: Primings and Supports', *Studies in Conservation*, vol.39, 1994, pp.145–53.

6. J.H. Townsend, 'Turner's Use of Materials, and Implications for Conservation', in *Turner's Painting Techniques in Context*, ed. J.H. Townsend 1995, pp.5–11.

7. J.H. Townsend, 'The Materials of J.M.W. Turner: Pigments', *Studies in Conservation*, vol.38, 1993, pp.231–54.

8. J.H. Townsend, 'Turner's Oil Paintings: Changes in Appearance', in *Colour, Appearance, Change: Evaluating the Look of Paintings*, 1990, pp.53–61.

9. L. Carlyle, 'Varnish Preparation and Practice 1750–1850', in Townsend 1995, pp.21–8.

10 John Everett Millais

1. W.H. Hunt, *Pre-Raphaelitism and the Pre-Raphaelite Brotherhood*, I, 1905, pp.237–46.

2. J. Bronkhurst, 'Ophelia', in *The Pre-Raphaelites*, exh. cat., Tate Gallery 1984.

3. Hunt 1905, I, pp.237–46.

4. Ibid., pp 247–8.

5. Sally Woodcock, pers. comm., Fitzwilliam Museum, Cambridge, MS.141-1993, p.261.

11 William Holman Hunt

1. *The Pre-Raphaelites*, exh. cat., Tate Gallery 1984.

2. W.H. Hunt, *Pre-Raphaelitism and the Pre-Raphaelite Brotherhood*, 2nd ed., I and II, 1913.

3. Sally Woodcock, pers. comm., Fitzwilliam Museum, Cambridge.

4. J.D. Batten (ed.), *Papers of the Society of Mural Decorators and Painters in Tempera*, II, 1907–24, pp.5–7, Brighton 1925.

5. Sally Woodcock, pers. comm., Fitzwilliam Museum, Cambridge, MS.327-1993, p.707.

6. Hunt 1913, p.339.

7. G. Field, *Rudiments of the Painter's Art or a Grammar of Colouring*, 1850, p.146.

8. M.R. Katz, 'William Holman Hunt and the "Pre-Raphaelite Technique"', *Historical Painting Techniques, Materials, and Studio Practice*, ed. A. Wallert, E. Hermans and M. Peek, Leiden 1995, pp.158–65. L. Sheldon, 'Methods and Materials of the Pre-Raphaelite circle in the 1850s', *Painting Techniques: History, Materials and Studio Practice*, I.I.C. (1998), pp.229–34.

12 James Abbott McNeill Whistler

1. E.R. and J. Pennell, *The Life of James McNeill Whistler*, 5th rev. ed., 1911, pp.34–5.

2. M. Menpes, *Whistler as I Knew Him*, 1904, pp.69–71.

3. Pennell 1911, p.160.

4. Margaret MacDonald, pers. comm., the Centre for Whistler Studies, University of Glasgow.

5. Pennell 1911, p.113.

6. Ibid.

7. Ibid.

8. Proposition no.2 in the *Ten O'Clock Lecture*, 1885.

9. S. Hackney, 'Art for Art's Sake: The Materials and Techniques of James McNeill Whistler (1834–1903)', in *Historical Painting Techniques, Materials and Studio Practice*, ed. A. Wallert, E. Hermans and M. Peek, Leiden 1995, pp.186–90.

10. H. Taylor, *James McNeill Whistler*, 1978, p.64.

11. A. McLaren Young, M.F. MacDonald, R. Spencer and H. Miles, *The Paintings of James McNeill Whistler*, New Haven and London 1980, pp.70–1.

13 George Frederic Watts

1. M.S. Watts, *George Frederic Watts: The Annals of an Artist's Life*, 1912, II, p.200.

2. Ibid., p.197.

3. Mrs R. Barrington, *G.F. Watts: Reminiscences*, New York 1905, p.29.

4. Ibid., p.30.

5. Ibid., p.86.

6. Watts 1912, II, p.197.
7. XRD results are consistent with plaster of Paris.
8. Mrs M.P. Merrifield, *Original Treatise on the Arts of Painting (manuscripts of Jehan Le Begue)*, 1849, repr. New York 1967, I, pp.92–3. In Merrifield's 1844 translation of *A Treatise on Painting*, written by Cennino Cennini, she does not specifically mention the use of plaster of Paris, but refers to the gesso as simply plaster. In another reference she refers to 'gesso marcio – plaster of Paris stirred with water until it loses its power of setting', p.cclxxxii and n.
9. B. Federspiel, 'Questions about Medieval Gesso Grounds', in *Historical Painting Techniques, Materials and Studio Practice*, ed. A. Wallert, E. Hermans and M. Peek, Leiden 1995, pp.58–64.
10. M.J.F.L. Merimée, *The Art of Painting in Oil and in Fresco: being a History of the Various Processes and Materials Employed, from its Discovery, by Hubert and John van Eyck, to the Present Time*, trans. from the original French treatise of M.J.F.L. Merimée, 1839, p.218.
11. Watts 1912, III, pp.56–60.
12. Barrington 1905, p.65.
13. Watts 1912, III, p.58.
14. Barrington 1905, p.66.
15. Ibid., p.76.
16. Barrington 1905, p.165–6.
17. Letters to his patron James Smith, transcribed by David Stewart, made available by kind permission of the Watts Gallery, Compton, and National Museums and Galleries on Merseyside.

14 John Singer Sargent

1. R. Ross, 'The Wertheimer Sargents', *Art Journal*, 1911, pp.1–10.
2. Ibid., p.7.
3. K. Adler, chap. 4, *The Jew in the Text*, ed. Linda Nochlin and Tamar Garb, 1995, p.84.
4. J. Ridge and J.H. Townsend, 'John Singer Sargent's Later Portraits: The Artist's Technique and Materials', *Apollo*, vol.148, no.439, 1998, pp.23–30.
5. R. Ormond and E. Kilmurray, *Sargent: Catalogue Raisonnée*, exh. cat., Tate Gallery 1998. We are grateful to both R. Ormond and E. Kilmurray for allowing us to see drafts of their catalogue of Sargent's paintings.
6. Ibid.
7. A. Zebala, 'An Investigation of John Singer Sargent's Murals "The Triumph of Religion" at the Boston Public Library', *Art Conservation Training Programs Conference*, 1988. Sargent's palette presented to the Royal Academy, London was analysed by Joyce Townsend.
8. J.H. Townsend, 'Whistler's Oil Painting Materials', *Burlington Magazine*, vol.136, 1994, pp.690–5.

15 Gwen John

1. National Library of Wales (NLW) 22278A fo.5^{r-v}, quoted in Cecily Langdale, *Gwen John*, 1987, p.21.

2. GJ to Ursula Tyrwhitt, postmarked 30 Sept. 1909, NLW 21468D fo.37r, quoted in Langdale 1987, p.139.
3. At least one of the portraits was sent to exhibition at the New English Art Club in 1910. *Nude Girl* was sold in 1911, while *Girl with Bare Shoulders* remained in the artist's studio until her death.
4. J. Hone, *The Life of Henry Tonks*, London and Toronto 1939, p.75.
5. TGA TAM 21C 8/22, microfiche of Michael Holroyd's Collection.
6. NLW 21468D fos.32v–3, postmarked 15th Feb. 1909, quoted in Langdale 1987, p.44.
7. Langdale 1987, p.32, fig.40.
8. Both Bourgeois Aîné and Lefranc marketed this size of canvas.
9. J.-G.Vibert, *The Science of Painting*, 1891, p.114. The 8th edition of Vibert was translated from the French by Percy Young in 1892. Percy Young was colourman to the Slade School, having his shop in 137 Gower St. His canvases were used by GJ (*Self Portrait* of 1902) so it is possible that GJ would have known of Vibert's work.
10. E.R. and J.Pennell, *The Life of James McNeill Whistler*, 1908, II, p.231.
11. Ibid., p.233.
12. Ibid., p.232.
13. Letter to John Quinn, 25 Jan. 1913, TGA 838.1. Correspondence now in the New York Public Library.

16 Duncan Grant

1. Scrapbook with undated newspaper cuttings, *Evening Standard*. TGA 7243.10.
2. F. Spalding, *Duncan Grant: A Biography*, 1997, p.110.
3. Minutes of the House Committee, 30 June 1911, as mentioned in F. Spalding, 'The Borough Polytechnic Decorations 1911', TGA 7025.1.
4. Borough Polytechnic Finance Report, 12 Dec. 1911, as mentioned in ibid.
5. Beginning at the end of the left-hand side wall as one entered the dining hall they were *The Zoo* by Roger Fry, *The Round Pond* by Bernard Adeney, *The Footballers* by Duncan Grant. The top end wall sported *The Fair* by Frederick Etchells, and continuing back down the right-hand wall were *The Paddlers* by Albert Rothenstein, *The Bathers* by Duncan Grant and *Punch and Judy* by Macdonald Gill.
6. D.B. Turnbaugh, *Private: The Erotic Art of Duncan Grant*, 1989.
7. Spalding, 'The Borough Polytechnic Decorations 1911', TGA 7025.1, p.3.
8. Conversations with David Brown in *Duncan Grant to 1920, The Basic Outline*, 11 Aug.–28 Sept. 1972, TGA 7241.1, p.5.
9. *Eye Witness*, 9 Nov. 1911, p.661, quoted in Spalding, 'The Borough Polytechnic Decorations 1911', TGA 7025.1, p.5.
10. Scrapbook with undated newspaper cuttings, *Morning Post*, 1911. TGA 7243.10.
11. Ibid.
12. Scrapbook with undated newspaper cuttings, article by C. Lewis Hind, untitled and undated. TGA 7243.10.

17 David Bomberg

1. W. Lipke, *David Bomberg: A Critical Study of his Life and Work*, 1967, pp.25–34.
2. D. Bomberg, 'The Bomberg Papers', ed. David Wright and Patrick Swift, X, *Quarterly Review*, vol.1, no.3, June 1960, p.185.
3. R. Cork, *Vorticism and Abstract Art in the First Machine Age*, I. Origins and Development, 1976, p.204.
4. R. Cork, *David Bomberg*, New Haven and London 1987, pp.82–7.
5. D. Bomberg, *Works by David Bomberg*, exh. cat., Chenil Gallery, July 1914.
6. *Daily Chronicle*, 25 June 1914.
7. Alice Mayes, private correspondence to Richard Cork, 17 July 1973, in Cork 1976, p.204.
8. Bomberg 1914.
9. Cork 1976, p.211.
10. R. Cork, *Poems and Drawings from the First World War, David Bomberg's War Poetry*, exh. cat., Gillian Jason Gallery, 1992, p.12.

18 Walter Sickert

1. Ethel Sands's archive of Sickert's letters, TGA 9125.
2. J.S. *Degas*, exh. cat., Metropolitan Museum of Art and National Gallery of Canada, 1988–9.
3. J. Rothenstein, *Modern English Painters*, I. Sickert to Lowry, rev. ed. 1984, pp.32–46.
4. Ethel Sands's archive.
5. W. Baron, *Sickert*, 1973, pp.131–48.
6. B. Dunstan RA, *The Painting Methods of the Impressionists*, New York 1976, pp.170–7.
7. Baron 1973, pp.131–48.
8. W. Baron and R. Shone, *Sickert*, exh. cat., Royal Academy of Arts 1992, p.252.
9. Baron and Shone 1992, pp.58–9.
10. A. Wilton, Tate Gallery Acquisition file.
11. Baron and Shone 1992, p.72; W.R. Sickert, 'Degas', *Burlington Magazine*, vol.31, no.176, Nov. 1917, pp.183–92.

19 Philip Wilson Steer

1. B. Laughton, *Philip Wilson Steer*, Oxford, 1972.
2. D.S. MacColl, *Life Work and Setting of Philip Wilson Steer*, 1945, pp.177–8.
3. Ibid., pp.87–8.
4. Ibid., p.109.
5. Ibid.
6. Ibid., p.110.
7. Ibid., p.109.

20 Stanley Spencer

1. J. Rothenstein, *Modern English Painters*, II. Nash to Bawden, 1984, p.119.
2. K. Bell, *Stanley Spencer: A Complete Catalogue of the Paintings*, 1992, pp.66–76.
3. *Stanley Spencer R.A.*, exh. cat., Royal Academy of Arts 1980, with contributions by R. Carline, A. Causey and K. Bell, p.92.
4. Ibid., pp.9–12.
5. Ibid., p.39.
6. M. Chamot, D. Farr and M. Butlin, *Tate Gallery Modern British Painting, Drawing And Sculpture Catalogue*, II. Artists M–Z, 1964, pp.661–2.

7. TGA 8419.1.12, letter from Spencer, dated 8 Feb. 1950. I am grateful to Adrian Glew for drawing attention to this letter.
8. Rothenstein 1984, p.96.
9. R. Carline, *Stanley Spencer at War*, 1978, p.166.
10. G. Spencer, *Stanley Spencer*, 1961, pp.175–6.
11. P. Elek, *Stanley Spencer the Man: Correspondence and Reminiscences by John Rothenstein*, 1979, p.125.
12. Carline 1978, p.161.
13. *Stanley Spencer, R.A.*, 1980, p.92.
14. T. Green, 'Surface Dirt Removal from Unvarnished Paint Films', *Dirt and Pictures Separated*, 1990, pp.51–5.
15. *Stanley Spencer, R.A.*, 1980, pp.19–29.

21 British School

1. K. Hearn, *Dynasties*, exh. cat., Tate Gallery 1995, p.63, pp.74–5.
2. D. Eckstein, T. Wazny, J. Bauch and P. Klein, 'New Evidence for the Dendrochronological Dating of Netherlandish Panels', *Nature*, vol.320, 1986, pp.465–6.
3. Hearn 1995, p.75.
4. Ibid.
5. S. Foister, 'The Production and Reproduction of Holbein's Portraits', in ibid., pp.21–6.

22 Sir Joshua Reynolds

1. C. Proudlove, 'The Early Norwich Artists: Their Techniques and the Dutch Example', in A.W. Moore, *Dutch and Flemish Painting in Norfolk*, 1988.
2. J. Egerton, *George Stubbs 1724–1806*, exh. cat., Tate Gallery 1984, p.97.
3. R. Jones, 'Notes for Conservators on Wright of Derby's Technique and Studio Practice', *The Conservator*, no.15, 1991, p.14.
4. N. Penny (ed.), *Reynolds*, exh. cat., Royal Academy 1986, pp.287–8.
5. H. Dubois, 'Aspects of Sir Joshua Reynolds' Painting Technique: A Study of the Primary Sources with Reference to the Examination of the Paintings', unpub. thesis, Hamilton Kerr Institute 1992–3, p.3. The notes are in the Ledgers at the Fitzwilliam Museum. See also this volume, pp.60–5.
6. D. Rice, 'Encaustic Painting', *The Dictionary of Art*, ed. J. Turner, x, 1996, pp.196–200. See also Dubois 1992–3, pp.34–9. The author makes reference to all the early papers on wax in painting.
7. Caylus and Majault, *Mémoire sur la peinture à l'encaustique et sur la peinture à la cire*, Geneva 1755.
8. J.H. Müntz, *Encaustic: or, Count Caylus's Method of Painting in the Manner of the Ancients*, 1760.
9. Graves and Cronin, *History of the Works of Sir Joshua Reynolds*, 1899–1901, III, pp.1020–1.
10. Caylus and Majault 1755, pp.53–60.
11. Ibid., pp.87–133.
12. Müntz 1760, pp.19–20.
13. Dubois 1992–3, App. II, p.6.
14. Ibid., App. I, p.7.
15. J. Mills and R. White, 'The Mediums used by George Stubbs: Some Further Studies', *National Gallery Technical Bulletin*, vol.9, 1985, pp.60–4.

16. M.K. Talley, '"All Good Pictures Crack", Sir Joshua Reynolds's Practice and Studio', in Penny 1986, p.63.
17. G.W. Fulcher, *Thomas Gainsborough*, 1856, p.151.

23 James Abbott McNeill Whistler

1. A. McLaren Young, M.F. MacDonald, R. Spencer and H. Miles, *The Paintings of James McNeill Whistler*, New Haven and London 1980, pp.63–4.
2. E.R. and J. Pennell, *The Life of James McNeill Whistler*, 5th rev. ed., 1911, p.110.
3. Ibid., p.115.
4. Ibid.
5. Sally Woodcock, pers. comm., Fitzwilliam Museum, Cambridge, MS.110-1993.
6. Ibid.
7. P. Wyer, 'Die Ludwigschen Petroleumfarben: die Verwendung von Petroleum in der Olmalerei', *Zeitschrift für Kunsttechnologie und Konservierung*, vol.7, no.2, 1993, pp.343–58.
8. D. Sutton, *Walter Sickert: A Biography*, 1976, p.39.
9. Pennell 1911, pp.114, 232.
10. M. Menpes, *Whistler as I Knew Him*, 1904, p.69.
11. Pennell 1911, p.115.
12. Ibid.
13. J.H. Townsend, 'Whistler's Oil Painting Materials', *Burlington Magazine*, vol.136, 1994, pp.690–5.

24 Ben Nicholson

1. BN, Notes on 'Abstract' Art -2, TGA 8717.3.1.7.
2. J. Lewison, *Ben Nicholson*, exh. cat., Tate Gallery 1993, p.40.
3. BN, *Studio International*, ed. Maurice Sausmarez, 1969, p.24.
4. BN, Notes on 'Abstract' Art -3, TGA 8717.3.1.7. Nicholson's adoption of relief carving is discussed at greater length in Lewison 1993.
5. BN to Tate Gallery, 13 Sept. 1958, Tate Gallery Records.
6. BN, Notes on 'Abstract' Art -2, TGA 8717.3.1.7.
7. BN to Ronald Alley, 14 Aug. 1962, Tate Gallery Records.
8. Wilhelmina Barns-Graham to Sir Alan Bowness, Director, Tate Gallery, 16 Jan. 1983, Tate Gallery Records.
9. BN to Norman Reid, Director, Tate Gallery, received 1 Sept. 1955. Tate Gallery Acquisition file, BN 1940–60, no.6764, Tate Gallery Records.
10. BN to Norman Reid, 15 Sept. 1955, Tate Gallery Acquisition file, BN 1940–60, no.6831, Tate Gallery Records.
11. Artist's statement in D. Baxandall, *Ben Nicholson*, 1962, p.2.
12. BN, 'Some comments about the framing of my work', letter to Tate Gallery, 28 June 1979, Tate Gallery Records.
13. Tate Gallery Acquisition file, BN 1940–60, no.6831, Tate Gallery Records.
14. BN to Christine Leback Sitwell, Tate Gallery, 3 Aug. 1979, Tate Gallery Records.
15. Anneliese Hoyer, Librarian and Curator of Prints, San Francisco Museum of Art, to Martin Butlin, Tate Gallery, 14 Oct. 1958, Tate Gallery Records.

16. J. Lewison, *Ben Nicholson: The Years of Experiment 1919–39*, Cambridge 1983, p.83.
17. W. Kandinsky, *Concerning the Spiritual in Art*, quoted in J. Lewison, *Ben Nicholson*, Oxford 1991, p.16.
18. BN in *Unit One* statement, quoted in Lewison 1991, p.16.

25 Alfred Wallis

1. *Western Morning News*, 3 Feb. 1938.
2. *St Ives Times*, 25 Feb. 1938, p.4.
3. M. Gale, *Alfred Wallis*, 1998. I am grateful to Dr Gale for letting me read the manuscript of his book.
4. Dr Roger Slack's tapes, 1960s. With thanks to Dr Slack for allowing access to his invaluable resource of taped interviews and recollections.
5. A.D. Wood, T.G. Linn, W. and A.K. Johnston, *Plywoods: Their Development, Manufacture and Application*, London and Edinburgh, rev. ed. 1950, pp.436, 469–73.
6. E. Mullins, *Alfred Wallis: Cornish Primitive Painter*, 1967, p.58.
7. B. Nicholson, *Horizon*, vol.7, no.37, 1943, p.53.
8. S. Berlin, *Alfred Wallis: Primitive*, 1949, p.66.
9. F.R.S. Yorke (ed.), *Specification 1949*, 1949, p.895.
10. Mullins 1967, p.58.
11. M. Mellis, in *Artists from Cornwall*, Bristol 1992, p.19.
12. Dr Slack, pers. comm., 19 Nov. 1997.
13. Dr Roger Slack's tapes, 1960s.
14. J. Turner, *Brushes: A Handbook for Artists and Artisans*, New York 1992.
15. Illustrated in Berlin 1949, fig.28.

26 Edward Wadsworth

1. EW correspondence, Tate Gallery Aquisition file, Tate Gallery Records.
2. Ibid.
3. TGA 7029.
4. M. Armfield, *A Manual of Egg Tempera Painting*, 1930.
5. J. Rothenstein, *Modern English Painters*, II, 3rd. ed., 1984.
6. C. Signy, 'Plywood and Its Use as a Painting Support', unpub. thesis, Courtauld Institute of Art, 1983; A.D. Wood, T.G. Linn, W. and A.K. Johnston, *Plywoods: Their Development, Manufacture and Application*, London and Edinburgh, rev. ed. 1950.
7. J. Dunkerton, 'Tempera Painting in England 1880–1950: Techniques and Conservation Problems', unpub. thesis, Courtauld Institute of Art, 1979.
8. TGA 7029.
9. Ibid.
10. B. Wadsworth, *Edward Wadsworth: A Painter's Life*, 1989.
11. Ibid.

27 Francis Bacon

1. J. Russell, *Francis Bacon*, London, Paris and Berlin, 1971.
2. D. Sylvester, *Interviews with Francis Bacon 1962–79*, 1980.
3. Sylvester 1980, p.66, interview 2, 1966.
4. Ibid., pp.17–18, interview 1, 1962.

5. Ibid., p.17, interview 1, 1962.
6. Ibid., p.18, interview 1, 1962.
7. R. Alley, *Francis Bacon Catalogue Raisonnée*, 1964, p.35.
8. Ibid., pp.259, 264.
9. Ibid., p.260. repr. p.259.
10. A. Durham, 'Note on Technique', in *Francis Bacon*, exh. cat., Tate Gallery 1985, pp.231–3.
11. Sylvester 1980, p.160, interview 7, 1979.
12. Ibid., p.20, interview 1, 1962.
13. Ibid., pp.38–40, interview 2, 1966.
14. M. Gale, 'Three Studies for Figures at the Base of a Crucifixion, c.1944', draft catalogue entry, Tate Gallery.

28 Peter Lanyon

1. PL, transcript of a talk 'Landscape Coast Journey and Painting', 1959, TGA TAV216AB.
2. Letter from Sheila Lanyon to David Brown, 12 Jan. 1983, Tate Gallery Records.
3. PL 1959, TGA TAV216AB.
4. D. Mulley, 'A Study of those Properties of Hardboard which are Relevant to its Use as a Painting Support', Internal Conservation Department Report, Tate Gallery.
5. PL, written document relating to *Saracinesco* of 1958.
6. Ibid.
7. PL, '*Offshore* in Progress', *Artscribe*, vol.34, 1982.
8. Ibid.

29 Thomas Jones

1. 'Memoirs of Thomas Jones', *Walpole Society*, vol.32, 1946–8, p.9.
2. Ibid.
3. Ibid., p.110.
4. Ibid., p.111.
5. F.W. Hawcroft, *Travels in Italy Based on the Memoirs of Thomas Jones*, Whitworth Art Gallery 1988, p.91, citing Anthony Blunt, 'Recorders of a Vanished Naples – 1. Thomas Jones', *Country Life*, 23 Aug. 1973, p.43.
6. Hawcroft 1988, pp.114–19.
7. I am grateful to Peter Bower for technical information on this handmade paper.
8. Hawcroft 1988, p.498.
9. 'Memoirs' 1946–8, p.84.
10. Extract from Jones's transcribed diaries, private collection. I am grateful to Judy Egerton for helping with access to these transcripts and Joseph Sharples for help with the Italian.
11. Ibid., 'Cose di comprare da Napoli / Latric at v a Carl & Oz – Vermil[n] at 2 carl & Oz / Roman brown otmer – Naples Yellow in quazzo – / Terra Nigra or Cologn [n] Earth – White 4 ib' ('otmer' is thought to be mistranscribed and should read ochre, 'quazzo' should be guazzo meaning gouache, 'Carl' is an abbreviation of Carline a unit of currency which according to Jones's conversion of currency approximated to 10d in British coinage).
12. Ibid.
13. P. Conisbee, 'Pre-Romantic Plein-Air Painting', *Art History*, vol.2, no.4, 1979, p.425.

30 John Constable

1. R.B. Beckett (ed.), *John Constable's Correspondence* : VI. *The Fishers*, Ipswich 1969, p.189.
2. L. Parris and I. Fleming-Williams, *Constable*, exh. cat., Tate Gallery 1991, pp.275–6 and see also pp.46–9 for general bibliography on John Constable. See also *Tate Gallery 1984–86: Illustrated Catalogue of Acquisitions*, 1988, pp.21–3.
3. S. Cove, 'Constable's Oil Painting Materials and Techniques' in Parris and Fleming-Williams, 1991, pp.493–529, and also 'Constable's Oil Sketches on Paper and Millboard', in *Institute of Paper Conservation Conference Papers*, 1992, pp.123–8. See also 'Mixing and Mingling: John Constable's Oil Paint Mediums c.1802–37, Including the Analysis of the 'Manton' Paint Box', *Painting Techniques, History, Materials and Studio Practice*, ed. A. Roy and P. Smith, 1998, pp.211–6.
4. R.D. Harley, *Artists' Pigments, c.1600–1835*, 1970, pp.91–2.
5. G. Field, *Chromatography; or, A Treatise on Colours and Pigments, and of their Powers in Painting*, 1835, pp.77–8.

GLOSSARY

Acrylic resin: modern synthetic paint and varnish medium used by artists in either gel or emulsion form, producing a flexible film when dry.

Age cracks: sharp-edged cracks in the paint and ground caused by embrittlement of the medium and dimensional changes in the support.

Alkyd resin: synthetic resin combined with drying oils and used as binding medium for household, industrial and artists' alkyd paints.

Alla prima: painted directly in one attempt, in contrast to paintings built up in several planned stages.

Amber: a fossil resin. The name was sometimes used in the nineteenth century for **Copal**.

Animal glue: water-soluble glue obtained from the hide, sinews or hoofs of animals. *See also* **Gelatine** and **Size**.

Artists' colourman: professional tradesman supplying materials for artists.

Asphaltum: *see* **Bitumen**.

Aureolin (cobalt yellow): yellow pigment (potassium cobaltinitrite) first introduced as an artists' colour in 1861.

Azurite: a blue pigment derived from the naturally occurring mineral of the same name. Basic copper carbonate. Known as bice in the sixteenth and seventeenth centuries.

Barytes: barium sulphate. Stable, white pigment used as an extender in paints and primings from the eighteenth century.

Binder: *see* **Medium**.

Binding medium: *see* **Medium**.

Bitumen: a naturally-occurring, non-drying, tarry substance used in paint mixtures, especially to enrich the appearance of dark tones.

Bladders: portable containers for prepared oil paint made from animal bladders. Used until the introduction of tubes in the nineteenth century.

Blind stretcher: an adjustable stretcher with panels inserted to provide continuous support and protection at the back of the canvas.

Bone black: a black pigment prepared from carbonised bone or ivory, composed principally of calcium phosphate and carbon.

Brown pink: a lake pigment made from a yellow vegetable dye (usually quercitron).

Burnisher: a tool used to polish a dried surface of paint or gold leaf.

Cadmium orange: a variant of **Cadmium yellow**.

Cadmium red: opaque, scarlet pigment made from cadmium sulpho-selenide, sold in London from the 1880s.

Cadmium yellow: cadmium sulphide, an opaque, bright yellow pigment available from the 1840s.

Camaïeu: a monochrome wash applied to the ground to define an area of the composition.

Camera lucida: an optical instrument, useful in daylight, with which an image may be projected on to a plane surface for tracing.

Canvas: a strong, woven cloth made traditionally from linen thread, though jute, hemp or cotton may also be used.

Cartoon: a full-size preparatory drawing from which the final work is traced or copied.

Casein: a protein-based adhesive derived from milk and milk products.

Cerulean blue: an opaque, greenish blue made of cobalt stannate and used from 1860. Also called coerulean blue.

Chain and laid lines: ribbed appearance in paper caused by the wires of the mould during manufacture.

Chalk: a naturally occurring mineral containing calcium carbonate or its manufactured equivalent.

Charcoal: a soft, black stick for drawing made by charring willow twigs.

Charcoal black: an opaque, bluish black pigment made by grinding charcoal.

Chiaroscuro: a depiction of space and form using strongly contrasted light and shade.

China clay: *see* **Kaolin**.

Chrome green: a manufactured mixture of Prussian blue and chrome yellow. To be distinguished from viridian and opaque oxide of chromium.

Chrome red: a range of opaque red pigments made from basic lead chromate. Bright red tones became available in the 1840s.

Chrome yellow: a range of opaque yellow pigments made from lead chromate. Not all stable, they were introduced in 1814.

Cobalt blue: an opaque blue, manufactured pigment made of cobalt aluminate, first invented in 1802 and used by artists soon afterwards.

Cologne earth: a brown, translucent pigment made from lignite. It contains much organic matter and iron oxide.

Copal: a fossilised tree resin. Sometimes referred to in the nineteenth century as amber.

Copper resinate: bright green, translucent paint made by combining copper compounds with natural resins and mixed with oil to form glazes. It often turns brown on prolonged exposure to light.

Crayon: drawing-stick composed of pigment bound in oil or wax.

Cusping: arcs of in-plane distortion in the weave at the edge of a canvas, caused when it was first held taut with tacks or cords for priming.

Dead-colouring: initial painted design, usually applied thinly in muted or monochrome tones.

Diluent: a volatile liquid used to thin down oil paint.

Distemper: an aqueous paint in which the binder is usually glue size.

Double canvas: a support consisting of two canvases, attached to the same stretcher, one over the other.

Drying of oil paint: rapid evaporation of solvent or diluent is followed by a long period of oxidation and cross-linking of the unsaturated fatty acid triglycerides that constitute oil.

Drier (siccative): a material added to oil in order to increase the rate of drying through oxidation and cross-linking of the molecules.

Drying cracks: visible cracks formed during the drying of paint. See fig.56, page 64.

Drying oil: a plant-derived oil which has the property of drying in air to form a tough film, namely linseed, walnut and poppy oils. In certain periods it may mean any of these oils to which a drier has been added.

Earth pigments: traditionally these are naturally occurring, iron oxide pigments varying in colour between red, yellow, orange and brown, usually only of moderate intensity. The class includes ochres, siennas and umbers. Artificial forms of ochre called Mars colours were made from the late eighteenth century.

Egg-oil emulsion: a medium made by combining egg yolk with a drying oil.

Egg tempera: *see* **Tempera**.

Emerald green: brilliant, opaque, bluish green made of copper aceto-arsenite. First made in Germany in 1814. It is highly poisonous.

Extender: a white or colourless pigment added to paint in order to make the pigment go further and to modify its handling qualities.

Fat: paint with a high medium content. *See also* **Lean**.

Filler: *see* **Extender**.

Flake white: *see* **Lead white**.

French ultramarine: blue artificial equivalent of natural ultramarine, first made in France in 1826–7.

Gamboge: a natural, translucent, strongly coloured, yellow resin exuded from trees in south-east Asia. Used more in watercolour than oil.

Gelatine: a refined form of animal glue.

Gesso: a white aqueous priming material. The word is Italian for **Gypsum**.

Gilding: the application of gold paint or gold leaf.

Glaze: a layer of translucent paint applied over an area to modify its colour or enrich its hue.

Glue size: *see* **Size**.

Gold leaf: the metal gold, beaten into leaves and applied to paintings and frames.

Golden section: the division of a straight line or plane figure such that the smaller is to the larger as the larger is to the whole.

Gouache: an opaque, aqueous paint.

Grain: *see* **Woodgrain**.

Graphite: soft, black, naturally occurring form of carbon; used in pencils.

Green earth: a semi-translucent, naturally occurring, green pigment.

Grinding of paint: the wetting and dispersing of pigments in a medium, using a slab and muller (see fig.174).

Grisaille: a technique of monochrome painting in shades of grey.

Ground: a field on which to paint, usually a lean, opaque paint applied as a single, unmodified colour to the support in readiness for painting.

Gum: water-soluble, carbohydrate-based, plant materials traditionally used as the binding medium for watercolour, gum arabic, gum tragacanth, gum karaya.

Gypsum: calcium sulphate dihydrate. An inert white extender used in paints and primings.

Hatching: see fig.168.

Heat-bodied: oil made thicker through heating to improve its drying qualities.

Hessian: coarse, woven fabric, usually jute, similar to sacking or burlap.

Household paint: paint made for decorators rather than for artists.

Impasto: thickly applied paint which stands out from the surface in relief.

Imprimatura: a thin layer of paint applied to the ground to modify its colour.

Indian yellow: bright, translucent yellow pigment originally manufactured from the urine of cows fed on mango leaves. Made synthetically since the late nineteenth century.

Indian red: a bright, opaque, slightly purplish red earth colour.

Intermediate varnish: a layer of varnish applied to the whole or part of a painted surface before continuing to paint.

Iodine scarlet: a scarlet pigment, mercuric iodide, manufactured from the early nineteenth century.

Ivory black: *see* **Bone black**.

Kaolin: also known as china clay or pipeclay, names derived from its principal uses. A transparent, finely divided, inert material (aluminium silicate), which has been used as an extender in paint and which also occurs naturally with certain pigments, for example ochres.

Lamp black: black pigment made from the soot from burning oils or resins.

Lake pigments: translucent pigments made by precipitating a dye onto a base such as aluminium hydrate. Lakes may be red, yellow or brown.

Lead-tin yellow: bright, opaque yellow pigment, the shade varying according to the temperature during manufacture by fusing together lead, tin and silica.

Lead white: basic lead carbonate, synthetically prepared for use as an opaque white pigment.

Lean: paint with low medium content.

Lemon yellow: bright, opaque yellow pigment made from either barium chromate or strontium chromate or any other yellow of a pale cool hue.

Light red: opaque earth colour made by calcining yellow ochre.

Lignin: a polymer occurring in certain plant cell walls, especially trees, making the plant rigid.

Linen: thread or woven cloth made from the flax plant.

Lining: a canvas attached with an adhesive to the back of a painting in order to reinforce the original canvas. The operation traditionally involves heat and pressure.

Linseed oil: oil extracted from flax seeds, which dries in air to form a tough, flexible film. Mixed with pigments to form oil paint.

Lithopone: fine, opaque white pigment made by co-precipitating zinc sulphide and barium sulphate. Patented in 1874. Used more commonly in household than artists' paints.

Loom: rigid wooden framework used for stretching fabric.

Madder: purplish red dye extracted from the madder plant (*Rubia tinctorum*) and used to make madder lake and rose pink.

Magilp: *see* **Megilp**.

Mahogany: fine-grained, tropical hardwood used for English furniture since the late seventeenth century and as a support for paintings, particularly in the nineteenth century.

Malachite: a green mineral, basic copper carbonate, similar to **Azurite**.

Mars colours: manufactured earth pigments.

Massicot: opaque, relatively pale yellow pigment made from monoxide of lead.

Mastic: resin from the tree *Pistacio lentiscus* made into a varnish by being dissolved in alcohol or turpentine.

Medium: a material that allows artistic expression and then captures it. For paints the medium is the liquid component that dries on application. *See also* **Paint**.

Megilp: a gelled medium made by mixing together mastic varnish and an oil prepared with a lead **Drier**. Further spellings, magilp, magylph, meguilp and meguilph.

Naples yellow: opaque yellow made from lead antimonate or, more recently, from a mixture of less toxic pigments to give a similar colour.

Natural resin: translucent solid secreted by trees. May be dissolved in organic solvents and used as a varnish or added to the paint medium.

Nut oil: *see* **Walnut oil**.

Oak: temperate hardwood from the group *Quercus* and used extensively as a support for paintings until the early decades of the seventeenth century.

Ochres: *see* **Earth pigments**.

Oil: *see* **Drying oil**.

Oiling out: an artists' technique whereby oil is rubbed sparingly into dried paint just before further paint is applied or after painting to rewet sunken areas.

Orpiment: richly toned yellow pigment (arsenic sulphide). Occurs naturally and was also manufactured. Still in use in the early nineteenth century.

Oxide of chromium: opaque, dull green, manufactured pigment (anhydrous oxide of chromium), in use by artists since the mid-nineteenth century.

Paint: a fluid or malleable substance consisting of coloured pigments in a binding medium, which dries in air to form a solid film. It may be modified with extenders, driers or thinners.

Paint shrinkage: *see* **Drying cracks**.

Palette: a board used for mixing colours; alternatively the range of colours typical of an artist's work.

Panel: a rigid support for painting on, traditionally made of joined planks of wood.

Paraloid B-72: very stable, colourless picture varnish made from acrylic resins.

Pastel: friable painting material in stick form, usually consisting of pigments, extenders and a minimal amount of medium, which can be gums, glues or oils.

Patent yellow: opaque yellow (lead oxychloride), first made in the 1770s.

Pencil: a drawing implement of graphite mounted in wood or, in the eighteenth century, a small paint brush.

Pentimento: an area of a painting which can now be seen to have been altered by the artist.

Perspex: transparent, rigid, plastic sheeting, polymethyl methacrylate. Also known as Plexiglas.

Phthalocyanine blue (also called Monastral blue or Mona blue: organic blue dyestuff, copper phthalocyanine. Semi-translucent, slightly greenish blue, introduced commercially in 1936.

Pigment: small coloured particles ground with the medium to form paint.

Pipeclay: *see* **Kaolin**.

Plain-woven: the simplest type of weaving, one up and one down in both directions. Also known as tabby weave.

Plaster of Paris: a white powder (usually calcium sulphate hemihydrate) which when mixed with water forms fully hydrated calcium sulphate, a white solid.

Poppy oil (also called poppyseed oil): drying oil extracted from the seeds of the opium poppy (*Papaver somniferum*). It yellows less than linseed oil but takes longer to dry and forms a less hard paint film.

Potters' coral: stannic or other metallic oxides used mainly in ceramics and fresco; permanent but of low tinctorial strength.

Priming: the application of size and/or the ground to a support to prepare the surface for painting.

Prussian blue: semi-translucent, intensely coloured, slightly greenish blue pigment first advertised for sale in Berlin in 1710. It is ferric ferrocyanide.

Quartz: *see* **Silica**.

Red lead: very bright, opaque, orangey red pigment (tetroxide of lead).

Refractive index: the degree to which rays of light are bent while passing through a transparent substance. A pigment with a comparatively low refractive index similar to that of oil, e.g. chalk, appears transparent in an oil medium, while one with a high refractive index, such as lead white, appears opaque.

Scumble: very thin layer of opaque paint which partially hides the layer beneath, frequently lighter in tone.

Sepia: black or dark brown secretion from the ink-bag of the cuttle-fish.

Sgraffito: the partial scraping away of the top layer of paint to reveal a differently coloured substrate as part of the design.

Siccative: *see* **Drier**.

Sienna: translucent yellow ochre. Burnt sienna is made by burning raw sienna and is browner in tone.

Silica: silicon dioxide, occurring naturally as quartz or sand and found as an impurity with earth pigments. A major component of glass.

Silver leaf: the metal beaten into leaves and applied to paintings and frames.

Size: traditionally a weak solution of animal glue used in the priming of canvas and panels, but may also be made from other adhesives.

Smalt: potash glass coloured blue by fusing with cobalt oxide and ground up to form a pigment. Used in painting from the late fifteenth century, eventually falling out of use during the nineteenth century after synthetic ultramarine became available. Pale grades were also used as drying or bulking agents in oil paint.

Squaring up: A method of transferring a drawing to another surface on a different (larger) scale. A grid of lines is drawn on both surfaces and each block is copied free-hand onto the new surface.

Stand oil: *see* **Heat-bodied oil**.

Stearates: naturally occurring components of drying oils which may also be added to tube paints to improve their storage properties.

Strainer: a fixed wooden framework to which canvas is attached for painting.

Stretcher: an expandable framework, traditionally made of wood, to which canvas is attached for painting.

Strip-lining: the reinforcement of a painting's tacking edges with strips of fabric and an adhesive.

Strontium yellow: a lemon-coloured pigment, strontium chromate.

Studio: the room in which an artist works; alternatively the group of assistants or apprentices working with him and using the same style and techniques.

Sulphur: a naturally occurring yellow mineral of volcanic origin.

Support: solid or flexible surface for painting on.

Synthetic resin: man-made resins chemically distinct from natural resins. Used as picture varnishes and also as binding media in modern paints, for example alkyd and acrylic resins.

Tack-holes: holes in the canvas made by the tacks used for fixing it to the stretcher or strainer.

Tacking edge: the outside edge or margins of a stretched canvas into which tacks are inserted to fix it to the stretcher or strainer.

Talc: white extender, magnesium silicate.

Tempera: literally any binding medium but, in the period covered by this book, an aqueous binding medium such as egg, glue or gum.

Template: A single drawing prepared for multiple reproduction by various means and used by the artist or his studio.

Thinner: *see* **Diluent**.

Thixotropic: the property whereby a material will flow under stress but retain the resulting form when the stress is removed.

Titanium white: bright, opaque white pigment (titanium dioxide) which came into use as an artists' material in the early twentieth century.

'Tooth': a deliberate roughening of a surface in order to give greater purchase to the artist's brush.

Turpentine: a volatile liquid distilled from the resin exuded from pine trees and used as a thinner or diluent in painting.

Ultramarine ash: a very palely coloured grade of natural ultramarine.

Ultramarine blue, natural: a fine quality, expensive pure blue pigment extracted from the semi-precious stone, lapis lazuli.

Ultramarine blue, synthetic (also called French ultramarine): chemically identical to natural ultramarine, first produced in France in 1826–7 and manufactured ever since. Inexpensive compared to the natural variety.

Umber: dark brown earth pigments which contain manganese dioxide as well as iron oxides. Raw umber has a greenish undertone; when it is heated in a furnace, burnt umber is produced, which has a warmer tone.

Underbound: paint formulated with insufficient medium or made leaner when an artist extracts some of the medium, for example by painting on to an absorbent ground or by leaving his paint on blotting paper before painting.

Underdrawing: preliminary drawing subsequently covered by painting.

Underpainting: preliminary application of paint in a composition. Known as **Dead-colouring** when it is in monochrome or in muted naturalistic tones.

Vandyke brown: the name given to **Cologne earth** since the late eighteenth century.

Varnish: a transparent, resinous, usually glossy coating given to paintings after they are finished to protect them and also to saturate the colours. Varnishes containing natural resins turn yellow and become less transparent with age. Some synthetic resins do not. *See also* **Intermediate varnish**.

Venetian red: a brick-red earth colour of natural or synthetic origin.

Verdigris: opaque green pigment, an acetate or carbonate of copper.

Vermilion: bright, opaque red pigment which occurs naturally as cinnabar, mercuric sulphide, and has been manufactured for many centuries.

Viridian: deep, transparent green pigment, hydrated chromic oxide, discovered in the 1830s, but not widely available until the 1860s.

Walnut oil: a drying oil extracted from common walnuts. It yellows less than linseed oil but takes longer to dry. It was recommended for use with light-coloured paint.

Wash: a thin coat of diluted paint.

Watercolour: a technique using thin washes of translucent, aqueous paint, which is usually applied to a light-toned, absorbent ground.

Wax: soft, translucent substance with a low melting point. Beeswax is the most common of the waxes, and is obtained from the honeycomb of the common bee. Spermaceti wax, which is whiter and has a lower melting point, was derived from the sperm whale.

Wet ground: *see* **Wet-in-wet**.

Wet-in-wet: the application of one colour next to or on to another, before the first has dried, so that some disturbance of the earlier application can occur.

Whiting: finely powdered calcium carbonate or calcium sulphate.

Yellow ochre: generally opaque yellow earth pigment. Historically known also as light yellow.

Zinc oxide: *see* **Zinc white**.

Zinc white: an opaque, cool white, manufactured pigment, zinc oxide. Introduced as a watercolour pigment in 1834, it was produced in a suitable form for oil painting in the 1850s.

Zinc yellow: bright, lemon yellow manufactured pigment, zinc chromate, available from the mid-nineteenth century.

These definitions have been kept as concise as possible and relate to the usages found in this book. Further definitions may be found in the following publications: D. Bomford, C. Brown and A. Roy, *Art in the Making: Rembrandt*, 1988; D. Bomford, J. Dunkerton, D. Gordon and A. Roy, *Art in the Making: Italian Painting before 1400*, 1989; D. Bomford, J. Kirby, J. Leighton and A. Roy, *Art in the Making: Impressionism*, 1990; R.J. Gettens and J.R. Stout, *Painting Materials: A Short Encyclopaedia*, New York 1966; S. Hackney (ed.), *Completing the Picture*, 1982; R.D. Harley, *Artists' Pigments c.1600–1835: A Study in English Documentary Sources*, 1982.

CREDITS

The publishers have made every effort to trace all the relevant copyright holders and apologise for any omissions that may have been made.

Text Credits

Roberson Archive papers quoted by permission of the Syndics of the Fitzwilliam Museum to whom rights in this publication are assigned.

Artists' Copyright Credits

Francis Bacon © Estate of Francis Bacon
ARS, NY, & DACS, London 1998

Gwen John © Estate of Gwen John 1998 All rights reserved
DACS

Ben Nicholson © Angela Verren-Taunt 1998 All rights
reserved DACS

Walter Sickert © Estate of Walter Sickert 1998 All rights
reserved DACS

Stanley Spencer © Estate of Stanley Spencer 1998 All rights
reserved DACS

Edward Wadsworth © Estate of Edward Wadsworth 1998 All
rights reserved DACS

Photographic Credits

Photographs of microscopic details were provided by the authors of the respective chapters unless specified otherwise.

fig.4 Reproduced courtesy of the Trustees of the National Gallery, London.

fig.11 Spike Bucklow of the Hamilton Kerr Institute.

fig.27 The British Museum, London.

fig.33 Courtesy of The National Portrait Gallery, London.

fig.36 Dr Aviva Burnstock of the Courtauld Institute of Art (formerly of the National Gallery).

fig.42 Dr Ashok Roy of the National Gallery.

fig.51 The Wallace Collection.

fig.66 Reproduced by permission of the Ruskin Gallery, Collection of the Guild of St George, Sheffield.

fig.85 Reproduced courtesy of the Trustees of the Watts Gallery, Compton. Photograph by Frank Hollyer.

figs.87, 88 Reproduced courtesy of the Trustees of the Watts Gallery, Compton.

fig.98 © 1998 The Museum of Modern Art, New York.

figs.110, 112, 113 Reproduced from R. Cork, *Vorticism and Abstract Art in the First Machine Age*, Gordon Fraser, 1976.

fig.117 Collection Peter Booth.

fig.119 Walker Art Gallery, NMGM.

fig.124 Reproduced from J. Hone, *The Life of Henry Tonks*, 1939, by permission of Heinemann Ltd.

fig.125 Reproduced from D.S. MacColl, *Life, Work and Setting of Philip Wilson Steer*, Faber and Faber Ltd., 1945.

fig.130 National Museum of Wales.

fig.136 Reproduced courtesy of the Statens Museum for Kunst, Copenhagen. Photograph by Hans Petersen.

fig.146 Kindly supplied by Tom Pocock.

fig.150 © Hunterian Art Gallery, University of Glasgow.

fig.158 © N. Pollard.

fig.159 Collection M. Bustin.

fig.161 Collection R. Slack.

fig.167 Reproduced from *Unit One*, ed. Herbert Read, Macmillan Inc. 1934, p.96.

figs.173, 174 Reproduced by permission of Sheila Lanyon. Photographs by David Hughes.

fig.185 Reproduced courtesy of the Statens Museum for Kunst, Copenhagen. Photograph by Hans Petersen.

INDEX